S0-BZT-123

An Introduction to
VISUAL
Communication

Susan B. Barnes
General Editor

Vol. 2

The Visual Communication series
is part of the Peter Lang Media and Communication list.
Every volume is peer reviewed and meets
the highest quality standards for content and production.

PETER LANG
New York • Washington, D.C./Baltimore • Bern
Frankfurt • Berlin • Brussels • Vienna • Oxford

SUSAN B. BARNES

An Introduction to

VISUAL

Communication

From Cave Art to Second Life

PETER LANG
New York • Washington, D.C./Baltimore • Bern
Frankfurt • Berlin • Brussels • Vienna • Oxford

Library of Congress Cataloging-in-Publication Data

Barnes, Susan B.
An introduction to visual communication:
from cave art to second life / Susan B. Barnes.
p. cm. — (Visual communication; v. 2)
Includes bibliographical references and index.
1. Visual communication. I. Title.
P93.5.B38 302.2'22—dc23 2011028980
ISBN 978-1-4331-1258-4 (hardcover)
ISBN 978-1-4331-1257-7 (paperback)
ISBN 978-1-4539-0146-5 (e-book)
ISSN 2153-277X

Bibliographic information published by **Die Deutsche Nationalbibliothek**.
Die Deutsche Nationalbibliothek lists this publication in the "Deutsche
Nationalbibliografie"; detailed bibliographic data is available
on the Internet at http://dnb.d-nb.de/.

The paper in this book meets the guidelines for permanence and durability
of the Committee on Production Guidelines for Book Longevity
of the Council of Library Resources.

© 2011 Peter Lang Publishing, Inc., New York
29 Broadway, 18th floor, New York, NY 10006
www.peterlang.com

All rights reserved.
Reprint or reproduction, even partially, in all forms such as microfilm,
xerography, microfiche, microcard, and offset strictly prohibited.

Printed in the United States of America

☀ Contents

☀ Acknowledgments

This book is dedicated to Neil Postman, an amazing scholar, who never completely understood visual communication, although he was able to critique it.

No book is ever completed without assistance from others. First, I would like to thank The College of Liberal Arts at the Rochester Institute of Technology for funding my graduate assistant, Bonnie McCracken. I would like to thank her for her work on helping me prepare this manuscript. Second, the reviewer of the text needs my thanks for providing helpful suggestions. Finally, I want to thank Mary Savigar for believing in this project when other editors did not. This book has been a ten-year process. So, I give a special thanks to everyone that helped along the way.

☀ Introduction

Technological changes have radically altered the ways in which people use visual images and the role they play in contemporary culture. Since the invention of photography, imagery has increasingly been used for the purposes of entertainment, journalism, information, medical diagnostics, instruction, and communication. These functions move the image beyond aesthetic issues associated with art and into the realm of communication studies.

Besides technological change, theories relating to the nature of symbolism, such as Suzanne Langer's *Philosophy in a New Key* (1957) and Nelson Goodman's *Languages of Art* (1968), combined with the cognitive theories of Jean Piaget (1971) and Jerome Bruner (1966), have fostered new ways of thinking about how visual images are used in cognitive development. Of particular importance is the work being done at Harvard's Project Zero, founded by Nelson Goodman and later directed by Howard Gardner. Gardner's research on cognitive approaches to creativity has provided an important insight into how the mind works, and his theories challenge the notion that language and logical symbol systems take priority over other types of expressive and communicative ones. For instance, Gardner's (1983) notion of "multiple intelligences" does not privilege one mode of communication over another. By moving abilities such as spatial and bodily-kinesthetic intelligences out of the domain of artistic talent and into the realm of cognitive experience, an argument can be made for the development of instructional techniques that enhance visual thinking.

A further argument for the study of visual communication can be found in both the historical and contemporary development of interfaces designed for computer-based communication. The original development of graphical user interfaces, such as Windows and the Macintosh, was based on the work of Piaget and Bruner. These interfaces combine visual and verbal symbol systems together to create what J. David Bolter (1991) called a *new picture writing*: "Reorganizing and activating [iconic] elements *is* writing, just as putting alphabetic characters in a row is writing" (p. 51).

In addition to developing new symbol systems, interface researchers Byron Reeves and Clifford Nass (1996) discovered that people often respond to media in similar ways in which they react to people and places. Although this notion may seem strange, consider how many people who live alone watch television while they eat. Or, think about the ways in which people talk about their computers. Similarly, Joshua Meyrowitz's (1985) research on television and space, Gumpert and Cathcart's (1986) seminal book *Intermedia,* and current theories relating to the Internet presented in Strate, Jacobson, and Gibson's (1996) *Communication and Cyberspace* described the blurring boundaries between physical space and mediated cyberspace.

Of growing importance in the contemporary media landscape is visual communication. Contemporary culture is dominated by visual imagery, especially images created, distributed, and consumed through digital technologies. This has led many scholars to argue that contemporary culture is a visual one. Nicholas Mirzoeff (1998) defines visual culture as a concern with visual events in which individuals seek information and meaning through interaction with a visual technology, including magazines, television, computer screens, and virtual reality. In contrast to this trend, Western culture has tended to privilege the spoken and written word as the highest form of intellectual practice. Visual representations have tended to be viewed as talents rather than forms of intelligence. But, the widespread usage of visual imagery is currently challenging the hegemony of the word. As a result, the study of visual forms of communication is more important than ever.

Scholars have recognized the changing role of visual imagery in culture. For example, E. H. Gombrich (1999) asserted that there is an overriding demand for images in Western culture. For instance, homes that lack television sets are considered deprived. He argues that the relationship between image and society can be viewed as an ecological system—social situations influence image making and vice versa. According to Gombrich (1999), this interplay can be compared to "the influence of the environment on the various forms of life" (p. 10). Visual society could be considered an *ecological niche* that favors visual forms of communication over verbal ones. However, this preference does not necessarily mean that visual symbols totally replace verbal ones, but rather, the visual takes center stage and words are used to support the image. For example, the captions associated with photojournalism help to shape the ways in which viewers interpret the photographs.

There is no grand theory about visual communication. Different authors use various theoretical references. For example, in *Visual Communication: Images with Messages,* Paul Lester (2011) utilized Aldous Huxley as a theoretical framework. In *Practices of Looking* (2001) Marita Sturken and Lisa Cartwright draw on theories of cultural studies, and in the book *Handbook of Visual Communication* (2005) Smith, Moriarty, Barbatsis & Kenney present a number of different approaches to the study of visual communication, including aesthetics, perception, representation, visual rhetoric, cognition, semiotics, reception theory, narrative, media aesthetics, ethics, visual literacy, and cultural studies. The overall theoretical foundation for this book is based on media ecology, the study of technology and cultural change and the foundations for the development of digital technology. Neil Postman, the founder of the media ecological tradition, considered himself to be a "visual moron." However, he did teach the works of Suzanne Langer as part of his program. In contrast, Neil's friend, Alan Kay, the developer of graphical user interfaces, was attempting to create a visual language for computers. What Postman and Kay share in common is a theoretical grounding in works by psychologists, philosophers, and Marshall McLuhan. As a result, the thinking of media ecologists and the developer of graphical interfaces, which made the computer a visual medium, are similar. This book describes the theoretical and historical backgrounds of visual media along with some of the cultural changes occurring with the introduction of digital media into society.

As media become increasingly visual, a challenge facing the study of visual communication is the multiple levels of meanings associated with visual symbols. Goodman (1978) contended that the way in which one understands a symbol depends upon the setting in which it is encountered and the graphic context that surrounds it. Moreover, the particular mind of the viewer plays an important role in symbol interpretation. To date, we have no single theory regarding the interpretation of visual imagery. Instead, we have a variety of theories that have developed from the diverse disciplines of art history, cognitive theory, communication theory, cultural theory, feminist studies, graphic design, literary theory, semiotics, and psychology. These different approaches have been applied to a variety of forms of visual communication. For example, the semiotic approach has been widely used for the

study of photography and film. Zettl's (1990) approach, grounded in the artistic theories of Kandinsky and the historical Bauhaus movement, can be applied to video imagery. In contrast, graphic designers have established their own set of principles. Additionally, new theories are emerging for the study of digital forms of visual communication (see Bolter and Grusin, 1999). Although certain theories are often associated with particular visual media, many of these ideas can be applied to other media. For example, various visual theories could be applied to the World Wide Web, which supports both personal web pages and the distribution of microcinema. Consequently, this text does not attempt to propose one "grand theory" of visual communication, but rather, it attempts to present an overview of many theoretical approaches and ideas that have guided researchers in the analysis of visual symbols, their meaning, and their relationship to culture. As James Carey (1989) asserts, "Communication is a symbolic process whereby reality is produced, maintained, repaired, and transformed" (p. 23). In contemporary communication environments, visual symbols are becoming a predominant form of cultural expression; as a result, the production, distribution, and reception of visual messages should be studied as an integral part of the communication discipline.

OVERVIEW OF THE BOOK

The first chapter of this book defines visual communication and examines the relationship between visual communication theory and cognitive science. The remainder of the book is divided into three parts: Part I: Developing Visual Literacy Skills, Part II: Understanding Visual Media, and Part III: Visual Communication in Cultural Contexts. Because there are more chapters than weeks in a semester, teachers can pick and choose which chapters to study. For example, Chapters 1–6, 8, 9, and 11 are recommended for a focus on Visual Literacy. Digital media are featured in Chapters 1, 3, 4, 6, 8, 11, and 12. For more of a media focus, Chapters 7–11 describe specific types of media. For the cultural perspective, Chapters 1, 3, 4, 6, 8, 13, and 14 discuss culture. However, most chapters have a section on digital technology and cultural change.

There are special features in the book. First, a number of "Boxed Topics" are included that enable artists, designers, and scholars to speak about their own works. Terms and websites are noted at the end of each chapter, along with suggestions for student exercises. Finally, during the course of the research for this book, a number of YouTube videos were located that illustrate the designer, developer, or concept being discussed in the book. These video addresses are provided with key terms to help find them at YouTube (http://www.youtube.com). This book introduces students to visual literacy terminology, methods for analyzing visual media, and theories on the relationship between visual communication and culture. By exploring both the meanings associated with visual symbols and the relationship of visual communication to culture, the goal of this book is to provide students with methods to better understand the visually oriented world in which they live.

☀ Digital Visual Communication Theory

Visual communication is a fundamental human experience. Visual symbolism originates at the dawn of civilization to meet the need for human expression and since has played an integral role in culture and communication. We use imagery for a variety of reasons, including the expression of cosmic anguish, the urge to play, art for art's sake, and the desire to represent the physical world in an imaginary virtual one. In primitive times, humans visualized their relationship to the world through animal drawings and symbols. Their prehistoric cave paintings portray their relationships to their environment that provides insight into primitive attitudes toward the cosmos, humankind, and eternal values. Similarly, the visual images in today's culture reflect our own current values, beliefs, and attitudes toward our own environment. The persistence and ubiquity of visual symbols clearly shows their importance to cultures throughout history, but these same qualities make the study of visual communication seem daunting. The best place to begin, then, is with the most basic question: What is visual communication?

DEFINING VISUAL COMMUNICATION

Currently, visual communication is so pervasive in our lives that we often take it for granted. In fact, many books on the subject forget to define the term itself. Therefore, we must first look to a general description of human communication to define visual communication. According to Gumpert and Cathcart (1986), "Traditionally human communication has been viewed as a speaker saying something to a listener" (p. 17). This is a simple sender-message-receiver view of communication adapted in many ways, for example, speaker-message-audience or actor-performance-audience. "Even with the development of the printing press, radio, film, and television, we have continued to look upon human communication as basically one human being directing words and gestures at another human being" (Gumpert & Cathcart, 1986, p. 17). However, mass media messages, such as advertising and film, are often created by groups of people or organizations rather than one person. In these instances, the speaker is an organization sending a message to an audience.

Included in any general description of human communication would be the visual aspect of it. However, visual communication itself focuses on understanding the composition and interpretation

Figure 1-1: Drawing from a piece of cave art of three animals moving in a circular composition. Author's illustration.

of visual messages created through any type of medium: paint, crayons, pencils, cameras, computers, and others. Visual messages can be distributed through individual sheets of paper, clothing, photographs, newspapers, magazines, signs, billboards, television, movies, video games, the World Wide Web, YouTube, and visual blogs.

Today's environment is filled with so many different visual media that it is difficult to list them all. The messages distributed through these media vary a great deal. Some messages are designed to help us

navigate our natural environment, such as traffic signs or GPS systems. Others are developed to support our social and economic institutions; for instance, advertising is created to sell products and services. Still other visual messages, like greeting cards and children's drawings, share personal feelings with the ones we love and when we combine these ideas together, we can define visual communication as the process through which individuals—in relationships, organizations, and cultures—interpret and create visual messages in response to their environment, one another, and social structures.

Figure 1–2: Course Party in Second Life (Barnes & Hair Advertising Course).

With this definition in mind, we can now understand how visual communication developed into a subject of study. The widespread use of television, which brought to our attention how individuals communicate visually, became a major topic of discussion in the 1970s. At that time, John L. Debes (1970) coined the term *visual literacy* and he organized the first national conference:

> Visual literacy refers to a group of vision competencies a human being can develop by seeing…. The development of these competencies is fundamental to normal human learning. When developed, they enable a visually literate person to discriminate and interpret the visible actions, objects and/or symbols, natural or man-made, that he encounters in his environment. Through the creative use of these competencies, he is able to communicate with others. Through the appreciative use of these competencies, he is able to comprehend and enjoy the masterworks of visual communications. (p. 14)

Visual literacy is a requirement for the understanding of visual communication and its visual messages. Moreover, becoming visually literate makes people more resistant to the manipulation and visual persuasion embedded in TV commercials, political campaigns, and advertisements. By learning about the devices and conventions used by the media industries to develop image-oriented messages, individuals can become aware of how meaning is created and they are less likely to uncritically accept visual messages. Moreover, learning to "read" visual conventions and developing a vocabulary in which to discuss visual information helps individuals to better analyze and critique today's increasingly mediated visual world.

VISUAL COMMUNICATION THEORY

During this past century, the work of many American scholars has contributed to our understanding of visual communication, including Nelson Goodman (1978) Suzanne Langer (1953, 1957), Jean Piaget (1971), Jerome Bruner (1966, 1986, 1990), and Howard Gardner(1983, 1993, 1999). Goodman's philosophical work on media and symbol systems has contributed to our understanding of nonlinguistic symbols. He identifies two types of symbol systems: notational and nonnotational. Notational systems have a unique set of separate characters that isolate the object or objects for which they stand. For example, the words in a language represent people, places, and things, and individual words are combined into sentences, paragraphs, and pages of text. Similarly, the notes written on a musical score represent sounds, and the separate notes can be combined in any number of different ways to create a musical composition. Simply stated, notational symbol systems can be broken down into smaller components. In contrast, nonnotational symbol systems cannot be broken down because the image cannot

be divided into separate parts. Take, for example, the simple image of a smiley face. If the dots of the eyes were removed from the circle, they would lose their meaning as eyes because it is the relationship between all of the visual elements in a smiley face that communicates the idea of a face.

Philosopher Suzanne Langer makes a distinction between notational and denotational symbol systems. However, she uses the terms discursive and presentational forms instead of notational and nonnotational. Discursive forms, such as language and math, are composed of digital symbols or symbols that have an arbitrary relationships to the objects they represent, which is similar to notational symbols. For example, the words c-a-t- and g-a-t-o are arbitrary letter combinations that represent the same small furry animal. In contrast, presentational forms are not composed of arbitrary symbols because they represent their objects or call them to mind. Presentational forms include drawings, paintings, photographs, and dance. Analog symbols represent in their form important characteristics about the objects for which they stand. In communication theory, symbols that contain characteristics of their referents are called analogic because they are analogous or similar to what they represent. For example, road maps, portraits, and photographs are similar to the objects and people that they portray. Often, analogic symbols represent the structure of relations among parts of an object abstracted by the mind. For instance, the smiley face "brings to mind a human face, not because real human faces are composed of three black dots and a curve, but because the structural relationship among the dots and the curve in the symbol corresponds to the structural relationship among eyes, nose, and mouth that the mind abstracts from the sensory perception of human faces" (Nystrom, 2000, p. 28). In contrast, digital symbols are arbitrary because there is no relationship between the symbol and the object it represents. Language is an example of a digital symbol system because words do not "look" like the objects to which they refer. Moreover, there is no particular reason why the letters f-a-c-e were combined together to denote a particular part of the human body.

Figure 1–3: Analog and Digital Communication. Author's illustration.

Constructivist View

Besides developing a theory about symbol systems, Goodman argued for a constructivist philosophy that could be applied to science, art, and cognition. Constructivists believe "that contrary to common sense there is no unique 'real world' that preexists and is independent of human mental activity and human symbolic language; that what we call the world is a product of some mind whose symbolic procedures construct the world" (Bruner, 1986, p. 95). According to this view, perception occurs only within an individual's set of symbol systems. Bruner, Gombrich, and many others, who have examined the nature of visual communication, share this idea. For Goodman, the activity of world making is a complex and diverse set of actions that involve language and other symbol systems. Much of what we know, do, and understand in the arts and daily life involves the use, interpretation, application, invention, and revision of symbol systems. Moreover, Goodman asserts that the understanding of symbol systems is heavily dependent upon customs and culture. For example, language (a notational and digital symbol system) requires a person to know the language being used. Similarly, art (a denotational and analog symbol system) is understood in terms of a person's culture.

E. H. Gombrich (1969, 1972), in his research on visual representation, contended that social forces influence the creation and understanding of pictorial imagery. He argues that a correct reading of an image depends upon three variables: the code, the caption, and the context. Codes are the structures of a message that enable it to be transmitted. For example, words are the code of language and the code in digital computer systems is binary math. Any image created, scanned, or edited on a computer is first turned into a binary code before it can be sent across a network or output on a printer. In addition, all images distributed through the World Wide Web are first encoded into a binary code.

When we look at an image, it can be interpreted in many different ways. The context in which an image is seen can influence our interpretation of it. For example, a picture of a UFO published on the front page of *The New York Times* would be interpreted differently from the same picture featured on the front page of the *National Inquirer*. This occurs because our attitudes about the reliability of these publications influence the ways in which we understand the meaning of the image. Captions or accompanying text also helps us interpret the meaning of an image. For instance, to understand the meaning of a photograph printed on the first page of a newspaper, we must read the headline, caption, and/or accompanying story. In photojournalism, the caption provides information to help the reader understand the picture. However, the information extracted from an image could be independent of the intention of the image-maker. For instance, information taken from advertising images is often unintended. Feminist, rhetorical, postcolonial, and the Personal Impact Assessment technique (described in Chapter 4) are approaches to advertising analysis and are designed to reveal some of the underlying messages in photographs.

Piaget and Learning Mentalities

Jean Piaget's research on children and learning has also influenced the development of visual theory. His studies revealed that there is a point in child development in which the visual dominates the logical understanding of events. Symbolic codes transparently structure our thoughts, actions, and view of the world. Piaget believed that children and adults have a single mentality that develops through three stages until it reaches the final stage of linguistic reasoning. The first stage is the doing stage, in which objects are grasped. Thinking in this stage is action, and children act without thinking ahead about the consequences. As children grow, they move into an image stage around the age of 6. For example, when shown a squat glass of water poured into a tall, thin glass, children will say that there is more water in the tall glass rather than the squat one. This occurs because the child is being dominated by the visual image, and visual logic says there is more water in a tall glass. Around the age

of 11 or 12, children progress to a stage of facts and logic in which they begin to move away from the immediacy of the visual environment.

Building on the work of Piaget, Jerome Bruner (1966) developed a theory about different representational stages of learning or different learning mentalities. Bruner studied children and concluded that there are three stages in which human beings translate experience into a working model of the world. Bruner called the first stage *enactive,* or learning through action. In the enactive stage, "representation is based, it seems, upon a learning of responses and forms of habituation" (Bruner, 1966, p. 11). The second stage, *iconic,* uses a "system of representation that depends on visual or other sensory organization and upon the use of summarizing images" (Bruner, 1966, pp. 10–11). Finally, in the third stage, *symbolic,* "there is representation in words or language" (Bruner, 1966, p. 11). However, there is a major difference between iconic representation and symbolic representation. In symbolic representation, the words used to represent the world are arbitrary.

The arbitrary meanings assigned to words introduce syntax and grammar into the process of perception:

> We observe an event and encode it—the dog bit the man. From this utterance we can travel to a range of possible recodings—did the dog bite the man or did he not? If he had not, what would have happened? And so on. Grammar also permits us an orderly way of stating hypothetical propositions that may have nothing to do with reality. (Bruner, 1966, pp. 11–12)

According to Bruner, the ability to view the world through language creates an idea of reality that is not possible with actions or images. However, despite their development through the symbolic stage, people continue to acquire knowledge through enactive (social-gestural) and iconic (spatial-visual) forms of representation. In contrast to Piaget's view of a single mentality that goes through stages, Bruner argued that there are different mentalities in a single mind.

Gardner's Theory of Multiple Intelligences

Howard Gardner further developed the idea of different mentalities when he proposed his theory of multiple intelligences. Gardner's (1983) theory describes a modular view of the human mind in which the mind is composed of separate organs or information-processing devices. In *Frames of Mind*, he argued for the existence of seven separate human intelligences, including linguistic, logical-mathematical, musical, bodily-kinesthetic, spatial, interpersonal, and intrapersonal. Gardner (1999) defined intelligence as "the ability to solve problems or to create products that are valued within one or more cultural settings" (p. 33). The multiple intelligence theory is based on accumulating knowledge about the human brain and culture. Its goal is to conceptualize the cognitive aspects of the human mind as many semi-independent intelligences. These intelligences work together to enable people to develop their intellectual and social capabilities. People decide how they are going to constructively use their different intelligences, and they use these intelligences in different ways.

An important aspect of the theory of multiple intelligences is the recognition that knowledge acquisition and representation use a variety of intelligences and that all symbolic forms of representation are equally important. Symbolic forms are systems of knowledge, perception, and experience, including myth, arts, sciences, history, and religion. Symbol systems are defined by the ways in which their syntactic and semantic features are used symbolically. Syntactic features are the ways in which letters, words, or symbols are put together to form words, sentences, or images, for example, the letters, in the alphabet, notes of a musical score, and the patterns of line and color in a painting. Semantic features are the ways in which we construct meaning from symbols. From the view of multiple intelligences, our minds use different symbol systems to make meaning of the world and these systems are provided by culture. However, different cultures may have different symbolic preferences. For example, American

culture has a preference for visual symbols, and the widespread use of visual media in the United States has led some scholars to argue that a new type of visual intelligence has now emerged.

Box 1.1: In His Own Words: Howard Gardner

Bio: Howard Gardner was born in Scranton, Pennsylvania, in 1943, to refugees from Nazi Germany. He received all of his postsecondary education at Harvard University, and he is currently the John H. and Elisabeth A. Hobbs Professor in Cognition and Education at Harvard. He is a senior fellow of Harvard's Project Zero that was originally founded by Nelson Goodman. For over 20 years, he has been researching the use of multiple intelligences in education to develop more personalized curriculum, instruction, and assessment.

Q. Is there an artistic intelligence?

A. Strictly speaking, no artistic intelligence exists. Rather, intelligences function artistically—or nonartistically—to the extent that they exploit certain properties of a symbol system. When someone uses language in an ordinary expository way, as I am doing here, he is not using linguistic intelligence aesthetically. If, however, language is used metaphorically, expressively, or in ways that call attention to its formal or sensuous properties, then it is being used artistically. By the same token, spatial intelligence can be exploited aesthetically by a sculptor or painter and nonaesthetically by a geometer or a surgeon. Even musical intelligence can function nonaesthetically; consider the bugle call that summons soldiers to a meal or to a flag raising. Conversely, patterns designed by mathematicians for mathematical purposes have ended up on display in art galleries; consider the enigmatic drawings of M.C. Escher [see Chapter 2].

Whether an intelligence is deployed for aesthetic purposes represents personal and cultural decisions. For instance, a person can apply linguistic intelligence as a lawyer, a salesperson, a poet, or an orator. However, cultures also highlight or thwart artistic uses of intelligences. In some cultures, almost everyone writes poetry, dances, or plays an instrument; in contrast, Plato sought to eliminate poetry from his Republic, while Stalin scrutinized every poem as if it were a diplomatic missive (Gardner, 1999, pp. 108–109).

The Cognitive Revolution and Visual Intelligence

Besides theories of multiple intelligences, the cognitive revolution has also contributed to visual theory. The cognitive revolution began in the 1950s when psychologists, linguists, philosophers, and anthropologists joined forces to explore symbolic activities and how people construct and make sense of their world. Nelson Goodman and Jerome Bruner were leaders in this new intellectual movement. Today, Bruner's and Gardner's theories on multiple intelligences have been adopted by many academics as a way to describe human cognitive processes.

As the cognitive revolution progressed, the study of cognition became fractionalized and technicalized. Bruner (1990) stated the following: "Very early on, for example, emphasis began shifting from 'meaning' to 'information,' from the *construction* of meaning to the *processing* of information. These are profoundly different matters" (p. 4). A key reason for this change was the introduction of computers because they could be used to simulate mental processes. Bruner and Goodman were interested in how the mind constructs meaning through symbols. In contrast, other scholars wanted to better understand how the mind processes symbolic information. The study of information processing is very

different from an examination of meaning making because one looks at how the mind works and the other at how it understands the world. As the study of cognition progressed, a rhetorical shift occurred in discussions about the human mind.

Computational metaphors and computer terminology began to be used to describe human cognitive activities. For example, we now say that the mind "processes" or "computes" information. Using computers to create theoretical models to explain how the mind, perceives symbols reinforced this linguistic change. Very quickly the computer became the model for mind and many researchers began focusing on how the mind processes information rather than how it constructs meaningful worldviews. According to Bruner (1990), "Cognitive processes were equated with the programs that could be run on a computational device, and the success of one's effort to 'understand,' say memory or concept attainment, was one's ability realistically to simulate such human conceptualizing or human memorizing with a computer program" (p. 6). Philosophers, such as Daniel Dennett, began to believe that actual minds and their processes could be explained in the same way as "virtual minds" or models of mind simulated on computers. The study of human information processing evolved into the new discipline of *cognitive science*. Cognitive scientists explore the nature and functioning of the mind through computers, and cognitive science is a meeting ground between artificial intelligence research and human psychology.

Many cognitive scientists have explored visual cognition and developed models to describe shape recognition and imagery. According to Steven Pinker (1984), "Visual imagery has always been a central topic in the study of cognition" (p. 36). It is important because we need to better understand the human ability to reason about objects and scenes. Moreover, the study of imagery is connected to mental representations and their use in the interaction between perception and cognition or seeing and knowing. Mental imagery is used when people create scientific, literary, creative, and mathematical works. On a more practical level, the study of imagery is concerned with spatial abilities such as memory for literal appearance, spatial transformation, and the matching of images against visual stimuli. Cognitive scientists have been working for many years to develop computer programs that can recognize the shapes of objects, and they have been successful. For instance, computers have been taught to pick up soda cans and drive cars. Presently, researchers are working on developing theories of visual mental image representation and processing with the aid of computer simulated models.

Building on cognitive science research and the work of neurophysiologists, Donald D. Hoffman (1998) argued for the existence of visual intelligence. He stated, "Just as we enjoy rich literature that stimulates our rational intelligence, or a moving story that engages our emotional intelligence, so also we seek out and enjoy visual media that challenge our visual intelligence" (p. XII). The visual system constructs visual worlds based on the images perceived by the eyes. For example, marketers, advertisers, and corporations understand how to use visual intelligence to persuade consumers to purchase products. However, most people do not understand how or why these visual messages are influencing them.

Similarly, communication theorist Ann Marie Seward Barry (1997) contended that there is a visual intelligence. She defined it as follows:

> …A quality of mind developed to the point of critical perceptual awareness in visual communication. It implies not only the skilled use of visual reasoning to read and to communicate, but also a holistic integration of skilled verbal and visual reasoning, from an understanding of how the elements that compose meaning in images can be manipulated to distort reality, to the utilization of the visual in abstract thought. (p. 6).

The proliferation of visual media is a primary reason why researchers argue for the recognition of visual intelligence as an important skill for students to develop.

Applying Cognitive Theory to Digital Media

Beyond calling attention to the existence of different types of human intelligences, the cognitive revolution also helped to develop new learning theories. A Constructivist view of education emerged that was based on the work of Bruner, Piaget, and Goodman, and these principles were applied to the development of computer software. Constructivist educational principles assert that students actively construct knowledge within a learning community. Seymour Papert (1996) described constructivism as a theoretical movement that contends learning also best occurs when it is self-directed:

> It complains that much traditional teaching is based on a model of a pipeline through which knowledge passes from teacher to student. The name constructivism derives from an alternative model, according to which the learner has to construct knowledge afresh every time. (p. 45)

In order for the computer to be a medium of communication, Alan Kay decided that computer programming languages should be developed on a level that children can understand, allowing them to read and write with this new medium. Kay (1990) defined reading and writing as follows: "The ability to 'read' a medium means you can *access* materials and tools created by others. The ability to 'write' in a medium means you can *generate* materials and tools for others. You must have both to be literate" (p. 193). Building on the cognitive research of Bruner, Kay applied Bruner's idea of different learning mentalities to computer interface design. Kay's model was described by using the slogan, "Doing with Images makes Symbols." Kay (1990) stated, "The slogan also implies—as did Bruner—that one should start with—be grounded in—the concrete 'Doing with Images,' and be carried into the more abstract 'makes Symbols'" (p. 196).

Similar to Piaget, Bruner, and Gardner, Kay believed that the process of thinking and problem solving uses several different mentalities. Kay (1990) argued that the most important creative work in disciplines such as science and music are done in the initial two mentalities, doing (enactive) and image (iconic). In these disciplines, problem solving is not necessarily linked to the symbolic mentality or language. He further argued that there is a difference between using the iconic and symbolic mentalities because

> The visual system's main job is to be interested in everything in a scene, to dart over it as one does with a bulletin board, to change context. The symbolic system's main job is to stay with a context and to make indirect connections. (p. 196)

People who use their iconic mentality tend to be very creative; it is difficult for them to get anything accomplished because they often get distracted. Conversely, people who use the symbolic mentality are good at getting things finished because they can focus for long periods on a single context; however, they have a hard time being creative because they often get blocked. "In other words, because none of the mentalities is supremely useful to the exclusion of the others, the best strategy would be to try to gently force synergy between them in the user interface design" (Kay, 1990, p. 196).

To create this synergy, Kay incorporated three different levels of symbolic representation into his design. The mouse would be used as a form of enactive representation to actively navigate and manipulate text and icons displayed on a computer screen. Icons and windows were incorporated into the design as a level of iconic representation.

> The use of icons as signs in computer graphics had been in practice for years. Informally, they seemed to work much better than labels. Semiotics provided an explanation. In semiotic theory a sign is not a word but actually constitutes an entire sentence. (Kay, 1990, p. 201)

On the symbolic level of Kay's interface design, an object-oriented programming language called Smalltalk was developed. Object-oriented programming environments use a building block approach to writing software programs. Instead of writing a program as one long list, object-oriented programming

breaks programs down into individual objects. When Apple and Microsoft adapted Kay's design for the Macintosh and Windows, they did not build their designs on top of an object-oriented programming environment. Thus, this symbolic level of the programs is missing. Instead, they focused on the visual aspect of the interface design.

Graphical interfaces were first introduced to the public in 1984 with the Macintosh. In his book, *Insanely Great: The Life and Times of Macintosh, the Computer That Changed Everything*, Steven Levy (1994) argued that graphical interfaces were a key factor in making computers accessible to the general public. Based on the popularity of Macintosh, Microsoft developed its own graphical interface called Windows for MS-DOS users. Kay's original design was developed to enable children to learn how to program. In contrast, the Macintosh and Windows interfaces were created to make operating a computer easier or user friendly. By representing computer operations primarily on iconic and enactive levels, people do not have to learn complicated programming languages or commands to operate their computers. However, while creating user-friendly designs, a new iconic vocabulary developed around the metaphor of a desktop. The desktop metaphor transforms the computer's screen into a simulated desktop over which people can sprawl documents and folders. By clicking on the folder icons with a mouse, computer users can electronically open up a whole library of folders as if they existed in a paper form on top of a desk. In the case of graphical interfaces, cognitive theory was applied to computer design and a new symbol system emerged.

Figure 1–4: The Author's Desktop with icons. The background is a photo by the author.

Visual computer symbols help people operate word processing, desktop publishing, and digital video software programs. Additionally, many different graphical interfaces have been developed to help people use digital devices, such as portable digital assistants (PDAs) and Web TV. Graphical interfaces designed for digital devices and software programs create new icons, and these icons are added to the

visual language emerging through the use of digital media. The development and use of computer icons are an example of how visual symbols are constantly changing within culture.

Box 1.2: In His Own Words: Alan Kay

Bio: Dr. Alan Kay has undergraduate degrees in mathematics and molecular biology from the University of Colorado. He earned his doctorate in computer science at the University of Utah, where he was a member of the Advanced Research Projects Agency (ARPA) research team. He also worked on the original design for Palo Alto Research Center (PARC) that developed many of the concepts and technologies used in personal computers, including overlapping windows, laser printers, ethernet networking, and bit-mapped graphical display screens.

One of the problems is how to get concrete signs to be more abstract without simply evoking the kinds of symbols used by the symbolic mentality. More difficult is how to introduce context in a domain whose great trait is its modeless context-freeness. In most iconic languages, it is much easier to write the patterns than it is to read them. One of the most interesting puzzles in iconic programming (and iconic communication in general) is why there is such a disparity between how understandable images are while they are actively being constructed and how obscure even one's own constructions can appear even the next day. (Kay, 1990, p. 202)

VISUAL MEDIA AND CULTURE

Today, symbolic thought and action are considered multimodal because we use a variety of symbol systems to understand the world and communicate with each other. *Multimodal thinking* uses a wide range of physical, perceptual, and cognitive skills to develop an individual's intellectual and social potentialities. Presently, most symbolic skills are learned through verbal language, but people also need to become competent in the other modes of communication. For example, children often lack the skills to comprehend the compositional structure and intended meaning of visual images distributed through television, film, and video games.

Different cultures are characterized by their primary modes of symbolic behavior, and our perceptual organization of symbolic communication is primarily shaped by the culture in which we live. Larry Gross (1974) identified the following primary modes of symbolic behavior: linguistic, social-gestural, iconic, logico-mathematical, and musical. Modes derived from these primary ones include poetry, dance, and film. Although modes of symbolic communication precede the development of technological media, these media are used to store and transmit primary patterns of symbolic behavior. More important, the media combine the primary modes together in various ways to communicate messages.

Symbolic Experience

Language is the primary mode of symbolic thought and communication. It dominates our consciousness so completely that people often view it as the embodiment of thought and intelligence. However, language is only one of many different modes of symbolic communication. Beyond language, every member of a culture learns social-gestural modes of thought and action. However, most people are not aware of when or why they communicate gestural messages. People will become consciously aware that their gestures convey information in the following ways: (a) by visiting a foreign culture, (b) by being trained to observe social-gestural behavior patterns (ethnographic or psychiatric training),

or (c) when attempting to convey misleading information. For instance, people who want to successfully "pass" in higher social circles will read books on etiquette and try to follow the behavioral rules.

Presently, culture is very visually oriented and iconic symbols are frequently used as a method for conveying information. Visual images and symbols communicate and express ideas in ways that cannot be formulated through any of the other modes. For example, pictures easily convey information about objects and their relationships in space. Rudolf Arnheim (1969), a leading researcher in visual thinking, stated that pictures perform "the task of reasoning by fusing sensory appearance and generic concepts into one unified cognitive statement" (p. 148). Both the picture and spectator are necessary for this process to occur because pictures do not interpret life; people do. Spectators must decide what the image symbolizes based on their personal and cultural experiences. Arnheim (1969) said that in an ideal culture, no object is perceived or action performed without having an open-ended number of interpretations.

According to Piaget (1971), logico-mathematical knowledge is one of the three main categories of knowledge, and it takes a more differentiated form in higher ranges of human intelligence. Certain logical aspects of natural and cultural actions are based on logico-mathematical knowledge. As a result, there is a difference between knowledge and verbal language because knowledge can be communicated through a variety of symbol systems. For example, logic cannot be reduced to a system of notations that are inherent in speech or in any type of language. Logico-mathematical knowledge "consists of a system of operations (classifying, making series, making connections, making use of combinative or 'transformation groups,' etc.), and the source of these operations is to be found beyond language, in the general coordination of action" (Piaget, 1971, pp. 6–7). Thus, logico-mathematical codes can communicate knowledge.

Statements obtained from eminent mathematicians reveal that their thought process is not necessarily done in a linguistic mode. In contrast, mathematicians contend that they can visualize spatial configurations and create "mental pictures." For example, Albert Einstein used visual thinking when he was working on mathematical problems. Gardner (1993) contended that the "ability to keep invented spatial configurations in mind and to operate on them in diversely instructive ways played an indispensable role in Einstein's original scientific thinking" (p. 104). According to Einstein, language was not his preferred mode of thought.

Musical codes exist in every culture. People perceive and think in musical language in similar ways in which they think in terms of vocabulary and grammar. Gross (1974) stated the following: "The ability to decode the structure of musical organization is dependent upon the competence of the listener in the particular cultural code or style in which a piece has been formed" (p. 71). Only people who have acquired culturally determined habits and qualities can perceive musical meanings, and the ability to appreciate and create music depends upon attaining a basic competence in musical codes. To a degree, the comprehension of different symbolic modes depends upon developing an understanding of each system. Of particular importance is learning the symbolic mode favored by the culture in which one lives. For example, visual symbols are used extensively in American culture, and, therefore, developing visual skills is important for understanding American cultural messages.

Besides language, research has shown that people learn through symbolically coded information transmitted through media. Diagrams, pictures, photographs, and film can all convey information to their viewers. Although language is considered the primary symbolic mode in which people make meaning and understand their world, some people do learn and think through other symbolic modes.

Computers as Multimodal Media

As previously discussed, graphical interfaces were originally designed to create a synergy between several different symbolic modes. Technologically, the development of graphical interfaces was depen-

dent upon the creation of computer screens that could display graphics just as easily as they could represent words. Today, computer screens combine several different symbol systems together into one multimodal medium. For instance, the World Wide Web combines language, pictures, music, and video together. Similarly, television combines visual imagery with spoken and written language. Print media use the written word and images. Besides using a variety of symbolic modes, computers also combine all media together into one medium or *monomedium*. A single computer system can be used to create printed publications, edit video, and play music CDs.

Multimedia is the term frequently used to describe the integration of media by combining together text, graphics, animation, video, and sound. Mark von Wodtke (1993) stated the following: "Media integration could occur in a variety of ways, relating multimedia computing to telecommunications, publishing, video, and TV, as well as manufacturing and construction" (p. 8). For example, desktop publishing enables you to easily integrate text and graphics together to produce a document that can be output on either a laser printer or high-quality printing press. Similarly, desktop video programs allow you to edit video and sound together. Depending upon your system, the finished product could be output to video, played on your computer, saved on a CD, or sent to a friend through the Internet.

Boxed Topic 1–3: Case Study: The Desktop Interface

The desktop metaphor, direct manipulation, and multimedia are three concepts that were developed at Xerox PARC and introduced to computer professionals with the Xerox Star computer system. These three concepts have been incorporated into a number of other software designs, including Macintosh and Windows. The working environment displayed on the Star's computer screen was called the "desktop." The desktop was an electronic analog for an office environment. On the screen were small pictures or icons representing familiar office objects. These objects include file folders, file cabinets, and in-mail and out-mail baskets. Objects displayed on the "desktop" were directly manipulated with a mouse.

Direct manipulation of visual objects by a mouse is the replacement for complex command language syntax that is typed into a keyboard. Direct manipulation can be compared to driving an automobile. When driving, the scene is directly visible through the front window. When making a turn, the driver rotates the steering wheel to the left. As the car moves, the scene changes to provide visual feedback that enables the driver to refine the turn. Similarly, direct manipulation in computing provides immediate visual feedback in the process of operating the machine. Direct manipulation allows computer users to easily move back and forth between graphics and text programs without typing any command syntax. Direct manipulation and the display of icons to operate the machine made computer interaction easier or user-friendly.

After seeing a demonstration of the Xerox Star system, Steve Jobs developed a graphical interface for Apple's Macintosh computer. The first thing users saw when they turned on their Macintosh was a beaming, happy face that quickly turned into an arrow you could use to point to all the little icons on screen. By clicking on the folder icons, the user could electronically open an entire library of folders as if they existed in paper on top of a desk. Susan Kare was the graphic artist who designed the original Macintosh icons that transformed the personal computer screen into the fanciful illusion called the "desktop."

Digitalization of Visual Communication

The computer can combine all these various symbol systems and media together into a monomedium because it transforms information into a binary code, which is a digital symbol system. Analog and digital describe two different ways in which messages are formatted to be transmitted through media. *Analog media* formats correspond to something else. For example, an electronic format for replicating sound or images uses electrical impulses that modulate the current, and the modulated current directly corresponds to the sound or image represented. In contrast, digital media replicate information by converting it into a binary code of ones and zeros that represent on/off signals. The binary signals of 1s and 0s have no correspondence to what they represent. Because all information in digital systems is converted into a binary code, digital media can support a wide range of media types. For example, web pages can be designed that are text only; or they can be full multimedia displays with graphics, video clips, and sounds; or they can be formatted for cell phone usage.

Nicholas Negroponte (1995) described the difference between analog and digital media as the difference between atoms and bits. Atoms make up physical media, such as books and video cassettes. To get books from the printing plant into the hands of readers, they have to be physically transported on trucks over highways and into stores. However, when books are in a digital format, they can be sent directly from the source of information to the reader through the Internet. Digital books are much easier to transport from one place to another, and it takes less time to move them around the world. Negroponte argued that we are moving toward a universal, fiber optic, high-speed communication network or information highway that can carry hundreds of channels of video programming. More important, a shift from broadcast to fiber optic television systems makes the air waves (or ether) available for new types of mobile communication services, such as cell phones and hand-held wireless web devices. Broadcast communication technologies that now use the air waves will shift into the ground and distribute information through wires. In contrast, telephone technologies that now travel through wires will shift into the air waves. This idea is called the "Negroponte Flip"—what's in the ground will move into the air and what's in the air will move into the ground. The Negroponte Flip focuses on how messages are sent and received. Negroponte viewed mass communication systems as a method for delivering information to large audiences through media channels. However, in contrast to traditional mass media, digital technologies, such as the Internet and World Wide Web, are interactive, and they enable organizations and individuals to converse back and forth with each other because interactivity supports two-way or multidirectional communication.

Von Wodtke (1993) described this change as follows: "*Interacting* involves viewing and doing what you visualize—the way people use computers. This is changing how society relates to electronic media…. For example, children no longer just passively view TV; for better or worse, they become interactively involved in video games" (p. 10). Adults also become more active when they are using digital media because the interactive feature of computing enables them to manipulate media right on their computer's desktop. Similarly, students can interactively find information through technologies such as the World Wide Web.

The use of the computer as a medium for the storage and distribution of information is having an impact on all visual media. Gradually media are becoming digital and converging. Media convergence is the integration of all types of mediated communications into an electronic, digital format propelled by the widespread use of computers and networking systems. Convergence radically changes mass media—television, books, magazines—and paves the way for the invention of multimedia products that mix text, data, graphics, and video together for distribution through digital networks. For instance, the World Wide Web adds television-like visuals, sounds, and graphics to information transferred from the printed page to the electronic computer screen. The web is a new hybrid medium that contains

characteristics of both print-based and television media and blurs the boundaries between the different media industries. It is a multimedia technology that allows both individuals and organizations to distribute text, images, sounds, and video clips through the Internet. In contrast to older media such as books and television dominated by a single mode, new digital media support the distribution of multiple modes that can be mixed in a variety of ways. More important, these new digital media add the feature of interactivity to the visual communication process.

Understanding Visual Messages

We live in visual times. Consequently, scholars argue that we should develop a set of critical skills to help us understand the visual messages that surround us. We are assaulted by images from morning until night through television, newspapers, magazines, billboards, and computer screens. Visual messages distributed through technology use a variety of symbolic modes in different ways. For example, photography captures a moment in time as a still picture, and film records images, motion, and sounds together. Because the various media record, store, and transmit symbols in different ways, many different approaches have developed to examine visual messages. For example, semiotics, the study of signs, has greatly contributed to our understanding of visual communication. However, the semiotic approach tends to examine the relationship between symbols and referents without fully examining the formal, identifying features of specific symbol systems, such as composition, color, and visual hierarchies.

The first section of this book is designed to develop and enhance a student's visual literacy skills and develop a vocabulary in which students can discuss visual communication. It covers the basic elements of visual communication, human perception and perspective, signs and symbols, written symbols and typography, and the professional skill of graphic design. The second section examines individual media, including print media, photography, film, television, and digital media.

In many chapters, a different method of visual media analysis is introduced. Although methods are described within the context of a single medium, they can be applied to other media. For example, Barthes' method for analyzing photojournalism could be applied to documentary film, and Zettl's Applied Media Aesthetics approach can be used to analyze television and film. In the final section of this book, critical approaches to the cultural use of visual messages are explored. Critical approaches examine the larger cultural messages embedded in visual images that viewers do not generally fully understand. By providing many different ways to analyze visual media and messages, this book is designed to help students develop their visual literacy, visual reasoning, and critical visual evaluation skills.

SUMMARY

Visual communication is the process through which individuals, organizations, and cultures interpret and create visual messages in response to their environment, one another, and social structures. The cognitive revolution led to new ideas about the role of symbols in understanding the world in which we live. Scholars from the disciplines of philosophy, psychology, cognitive science, and communication have further developed theories relating to the nature of visual communication. Moreover, cognitive and constructivist theories have been used in the development of computer interface design, which has been applied to many new visual technologies. As people use these technologies, they introduce a new visual language into culture.

Central to an argument for the development of visual intelligence is the proliferation of visual media. The ability of images to be coded in a digital format enables the development of new types of digital services, including smart phones, YouTube, and Twitter. Today, we learn with information

transmitted through the printed word, film, diagram, photograph, picture, and computer. With the widespread use of visual information, students need to be able to "read" visual symbols, develop an understanding about visual communication, and be aware of cultural attitudes and conventions that shape their understanding of visual messages.

WEBSITES

- *Howard Gardner*
 http://www.youtube.com/watch?v=l2QtSbP4FRg
 Type "Howard Gardner" into http://www.youtube.com/

- *Alan Kay*
 http://www.youtube.com/watch?v=tQg4LquYouU
 Type "Alan Kay" into http://www.youtube.com/

- *Nicholas Negroponte*
 http://www.youtube.com/watch?v=vc8Ks6KOySg (TED Talks)
 Type "Nicholas Negroponte" into http://www.youtube.com/

EXERCISES

1. As you travel between your home and school, see if you can list all of the different types of visual media that you encounter. What types of different visual messages are there in the following places?
 - A supermarket
 - An airport
 - A city street
 - A train station
 - A church or synagogue

2. Examine a painting from a museum utilizing the multiple intelligence approach:
 a. Narrative—Write a story about the painting.
 b. Quantitative—Figure out how much the art materials cost and compare that to the value of the painting.
 c. Logical—Develop a theory about why this painting is important and considered to have value.
 d. Aesthetic—Describe the colors, shapes, and/or objects depicted in the painting and how they work together to create a composition.
 e. Hands-on—Develop a dance or series of gestures to express what you see in the painting.

3. It is difficult to become aware of how our own cultural settings shape our opinions and attitudes. Research the following items about a different cultural setting (such as Mexico or Asia) and compare them to your own. How are they similar or different?
 - Customs of dress
 - National foods
 - National holidays
 - National flag (see if you can explain the symbols)
 - Symbols or images that are used to represent the culture

4. Christmas is a holiday that is celebrated in many different countries around the world. Pick three countries on three different continents to compare and contrast the differences and similarities between the ways in which people celebrate this holiday. What type of symbols does each culture use and why?

5. Watch a popular American television program such as *Law and Order* or *Two and a Half Men*. How do these programs depict the American lifestyle, values, and beliefs? How are the people and situations depicted in these programs similar or different from your own gestural behaviors, lifestyle, values, and beliefs? Is the program a positive representation of American life? Would you recommend this program for export to other countries? Why or why not?

6. Using Kay's model of interface design, describe how Internet browsers (e.g., Internet Explorer, Firefox, Google Chrome, and Safari).utilize enactive and iconic representations to support computer interaction.

KEY TERMS

Analog media formats correspond to something else. For example, an electronic format for replicating sound or images uses electrical impulses that modulate the current.

Analogic symbols are analogous or similar to what they represent, for example, road maps, portraits, and photographs.

Codes are the structures of a message which enable it to be transmitted. For example, words are the code of language, and the code in digital computer systems is binary math.

Cognitive science explores the nature and functioning of the mind through the use of computers.

Desktop metaphor is a computer environment that uses visual icons of objects typically found in an office to help make it easier for people to use computers.

Digital media replicate information by using primarily on–off signals, transmitted electronically or through fiber optics. These on–off or binary signals can be used to represent numbers, text, graphics, images, video, and sound.

Digital symbols are totally arbitrary, for example, words in language.

Interactivity is two-way communication between the source and receiver of information, or it can be multidirectional communication between any number of sources and receivers.

Media convergence is the integration of all types of mediated communications into an electronic, digital format that is propelled by the widespread use of computers and networking systems.

Monomedium is a term used to describe computers because they can integrate all types of media together into one medium.

Multimedia is a term that is used to describe the integration of text, images, audio, and data in digital environments, such as the World Wide Web and computer applications.

Multimodal thinking utilizes a wide range of physical, perceptual, and cognitive skills to develop an individual's intellectual and social potentialities.

Nonnotational symbol systems are unsegregated and continuous, for example, pictorial systems.

Notational symbol systems have a unique set of separate characters that isolate the object or objects for which they stand, including musical scores or the alphabet.

Semiotics (semiology) is the study of signs.

Symbolic forms are systems of knowledge, perception, and experience, including myth, arts, sciences, history, and religion.

User-friendly is a term that was coined to describe the original Macintosh computer because its use of icons and a mouse to execute computer commands instead of typing in computer commands made computers easier to operate.

Visual communication is the process through which individuals, organizations, and cultures interpret and create visual messages in response to their environment, one another, and social structures.

Visual literacy is a basic system for learning, understanding, recognizing, and making visual messages that are negotiated by all types of people, not just trained professionals.

☀ DEVELOPING VISUAL LITERACY SKILLS

Chapters 2 through 6 present the foundation for understanding visual literacy. Part I begins with a discussion of the basic elements used in visual design and ends with a chapter on graphic design. Graphic designers have been the people who generally create visual messages. This section is written to help scholars and students develop a vocabulary in which to discuss visual messages.

☀ **Elements of Visual Literacy**

Learning to become visually literate begins with an understanding of the basic elements used in visual statements. The syntax of visual communication is the arrangement of these basic elements into a composition. Arthur Asa Berger (1995) said that every visual element "conveys a great deal of information and gives a sense of the importance of what we are seeing relative to other images and events in the text" (p. 81). The term *media text* refers to television, film, photographs, images, and also printed texts. This chapter explores how the basic elements used in visual communication interact with one another to create visual effects that convey different ideas or feelings, such as harmony or tension, happy or sad, arousing or calming. Designers arrange and combine elements together to build visual hierarchies that draw attention to particular elements in the composition, and the relationship among these elements conveys meaning to the viewer.

BASIC ELEMENTS

In visual communication, there are basic elements that construct a composition and follow rules of visual syntax. Visual syntax is the orderly arrangement of visual elements that makes up a composition and expresses an idea or evokes a feeling. All visual communication includes the basic elements of dot, line, shape, direction, volume, scale, and movement. According to Donis A. Dondis (1973), "The visual elements are manipulated with shifting emphasis by the techniques of visual communication in direct response to the character of what is being designed and the message purpose" (p. 16).

The process of composition is the most critical step in visual problem solving. Compositional decisions set the purpose and meaning of the visual message and how the receiver understands it. Designers combine basic shapes together, balance them into compositions, and add color to express an overall message. Professional designers learn the rules of visual syntax by solving specific design problems, such as the one described by Milton Glazer in the following box.

Box 2.1: Milton Glazer and Basics

Bio: Milton Glazer was born in 1929. Glazer was a graphic arts student in New York City, and he shared a loft with Seymour Chwast, Reynolds Ruffins, and Edward Sorel. They all became well-known designers and illustrators. In 1951, Glazer received a Fulbright scholarship to study etching under Giorgio Morandi in Italy. When he returned in 1954, he helped to form the Push Pin Studio with his former loft mates. Chwast and Glazer maintained the Push Pin Studio for over two decades, and their philosophies, techniques, and personal visions about graphic design had a major influence on the discipline. They united the process of image making, layout, and design into a total communication message

As a designer you are always concerned with…how much something will cost, what the benefit and value is if you, the customer, buy such and such. We are always involved with the reality of the need and desire between, usually, a client and its customer. We are the mechanism for transformation—taking an idea, bringing it to the customer and making it effective in terms of being able to produce the effect the client wants.

Packaging is a very interesting from this point of view. You have to understand the exact audience you are speaking to in every case. The cases change, so the form of address has to change. For instance, we are doing a lot of generic packaging for one line called "Basics." Now, there are two problems. One was to make the packaging look slightly better than the existing generic packaging, which is all black and white. But, basically, generic packaging is supposed to look terrible. Its intention is to produce the impression that no time was spent doing it and no cost. The truth of the matter is that generic packaging costs exactly the same to produce, from a physical point of view, as conventional packaging. It is run on the same press, and the fact that you do not use all the colours, does not mean a thing. In the end the cost is the same.

But it is very important to signal that no costs are involved. (Glazer, 1985, pp. 469–470)

Dot or Point

To begin a design, the person must be familiar with the basic elements of visual communication. A dot is the smallest irreducible unit of visual communication. In the natural environment, round shapes are very common; in contrast, straight lines or squares are very rare. For example, liquids, such as raindrops, often assume a round form. Dots and points have a strong visual power to attract the eye in both natural and human environments. When a number of dots are arranged on a surface, they create the illusion of being connected together. A series of dots tends to lead the eye, and this effect is intensified when the dots are closer together.

This perceptual phenomenon of visual fusion was explored by the Pointillist style of painting. Pointillist paintings only use four pots of paint—yellow, red, blue, and black, and they apply the paint with tiny pointed brushes in a dot pattern. Despite the limited number of colors, the paintings have a remarkable variation in color and tone because the eye tends to mix the dots of color together. Impressionist artists experimented with the process of blending, contrasting, and arranging dots of color to perceptually fuse and create an image in the eyes of the viewer.

Pointillism, the application of small deliberate strokes of pure color in juxtaposition, foreshadowed the development of the four-color halftone printing processes that enables continuous-tone photographs and illustrations to be reproduced in mass publishing. Halftone printing converts an image into a grid pattern of dots with a screen. Color photographs and graphics are converted into dot patterns

through electronic scanning. Scanners separate images into the colors yellow, magenta, cyan, and black by scanning the original art with a light beam that is split into three beams.

> Each beam goes to a photocell covered with a filter that corresponds to one of the additive primaries [colors], thus separating each area of the copy into its three components…. Color correction is done by feeding electrical currents from the photocells into four separate computers, one for each color and one for the black which is computed from the other three signals. (International Paper, 1989, p. 81)

Computerized scanners separate color images into four different dot screens. Each color is then printed on top of each other. When the four screens are combined, they create the final multicolored image that is a reproduction of the original.

Besides being a building block for mass printing techniques, the dot also has cultural and social connotations. According to Koch (1930), "the dot is the origin from which all signs start, and is their innermost essence" (p. 1). In earlier times, Masonic lodges communicated the secrecy of their guilds by way of the dot. Today, the system of Braille, which enables people who are visually challenged to read, is designed as a series of raised dots that represents the various letters of the alphabet. Throughout history, the dot has been used in systems of communication in a variety of ways.

Line

Lines are a series of dots placed next to one another and close enough together that the individual dots cannot be recognized. Lines can be rigid or fluid and they are the articulators of form. Lines can also be described as dots in motion because the line has a tremendous amount of energy, and it is never static. The fluid nature of the line supports both technical drawing and artistic experimentation. The lines created by artists can be very distinctive. For example, they can be smooth, liquid, and delicate, or they can be heavy, rough, and bold. However, the fluidity of a line is decisive and it has direction and purpose. Lines do something definite.

Figure 2–1: Lines create different types of feelings. Author's illustration.

Lines are also tools for notational systems, including writing, mapmaking, electric symbols, and music. In fact, the line is the most important element in many symbol systems, and lines have been used in visual communication since primitive times. Dondis (1973) says that lines can assume many different forms that express different feelings and moods. They can be spontaneous, delicate, undulating, broad, coarse, and fine. Additionally, lines can be as personal as handwriting. Nervous doodles are the result of unconscious activity under the pressure of thinking, and they can be amusing or a way to pass the time when people are bored. "Even in the bloodless, mechanical format of maps, plans for a house, cogs in a machine, the line expresses the intention of the maker and artist, and further, his most personal feelings and emotions, and most important, his vision"(Dondis, 1973, p. 44).

The human brain can anticipate a shape and fill in the missing line (see Figure 2–5, p. 28).One explanation for this tendency is the fact that people have notions about shapes based on previous knowledge and experience in their environment. Although lines do not appear frequently in nature, they do occur quite often in human environments, as cracks in sidewalks, telephone wires against the sky, bridges, buildings, and highways. Gombrich (1984) argued that people living in technological civilizations have become accustomed to the straight line and geometrical shapes that are found in

Figure 2–2: Alchemy symbols based on basic shapes.

our artificial environments. As a result, we extrapolate or "fill in" the triangular shape because of our experiences with similar forms. However, this explanation does not account for the universal tendency for people to assume continuity by filling in missing shapes. According to Gombrich (1984), "We expect things not to change unless we have evidence to the contrary. Without this confidence in the stability of the world we could not survive. Our senses could not cope with the task of mapping the environment afresh every moment" (p. 107). We tend to navigate the world with a set of internal ideas and assumptions with which we operate, unless or until they are disproved.

Certain animals, such as cats, respond to particular arrangements of horizontal or vertical lines. These simple forms are precoded in the animal's nervous system, and they help to orient the animal in space. Unlike animals, humans can code and remember simple forms in their memory. People store a wide range of categories, concepts, and configurations upon which they can test and interpret messages from the external world. For instance, when navigating in our environment, vertical and horizontal lines represent the relationship between upright humans and the horizontal earth.

Shapes

Lines can be used to create shapes. The basic shapes are circle, square, and triangle. Circles are figures whose points are all equidistant from the center point. Circles have been used as a symbol since prehistoric times. Squares are four-sided figures with their sides all the same length and angles equal. An equilateral triangle is a three-sided figure whose angles and sides are also equal. Combining these basic shapes together can create many physical forms found in nature and invented by humans.

In visual communication, the circle has been used as a symbol to represent eternity, and it denotes the heavens. Squares represent order, and the triangle is a symbol of spiritual unity (the trinity). Many different cultures and religions have used these broad interpretations. Moreover, the formal simplicity of these shapes invests them with an infinite number of subjective meanings.

Each shape has its own characteristic, and a great deal of meaning has been associated with each of them. Consider the square and the statement, "Mr. Jones is a square." The square is being compared to dullness. The ordinary aspects of the square shape are being applied to the human characteristic of being ordinary or dull. The square is also a symbol for the number four, which has a host of significations, including the four elements, the four corners of the heavens, and the four rivers of paradise.

The placement of a basic shape can also convey a meaning. Take, for example, the triangle and how its placement in a composition conveys meaning to different cultures. In ancient Egypt, the triangle is an emblem of the godhead. It is also a Pythagorean symbol for wisdom. In Christian religions, the triangle is understood as the sign of the triple personality of God. When a triangle is resting on its base, it is the sign for the female element, which is firmly based upon terrestrial matters while wanting

higher things. "The triangle standing upon its apex is, on the other hand, the male element, which is by nature celestial, and strives after truth" (Koch, 1930, p. 3).

Direction

The three basic shapes (square, triangle, and circle) each express a meaningful visual direction. The square depicts the horizontal and vertical. The triangle expresses a diagonal direction, and the circle a curve. Each one of these directions can be used in the creation of visual messages. The vertical and horizontal are primarily a human reference for well-being and maneuverability. Similar to animals, humans have a basic horizontal–vertical construct in relation to their environment. This relationship carries over into graphic space. Horizontal and vertical directions create stability. In contrast, the diagonal is an unstable directional force and a provoking element in visual communication. Curved directional forces are associated with the ideas of encompassment, repetition, and warmth. All three of these directional forces suggest a compositional intention toward the final effect and meaning of visual communication. When selecting a shape, designers are conveying a particular effect such as balance, unbalance, instability, or encompassment.

Volume or Weight

Shape and direction can influence weight. For example, basic regular shapes are generally perceived as heavier than irregular shapes. Additionally, the compactness or the degree to which the mass is concentrated around the center produces the effect of weight. Moreover, larger objects are considered heavier than smaller ones.

Color can also influence the weight of a shape. Red looks heavier than blue, and bright colors often are perceived as heavier than dark colors. A black area in a composition must be larger than a white area to counterbalance its size because white shapes appear larger than black ones. White surfaces look relatively larger than black ones because the light reflected from white versus black paper is about 16 to 1. As a result, the light being absorbed by the eye is 16 times as much as black, making white objects appear larger than black ones that are the same size.

Scale or Proportion

Scale or proportion is the relative size and measurement of an object. The size of elements is influenced by the overall size of the object, its shape and color, and its arrangement in the composition. A factor that influences the scale of elements in a design is the establishment of the visual hierarchy or the arrangement of elements according to visual importance. Elements that become the focal point of the design attract the viewer's eye. Additionally, the use of white space and cropping in a design can influence the scale or size of objects.

In information design, such as maps and building plans, scale is used to represent actual measurements in proportion to the page. A typical map scale is designed to have 1 inch represent 100 miles or 1 inch equal 10 miles. Understanding maps requires

Figure 2–3: The size of the computer is scaled with the size of the person. Photograph by University News Services, RIT. Used with permission.

people to visualize the information in terms of distance and the actual measurement it simulates. A key factor in establishing scale is human measurement. Manufacturers design products to fit average human proportions. In graphic space, the image of a person will set the scale for the other objects in the space. For instance, if an advertisement places a smaller than average person next to a car, viewers will perceive the car to be larger than it actually is.

Proportional formulas can also be used as a foundation for setting scale. For example, the most famous proportional formula is the Greek "Golden Mean." It is a mathematical formula established as a means to create visual elegance. Bisecting a square and using the diagonal of one half of the square as a radius to test the square formulate the Golden Mean. The result is a "Golden Rectangle" or a proportion of a:b=c:a. This classic scale was used in the design of ancient buildings and temples.

Many other scale systems have also been developed. One that has become popular in architecture today is the modular unit. The late French architect Le Corbusier would design an entire system based on the size of humans and their proportions. He established an average ceiling height, door size, window opening, and so forth. These repeatable sizes helped to unitize a system for mass-produced doors, windows, and modular housing.

Gestalt Theory

Visual objects appear every time we look at the real world. If there is something to be seen, people will see it as a figure or figures against a background. Our eye and brain naturally separate visual patterns into figure and ground. In primitive times, vision was an important aspect of human survival. Consequently, there are three important survival questions that vision provides answers to:

- What is an object?
- Where is it going?
- What is it doing? (Solso, 1994, p. 49)

In the two-dimensional organization of the world, objects must be distinguishable from other things or separated from their backgrounds. The contours of objects create shapes. People perceive contours when there is a sudden change in the gradient of brightness or color between adjacent objects in the field of view. The arrangement of contours is the first phase in the dynamics of two-dimensional form perception. In the next phase, the units of figure and ground are delineated.

Gestalt theory can be used to explain figure-ground relationships and the ways in which people perceive and organize visual patterns. Gestalt theory argues that visual perception is the result of organizing visual elements or shapes into groups. Principles from Gestalt theory explain the nature of figure and ground relationships and how several figures can share a common ground. Gestalt psychologists developed the Law of Pragnanz as a basic principle to regulate the segregation of the field of view into separate forms. The German word *pragnanz* is translated into English as "pregnant with meaning." The psychological implication of this idea is the notion that our mind seeks stable, regular figures in the environment, and people feel uneasy when they are unable to find such objects. People frequently feel uncomfortable when they see irregular and unstable figures and shapes, but they don't understand why. For example, artists and filmmakers sometimes exploit this phenomenon by creating unstable images and scenes in which people crave for stability.

Besides pragnanz, Gestalt psychologists developed four underlying principles of perceptual organization. They are associated with the following:

1. *Proximity* is the grouping together of objects with similar features. Proximity tends to compel the viewer to "see" the world in a particular way. For example, in a series of irregular dots, those that appear close to each other will also tend to be grouped together.

2. *Similarity* occurs when similar elements, shapes, sizes, and colors tend to be grouped together. People have an inclination to see similar elements as belonging to the same class. Many types of optical art and geometric clothing patterns take advantage of the tendency to organize ambiguous features in one direction and see the same characteristics as part of a different pattern.

3. *Continuation,* the natural flow of objects in one direction, is likely to be seen as belonging together. There is a strong visual tendency to see things in motion as, more or less, keeping on a course rather than making a sharp change midstream.

4. *Closure* relates to the law of continuation or the tendency to see figures as unitary, enclosed wholes. When the outline of a shape is incomplete, people tend to fill in the missing gaps to complete the shape.

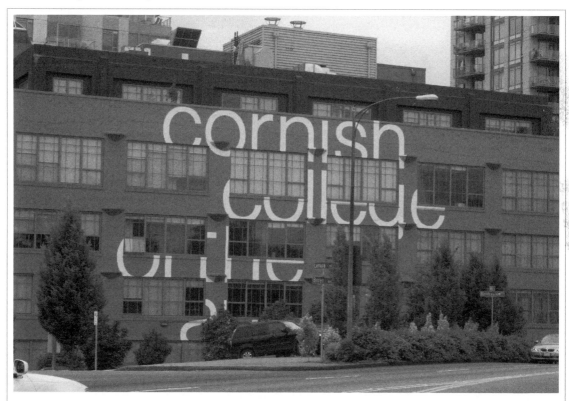

Figure 2–4: Cornish College of the Arts used the concept of Gestalt to write its name on the side of a building. Photograph by Roxanne O'Connell. Used with permission.

For many years, perceptual psychologists have studied the relationship between figure and ground illustrations. In some of these illustrations, the figure can also be seen as the ground and the ground as the figure. However, it is interesting that we cannot see the two figures at the same time. One figure must become the background in order to see the second figure. For example, if you look at an illustration of the two profiles and the chalice, you either see the profiles *or* the chalice. This occurs because the figure has a structure, while the background is relatively shapeless and unstructured. Additionally, the figure is in front of the background. As a result, the image is never seen as two different objects at once.

Optical Illusions

Many scientists are interested in geometric illusions because they are curiosities and a challenge to understand. According to Dember and Warm (1979), theories of illusion fall into three general categories:

> Some accounts focus upon errors which arise in sampling stimulus information. Others seek an explanation of illusions in terms of the "hardware" of the perceptual system, that is, at the neurophysiological level. Still others adopt a judgmental or cognitive approach to the problem. (p. 273)

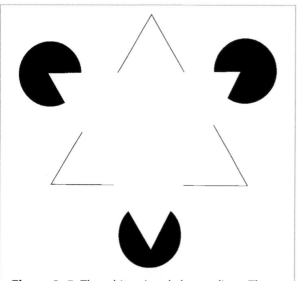

Figure 2–5: The white triangle has no lines. The eye fills in the shape based on the negative space. Author's illustration.

Some artists have integrated interchangeable figure-ground illusions into their art work. For example, M.C. Escher created many works designed to confuse the viewer about figure-ground relationships. In many of his works, Escher brings together a combination of different elements from reality. By using contours in two directions, both to the right and left, various figures share the same contours. As a result, two different spatial experiences coincide in one image and the figure-ground relationships become unclear.

Tone

Using tone and line creates contours. Lines represent the edges of a surface in a sketch or detailed mechanical drawing. The juxtaposition of darkness or lightness is also a juxtaposition of tone. According to Dondis (1973), "Variations in light or tone are the means by which we optically distinguish the complicated visual information in the environment" (p. 47).We see objects and shapes that are dark because they overlap what is light and vice versa. We reproduce nature in graphics, art, and film through the subtle steps of shades from dark to light. When we speak about tonality in nature, it is based on light. In contrast, when we talk about tonality in the graphic arts, we refer to pigment—white to black with a tonal scale between them. Tonal backgrounds can reinforce the illusion of reality by emulating the sensation of reflected light and cast shadows. For example, basic shapes begin to appear dimensional as soon as we add tonal information.

The perception of light and dark is so important to our navigation and understanding of the environment that we can easily accept and interpret monochromatic representations of reality. For instance, the varying tones of gray in photography, film, television, tonal sketches, and print-making represent a visual world that does not exist, but it is a world that we understand and accept because of the dominance of perceptual tonal values.

BALANCE

Balance has an important psychological and physical influence on human perception. According to Arnheim (1954), balance can be used for eliminating ambiguity and disunity. It is "an indispensable device for making an artistic statement comprehensible" (p. 24). As a result, equilibrium is a strong visual reference. Designers are influenced consciously and unconsciously by equilibrium when they make visual decisions.

Balance is a fundamental aspect of nature. For example, when people are suddenly pushed off balance, they generally have a look of alarm on their face. Direction, weight, and location demarcate balance. Elongated shapes whose spatial position veers away from the vertical or horizontal by only a small angle suggest a pull toward a direction. Pictorial shapes create axes, and these axes create directed forces that are either in or out of balance (see Figure 2–6).

Horizontal and Vertical Relationships

Visual expression and interpretation tend to stabilize all objects on a vertical axis with a secondary horizontal referent. The visual axis expresses the unseen but dominating presence of the primary axis that we see in an image. This is a hidden structure that we place onto a form. Arnheim (1954) contended that the axes created by a shape support movement in two opposite directions. For example, the ellipse moves in both upward and downward directions. A preference for one direction over the other is caused by many factors, including reading patterns and anchor points. In Western culture, most people read text from the left to the right, and this visual behavior pattern could influence how people look at shapes in an image. A more important factor in establishing a visual direction is whether the shape is "anchored." For example, "if one side of the shape is anchored to the frame and the other end is in free space—as for example, the triangle…the force will move toward the free end. Similarly, the shape of an arm will move toward the hand and that of the branch of a tree toward its tip"(Arnheim, 1954, p. 18).

Box 2.2: In His Own Words: Odilon Redon

Bio: French artist Odilon Redon was born in Bordeaux in 1840 and he died in Paris in 1916. He was a postimpressionist artist, and, in contrast to many of his contemporaries, Redon preferred graphic work. In the beginning of his career, he rejected color and any superfluous or obtrusive elements because they could be disruptive to visual and spiritual truths. Later in life he began to work in pastels. His work mixes fantastic themes with normal reality to express inner life. His aesthetic doctrine is summarized in the following phrase: "I speak to those who yield, quietly and without the assistance of sterile explanations, to the secret and mysterious laws of the sensibility of the heart."

And again, all proceeds from the universal life: a painter who draws a wall other than vertically draws badly because he would distract the mind from the idea of stability. The one who does not represent water horizontally would do the same (to cite only very simple phenomena). But there are in botanical nature, for example, secret and normal tendencies of life that a sensitive landscape painter could not disregard: the trunk of a tree; its character of force releases its branches according to the laws of expansion and to its vigor that a true artist has to feel and to represent.

It is the same with animal or human life. We cannot move our hand without displacing our entire body in order to obey the laws of gravity. A draftsman knows that….

There is a certain style of drawing that the imagination has liberated from the embarrassing concern of real details in order that it might freely serve only as the representation of conceived things. I have made several fantasies using the stem of a flower or the human face or with elements derived from skeletons which, I believe, are designed, constructed and built as it was necessary they should be. They are like that because they have a structure. Every time a human figure fails to give the illusion that it is going to step out of its frame, as it were, and walk, act or think, there is no truly modern drawing. (Redon, 1986, pp. 23–24)

Innate to human nature is a strong horizontal and vertical orientation. The opposition between a person's vertical upright posture and the vertical downward pull of gravity establishes this orientation. Additionally, a horizontal orientation is created by the earth's horizon line and is reinforced by architecture, furniture design, and city planning. Moreover, written and typographic design in Western culture has a strong bias toward the horizontal. We read lines of type from the left to the right and move down the page from the upper left-hand corner to the lower right-hand corner. These habits, developed in reading, can carry over into the ways in which we orient ourselves toward graphic space.

Formal and Informal Balance

People have a need to create clarity and order in their natural and technological environments. Designers and art directors are aware of the need people have for spatial organization in design. To meet this need, designers will arrange the elements of a composition on each side of an imaginary axis in the compositional space to create a feeling of equal or formal balance. In advertising, products that want to convey a message of formality, sophistication, and elegance generally balance elements together.

In contrast, asymmetrical or informal balance creates a situation in which the asymmetry generates stress, energy, and visual tension or excitement. Asymmetrical balance conveys the feeling of dynamic movement, an impression that many advertisers want to make. Phillip Meggs (1989) contended that early in the 20th century, the modern art and design movement rebelled against symmetrical balance and adopted asymmetry. Traditionally, asymmetry suggests a lack of proportion between the parts of a composition. "Asymmetry has been redefined as dynamic equilibrium or the creation of order and balance between unlike or unequal things" (Meggs, 1989, p. 76). Symmetry generally suggests rest and connection. In contrast, asymmetry conveys the idea of motion and opening. The one connotes order, law, formal rigidity, and constraint, and the other, arbitrariness, accident, life, play, and freedom. According to Meggs, "A decision to use symmetrical or asymmetrical composition should grow out of the subject matter and design intent, for both can be effective approaches to graphic space" (p. 78).

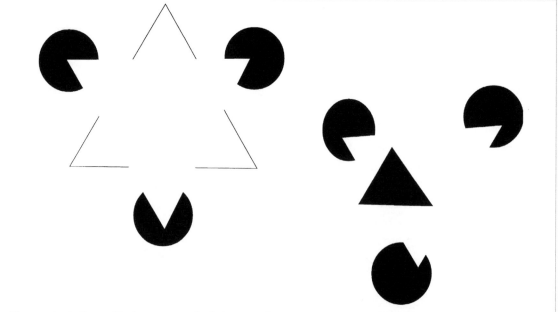

Figure 2–6: Formal balance is on the left and informal balance is on the right. The image on the right creates more of an uneasy feeling. Author's illustration.

VISUAL DISSONANCE

Visual dissonance is a state of psychological tension created when a person experiences a discrepancy between what they expect to see and what they actually see. According to Solso (1994), our eyes view the world of art with expectations influenced by our personality and cognitive structure or knowledge systems. Sometimes our expectations are fulfilled, but at other times they are not. When viewers see something unexpected or their expectations go unfulfilled, they will either resolve their tension or abandon the piece and consider another. "An important part of human motivation is found in dissonance reduction, in that people do not (normally) choose to live in a state of psychological tension. In psychological terms, such a state is aversive, to be avoided or resolved" (Solso, 1994, p. 122).

Artists, designers, and filmmakers will create unexpected forms and relationships experienced as visual dissonance. This is a way to gain our attention and engage the spectator in further intellectual work. More of an intellectual effort is required when we see an unexpected image because people attempt to reconcile their expectations with what is actually being seen. Most people try to overcome visual dissonance through cognitive means. Solso (1994) offered the following suggestions for reducing visual dissonance: (a) reduce the importance of one of the dissonant elements, (b) reinterpret the elements, or (c) change one of the dissonant elements.

Many works of art intentionally generate a form of visual dissonance or tension to engage the viewer in seeking a resolution. This is a technique frequently used by artists expressing visual statements concerning social conditions. Their intent is to motivate the thinking viewer to find a deeper message within the art. Consequently, these types of works demand active participation from the viewer in the construction of their social reality.

COLOR

From the time of Aristotle to the time of Newton, people believed that light had no color and that color was an inherent attribute that permeated opaque and transparent objects. However, Newton's experiments changed people's perception about the origin of color. Newton passed a beam of sunlight from the slit in the window shade through a glass prism. The light emerging from the prism was dispersed into its elements—the seven rays of color (red, orange, yellow, green, blue, indigo, and violet). Others had seen this occur, but Newton was the first to define the spectrum. Although we are taught that white and black are colors, in reality they are the polarities of light and dark. In pigments, black is the total absorption of all colors and white is the total reflection. Newton's discovery radically altered people's understanding of color.

For instance, Impressionist painters used this new understanding of light to study nature. According to Itten (1970), Impressionist painting was the study of sunlight and how the light alters the local tones of natural objects. Moreover, Impressionist painters studied the light of the atmospheric world of landscapes. For example, Monet (1840–1926) diligently examined light at each hour of the day to understand the progression of the sun by using a fresh canvas each hour and painting the changes.

The colors of pigments were described earlier. In contrast, the colors of light are different, and this point is essential for computer graphic artists. Instead of all colors mixing to make black, in light, black is the absence of light. White is created when all of the colors of the spectrum are mixed together. Newton's experiment was actually showing the colors of light; however, this new awareness of color influenced painters working with pigments.

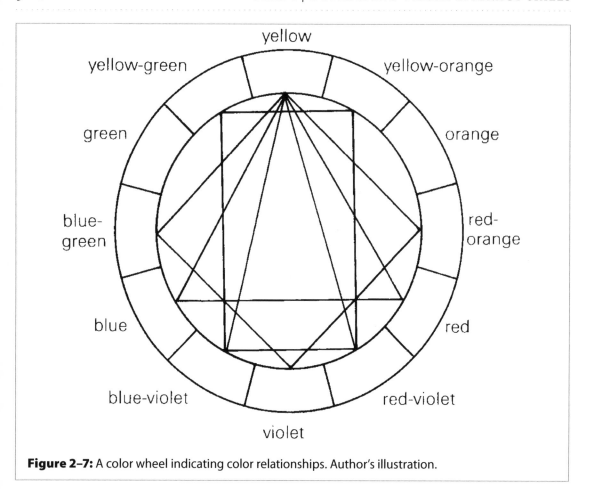

Figure 2–7: A color wheel indicating color relationships. Author's illustration.

Color Basics

Color has three dimensions: hue, value, and brightness. Hue is the actual color itself and is often called chroma. We categorize colors as primary colors: yellow, red, and blue (when using pigments); green, red, and blue (for light and in computer graphics); and cyan, magenta, and blue (in four-color process printing). Secondary colors are orange, green, and violet when using pigment; in computer graphic systems they are orange, yellow, and violet. In their book *Computer Graphics for Designers and Artists,* Kerlow and Rosebush (1986) described how computers represent color. On computer screens, the most common variables used to represent color are the red-green-blue (RGB) spectrum. These variables represent the luminance or brightness of the three additive primary colors of light and, when mixed, red, green, and blue become white. Besides the RGB range, used in computer graphics, artists and designers also use other color spectrums.

> Pigment-oriented systems work with the subtractive primaries, cyan, yellow and magenta (CYM). The CYM gamut absorbs light, and the mixtures of pigments in equal proportions produces black. CYM colors are useful in printing and painting, and like RGB, the CYM gamut can be represented as a cube. (Kerlow& Rosebush, 1986, p. 110)

The basic six colors (red, blue, yellow, orange, green, and purple) can be expanded and mixed to create multiple variations of color hues. *Value* is based on the purity of a color from the pure hue to gray. Pure colors are simple, and folk artists and children generally use them. According to Dondis (1973), "The more intense or saturated the coloration of a visual object or event, the more highly charged it is with expression and emotion" (p. 51). When we add black to a color, it is called *shade.* Conversely,

when we add white to a color it is called tint. Successful color relationships often depend more on how values, rather than hues, are combined.

Brightness is the intensity or vividness of a color. The brighter the color, the more "saturated" it is. Strong, saturated colors appear to be bright; in contrast, weak or dull colors appear to be gray. Another visual phenomenon that influences the creation and comprehension of visual messages is *afterimage*. Our perception of the saturation and value of colors is influenced by the color and value of surrounding colors. The negative afterimage that a color produces is its complementary color or opposite color on the color wheel. To observe this phenomenon, stare at a color for a long time and you will begin to see the color's complementary color. For instance, if you stare at the color yellow, purple will appear in the blank area of your afterimage.

Harmony

Color harmony is the effect of two or more colors together. Individuals often differ in the opinions about harmony and discord. Harmony and discord refer to an agreeable–disagreeable or attractive–unattractive scale. In contrast to accepting subjective views on color harmony, Itten (1970) argued that objective color harmony principles should be established. He proposed the following general statement: "All complementary pairs, all triads whose colors form equilateral or isosceles triangles in the twelve-member color circle, and all tetrads forming squares or rectangles, are harmonious" (p. 21).

Color and the Environment

In the animal kingdom, color plays an essential role in survival. For instance, the coloring of some animals is necessary for mating. A dramatic example of this is the male peacock that courts with his colorful feathers fanned. For other animals, color helps to conceal them from prey and predators. For example, a lion can get lost in the tall grass of the African plains and deer blend in with the woods.

Color can also play an important role for humans. Psychological studies have shown that color influences our emotions and feelings. Therefore, hospitals paint rooms warm and friendly colors to make people feel more relaxed. Similarly, industry has studied the psychological uses of color to increase employee productivity and reduce fatigue. It has been discovered that people are livelier when they work in a red light vibration; however, they are also prone to tire more easily. Additionally, marketers examine how color influences purchasing decisions and how color can be used to persuade people to buy particular products. Don (1977) described color and the shopping experience:

> To walk down any supermarket's aisles with the shelves stocked with hundreds of items row upon row is like being in Alice's Wonderland. For the brightly decorated packages in full color virtually scream at us, "Eat Me!", "Drink Me!", "Buy Me!" If we are unconscious to the effects of colors, we'll pick up a package that appeals to us and purchase the product not on the basis of its quality but because of its appearance. The continual improvements in advertising techniques leave the mind dazed. When we watch television on a color set, we see commercials comparable to the imagination and beauty of Disney's *Fantasia*. In fact, commercials are often more visually entertaining than the shows themselves. (pp. 16–17)

Designers use color as a way to direct our attention. According to designer Roger Black, the first color is white, the second color is black, and the third color is red. White is the best background color because black holds the highest contrast to white. The contrast between black and white makes pages easier to read. Designers who are concerned about legibility issues will try to avoid putting yellow type on orange backgrounds because there is not enough contrast between the figure and the ground to read the text. After white and black, the next important color is red. Black (1997) believed that red is the best color because the color yellow cannot be read against white and blue fades against black. In contrast, red headlines sell magazines on newsstands twice as much as any other color because red

attracts attention. "There are certain hardwired facts about human visual response that you'd be a fool to ignore. Like instinctive reactions to colors. Red is nature's danger color and is a great way to add accent to a black-and-white page" (Black, 1997, p. 36).

Contrast between colors on a page both draws attention to page elements and enhances readability. However, colors also have symbolic connotations. Red is a color of danger and warning. It is used in stop signs and for fire engines because red captures our interest. Color can help communicate nuances of meaning that scream out for attention or whisper quietly in the background. Generally, designers use bright colors in small areas to accent or highlight; in contrast, pale or dull colors are applied to large areas as a subtle tint. Warm colors—red, yellow, and orange—are more dynamic and active. They often attract more attention than the cool colors of blue, green, and purple. Beyond having different levels of visual attraction and symbolic meaning, colors also have cultural connotations. Jan V. White (1990) contended that surveys have revealed some useful pointers about the use of color, "for instance: Sugar is never packaged in green, because green carries connotations of sourness. It is packaged in blue, because blue is a color we associate with sweetness" (p. 22).

When colors have an implied meaning, they can help to express an idea. For example, in web design, black was the normal default color for type and blue type generally meant that a link is connected to it. By clicking on the blue type, another page will be revealed. After the blue type has been selected, its color will change to purple to show that it has already been chosen. These color associations in web design are relatively new, but most web users learn their meaning fairly quickly.

The colors a designer uses can help to set a tone for the composition. When viewing visual communication, check to see if the colors support the verbal information being conveyed. If the message features green, does it discuss money, financial issues, or gardening? If the design uses black backgrounds with reversed white type, is it describing a serious topic or issue? Designs that use a rainbow of colors tend to create a visual "circus" effect, and this effect should not be used in serious designs. Simply stated, the colors selected for a design should match the type of textual information being presented. If there is a conflict between the colors and the message, the message will not be expressed clearly.

Box 2.3: Colors and Their Meaning

The meanings associated with color come from both the natural and human environments. Associations such as orange for autumn leaves, blue to represent the sky, and green for pastures are inspired by natural phenomenon. In contrast, the following associations are human conventions that we learn: blue for boys, yellow to represent taxi cabs, and red and green to symbolize Christmas. A new color association that has developed since the introduction of the World Wide Web is that of purple with a link to a page that has been previously selected.

Red:	fire, stop, embarrassment, hot, aggression, daring, error, warning, Christmas
Orange:	cheerful, autumnal, warm, Halloween
Yellow:	jaundice, sunny cheerful, happy, taxi cabs, warning, caution, Easter
Green:	money, go, nature, envy, illness, health service, safety, security, pastoral
Blue:	sky, cold, water, peaceful, male, sad, link
Purple:	royalty, rage, a dumb dinosaur, selected (web design)
White:	purity, honesty, snow, clean, innocent
Black:	evil, ghostly, death, fear, mourning, night
Gray:	overcast, gloom, old age

Color and Culture

Designers use colors to achieve particular results, such as attract attention, buy a product, or express an idea. The use of color in design is based on human tendencies to react in particular ways toward certain colors. Additionally, our response to color is also shaped by cultural conventions. Moreover, language can also influence our understanding of color. For example, Latin speakers do not tend to distinguish blue from green. In ancient times, the Egyptians used the color blue in their paintings. But, they did not have a word for the color. People living in cultures that do not have words to represent specific colors will have difficulty understanding these colors. Ideas about color are filtered through a linguistic system that conveys notions about visual experiences. Additionally, the classification of color is generally not linked to a particular color reference but instead to a cultural concept.

In any system, units are defined in terms of their relationship to other units, for example, a color's relationship to its opposite color. The different ways in which cultures make the continuum of colors relevant by categorizing and identifying hues or chromatic units correspond to different color systems. For example, Africans often categorize color on two basic extremes—white and black. Between these two extreme limits is placed the color red. "For the African the three colours therefore form a sort of continuum, ranging from white to black, but passing through an aphelion where red is situated" (Zahan, 1977, p. 57). In contrast, Western cultures often use the color relationships depicted in the color wheel. Subgroups within a culture can also perceive colors differently. For instance, artists develop the ability

Box 2.4: Case Study: African Color Symbolism

Throughout Africa, nature has been the primary influence on color perception. When Africans invented dying techniques, they looked to nature and imitated it. Unlike Western culture, their system for categorizing color is not based on scientific discovery. Similar to ancient culture, Africans make a distinction between the three basic colors of white, red, and black. To be able to understand this concept of color, we must forget the 18th-century discovery about light that replaced symbolic concepts about color with scientific theory. By suspending our understanding of modern physics, we can explore another cultural perspective.

There is a difference between perceiving colors and classifying them. Africans perceive many different shades of colors; however, they tend to categorize them as white, red, and black. According to Zahan (1977), the statement that Africans distinguish three fundamental colors is intended to mean the following: "a) that to designate the different shades, which are sometimes highly varied, African languages use terms that refer to the three above mentioned basic colours: b) that very specific emotional, social, religious, esthetic and moral values are attached to white, red and black" (pp. 55–56).

These three colors foster a rich and varied chromatic vocabulary for some African populations. "For the Bambara of the Niger valley, for example, red includes: lemon yellow, café-au-lait brown, tender green and purple; —black: light blue, dark blue, dark green and grey; — white: bright white and pale white" (Zahan, 1977, p. 56). Similarly, Zahan (1977) reported "that among the M'bay of Moissa in the Republic of Tchad the following colours are classified as red: pink, light pink, mauve, yellowish green, bright green, yellow, orange and a warm brown; white includes: light grey, light green, light beige; and under black we find: grey, dark grey, very dark red, dark green, medium blue, dark blue and dark brown" (p. 56). White, red, and black indicate an entire "range of luminosity, or a number of light gradations that are subject to modifications depending on the culture or the altitudes at which these people live on the African continent" (p. 56).

to distinguish color variations within primary and secondary color categories. This is often done by learning the various names associated with paint pigments, for instance, phthalocanine blue, Prussian blue, cobalt blue, phthalocanine green, viridian green, hooker's green, and so forth.

Besides shaping the ways in which people generally comprehend color, culture also influences our understanding about the cultural meanings associated with particular colors. For example, Umberto Eco (1985) studied nation flags and discovered that the symbolic values assigned to colors change in different countries. "Red, for example, symbolizes bravery, blood and courage in many countries (Afghanistan, Austria, Italy, Bulgaria, Burundi, Chile, Ecuador, etc.), but it also represents animals in Bolivia and faith in Ethiopia. White, almost universally, stands for peace, hope and purity" (p. 174). However, in Congo Kinshasha, blue represents the idea of hope. In contrast, the color blue stands for sky and sea in most other nations.

LOOKING AT VISUAL IMAGES

Every day we make visual judgments in the act of seeing. Visual communication conveys messages through basic visual elements, balance, and color. In her book *Visual Metaphors,* Evelyn Payne Hatcher (1974) argued that the arrangement of basic forms in space can be associated with meanings, which bridge cultural boundaries. Her study tested the idea that form qualities are interpreted in similar ways by all human beings. However, her explorations about the similarities in the interpretation of graphic forms raised a dilemma. While people will find similar form meanings associated with form qualities, forms have many different qualities, and different people will select different qualities based on how important they deem each quality over others. Stated another way, different cultures tend to use different organizing concepts when they view a work of art. Hatcher stated the following: "The same circular dry painting seems essentially static to an Anglo and full of movement to a Navajo" (p. 215).

This occurs because visual training is culturally influenced, and people in different cultures learn to analyze the arrangement of shapes, figure and ground, and light and dark using different organizing principles. Although individual shapes may have similar cross-cultural meanings, when shapes are arranged into patterns, different cultures will look at the patterns in different ways. Consequently, identifying cross-cultural meanings associated with patterns is difficult.

Visual Perception

Human vision also influences how people experience visual communication. The eye will focus sharply upon a very small area, such as the word in the middle of a printed sentence, while the words on either side lose their definition. By the end of the line, the words will become indistinct gray blurs because our vision becomes indistinct and fades at the periphery. Additionally, our eyes are constantly in motion, scanning, shifting, and selecting objects in the environment.

More important, our perception is limited. For example, what we see on the television screen is very different from what is actually going on. The rapid variations in the intensity of the dots illuminated on the screen, or the variation of dots combined on a printed page to create a photograph, illustrate the limits of the eye's resolution. Magnify a photograph printed in a book and the actual image will be revealed as a series of dots. Besides mediated forms of communication, this phenomenon also occurs in the natural environment. Gombrich (1984) stated the following:

> Like the elements of the screen in the print, so the pebbles of a beach, the bricks of a wall or the leaves of a tree will fuse at a certain distance into larger areas, which are experienced as "textured" depending on the way the elements reflect the light. (p. 95)

Starting in the 1950s, James J. Gibson developed an ecological theory about perception. The ecological perspective asserts that perceiving is a process that occurs in an animal-environment system, not only in an animal. This view argues that perception is the detection of information, and it is called direct perception because perceivers are said to quickly perceive their environment. "Knowledge of the world is thought to be unaided by inference, memories, or representations" (Michaels & Carello, 1981, p. 2). In contrast, a different set of theories views perception as *mediated* or *indirect* because perception is thought to involve the intervention of memories and representations. "Gibson, on the other hand, holds that stimulation is extraordinarily rich and provides such a precise specification of the environment that a perceiver need only detect that information, not elaborate it" (Michaels & Carello, 1981, p. 2).We understand the environment by seeing surfaces and objects in our field of view.

Gibson argued that depth perception is actually a function of the way in which light structures the surfaces of objects within a field of view. The richness and accuracy of this information enables people to directly perceive their environment. Another influence on our perception is atmospheric perspective. Atmospheric perspective makes objects appear smaller in the distance, and parallel lines look as if they become closer and merge the farther away we are from them. Moreover, the atmosphere tends to make objects appear lighter in value and cooler in color as they become more distant from us. These visual phenomena influence the ways in which we experience information in both the natural environment and graphic space.

In contrast to Gibson, most psychologists argue that experience influences present experience. When the eye sees a shape, the new image gets into contact with the memory traces of shapes that have occurred throughout the person's life. According to Arnheim (1954), "Images of clear-cut shapes are often strong enough to resist any observable influence of the memory traces they meet. [But,] sometimes they may contain ambiguous features, which can change under appropriate influence" (p. 38). For instance, an ambiguous image with a title can influence how a person perceives it.

Perceiving and comprehending visual imagery is a complex process. Computer scientists studying visual cognition are just beginning to realize how complex it actually is: "Recognizing and reasoning about the visual environment is something that people do extraordinarily well; it is often said that in these abilities an average three-year old makes the most sophisticated computer vision systems look embarrassingly inept" (Pinker, 1984, p. 1). Our understanding of visual imagery is a combination of perception and culturally learned associations.

SUMMARY

There are many factors involved with seeing and understanding visual images. The term Gestalt is frequently used to mean that we see images by organizing shapes, lines, dots, and so forth, into groups. The total grouping has more meaning than the individual parts. Generally, theories relating to the perception of forms have centered on Gestalt principles, discussed in this chapter. The work of Gibson supports the idea of Gestalt because it is the relationship between objects and surfaces that enables us to perceive the world.

Although most people may comprehend the basic meanings associated with the content of an advertising photograph or image, the feelings conveyed by the visual elements used in the message may not be understood as easily. For example, the types of feelings conveyed by layout and balance in advertisements are not always consciously understood. Beyond recognizing the obvious signs and symbols depicted in a visual message, decoding visual communication also requires a knowledge of the psychological and cultural connotations associated with visual elements. For example, designers, artists, and filmmakers, who use the technique of visual dissonance, are challenging the viewer to participate

in the meaning-making process. This technique attempts to motivate the viewer to become involved in the process of meaning making by socially constructing the interpretation of the visual message. While some visual images are easy to understand, others can influence us on an emotional and a social level.

WEBSITES

- *Color Theory*
 http://home.bway.net/jscruggs/notice2.html
 http://desktoppub.about.com/od/howcolorworks/How_Color_Works.htm
 http://colortheory.liquisoft.com/
 http://www.colormatters.com/colortheory.html

EXERCISES

1. Take a photograph from a magazine or newspaper and make a list of one-word and short phrases that describe the literal message and underlying compositional meaning. Write a short report that describes the messages expressed through the photograph.

2. Select a photograph you have taken or image that you have created. Think about what effect or message you intended to communication and write it down. Exchange the photo or image with another person and ask that person to write down the message that he or she received from the image. Compare your intentions with the response.

3. Find an advertisement that has a poor visual design and one that is difficult to read or understand. Analyze how the ambiguity of the design contributed to the failure of message receipt.

4. Have everyone in the class find what they think is the perfect red. Compare the differences and similarities between the examples selected.

5. Construct a color system based on your school colors and black and white (e.g., purple, black, and white; maroon, black, and white; orange, black, and white, etc.). Explain how you categorized these colors.

6. Everyone has his or her own set of personal symbols. Select a basic shape that you feel best represents yourself and explain why.

7. Find images that are examples of the different concepts described in this chapter, such as balance, visual dissonance, harmony, and so forth.

KEY TERMS

Afterimage is a visual phenomenon in which our perception of the saturation and value of colors is influenced by the color and value of surrounding colors.

Atmospheric perspective makes objects appear smaller in the distance and parallel lines look as if they become closer and merge the farther way we are from them.

Brightness is the intensity or vividness of a color.

Gestalt theory argues that visual perception is the result of organizing visual elements or shapes into groups.

Hue is the actual color itself and is often called chroma.

Media text is a term used by researchers who support the point of view that the audience's reception of the media (advertising, radio, magazines, newspapers, television, and film) builds on the idea of reading. Audiences read and interpret media texts in ways that are similar to written ones.

Text refers to media content and events, such as television programs, films, magazine and newspaper articles, and websites.

Value is based on the purity of a color from the pure hue to gray.

Visual dissonance is a state of psychological tension created when people experience a discrepancy between what they expect to see and what they actually see.

Visual fusion is the perceptual phenomenon that occurs when the eye blends and organizes small elements of an image to perceive them as complex and varied forms.

Visual hierarchy is the visual emphasis placed on elements in a layout that directs the viewer's attention as he or she is looking at the image.

Visual syntax is the orderly arrangement of visual elements that make up a composition and expresses an idea or evokes a feeling.

☀ Perspective, Vision, and Culture

As discussed in the previous chapter, captions and basic shapes can help to make meaning out of a visual message. Captions appeal to our logic, while shapes influence us on an emotional level. Similarly, perspective appeals to our logic. However, unlike logical reading, which is formally learned, we learn perspective informally through our culture. For instance, parents often point to images in pictures and say the name of the object for their children. In addition to culturally learned aspects of understanding visual messages, our physical perception of visual images also influences the way in which we see and perceive visual messages.

Basic shapes are the building blocks of composition, and they can also be arranged into schemata to convey information to the viewer. A schema is the organization of information and the rules that govern its use. "Schemata represent the structure of an object, scene or idea" (Solso, 1994, p. 116). For example, a variety of "how to" drawing books provide step-by-step instructions to enable amateur artists to create pictures. These books illustrate formulas based on simple geometric forms to help people draw children, hands, feet, animals, and so forth. With the aid of these books, people can be taught to construct objects from simple geometric shapes.

Over the years, many different schematic drawing systems have developed. Many of these systems are designed to provide people with information. For example, subway maps reduce information down to its important features by paying little attention to actual geography. People use schemata, such as maps, every day to help them navigate through the environment. In contrast to schematic drawings, perspective is a more complicated method for conveying

Figure 3–1: A schemata: Basic shapes can be used to create a more complicated image. Author's illustration.

information. Perspective is a system in which objects are represented with distance and depth and it is a device for simulating dimension. Perspective turns the surface of the picture plane, the picture's flat surface, into a three-dimensional space. This illusion is created through angles, warps, atmosphere, perspective, and color.

PERSPECTIVE

Robin Landa (1983) said the following:

> At different points in the history of art the idea of volumetric space on a flat surface has held very different meanings. The Renaissance viewed it as a reflection of the true physical nature of the world. This use of volumetric space was ordered, based on a rational system called perspective. (p. 44).

The rules of perspective are socially constructed and altered over time. For example, drawings created before the development of linear perspective tend to distort or elongate human faces to include both eyes.

Filippo Brunellesch invented linear perspective around 1413 (see Kemp, 1990). During the Renaissance, rules of perspective were based on the assumption that larger images will appear closer to the spectator than smaller ones. This is a visual rule that is recognized by most people living in Western culture because they have been constantly exposed to drawings, paintings, and photographs that use perspective. However, not all cultures understand linear perspective. For instance, when Kenyan villagers were shown photographs, many of them failed to recognize the picture. Kenyans might recognize some individual elements in the picture, but they did not see the lines as a road going back into space. Consequently, the ability to read linear perspective is both historically and culturally bound.

Primeval Art and Perspective

For people living in Western cultures, primeval pictorial composition does not appear to be rational. First, primeval art does not have a rectangular orientation that is a characteristic of linear perspective. Second, images are often drawn on top of each other in a style that does not look naturalistic. Primeval art does not look naturalistic because it does not imitate the appearance of things as they exist in nature. For instance, different parts of an object or animal are shown as they are, not as they momentarily appear to an onlooker. Objects are drawn frontally or in profile to display their most characteristic features of the object from different sides. For example, the body of an animal is drawn in profile but the horns or the hooves are shown frontally. This type of perspective is known as perspective tordue, twisted or warped perspective. To eyes accustomed to seeing images drawn in linear perspective, perspective tordue often looks irrational.

Perspective in Egyptian Art

Similar to primeval art, Egyptian art also lacks linear perspective. For instance, details in Egyptian drawings do not show slanted surfaces because this type of representation requires the use of linear perspective. As a result, Egyptian pictures are flat-looking. Although they look flat, Egyptian pictures are highly technical. For example, their drawings depict specific aspects of Egyptian social life, and elements of Egyptian art are shown in "standard views." For instance, body and facial features are characteristically shown in the same typical way—eyes are shown from the front, while the face is in profile.

In Egyptian compositions, frontal and profile views are intermingled to show the pharaoh in the most complete and dignified way possible. However, when physical activity is shown, the artist aban-

dons the composite view. In contrast to the pharaoh, the dignity of working Egyptians did not have to be preserved. Janson (1995) stated the following:

> The Egyptian style of representing the human figure, then, seems to have been created specifically for the purpose of conveying in visual form the majesty of the divine king. It must have originated among the artists working for the royal court. It never lost its ceremonial, sacred flavor, even when, in later times, it had to serve other purposes as well. (p. 62)

In Egyptian art there is no consistent view of the objects as wholes; in contrast, the pictures are combinations of standard views of individual features or parts of objects. The orientation and position of the objects in space are secondary. To us today, the Egyptian placement of the human body upon a vertical plane appears highly artificial. However, this was very logical for Egyptians who were showing the relationships between humans and eternal space. The logic of these images is grounded in a social and religious belief system. When comparing Egyptian art to our concepts of linear perspective, drawing occluded objects shows depth and distant objects contain fewer details than closer ones. Typically, closer objects are placed lower in the picture and distant ones higher up.

Additionally, Egyptian art follows conventions for geometric proportions defined during the Early Dynastic Period and they continued to be used with little modification for over 3,000 years. Grids or matrixes were used to rigidly control the ratio of body parts in a drawing. These grids were first drawn on the surface; figures were then drawn on the grids, and skilled painters finished the picture. Many Egyptian drawings were created to portray life in the afterworld and the Egyptian eye did not see pictures as we do today. If cattle were drawn in perspective with animals growing smaller to show distance, the Egyptian would probably interpret the image in the following way: The cattle's owner had some normal-sized cows, some medium-sized cows, and some small ones. For Egyptians, showing cows all the same size without showing diminishing sizes (a rule demanded by linear perspective) is a valid method for representing reality. Within the conventions of Egyptian art, differences in scale show the differences in importance rather than size. For instance, a gigantic figure of the pharaoh is drawn of him confronting a small enemy stronghold. The pharaoh is larger because he is more important than the enemy.

Egyptian art often portrays religious concepts and actions, and it does not show objects and situations that occurred in the real world. In contrast, the Greeks viewed images as descriptions of actual events, rather than religious or symbolic ones. In Greek culture, a gigantic figure in an image would suggest a story about a giant among pygmies. Consequently, it is believed that the Greeks read the

Box 3.1: Case Study: Logic of Egyptian Images

The Narmer Palette has a strong sense of order. It is divided into horizontal bands, or registers, and each figure stands on a line that denotes the ground. The modern notion of representing a scene as it would appear to a single observer is unknown to Egyptian artists. Artists draw for clarity and not illusion. They select the most revealing view of the subject to be depicted.

Three views are possible in Egyptian art: full face, strict profile, and vertically from above. Notice how the larger figure has two competing profiles. The eye and shoulders are in a frontal view, while the head and legs are in profile. This formula shows the pharaoh in the most complete possible way, and he moves in the aura of his divinity. The artist is not concerned with the fact that this method of representing the human body makes movement and action impossible. The position reflects the divine nature of the pharaoh—ordinary mortals act, the pharaoh simply is. This symbolic stance continually appears in Egyptian art down to Roman times.

pictograms of the Egyptians as representations of imagination rather than actual world events.

Greeks

Greek artists before 500 BC mimicked Egyptian art conventions. However, with the emergence of Greek society and the classical Greek state, a more democratic, humanistic, and naturalistic mode of representation emerged. A major stylistic difference between Egyptian and Greek art is the orientation of human figures. In Greek art, faces are shown in three-quarter views, eyes are drawn in reference to the head, and objects are foreshortened. In contrast to the Egyptians, the Greeks do show slanting surfaces, and they use the most primitive forms of perspective. For example, limbs are drawn foreshortened in their vase paintings to increase the drama of the image. Foreshortening is a technique also used in linear perspective. To understand the idea of foreshortening, hold a pencil up in front of your eyes so you can see both the point and eraser. Now slowly turn the eraser of the pencil toward your face. The length of the pencil will progressively diminish. This decrease in size of the pencil is called foreshortening. Although the Greeks used foreshortening, they did not follow

Figure 3–2: On the Namer Vase the larger figure in the middle is more important than the smaller images of people around him. Perspective is not used. Author's illustration.

the rules of strict linear perspective. Early Greek drawings from the geometric period are basically stick figures with limbs and a body that is slightly thickened. "All the axes of the component parts of these figures are set in the plane of the picture, irrespective of their orientation in real space; and there is no representation of occlusion or 'overlap'" (Dubery & Willats, 1983, p. 15). Over time, the shapes in Greek drawings became more refined, and eventually they started to resemble true silhouettes. Overlap began to be introduced, and "then the principal axes of the forms began to be shown in foreshortened positions in relation to the picture plane" (Dubery & Willats, 1983, p. 15).

Ivins (1946) asserted that the Greeks did not use linear perspective because they perceived the world using tactile-muscular awareness: "The tactile-muscular awarenesses of things are awarenesses of things here, literally at hand. Infinity, wherever it is, as by definition escapes handling and measurement. Intuitively it belongs in the field of vision" (pp. 41–42). Although Greek artists knew the principles of perspective, they did not apply them to their work. Ivins argued that linear perspective is based on the idea of infinity and infinity is an idea missing in Greek culture. Without an understanding of the idea of infinity, the Greeks could not understand the idea of a vanishing point that is a central element of linear perspective. Additionally, Greek artists created things in their own right, and they did not attempt to match the sights of the visible world with the artistic one.

The Greek philosopher Plato criticized the idea that artists could portray the real world. He argued that artists could only see the "appearances" of the world because the world seen by the eye is an illusion. According to Plato, the shifting world of the senses leads people away from the logic of truth.

"The picture conjured up by art is unreliable and incomplete, it appeals to the lower part of the soul, to our imagination rather than to our reason, and must therefore be banished as a corrupting influence" (Gombrich, 1969, p. 127). As a result, Plato argued that artists should be banished from the state.

Despite Plato's criticism, Greek art continued. Over time, objects represented in Greek art began to appear more natural and realistic. The Greeks observed and adjusted visual forms to match natural appearances. Gombrich (1969) argued that it is through stages of schema and correction or constructing a form and adjusting it to match nature that artists portray the natural world. To create images that represent the visible world, the artist must first know how to construct a shape or form. As a result, Gombrich asserted, Greek art went through a gradual accumulation of form corrections based on the observation of reality. Techniques such as foreshortening and modeling in light and shade began to produce images that resembled natural objects. With the continued systematic study and modification of graphic forms, artists eventually replaced the concept of making objects of art with the idea of using art to represent reality. This conceptual shift set the stage for Renaissance art with its emphasis on pictorial realism.

Box 3.2: In His Own Words: Ivins Describes Greek Tactile Awareness

Bio: William M. Ivins, Jr., was the curator of prints at the Metropolitan Museum of Art in New York City from 1916 until 1946. His book How Prints Look *(1943) is considered to be the best introduction to the technical study of printmaking. In* Art & Geometry: A Study in Space Intuitions *(1946), Ivins proposed a controversial view, which argues that the Greek worldview hampered the Greeks' development of art. More important, he presented a concise history of the development of mathematical or linear perspective.*

When we look at a shelf or table covered with objects of the same size, those in the back rows are visually overlapped by those in the front rows and appear to be smaller than they are. But, if we shut our eyes and reach out with our hands and feel the objects, not only are all the objects tactually of the same size but there is no overlapping of further objects by nearer ones. The only way of preserving these tactile awarenesses in a pictorial statement is by arranging the images of the objects in the picture plane in such a way that all the objects are of the same size and none overlaps another. The simplest way of doing this is by arranging the images of the separate objects in several nonoverlapping rows, one above the other. If we think about the matter in this way, the arrangement in rows becomes a pictorial device not to indicate visual depth but to save the tactile awarenesses, i.e., to represent things as they are tactually known. It seems to me, in view of the general Greek attitude, that this is what it is. (Ivins, 1946, pp. 30–31.

Renaissance and Perspective

In contrast to earlier cultures, Renaissance artists strive for precise visual realism. "For almost four hundred years from 1500 it served as the standard technique for any painter who wished to create a systematic illusion of receding forms behind the flat surface of a panel, canvas, wall or ceiling" (Kemp, 1990, p. 7). Artists celebrated the ability of painting to deceive the eye, the very characteristic of painting that Plato disapproved of. But to imitate nature, it first must be taken apart and put back together again. After breaking objects down into their primary shapes, artists can then place them into a realistic scene with the use of perspective.

In the Renaissance, perspective was described by using the metaphor of a "window." When we look at a linear perspective drawing, we are to believe that we are looking through a rectangular window

Figure 3-3: Technologies were used during the Renaissance to help artists draw in perspective. Dover Pictorial Archive Series, "Great Woodcuts of Albrecht Durer." Used with permission.

into space. The definition of a picture plane as a window implies that the artist must select a position in which to view the scene. The artist's fixed point of view becomes the spectator's point of view. To help artists maintain a fixed position, a variety of mechanical aids were developed. Dürer illustrated these devices in a series of woodcuts. The first device is a piece of glass in a frame. Using this tool, the artist simply traces the contours that appear on the glass with a paintbrush. When the artist is finished, the drawing is transferred to a panel for painting.

Another type of drawing device used a frame with a network of squared lines that are similar to a map. The artist's drawing paper is also squared up. As the artist observes the contours from a fixed viewing location in relation to the squares within the frame, these contours can then be drawn on the corresponding squares on the paper. To maintain a fixed location, the artist keeps his or her eye in one position by using a sight vane. This second method is also used to reduce or enlarge a drawing proportionally.

Besides drawing devices, some Renaissance paintings use the optical technique known as atmospheric perspective, which is based on an actual natural atmospheric phenomenon. In the real world, the atmosphere is never completely transparent. In contrast, the air between objects and us can act as a hazy screen that interferes with our ability to see distant shapes. Objects in the distance are not as clearly defined as ones that are close to us. In painting, the use of atmospheric perspective is closer to how we actually perceive deep space.

Linear perspective, drawing devices, and atmospheric perspective are all techniques used by Renaissance artists to realistically paint the world. Additionally, Renaissance artists bring all visual elements together into a total composition that uses proportional standards. Artists are limited to a single theme and the composition is often intelligent and rational. Hauser (1957A) contended that during the Renaissance, art became part of a rationalization process:

> The things that are now felt as "beautiful" are the logical conformity of the individual parts of a whole, the arithmetically definable harmony of the relationships and the calculable rhythm of a composition, the exclusion of discords in the relation of the figures to the space they occupy and the mutual relationships of the various parts of the space itself. (p. 15)

Perspective is space viewed from a mathematical standpoint; proportions of individual forms are systematically organized, and "all criteria of artistic quality are subjected to rational scrutiny and the laws of art are rationalized" (Hauser, 1957A, p. 16). Central to the rationalization of art is the use of linear perspective. The geometry of a painting suggests that all of the painting's objects and features

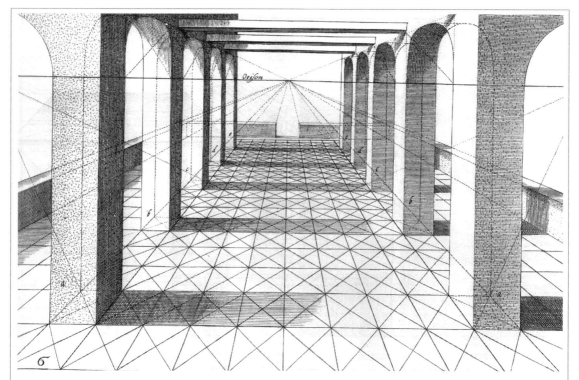

Figure 3–4: One-point linear perspective goes back to a vanishing point. Dover Pictorial Archive Series, "Studies in Perspective." Used with permission.

converge on a single point near the back or center of the picture. Today, we are so used to seeing drawings and paintings using this technique that we are not consciously aware of how perspective works.

Linear Perspective

Two ideas that are central to linear perspective are the horizon and vanishing points. In nature, the visible horizon is the immense and distant circle that is the extremity of our planet. Although the horizon is curved, in pictures it is drawn as a straight line. Where the horizon is placed in the picture, it shows how high up or low the artist is in relationship to the objects in the picture. When painting any scene, the artist fixes the position in which he or she is painting from by drawing a horizon line. Often objects will cover the horizon line. Although the horizon may not appear in the final picture, it still indicates the relationship between the artist and objects in the scene. Cole (1921) described how this works:

> We may consider the horizon as a distant imaginary line parallel to the front of our face and stretching across the view at the actual height that our eye is from the ground; so if standing in a room our horizon would be roughly 5 ft. 6 in. from the floor, or if we are sitting 3 ft. 6 in.
>
> If our model is standing on a throne and we sit to paint on the low stool, our horizon is about the level of his feet. Out of doors a slight rise on otherwise level ground would present a similar effect.
>
> In a room we can find the horizon by measuring the height of our eye from the ground and chalk-marking that height on the wall facing us. Out of doors on hilly ground a stick with the height of our eye marked on it can be stuck in the ground just in front of us; where that mark cuts the view will be the horizon. (pp. 24–26)

A vanishing point is the point at which any system of parallel lines converges, and the vanishing point extends into infinity. All horizontal lines converge in vanishing points on the horizon line. Artists often use either one-point or two-point perspective when they are creating pictures. In one-point per-

spective, the center line is the vertical line in the picture plane that intersects the horizon line at the center vanishing point. One-point perspective allows an artist to see two sides of a cube. In contrast, two-point perspective enables artists to show three sides of a cube. Our understanding of perspective depends on the culture in which we live.

CULTURE

The art of each epoch is a means of communicating the culture's beliefs about the cosmic order. In the 15th century, perspective was a new invention that was in harmony with the basic feelings of rationalism and scientific inquiry. An architect named Brunelleschi (1377–1446) first successfully developed perspective. However, Leonardo da Vinci (1452–1519) was the first person to formally set down its principles. Gregory (1970) argued that perspective was not simply created by artists looking at scenes and drawing what they saw:

> It is much more likely that perspective was discovered through measurement, and was only applied consistently with the aid of instruments, especially the camera lucida and the camera obscura. These give optical projections allowing the scene to be traced directly from an image. (pp. 112–113; see Figure 3–3)

Around 2002, artist David Hockney proposed a theory that "painters secretly used lenses—both concave mirrors and the more common transparent glass sort—to enhance the realistic details of their pictures" (Carrell, 2002, p. 77). Artists, including Jan van Eyck and Jean-Auguste-Dominique Ingres,

Box 3.3: In His Own Words: Gombrich on Leonardo and Universal Images

Bio: Sir Ernst Gombrich was a professor of the History of the Classical Tradition at the University of London frottm 1959 to 1976. He was knighted in 1972 and awarded the Order of Merit in 1988. He has received many worldwide awards and distinctions including the Goethe Prize and the Gold Medal of the City of Vienna. He has written numerous books on art theory, the psychology of images, and art in relationship to culture.

Leonardo had discovered a law about the biological class called "trees" to which every individual tree belonged. Those who wanted to portray a tree in their garden had first to know about the structure and proportion of trees. But thanks in part to the influence of Platonism, the whole distinction could be given a different twist. For Plato, the universal is the idea, the perfect pattern of the tree exists somewhere in a place beyond the heavens, or, to use the technical term, in the intelligible world. Individual trees or horses or men, such as the painter may encounter in real life, are only imperfect copies of these eternal patterns, imperfect because base matter will always resist the flawless seal and prevent the idea from realizing itself. It was on these grounds that Plato himself denied art its validity, of what value can there be in copying an imperfect copy of the idea? But on the same grounds Neo Platonism tried to assign to art a new place that was eagerly seized upon by the emerging academies. It is just the point, they argued, that the painter, unlike ordinary mortals, is a person endowed with the divine gift of perceiving, not the imperfect and shifting world of individuals, but the eternal patterns themselves. He must purify the world of matter, erase its flaws, and approximate it to the ideal. He is aided in this by the knowledge of the laws of beauty, which are those of harmonious, simple geometrical relationships, and by the study of those antiques that already represent reality "idealize," i.e., approximated to the Platonic idea. (Gombrich, 1969, pp. 155–156).

Figure 3–5: Leonardo Da Vinci, Ginevra dé Benci. Dover Pictorial Archive Series, "120 Italian Renaissance Paintings." Used with permission.

used optics as a method to reflect images of models and objects onto canvas. "These projections compress a scene's complex, three-dimensional masses, gradually shifting light and color into clear, two-dimensional shapes whose outlines can be quickly and confidently traced" (Carrell, 2002, p. 78). The optics were not easy to use and the artwork still required the talent of the artist to paint the image.

Drawing devices and the camera obscura contributed to the development of perspective as a method for portraying reality in drawings and paintings. Besides perspective, the physical structure of the human perceptual system also plays an important role in shaping how we see the world and, consequently, how it is represented in visual communication.

VISION AND PERSPECTIVE

Plato believed that all of nature had an ideal form in the universe. What we see in the naturalized world was an imperfect version of the ideal. Similar to the philosophies of Plato, the study of visual perception goes back to classical antiquity. Euclid, the father of geometry, also started the science of optics around AD 300. Artists (Alberti, Dürer, and Da Vinci) and philosophers (Descartes, Berkeley, Newton) have explored the nature of visual perception. For instance, Descartes declared that sight was the "noblest and most comprehensive of the senses." And he advocated the invention of technologies, such as the telescope, to increase the power of sight.

How the Eye Works

When people see an object, their perception of it is based on a stream of neural activity initiated by light being reflected from the object's surface. Then, the eye transmits a signal to the visual cortex and the brain interprets the signals. The primary sensory instrument for detecting visual information is the eye. Similar to a "big window," the eye is open to a wide range of visual information. Therefore, people must select the objects that they are going to pay attention to. Using selective attention, people attend to certain stimuli available in the environment while filtering out other information. For instance, when students want to improve their study habits, they are often told to find a place that has the fewest distractions. Studying in a room with the television on can divert one's attention away from a book because the television's stimulus is more pleasant to attend to than the reading materials.

When people look at objects, the reflected light enters the eye through the pupil or opening in the eye. The colored iris surrounds the pupil. The surface of the eye is the cornea and the lens is behind the iris. Light passes through the cornea and aqueous humor to enter the inner eye through the pupil. The pupil regulates light entering the eye and the lens focuses the light on the sense cells of the retina. According to Livingstone (2002), there are layers of neural tissue that line the back of the eye:

The first layers are the ganglion, bipolar, and horizontal cells; the cells that respond directly to light, the photo-receptors, are, surprisingly, in the outermost layer. The photoreceptors contain light-absorbing chemicals, pig-

ments that generate a neural signal when they absorb light. The signals pass toward the front of the eyeball through the bipolar and horizontal cells to the ganglion cells, which send their signals from the eye via the optic nerve to the brain. (p. 24)

There are two types of light sensitive cells in the eye: rods and cones. Rods work under low light conditions, such as dusk or night when the lights are turned off. They specialize in making shades of gray. In contrast, cones produce a full range of color vision, and they are active in day and bright light conditions. Rods and cones respond to the light beams and translate the input into nerve impulses transmitted up the optic nerve through substructures to the visual cortex of the brain.

What our eyes see is not a picture of reality itself, but rather, information synthesized by our brains. Data from our eyes and other senses

Figure 3–6: Diagram of the eye. Author's illustration.

are synthesized and combined with experience to provide a working image of the world. What we call reality is actually a mental image. Culture and the ability to read visual schema can influence our understanding of images. Aumont (1994) stated the following:

> In principle, the perception of images, insofar as this can be separated from their interpretation (which is not always easy), is a process which is characteristic of the human species and which has simply become more cultivated in some societies than in others. The part played by the eye is common to everyone and should not be underestimated. (p. 50)

Humans have a limited vision, and they can detect some visual cues from a field of more than 180 degrees horizontally (about 90 degrees to the right and 90 degrees to the left) and 130 degrees vertically (about 65 degrees up and 65 degrees down). As visual impressions move away from the center, they become less distinct. In contrast to still objects, moving ones in our peripheral vision are significantly easier to detect. This aspect of human vision may be part of our evolutionary past, when the detection of moving objects was central to survival.

Dynamic Vision

Visual perception is an active process. Instead of fixing one's gaze on a single object, the eye muscles continually contract and relax. This muscle activity moves the eyeball so that it is directed on one feature and then another. Many eye movements, such as reading, are automatic. Eye movements are called *saccades.* Saccadic eye movements are rapid, voluntary eye movements between fixation points. They occur at irregular intervals an average of two to four times per second. In general, people gaze longer at interesting or puzzling things and spend a shorter time on simple or mundane ones. For instance, when designers create visual hierarchies, they are attempting to direct the eye's movement or saccades toward particular elements in the visual message.

Researchers have attempted to predict the ways in which an eye scans an image, but without specific instructions, viewers do not follow the same viewing patterns. Conversely, when people do receive instructions about how to look at an image, their informed gaze moves differently within the

field of exploration. Gaining an understanding about how to look at an image will change the way the eye moves around it.

Besides eye movement, our heads and bodies are in continual motion. As a result, the retina is perpetually moving in relationship to the environment. Vision is both a spatial and temporal sense. Three important time factors influence our vision:

- Visual stimuli vary across time because they are created in sequences.
- Our eyes are in constant motion, and the information the brain receives is always changing.
- Perception itself takes place over time and is not instantaneous; the processing of information occurs in time.

Additionally, vision specializes in the perception of distance. Our ideas about distance and space are connected to the body and its vertical movement. For instance, our experience of gravity enables us to feel it through our body. The relationship of the body in space relates to three-dimensional geometry. Cartesian geometry defines physical space in terms of three coordinates: vertical, horizontal, and spatial (x, y, z coordinates):

> The vertical axis is the direction of gravity and the standing gait; the horizontal dimension is constituted by the line of the shoulders parallel to the visual horizon before us; and, lastly, the third dimension is the depth which corresponds to the body moving forward in space. (Aumont, 1994, p. 22)

Human perception of vertical and horizontal space is perceived in a straightforward manner. In contrast, spatial depth perception is more difficult. Texture and perspective are two ways in which people perceive spatial depth. As previously discussed, objects are seen against a background, and the surfaces of objects have a variety of textures. For example, brick walls have a double texture. First, a series of bricks arranged into a wall or fireplace creates a pattern. Second, each individual brick has a textured surface. Most objects that we view are on an angle and the projection of their texture onto the retina creates a progressive variation in the texture-image or gradient. According to James J. Gibson, the texture gradient is the most important element in the direct perception of space. As we look at an object, the texture of a detailed surface becomes finer as the distance increases. The regularity of surface elements enhances the use of texture gradients for judging distances. For instance, when you look at bricks, they grow smaller and more densely packed from close to far away. With bricks, the geometrical optical effect created by the pattern of bricks resembles linear perspective.

Linear perspective uses the laws of geometric optics. Light rays go through the center of the pupil to create a real image with a central projection point. Similarly, in one-point perspective, lines converge at a central vanishing point. In both visual perception and perspective, people interpret diminishing size as distance. In visual perception, the combination of geometric optics and texture gradients makes it easy to differentiate an angle or the corner of an object from the edge of a surface. These optical characteristics enable people to perceive objects in physical space.

Monocular Versus Binocular Vision

Up to now, only one eye has been described. When people look at a two-dimensional image, such as a photograph or drawing, monocular (one eye) cues of depth provide the only depth information. In contrast, visual perception uses two eyes, and the second eye adds additional depth cues. Researchers have concluded that each eye receives a slightly different view of spatial information. "The eyes register a single image only if the corresponding retinal points are stimulated by the same part of the distal stimulus. When corresponding points are not stimulated, a double image results" (Murch, 1973, p. 195).

In the mid-1800s, Wheatstone discovered that the different images recorded by each eye contribute to the perception of depth. He and David Brewster (who invented the kaleidoscope) began to design

optical devices, called stereoscopes, capable of presenting a fused image from two pictures taken from slightly different points of view. The fused image produced the effect of three-dimensional space and depth perception. While developing the stereoscope, Wheatstone discovered that this technique could make lines printed on a flat surface stand out from their background. In the late 1800s and early 1900s, the stereoscope became a popular form of three-dimensional entertainment. Today, developers of virtual reality (VR) systems trace the history of this technology back to the work of Wheatstone and Brewster. VR systems use helmets with stereoscopic imaging to present information to the user. Over the past 150 years, sophisticated technologies have developed to both extend our sense of sight and improve our methods of picturing reality.

COMPUTER CULTURE

Since the Renaissance, both artists and scientists have developed new methods for representing objects. Presently, computer scientists are creating new types of digital visual communication systems. Computers introduce advanced visualizing methods for image creation, manipulation, and presentation. Most of these computer-generated image techniques rely on traditional linear perspective as a system for representing information. Morgan and Welton (1992) argued that all new images make reference to previous technologies and techniques: "Without this historical linking our perception would be diminished" (p. 79).

Computer imagery uses perspective as a historical link because a user's previous experience with perspective makes it easier for a person to understand the computer-generated pictures. Similar to Renaissance art, computer screens also use windows. In contrast to Renaissance windows (and real windows), computer windows do not always represent the natural world. Instead, computer windows are information spaces that contain data. Pictures, text, numbers, charts, graphs, and illustrations are all symbolic symbol systems used in the display of computer-generated information.

Computer systems can also be programmed to visualize imagined worlds. Similar to the impossible realities created in Escher's drawings, computer designers can invent worlds that never were and worlds that never can be. Currently, the most advanced type of computer-generated information space is VR. VR is considered the ultimate communication medium because it is a total sensory experience that enables people to interact with computer-generated objects:

> When immersed in virtual reality, users see, feel, interact with, and manipulate a computer-generated world not necessarily related in any way to the so called real world we all live in. VR applications have been developed for entertainment, which includes arcade games, medicine, and employee training. (Pavlik, 1996, p. 378).

Many VR applications have also been developed for the World Wide Web. These include VRML, or Virtual Reality Modeling Language, and QuickTime VR.

Many different types of VR systems are currently under development. VR technology designed to run on a personal computer, the Internet, or the World Wide Web is called *nonimmersive* VR. In nonimmersive systems, users view information on a computer screen, and they can also see objects in the real world. This type of three-dimensional computer display relies strongly on ideas of linear perspective to display objects. Although linear perspective is an underlying principle for the representation of computer-generated information, VR programs such as VRML also allow users to change their point of view as they navigate computer-generated space. The ability to navigate through three-dimensional scenes, information, and representations of reality is a distinguishing feature of VR technology.

In contrast to nonimmersive VR are *immersive* VR systems. Immersive VR surrounds the user within a computer-generated environment. These systems generally use goggles or a helmet with

small monitors positioned in front of the user's eyes. The monitors display stereoscopic imaging in which each eye views a different image, and the three-dimensional stereoscopic effect enhances the VR experience. This effect is similar to the stereoscope, invented in the 1800s.

Immersive VR systems are designed to manipulate the human perceptual system into believing it is in another world. Various visual and sensory stimuli are presented to the user in a way that makes sense from experiencing the real world. For instance, when the user walks forward, objects appear to get closer. Sight has been the primary focus of VR development. This sensation is further enhanced through sound and sometimes touch. For example, users generally navigate through VR space with the aid of a glove. When the user moves his or her hand, the glove picks up the movement and sends an electronic signal to the computer that is translated into virtual hand movement. In many systems, the virtual hand can generally be seen floating in the computer-generated world. Immersive VR navigation requires hand-eye coordination to navigate the digital environment. The use of hand-eye coordination is a second distinguishing feature of VR that differentiates it from other types of visual communication systems.

Culture and Perspective

Various types of perspective have been used throughout the ages in visual communication systems from the Egyptians to VR. As a result, perspective can be considered a type of visual system agreed upon by a given culture. Morgan and Welton (1992) contended that perspective

> is purely convention: it depends upon tacit acceptance by the members of a given culture, and other cultures may use other means to convey the same message. Since the conduct and perceptions of any group are likely to have been regulated by the same sets of conventions since childhood, [cultures] are likely to imagine that their codes have absolute validity. (p. 83)

For instance, people living in Western cultures might be inclined to think that Chinese or African art lacks accuracy because artists living in these cultures do not use linear perspective when creating images. Conversely, Chinese artists might find the use of linear perspective to be an unnatural and rigid depiction of nature.

Non-Western Perspectives

In Chinese art, linear perspective is absent, except in the most marginal ways. The vertical placing of objects in the space shows distance rather than size. As a result, parallel lines do not taper. "Chinese painting gives a far more accurate reflection of the flattened depth of field seen by an unwavering gaze" (Morgan & Welton, 1992, p. 80). Additionally, some Chinese drawings arrange the lines of objects toward a central axis of the picture. To Western eyes, the system looks similar to perspective. Although many Chinese and Japanese drawings appear to use perspective, this system was never consistently developed in these cultures as it was in the West.

In contrast to linear perspective, Japanese, Korean, and Chinese artists do use atmospheric perspective in their paintings because they represent distant objects as more diffused than closer ones. Visual distance is also achieved by placing distant objects toward the top of the scene and closer objects at the bottom. Similar to Egyptian art, the size of people in Chinese art is based on status. As a result, central figures are shown proportionally larger than peripheral ones. Moreover, the size of people is more or less independent of their proximity to the viewer.

The Chinese approach to art is poetic and deeply rooted in Chinese ideas about the nature of the universe. For example, Chinese artists learn to paint flowers by starting with a few petals and then moving on to many petals. They start with small leaves and then move to large ones. After the beginner learns the basic steps, he or she is beginning to learn the skill of painting. Moods and inspirations are

combined with the rules of painting to create a beautiful image. There is nothing in Western art that compares to Chinese painting. Moreover, the language used by the Chinese to discuss art is so radically different from Western ideas that art texts are difficult to translate between these two cultures.

Technology and Visual Relationships

Besides culture, technology has also influenced the development of perspective as a drawing system. In the 17th and 18th centuries the camera obscura enabled artists to optically represent the environment from a fixed viewing position. In contrast, during the 1800s, the introduction of new technologies, including railroad travel, telegraph, industrial production, and photography, altered the observer's relationship to the environment. Both people and information could travel faster. For instance, people could now sit on a train and view the world passing outside the train's window. A consequence of the change in traveling speed is the dissociation of the sense of touch from the sense of sight. As a result, the invention of the railroad altered the relationship between observers and the ways in which they viewed the world.

A remapping of the body in the 19th century began to occur as the loss of touch as a conceptual component of vision is detached from referential images in space. Touch became detached from sight, and sight became autonomous as a method for seeing the world. For instance, viewing the environment from a train window is very different from walking in a garden and touching the flowers. The former situation does not allow observers to feel the ground beneath their feet, pick the petals off a flower, or feel the cool water in a pond.

Jonathan Crary (1990) argued that different technologies express different cultural concepts. For example, a historical and technological relationship exists between the camera obscura and photographic camera. However, the cultural ideas expressed by each are very different. A central difference between these technologies is the role of the observing subject. With the camera obscura, the artist's eye fixes the point of view, and it becomes the observer's point of view. In contrast, cameras can replace the human eye.

Today, the role of the human eye is being supplanted by visual images created by technology. As a result, "visual images no longer have any reference to the position of an observer in a 'real,' optically perceived world" (Crary, 1990, p. 2). In computer-generated images, these images refer "to millions of bits of electronic mathematical data. Increasingly, visuality will be situated on a cybernetic and electromagnetic terrain where abstract visual and linguistic elements coincide and are consumed, circulated, and exchanged globally" (Crary, 1990, p. 2). As visual technologies develop, they are moving further and further away from observers perceiving objects in natural contexts. Natural perception is often replaced with mediated images created, distributed, and observed with the aid of visual technology.

Increasingly, first hand optical observation is being replaced by mediated experience. Changing forms of media can influence the role of the observer in relationship to a scene. For example, paintings, photography, and film have fixed points of view; in contrast, VR systems allow observers to change their point of view. The role of the observer in VR is very different from the role of the observer in Renaissance paintings. VR systems make a historical connection to Renaissance systems of perspective, but they do not limit the artist or spectator to a single, fixed– point of view. In Renaissance paintings, the artist chooses the position of the spectator to observe. In contrast, VR systems enable the spectators to select their own position as they navigate through a computer-generated environment. Thus, VR systems alter the relationship between the spectator or observer and image.

Box 3.4 Case Study: An Analysis of a Cubist Painting

Dubery and Willats (1983) asserted that the Cubist painting style uses a mixed system of perspective. Rather than thinking about painting as a window into space, Cubist artists wanted their paintings to stand as objects in themselves. To achieve this goal, they developed a series of devices that invert the normal rules of perspective and destroy the illusion of the real world by emphasizing the picture surface. First, the rectangular compositional forms in this picture fan out from the bottom of the picture like a hand of cards. Second, parts of the scene that would normally be hidden are included in the painting, and other parts that would normally be visible are missing. Third, the artist utilizes a technique called "false attachment." The top edge of the cup in the middle is falsely attached to the tablecloth, and the top edge of the cup on the right is falsely connected to the table. Additionally, objects are falsely attached to the frame of the picture. This use of false attachment attempts to blur the boundaries between the real world and the pictorial illusion. Fourth, the atmospheric perspective is reversed. Dull recessive colors dominate the image, while bright colors are at the top where the recessive colors normally are found. Finally, the artist introduces the non-visual symbol system of language by including a newspaper clipping to sign his name.

Changes in Perspective

Images are created during specific historical periods and artists use different types of visual communication technologies. As a result, human perceptual systems are not neutral instruments that faithfully transmit data. The eye leads us to consider the subject, and the brain interprets it based on cultural and technological influences. During the process of interpretation, many factors come into play, including the specific historical moment, values, beliefs, and cultural attitudes. Gregory (1970) argued that pictures are a remarkable invention which require special perceptual skills for seeing them:

> Apart from pictures and other symbols, the senses direct and control behaviour according to the physical properties of surrounding objects—not to some other, real or imaginary, state of affairs. Perhaps man's ability to respond to absent imaginary situations in pictures represents an essential step towards the development of abstract thought. (p. 32)

Observers see images. Besides perceiving an image, observers must also define their relationship to it. Observers are active partners in the image meaning-making process. First, observers must be able to identify what the image represents. Many real-world visual characteristics are found in images, such as visual edges, colors, size, and texture. More important, the ability to read the rules used in the drawing or visual system aids the process of understanding. For instance, knowledge about perspective is necessary to comprehend Western art and VR graphics.

Changes in cultural ideas can influence the ways in which observers view the world. For instance, lin-

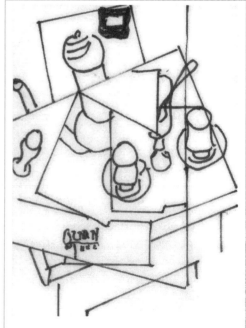

Figure 3–7: Cubists break up the painting surface into different planes of perspective. Author's illustration.

ear perspective is a system used by Western artists from the time of the Renaissance until the end of the 19th century, with the arrival of Impressionism and Cubism. Rather than depict realistic scenes, Impressionistic artists were interested in representing the psychological perception of reality through color and movement. Similarly, Cubist paintings often show objects from a variety of points of view, not just one. The principal effect of this new style of art was obtained through one's emotional reaction to the work. Cubist painters replaced the traditional rules of linear perspective with ones that create a dynamic tension between multiple vanishing points and they launched a Cubist war against perspective. Cubist paintings began to move "towards abstraction—or rather, to that point where only enough signs of the real world remain to supply a tension between the reality outside the painting and the complicated mediations on visual language within the frame" (Hughes, 1991, p. 29).

Modern art often breaks the previously established rules of art. The illusion of depth, linear perspective, and subject matter was thrown away and replaced by the search for a theory of art. Before the 20th century, Euclidian mathematics, Newtonian physics, and linear perspective dominated intellectual thought. However, as people moved into the 20th century, fundamental changes altered established views. Painters were no longer measured by linear correctness, and some artists even mocked the conventions of the past. It has been argued that a contributing factor to this intellectual change in the art world was due to the widespread use of the camera that could portray reality more accurately than most artists.

SUMMARY

Visual communication systems, such as perspective, are influenced by their historical epoch, cultural practices, and visual techniques. For instance, perspective tordue enabled artists to draw an animal's body in profile with its horns shown frontally to more fully describe the animal. Similarly, Greek artists drew a human face from a three-quarter view that showed two eyes instead of one. In Greek culture, Plato argued that the painter could not truly represent an object because artists can show the object only as it appears from one side. Plato's criticism of Greek art can be applied to the development of linear perspective. Perspective has to sacrifice the diagrammatic completeness of a form because only a limited number of sides can be shown in a picture. In contrast, the new technology of VR appears to have solved this problem because it enables users to navigate around computer-generated objects and view them from multiple perspectives.

WEBSITES

- *Leonardo's Perspective* http://www.mos.org/sln/leonardo/leonardosperspective.html
- *New Perspective*
 http://www.termespheres.com/perspective.html
- *Perspective Drawing*
 http://mathforum.org/sum95/math_and/perspective/perspect.html

EXERCISES

1. Build an image utilizing the rules of linear perspective in which you deliberately "bend" or change the rules to create an effect that is unsettling for our perceptions. It may be helpful to use photography, collage elements, and color.

2. Egyptian artists had a clearly defined visual system for showing status: larger people had more status than smaller ones. Look through a fashion magazine and find images that convey the concept of status. What conventions do contemporary photographers use to make one person appear more important than another? Describe the techniques.

3. Artists since the time of the Renaissance have used mechanical drawing aids. Students can use the grid concept shown in Figure 3–3 for this assignment. Find a magazine photograph of a person. Carefully draw a grid of boxes one inch by one inch on top of the photograph. On a piece of paper, draw a grid of boxes two inches by two inches. Using the grid as a guide, transfer the outlines of the figure in the photograph to the paper.

4. Read Plato's "Allegory of the Cave" from *The Republic* and compare the cave to newly developed virtual reality systems. What do you think Plato would say about today's visual media?

5. Find a Cubist painting in an art book. Make a copy of the painting and identify the different angles of perspective the artist used.

6. Place several objects on a table. Take photographs of the objects from four or five different positions to make sure that all sides of the objects are represented. Cut the images up into smaller pieces and put them back together into one single image that shows the different sides of the object. [Note: This exercise could also be done as a series of drawings that are cut apart and combined into one image.]

KEY TERMS

Binocular relates to the two eyes.

Foreshortening is the appearance of a decrease in size of an object as its length is turned away from the viewer.

Immersive virtual reality surrounds the user within a computer-generated environment; these systems generally utilize goggles or a helmet that feature small monitors positioned in front of the user's eyes.

Linear perspective is a drawing system in which the geometry of a painting suggests that all of the painting's objects and features converge on a single point near the back or center of the picture.

Monocular relates to one eye.

Nonimmersive virtual reality is a system in which users view information on a computer screen and they can also see objects in the real world. This type of virtual reality applies to personal computers, the Internet, and the World Wide Web.

Occluded objects occur when foreground objects cover, or partly cover, distant objects.

Perspective is the central projection of three-dimensional space onto a two-dimensional plane. Stated another way, it is a technique for making the objects in a picture on a flat surface appear to be the same size and in the same shape and position as they appear in actual physical space.

Perspective tordue is a technique of twisted or warped perspective that is used in prehistory for depicting animals and objects.

Picture plane is the picture's flat surface.

Reversed perspective represents principle figures in the background on a larger scale than subordinate figures in the foreground.

Saccadic eye movements are rapid, voluntary eye movements between fixation points; they occur at irregular intervals on an average of about 2 to 4 times per second.

Schemata are the organizational patterns of information and the rules that govern their use.

Selective attention is when people attend to certain stimuli available in the environment while filtering out others.

Texture gradient is the texture of a detailed surface that becomes finer as the distance increases.

Vanishing point is the point on the horizon to which all parallel horizontal lines on a plane, or on parallel planes, recede from the picture plane converge.

☀ Language of Images

Signs, Symbols, and Semiotics

Perspective is a concept that is culturally learned. In contemporary society, professional designers and scholars place signs and symbols into cultural classifications. These classifications can be different for professions and academics. For instance, professionals categorize visual symbols as either pictorial or graphic. In contrast, academics use terms from semiotics—signified and signifier. Additionally, linguistic concepts such as connotation, denotation, metaphor, and the semantic differential can also be applied to the process of understanding visual images.

Symbols can show actual objects or they can represent a concept. Visual symbols move from the concrete object to the abstract idea. Similarly, as language becomes more abstract, the intended meaning of words becomes more difficult to understand. In both verbal and visual communication, the process of abstracting eliminates characteristics that typify the object or idea. There are many different types of symbols that communicate visual information.

WHAT ARE SYMBOLS?

Symbolism is the basic vocabulary of subject matter in visual communication. Over time, the cultural function of symbols has changed. In primeval art, the symbol was potent and an active energizing force. It contained the perpetual power of renewal, which may be one reason primeval artists drew overlapping and interweaving figures on the same space. Contemporary symbols are different from the magical symbols of prehistory because today's symbols tend to be informational rather than magical. Every culture attaches it own beliefs, values, and ideals to symbols. Besides creating new symbols, age-old symbols from the past can be revitalized and integrated into new contexts. For example, the Nazis used an ancient good luck symbol as the symbol of the Third Reich.

Symbols represent ideas and concepts. According to Stiebner and Urban (1982), "Symbols in the closest sense of the word are cult objects which graphically describe a multitude of irrational meanings

and connections in representative form" (p. 14). For example, the crescent symbolizes the Moslem religion, the Star of David stands for the Jewish faith, and the cross stands for Christianity. Iconography is the study of symbols, and iconology is the study of symbols in relation to a specific historical period. Typically, the meaning associated with a symbol is both culturally and historically bound. Symbols can have many different layers of meaning, and some of these can even be contradictory because they vary from country to country, century to century, and individual to individual.

From the interior symbols of the mind to the exterior ones found in public space, the study of symbols can be both endless and fascinating. For instance, many people explore their personal dream symbols with dream dictionaries and workbooks (Chetwynd, 1980; Clift & Clift, 1986; Faraday, 1974; Miller, 1983). To better comprehend culturally shared symbols, authors have written dictionaries that describe the meanings of commonly found visual symbols that occur across cultures and historical periods. Some of these are written about specific visual languages, for example, Christian symbolism or commercial graphics. Still others are designed to be general-purpose symbol dictionaries (Cirlot, 1962; Cooper, 1978). However, symbols come in a wide range of types and categories.

SYMBOLS AS VISUAL LANGUAGE

The progression from concrete to abstract visual representation can be placed into two major categories: pictorial symbols and graphic symbols. Pictorial symbols include three-dimensional models, photographs, and illustrations, and they are images that clearly represent the object they depict. For example, realistic drawings, computer graphics, and photography accurately portray the objects to which they refer. In contrast, graphic symbols can range from realistic to abstract forms of representation. Thus, there are many levels to the language of visual symbols. Graphic symbols are categorized into three different levels of abstraction: image-related graphics, concept-related graphics, and arbitrary graphics.

Image-related graphics are characterized as outlines, silhouettes, or profiles of the object itself. For example, the camera obscura, described in the previous chapter, is a tool that enables artists to create image-related graphics. After projecting an image, its outline can be traced and then filled in with paint. Another technique frequently utilized by graphic artists is tracing the outline of an object and then filling it in with black. Although the details of the object are now missing, its shape is still highly recognizable. Frequently, camera technologies are used to help artists design image-related graphics.

Figure 4–1: Levels of visual abstraction: photograph, computer illustration, image related, concept related, and arbitrary. Verbal symbols: woman with a computer. Author's illustration.

In contrast to image-related graphics, concept-related graphics try to capture the essence or a more stylized version of the object. Inventing symbols that fall into this category is more difficult because people have to learn to make an association between the symbol and the object or idea it represents. People can

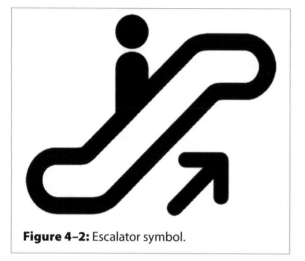

Figure 4–2: Escalator symbol.

create many different visual symbols; however, it is sometimes difficult for people to remember what the various symbols mean. To help solve this problem, Henry Dreyfuss (1972) developed the *Symbol Sourcebook* as a tool to aid designers in the process of standardizing and learning symbols. With increased global travel and commerce, the use of universal symbols has also increased. For example, it would be impossible to print all of the different languages on a package or product that will be shipped to hundreds of different countries. Instead, it is easier to place an international symbol on it. To make visual languages more accessible to people, the AIGA and U.S. Department of Transportation (DOT), in 1974, developed a set of 34 symbols to guide passengers through transportation facilities. These symbols are available off the web and free of charge (see http://www.aiga.org/content.cfm/symbol-signs).

As global travel and business has grown, symbols have multiplied at an alarming rate, and the multiplicity of these symbols in our international life has become a matter of concern. Dreyfuss (1972) said the following:

> As the world grows steadily smaller, the need for easy communication becomes increasingly acute, and man has apparently come full circle—from prehistoric symbols, to sophisticated verbal communication, and now back to symbols, to help us all live together in today's Tower of Babel. (p. 19)

Arbitrary graphics are abstract symbols that have no visual resemblance to an object. Letters, numerals, punctuation marks, and mathematical operators fall into this category. In a sense, language is a series of random graphics because words themselves are arbitrary visual symbols. Often arbitrary graphics take the form of geometric shapes that are designed for their aesthetic appeal. However, arbitrary graphics can be more difficult to understand because they are symbols that need to be learned in ways that are similar to learning the words of a language. For example, when a company updates an old logo or creates a new one, the public needs to be made aware of the change. People must learn to make an association between the company and its new symbol. To achieve this goal, companies will spend millions of dollars in advertising to create an association between the new logo and the company.

Signs and Symbols

Visual symbols help people locate available services in public spaces and identify hazardous situations. Public signs have been developed to enable both literate and illiterate people to easily identify restrooms, telephones, restaurants, and so forth. Visual signs are used in airports and on packages, clothing, and appliances. In the illiterate, pre-modern world, signs were used as visual guides to help traveling strangers find the shops of the baker, the barber, or the apothecary. Today, global travel again makes it necessary for cities to use visual signs to help travelers find the nearest telephone, hotel, elevator, or airport. Modley & Myers (1976) stated the following: "The number of these public [signs] is increasing rapidly. Some are accepted widely, some are not. There are even different symbols representing the same thing, and identical symbols standing for different concepts. Efforts are now underway to standardize

the most important symbols into a 'new universal language' through international efforts of careful selection, design, testing and education" (pp. vi–vii), such as the AIGA/DOT project described earlier.

Many public signs that we use today have historical origins. For example, in 1909, nine European governments agreed to use the same series of road danger signs. Between 1926 and 1949, intensive work on the development of international road signs led to the development and standardization of all European road signs. Similarly, the United States created a road sign system adopted by several other nations. Eventually, the idea of creating standardized pictographic international signs developed. A major influence on standardization was the Olympic Games. For example, Japanese designer Katzumie Masaru and his staff of 30 created the public signs used in the 1960 Tokyo Olympics. Every year the Olympics are held, a new design team creates the signage.

Despite recent attempts to create logical and clear public signs that are easily recognizable, many administrators often select public signs that have been previously used because they already have widespread public acceptance; for instance, the symbol of a man and a child used to indicate "pedestrian crossing" and the pictograph of a man or woman to represent "restrooms." Although these are common signs, they may not be the best graphic solutions for the ideas that they express. For example, compare Australian signs for road crossings and restrooms to ones made by other countries. Many different types of people cross roads and they all have legs; therefore, showing legs is a more logical solution than depicting a man and child to identify a place for pedestrian crossing. Similarly, designing symbols that indicate specific types of toilet facilities com-

Figure 4–3: Basic symbol for restrooms. AIGA. Used with permission.

bined with an image of a man or woman is a more complete symbol because it more clearly shows the type of facility available. By showing the facilities, the signs can indicate a bathroom with plumbing versus an outhouse.

Professional groups, such as architects, chemists, botanists, and astrologers, use common signs and symbols. Generally these are designed as arbitrary graphics with no visual relationship to the objects or concepts that they represent. For example, the International Organization for Standardization (ISO) has taken a leadership role in developing specialized graphic languages for people working in the professions of electrical and electronic engineering, machine tools, plumbing, welding, and other technical fields. Many professional organizations themselves publish handbooks that describe the visual language used in their profession. As visual technologies proliferate, new visual languages are emerging, such as the icons on a computer screen described in Chapter 1.

Academic Approach to Signs and Symbols

From an academic perspective, computer icons are signs that represent computer commands, and they help make it easier for people to operate a computer. A sign represents and refers to something. Signs tend to be arbitrary representations because they do not require a visual resemblance between the sign and the object to which they point. This is similar to the idea of arbitrary graphics used by designers because there is no visual likeness between the sign and object.

Philosopher Suzanne Langer (1957) has examined symbolic representations and their functions. She made a distinction between signs and symbols. Interpreting natural signs is a basic part of animal intelligence because animals respond to them. Similarly, people respond to signs when they answer a bell, watch the clock, obey a traffic sign, come when a baby cries, and close the window when they hear thunder.

> The logical basis of all these interpretations, the mere correlation of trivial events with important ones, is really very simple and common; so much so that there is no limit to what a sign may mean. This is even more obviously true of artificial signs than of natural ones. (p. 59)

For example, a gunshot could indicate danger, that someone has been shot, or the commencement of a race or parade. Similarly, bells can be associated with a variety of messages, for example, somebody is at the door, food is ready, school is beginning, or church service is ending.

One function of signs is to signal a state of affairs. Our daily lives are filled with signs that we interpret and respond to. "Signals serve as behavioral triggers or commands; they function as a stimulus to a conditioned response, so that the receiver behaves in response to the sign as it would a response to the actual presence of the [person or object]" (Nystrom, 2000, p. 22). Signs announce their objects to people, whereas symbols make people conceive or think about the object. Take, for example, two men talking about Ms. Kim in her absence. If one of them raises his eyebrow and looks at the door, this could be interpreted as a sign that Ms. Kim is about to walk through the door. The men would probably stop their conversation and direct their attention toward the actual Ms. Kim. In contrast, if the two men were talking about Ms. Kim without her being present, her name represents the concept of Ms. Kim. In this second instance, the name Ms. Kim is being used symbolically. Names enable people to talk about people and objects without them actually being present. According to Langer (1957), "Symbols are not proxy for their objects, but are vehicles for the conception of objects. To conceive a thing or a situation is not the same thing as to 'react toward it' overtly, or to be aware of its presence" (p. 61). For example, traffic signals function as signs because people must react properly to them or an accident could occur.

However, the terms sign and symbol are frequently confused. For example, professional books written about graphic design often use these terms interchangeably. Specific academic approaches to visual communication, such as semiotics, described later, define the term sign in different ways. C.S. Peirce (1998) defined a sign as "a thing, which serves to convey knowledge of some other thing, which it is said to stand for or represent" (p. 13). He identified three different types of signs: iconic, indexical, and symbolic.

Iconic signs resemble the things that they represent. For instance, the trash can icon on a computer screen is a sign that indicates a command to throw away documents into a virtual trash can. Iconic signs are used in a similar way as designers use the term image-related graphics.

In contrast, indexical signs make logical connections to the ideas they embody. Indexical signs are similar to concept-related graphics. For example, maps visually illustrate a particular geographic location: "A diagram is a kind of icon particularly useful, because it suppresses a quantity of details, and so allows the mind more easily to think of the important features" (Peirce, 1998, p. 13).

Finally, symbolic signs have no representational or logical relationship to the object they represent; thus, these arbitrary signs must be culturally learned. This term can be related to the concept of arbitrary graphics used by designers. Symbolic signs are often embedded with cultural meanings and they can evoke a stronger emotional response than iconic or indexical signs. For example, the flag of a country evokes strong feelings. Different theoretical and practical approaches to visual messages use the terms sign and symbol differently. Consequently, students doing visual communication research should understand whether the author of a book is a professional designer or an academic writing

Box 4.1: In Her Own Words: Suzanne Langer

Bio: Suzanne Knauth Langer was born in 1895 and she died in 1985. She studied with Alfred North Whitehead at Radcliffe College and went on to study at Harvard University and the University of Vienna. She received a PhD from Harvard in 1926, where she tutored in philosophy between 1927 and 1942. From 1945 to 1950, Langer lectured in philosophy at Columbia University, and in 1954, she became a professor of philosophy at Connecticut College. By distinguishing between nondiscursive symbols of art and discursive symbols used in scientific language, she argued that art is a highly articulated form of expression that symbolizes intuitive knowledge of life patterns or feelings and emotions that are difficult to convey through verbal language.

Symbols are not proxy for their objects, but are vehicles for the conception of objects. To conceive a thing or a situation is not the same thing as to "react toward it" overtly, or to be aware of its presence. In talking about things we have conceptions of them, not the things themselves; and it is the conceptions, not the things, that symbols directly "mean." Behavior toward conceptions is what words normally evoke; this is the typical process of thinking. (Langer, 1957, pp. 60–62)

from a particular perspective, because different authors with different theoretical perspectives use the terms sign and symbol differently.

Of course a word may be used as sign, but that is not its primary role. Its signific character has to be indicated by some special modification—by a tone of voice, a gesture (such as pointing or staring), or the location of a placard bearing the word. In itself it is a symbol, associated with a conception, not directly with a public object or event. The fundamental difference between signs and symbols is this difference of association, and consequently of their use by the third party to the meaning function, the subject; signs announce their objects to him, whereas symbols lead him to conceive their objects. The fact that the same item—say, the little mouthy noise we call a "word"—may serve in either capacity, does not obliterate the cardinal distinction between the two functions it may assume.

DENOTATIVE AND CONNOTATIVE MEANING

In both visual and verbal language usage, a distinction is made between denotation and connotation. In terms of language, denotation is the primary association a word has for members of a particular linguistic community. A connotation is the secondary association a word has for one or more members of the community. Connotations can be the same for nearly everyone in the community or specific to individuals. For example, the word "gay" is traditionally a synonym for the word "happy" or "cheerful." However, it has increasingly become a term used as a synonym for "homosexual." Often words elicit powerful emotional reactions with either positive or negative connotations. For example, the word "elderly" has a negative connotation; in contrast, the term "senior citizen" has a more positive one. These ideas can be applied to visual communication in the following way: A photograph of a family denotes them because they are shown in the picture. However, the connotations associated with the photograph will depend upon the viewer's prior knowledge or experience with the people and event portrayed. For instance, when a couple looks at a family portrait taken on their 50th wedding anniversary, it will bring back 50 years of memories. In contrast, each child and spouse in the portrait will make a different association with the image. For example, the son will remember it as the weekend he was caught in a rain storm and the daughter as the day she decided to go on a diet.

Denotation and connotation can be applied to visual communication because every choice a designer makes (the medium to use, type style, and illustration style) creates different connotations. However, the use of connotation is not a precise matter. Every social subgroup will have its own interpretation of an image, and individual experience will also shape the ways in which an image is understood. As a result, the nature of visual connotation is complex. When an image is used successively the same way for a long time, its connotation can become assimilated into its general meaning or denotation. Moreover, the meanings of images can change over time. The swastika is an example. At the time when Rudyard Kipling adopted it as a personal logo, the swastika was considered a good luck sign from Ancient Greece and North India. After the German Nazi party adopted a version of the swastika for its flags and uniforms, the contemporary meaning of the word changed. Today, people do not associate this symbol with an ancient good luck sign. In contrast, it is perceived as a symbol for Nazis and the horrors of World War II.

Graphic designers and art directors fine-tune their awareness of the denotations and connotations associated with visual symbols. To gain a greater understanding of the connotations associated with commercial messages, advertising agencies will test their creative concepts with actual consumers to make sure that the public does not have a negative connotation associated with their use of symbols.

Semantic Differential

Another tool used to evaluate the connotation of images or words is the semantic differential. It is a research instrument that can test a person's reactions to any concept or term. Charles Osgood developed the system originally to test the connotation of words, but it has been extended to test every other type of message carrier from television stars to clothing. The test uses a seven-interval scale with limits defined by sets of bipolar adjectives or oppositions (young/old, attractive/unattractive). The

Osgood and his associates developed the semantic differential in 1957. Osgood's early research subjects were Americans; however, he was interested in the possibility of doing cross-cultural studies and went on to examine 26 different language communities. Although he discovered definite cultural variations, he learned that members of cultural groups evaluated many concepts in similar ways. For example, the concept of "days of the week" is subject to cultural interpretation. In Western culture, Monday tends to be considered the worst day of the week; things tend to improve after that by gaining impetus on Friday and reaching a peak on Sunday. In contrast, Iranians believe that Saturday (compared to Monday) is the worst day and Friday (the Moslem holy day) is the best.

SUNDAY

Positive	_____ : _____ : _____ : _____ : _____ : _____ : _____	Negative
Calm	_____ : _____ : _____ : _____ : _____ : _____ : _____	Stressful
Awake	_____ : _____ : _____ : _____ : _____ : _____ : _____	Asleep
Energy	_____ : _____ : _____ : _____ : _____ : _____ : _____	Tired
Like	_____ : _____ : _____ : _____ : _____ : _____ : _____	Dislike
Large	_____ : _____ : _____ : _____ : _____ : _____ : _____	Small
Sunny	_____ : _____ : _____ : _____ : _____ : _____ : _____	Cloudy

Figure 4–4: Semantic Differential

Source: Osgood, C., Suci, G., & Tannenbaum, P. (1957). *The measurement of meaning*. Urbana: University of Illinois Press

concept of oppositions is central to both language and visual communication. It has been suggested that the human mind fundamentally uses binary oppositions—happy/sad, inside/outside, rich/poor. As a result, an awareness of one concept makes one aware of its opposite. After the bipolar descriptions are selected, many people are asked to rate each image or item on the scale. The response results are tabulated to measure the actual consumer connotations associated with the message. This information is then compared to the intended advertising message.

However, the connotations associated with many objects and visual images are constantly changing. Clothing provides a perfect example of how this works. Bell bottom trousers that were popular in the 1970s became popular again in the 1990s. Narrow trousers and short hair, which was the sign of rebellious youth for one generation, suggest conformity in another. Teenagers of every generation develop their own symbols of identity that include clothing styles and musical preferences. Companies such as the Gap encourage this type of behavior with their television commercials designed to appeal to teenagers. The task of many professional visual communicators (graphic designers, art directors, and filmmakers) is to create visual messages in which the intended message matches the received one. To accomplish this task, the connotations associated with messages need to be tested. Focus groups and the semantic differential are ways to do this.

METAPHORS AND METONYMIES

A metaphor is a figure of speech in which one object is spoken about in terms of something else. Metaphors make comparisons between dissimilar things. The following passage from Shakespeare's play *As You Like It* illustrates how metaphors work:

> All the world's a stage,
> And all the men and women merely players;
> They have their exits and entrances,
> And one man in his time plays many parts,
> His acts being seven ages.
> (William Shakespeare)

Lakoff and Johnson (1980) argued that the use of metaphor is both used and reflected in everyday language. For example, a war metaphor is frequently used to describe argumentation, and the "argument is war" metaphor has a wide variety of expressions:

> Your claims are indefensible.
> He attacked every weak point in my argument.
> His criticisms were right on target.
> I demolished his argument.
> I've never won an argument with him.
> You disagree? Okay, shoot!
> He shot down all of my arguments. (Lakoff & Johnson, 1980, p. 4)

By discussing the topic of debate with the war metaphor, people can better understand debating. According to Lakoff and Johnson (1980), "The essence of metaphor is understanding and experiencing one kind of thing in terms of another" (p. 5). In the previous example, argument is not a linguistic subcategory of war. In contrast, there is a difference between the ideas of argument and war. One is verbal discourse and the other armed conflict. However, the human mind can use metaphor without being aware of the metaphorical process. Consequently, Lakoff and Johnson (1980) argued that human thought processes are largely metaphorical in nature and "that the human conceptual system is metaphorically structured and defined" (p. 6).

Beyond everyday language, the use of metaphor is widespread in advertising copy and imagery. Advertising frequently uses metaphor to associate intangible concepts with tangible products. For example, we cannot see insurance or feel banking, and it is very difficult to test the quality of these services. However, consumers demand a strong sense of service and they need to be reassured about a company's effectiveness before they will use its products. To associate the concepts of power and security with services, advertising copywriters and art directors will use metaphor. For example, the State Farm insurance company compares itself to a good neighbor: "What's an insurance company like? It's like a good neighbor, that's what." Similarly, the Allstate insurance company compares itself to a pair of hands: "You're in good hands with Allstate." The Prudential life insurance company has been making a visual comparison between itself and the Rock of Gibraltar for many years, and the Travelers insurance company uses the image of an umbrella. Associating insurance with tangible objects creates a distinction between the companies and contributes to the awareness of the company's brand identity.

Besides making intangible ideas become more tangible, metaphor is also applied to complex products to show their essence. George Felton (1994) said that the job of an advertiser is to communicate the essence of a product to the consumer, and metaphor is the best way to do this:

> The qualities of the chosen image transfer to the original thing or idea and help explain it, make it more vivid or understandable. For example, a snowball rolling down a hill is a good metaphor by which to explain rumors—snowballs gain momentum and gather up material, becoming bigger, more dangerous, and more out of control, just like rumors. (p. 323)

Metaphor can also be applied to the design of visual messages. When metaphor is used in visual design, the observer must get involved and participate in decoding or understanding the meaning of the message. For example, if an image of an unfinished skyscraper with its I beams visible is combined with the headline, "It's not what's on the outside, but what's on the inside," people will make an association between the skyscraper's gridwork and the internal values that are implied in the advertisement. For instance, this image and headline could be applied to an advertisement for the YMCA, a college, or another type of nonprofit, human service-related organization.

Fused Metaphor

Besides pure metaphors, something standing for something else, advertisers also use fused metaphors. Fused metaphors are something that is already a part of the subject but is modified. For example, a promotional piece for an ABC television drama based on Herman Wouk's book *War and Remembrance* replaced the stem of a rose with barbed wire. The barbed wire has characteristics similar to the thorns of a rose. However, the fused image creates a visual tension between elements representing love and war because roses are a symbol of love and barbed wire is one for war. Pushing barbed wire and roses together into one image creates a powerful visual solution. In advertising, visual metaphors attempt to capture the psychological essence of a product or service rather than its literal meaning. Graphic fusion is a powerful tool in logo and graphic design. By fusing two diverse visuals together, a more powerful one can be expressed.

Although pure metaphor works well for intangible services, fused metaphors are an approach that works better with tangible products. Take, for example, the visual of a sponge cut into the shape of a hand and combined with the following headline: "This is what your hand looks like to most toxic chemicals." This fused metaphor expresses a powerful reason why people should wear hand protection when working with chemicals. Similarly, the antidrug campaign that shows a visual of an egg frying in a pan with a voice-over that states, "This is your brain on drugs," conveys a powerful message about what drugs do to human beings. Fused metaphors are strong message-building tools that enable people to comprehend ideas in new ways. As a result, fused metaphors are frequently used in the creation of advertising messages.

Metonymy and Messages

Related to the use of metaphor is metonymy. However, these are two different types of processes. Lakoff and Johnson (1980) said the following:

> Metaphor is principally a way of conceiving of one thing in terms of another, and its primary function is understanding. Metonymy, on the other hand, has primarily a referential function, that is, it allows us to use one entity to stand for another. (p. 36)

Besides being a referential device, metonymy also serves the function of providing understanding. "For example, in the case of the metonymy THE PART FOR THE WHOLE there are many parts that can stand for the whole. Which part we pick out determines which aspect of the whole we are focusing on" (Lakoff & Johnson, 1980, p. 36).

Metonymy is the use of one thing for another associated with or suggested by it. For example, the phrase, "the President has decided," can be changed to, "the White House has decided." The White House refers to where the President lives and the term is frequently used as a metonymy to refer to the President of the United States. In visual communication, metonymy is a device that can provide graphic impact or be used as a visual shorthand. For instance, portrait painting and photography will use a person's face, rather than his or her full body, to represent the entire person. Similarly, in an advertisement, part of an object can be shown to represent the entire object. By pushing part of an object off the page, viewers are invited to complete the image. This strategy often gets people more involved with the advertisement and causes them to pay attention to it.

Moreover, metonymy can help to express a feeling. For example, you cannot make a picture of the feeling of "comfort." But, you can create a list of the objects that produce the sensation of comfort, such as a cozy fire, slippers, and a comfortable armchair. Similarly, both painters and advertisers use images of tears and smiles to express the attributes of the emotions that provoke them. The use of metaphor and metonymy can increase the power of a symbol.

Metonym is frequently used in the media to stand for a large class of things or events. For instance, during the Gulf War, journalists were prevented from taking pictures of the destruction on the ground. To meet the demand for video images, video shorts of "smart bombs" were released that showed precise and limited destruction. The smart bombs acted as a metonym to suggest a war of few casualties and scientific accuracy. Additionally, the video game quality of these images made them easier for Americans to understand.

ICONS

Every culture has many symbols that gain rich connotations and convey powerful meanings. This type of symbol is called an icon. The term comes from the Greek word *ikon* that means image or portrait. The word was originally applied to the religious imagery of Orthodox Christianity. Christian images of Christ and incidents from his life and the life of a saint were generally stereotyped. Christian subjects were highly restricted by rigid conventions of representation. As a result, Christian icons created in later periods differ very little from earlier times. Although the style and quality of execution may change, the visual elements shown in the icon often do not change. In contemporary culture, people, places, and objects can represent the expression of human ideals and eventually become icons. Thomas A. Sebeok (1985) stated the following: "An iconic message is one which resembles—according to some conventionally accepted criterion—some agent of the real world to which it refers" (p. 456). An example of an icon is the American flag, because each of the 50 white stars "stands for" one of the 50 states, and the 13 stripes "stand for" the original 13 colonies of the original Union. "The important point here is

that their iconic relations can be grasped only by those already informed of the code, or convention (viz. American history) being used" (Sebeok, 1985, p. 456).

A contemporary icon that emerged during the 20th century is the Berlin Wall. The wall that divided Berlin for several decades became a metonym for the division of Germany into two states and a metaphor for the wary, closed minds that Western government saw in East German leaders. Many connotations became attached to it, including the differences between ideological beliefs, political systems, and the Cold War. When the wall was taken down, it became a global symbolic act—the removal of an obstacle between the eastern and western parts of Europe and between capitalistic and communistic political systems. Walls generally are symbols of defense or division. For example, a brick wall is used to depict an impasse or unyielding problem. With the Berlin Wall, it represented the particular problems associated with the Cold War and the conflict between capitalism and communism. Over time, it became an icon for this conflict.

Mass media frequently depend on icons to communicate messages. For instance, the simplest icon is a national flag because it represents a particular country. By combining a flag with other elements, a visual message can easily be conveyed. Other popular icons associated with geographic locations are the Eiffel Tower, Statue of Liberty, and Golden Gate Bridge. These structures are icons associated with Paris, New York, and San Francisco. A recent icon that has emerged is the lowering of the statue of Saddam Hussein. It has become an icon for the Gulf War.

Symbols and the Unconscious

Beyond the signs, symbols, and icons of which people are consciously aware, symbols can also exist on an unconscious level. An important idea developed during the 20th century was the theory of the subconscious. Besides the mental activities of which we are aware, there is another unconscious, mental world. This unconscious world is made apparent through our dreams, fantasies, and during times of emotional stress. According to Freud and his successors, people can be motivated to act by thoughts and feelings of which they have no awareness, and these repressed feelings can come alive in dream symbolism. Freud (1913) made many observations about dreams. First, he argued that dreams contain wish fulfillment. Second, dreams will often use disguises and distortions. Finally, dreams frequently can be connected to our recent activities and thoughts.

Building on the work of Freud, Jung (1964) argued that symbols imply more than their obvious meanings and that dream symbols can be linked to great themes of human existence, including birth, death, marriage, fear, and hope. According to Jung (1964), humans universally express the same emotions and they have a universal propensity to symbolically express themselves. Across the ages, similar archetypes, or archaic remains from the beginnings of human consciousness, have been used to show human feelings. Archetypes are representations that can vary a great deal in detail but not lose their basic pattern. Jung (1964) observed that understanding the relationship between modern and primitive humans is essential to understanding the symbols expressed in dreams. Dreams present images and ideas that can be compared to primitive ideas, myths, and rites, and dream imagery can "form a bridge between the ways in which we consciously express our thoughts and a more primitive, more colorful and pictorial form of expression" (p. 32).

Moreover, Jung observed that similar symbols could be found in diverse and widespread communities. For example, animals often play an important role in dreams and legends. Each animal often represents an aspect of the self, and animals signify the instinctual part of human nature. For instance, in an image of a mounted horseman, the horse often portrays the human will or consciousness. In our current age, the image of the horse rider is often replaced by the car driver, and the car driver may be the modern embodiment of the horse rider symbol.

Arthur Asa Berger (1999) argued that we can look upon the images of popular or mass-mediated culture as if they were dream symbols. By substituting television programs, films, commercials, and comic books for individual dreams, we could learn more about the national character, culture, and society producing the images. For example, a commonly depicted archetype is the hero.

Themes, such as the hero descending into a cave to save a precious object, can be found in the contexts of ancient myth and contemporary Hollywood films. Filmmakers frequently incorporate many human situations or motifs that are universal expressions of human feeling. Archetypes such as the hero, beautiful maiden, wise old man, and trickster appear repeatedly in a variety of visual media. These are the basic images of ritual, mythology, and vision that have inspired people throughout human history. According to Jung, archetypes help to organize images and ideas that emerge from a myth-producing level of the mind. For instance, archetypes such as the hero have played an important role in mythic narrative throughout the ages and are still being used today in contemporary film and advertising.

Metaphor and Computers

Since the beginning of the Internet, people have been using metaphors to describe it, such as the information highway. While Al Gore did not invent the Internet, he introduced the term at a 1978 computer meeting. When Gore's father was a senator, he developed the highway system for cars and trucks. Following in his father's footsteps, the younger Gore wanted to develop information highways. Metaphors can help to shape the ways in which people conceive of objects and things. Gill (2010) stated the following:

Box 4.2: Case Study: Jung and the Symbol of a Circle

Bio: When psychiatrist Carl G. Jung was first asked to write a book about his research on symbolism and psychology for the public, he said no. Afterward, he had a dream that made him change his mind. In the dream, he was standing in a public space and talking to a multitude of people who were listening and understanding his ideas. Several weeks later, Jung agreed to edit a book designed for the public. Working with collaborators, Jung developed the book, Man and His Symbols *(1964). The following is an excerpt from a text about symbolism in the visual arts, written by Aniela Jaffé (1964).*

The circle is a symbol of the psyche (even Plato described the psyche as a sphere). The square (and often the rectangle) is a symbol of earthbound matter, of the body and reality. In most modern art, the connection between these two primary forms is either nonexistent, or loose and casual....But the frequency in which the square and the circle appear must not be overlooked. There seems to be an uninterrupted psychic urge to bring certain abstract pictures [into consciousness the basic factors of life that they symbolize. Also, in of our time (which merely represent a colored structure or a kind of "primal matter"), these forms occasionally appear as if they were germs of new growth.

The symbol of the circle has played a curious part in a very different phenomenon of the life of our day, and occasionally still does so. In the last years of the Second World War, there arose the "visionary rumor" of round flying bodies that became known as "flying saucers" or UFOs (unidentified flying objects). Jung has explained the UFOs as a projection of a psychic content (of wholeness) that has at all times been symbolized by the circle. In other words, this "visionary rumor," as can also be seen in many dreams of our time, is an attempt by the unconscious collective psyche to heal the split in our apocalyptic age by means of the symbol of the circle. (pp. 284–285)

The Web evolved from being thought of as a superhighway into a destination, into a *place* to go for information of all kinds, a *place* to conduct business, a *place* to exchange ideas with others, a place to explore and gain new experiences. (p. 33)

As a place, the Internet is thought of as a destination. The highway metaphor makes us think it has places to go. We can virtually go to Egypt, Peru, or London to learn about these cultures. However, the space of a computer screen has an aspect ratio that is usually wider than it is high. It is closer to the ratio of a television set or a full-length movie screen. We expect the wider than high ratio to display images rather than text. "The interactive screens of computer simulations and games have created additional expectations, representing visual spaces that allow us to explore for ourselves" (Gill, 2010, pp. 35–36). Thus, the physical space of a computer screen tends to make people anticipate a visual rather than a textual display, and the metaphors we use tell us how to understand the technology. Using computer technology itself depends on metaphors and symbols.

DECODING VISUAL COMMUNICATION

There are many different ways to decode visual communication, from the Personal Impact Assessment developed by Rick Williams (1999) to the study of semiotics. Understanding the structure of myth and how mythic stories progress can also be a way to better understand Hollywood movies. The final section of this chapter discusses omniphasism, a method for uncovering unconscious messages in photographs; myth, a cultural conscious awareness of message organization; and semiotics, the conscious study of signs and symbols. Williams' work is built on ideas expressed by Jung.

Omniphasism

Omniphasism is a term coined by Rick Williams (1999) to mean "all in balance." He stated the following: "Through the balanced development of our Rational and Intuitive Intelligences, we can help develop systems that are more capable of fostering quality interdependence and co-existence than are the current rationally biased, unbalanced system under which we operate" (p. 162). This is a holistic approach that is based on the work of Jung. Williams uses this term to describe a Jungian dream-interpretation technique applied to visual imagery.

The technique called Personal Impact Assessment has seven steps:

1. Select an image (advertising images work well with this analysis).
2. List the primary words that you associate with the image (10–20 words).
3. List four to seven associative words that are associated with the primary word (e.g., Hat—Brain, Cover, Head, Protect, Sweat, Hot, Sun).
4. In each row of associative words, select the most significant word (e.g., Hat—Brain, Cover, Head, Protect, Sweat, Hot, Sun).
5. Relate the associative word to an inner part of yourself (e.g., protect—warrior self, travel—transforming self, movement—graceful self).
6. Review the inner symbols relating to the inner self listed in No. 5.
7. Write a story using the symbols of the inner self.

When I look at the inner-self list, the first thing I see is a series of contrasts among the first six concepts [steps]. To me this suggests a conflict between the **wounded, defensive, and fearful** parts of myself and the **unified, powerful, and balanced** parts of myself.

The next thing I notice is a relationship among the next six words [in step 5] that suggests action and change. One way to look at it is if I follow the guidance of my **intuitive self**, under the protection

of my **warrior self** moving with **grace**, the conflicts can be transformed toward a more **integrated, balanced** self.

This leaves a third group of six words that suggest what the transformation might look like. This group suggests that there can be reconciliation between my **sharing/open self and my hidden/inner self** and between **my growing/changing self and my safe/unchanging self** and between **my rational self and my core/intuitive self**. (Williams, 2009, p. 34).

The Personal Impact Assessment is a method for uncovering unconscious attitudes toward photographs and advertisements. Once learned, the method can have surprising results. For a full description of the technique, see Williams (2009).

Symbolic Language

Fromm (1951) argued that fairy tales, dreams, and myths use the same universal symbolic language. Moreover, he contended the following: "Symbolic language is the one foreign language that each of us must learn…it helps us to understand a level of experience that is specifically human because it is that level which is common to all humanity, in content as well as style" (p. 10). As a result, having knowledge about myth and mythic structure is one way to better comprehend visual messages.

Symbols, Myth, and Ideology

Understanding the history and culture of a certain cultural group depends upon a knowledge of the group's myths because they transmit cultural attitudes. A myth is a real or fictional story that appeals to the consciousness of people by expressing human emotions or depicting cultural ideals. For example, the myth of progress is an important aspect of American culture. It is characterized by the perpetual economic expansion of the society and personal material compensations. Although the myth of progress is particularly relevant to American culture, many similar mythical stories can be found across cultures. For example, many cultures have legends about virgins giving birth to heroes who die and are resurrected. "India is chock-full of such tales, and its towering temples, very like the Aztec ones, represent again our many-stored cosmic mountain, bearing Paradise on its summit and with horrible hells beneath. The Buddhists and the Jains have similar ideas" (Campbell, 1972, p. 8). Moreover, in the pre-Christian times, Egyptian mythology has the tale of the slain and resurrected Osiris. Similarly, Mesopotamia has Tammuz, Syria has Adonis, and the Greeks have the story of Dionysus. These various myths provided models for the early Christians and their representation of Christ.

Knowledge of mythic structure is one way to decode certain types of visual messages. For instance, American western films repeat essentially the same sequence over and over again:

> Strange man (usually wearing the color tan) arrives in town seeking someone.
> Bad man wearing black endangers him.
> A woman pleads with him to give up the pursuit of the bad man.
> The hero persists on his quest and ends up killing his enemy through skill and courage.

Many American adventure films follow the same mythic narrative pattern based on the archetypical figure of the hero. The hero himself can come from any cultural background and be ridiculous or sublime. No matter who the hero is, his journey follows the same archetypal pattern. The mythological hero is lured, carried away, or voluntarily goes to the threshold of adventure, where he encounters a shadow presence that blocks his passage. The hero either defends himself or appeases the presence to obtain its power and move into the kingdom of darkness (brother-battle, dragon-battle; offering, charm), or the hero is slain by the opponent and he descends in death (dismemberment, crucifixion). Beyond the threshold of adventure, the hero travels to an unfamiliar world with strange forces. Some

of these will test and threaten him; others will provide him with magical aids. When the hero arrives at the peak of his mythological rebound, he faces a supreme ordeal and gains his rewards. Finally, he returns under the protection of an emissary or he flees back home. "At the return of the threshold the transcendental powers must remain behind; the hero re-emerges from the kingdom of dread (return, resurrection). The boon that he brings restores the world (elixir)" (Campbell, 1949, p. 246).

Screenwriters working on movie and television scripts use the archetypal journal of the hero as a way to organize the plot of the story. In addition to archetypal and mythical patterns, television and film use visual symbols that incorporate images, words, gestures, clothing, settings, music, sounds, and visual effects to convey the ideology of a culture. Hal Himmelstein (1984) defined ideology as "a constructed belief system that explains economic, political, and social reality to people and establishes collective goals of a class, group, or in the case of a dominant ideology, the entire society" (p. 3). Simply stated, an ideology is the image a society creates for itself to perpetuate itself.

Dominant ideology is the normative way in which people interact with each other. For example, American television reinforces the structure of advanced capitalism with its concepts of competitive consumption. According to Himmelstein (1984), "Myth transforms the temporal common sense of ideology into the sacred real of cultural prehistory and thus of eternal truth. Myth thereby serves an important political or organizational function" (p. 4). Myth is both a living tradition and a cultural phenomenon because myths organize the ways in which groups of people view their world. To understand a culture, one must understand their cultural myths.

SEMIOTICS

Another aspect of culture that an individual needs to be aware of is the signs and symbols used in a culture. "Signs are things that stand for other things" (Berger, 1999, p. 1. Semiotics (referred to as semiology in Europe) is the study of signs. A sign can be any physical entity to which a community attributes meaning. This includes words, clothes, gestures, possessions, pictures, colors, or anything else that we give meaning to in our daily interactions. In semiotics, there are three ideas associated with signs—sign, signified, and signifier. Williamson (1978) defined these terms as follows: "A sign is quite simply a thing—whether object, word or picture—which has a particular meaning to a person or group of people. It is neither the thing nor the meaning alone, but the two together" (p. 17). The sign is made up of two parts, the signifier and the signified. The signifier is the material object and the signified is its meaning. "These are only divided for analytical purposes: *In practice a sign is always thing-plus-meaning*" (p. 17, emphasis in original).

Semiotic analysis considers almost any action, object, or image to be a sign in which something is represented. Consequently, semiotics has been applied to the analysis of images, theater, advertising, poetry, cinema, and so forth. Two linguistic theorists writing before World War I, Ferdinand de Saussure and Charles Sanders Peirce, developed the semiotic approach. Saussure developed a general theory of signs while he was teaching at the University of Geneva. After his death, Saussure's students compiled a book from their notes and his lecture notes and they were published under the title *Course in*

Figure 4–5: Diagram of Signifier and Sign.

General Linguistics (1916/1974). At the same time Saussure was developing his theories, American philosopher Peirce began publishing his own ideas about the impact of signs on society. Building on the work of Saussure and Peirce, a number of scholars, including Charles Morris, Thomas Sebeok, Umberto Eco, and Roland Barthes, further developed the study of semiotics. Over the years, semiotics expanded from a study of linguists to one that includes all types of visual communication.

The basic elements of semiotic analysis are the sign, signified, and signifier. Chandler (2009) describes this relationship as follows:

> The *sign* is the whole that results from the association of the signifier with the signified ([see] Saussure, 1916/1974, p. 67; Saussure, 1916/1983, p. 67). The relationship between the signifier and the signified is referred to as "signification," and this is represented in the Saussurean diagram by the arrows. The horizontal line marking the two elements of the sign is referred to as "the bar." If we take a linguistic example, the word "Open" (when it is invested with meaning by someone who encounters it on a shop doorway) is a *sign* consisting of:

- ▪ *A signifier*: the word *open*
- ▪ *A signified concept*: that the shop is open for business.

> In addition to sign, signified, and Signifier, the interpretant plays an important role in the process. The sign is also in the mind and people are in relationship to the sign (see Cobley & Jansz, 1997).

Culture Codes

Signs can be combined to form larger cultural associations and express complex ideas. According to Berger, these chains of associations become culture codes that are the keys to understanding the behavior beneath the seemingly randomness of visual imagery. These codes simultaneously operate on a variety of levels. Berger (1999) identified five different levels: universal, national, regional, local, and individual. Universal is a level that most people understand. For example, most people living in different cultures understand the general scenario of a boy meeting a girl. However, the context in which they meet might not be as easily understood. For example, if they meet at the Statue of Liberty, Americans might interpret that differently from someone living in a different country. For instance, to an American, the Statue of Liberty represents New York, while a foreigner might interpret the setting as representative of the entire United States. Depending on where the spectator lives, the Statue of Liberty can denote a specific city, a general geographic area (the East Coast), or an entire country. On a localized level, the Statue of Liberty represents a tourist attraction to a New Yorker, and it is a place that local residents do not frequently visit (in fact, there are probably many New Yorkers who have never even been there). From an individual perspective, the statue may remind someone of their arrival in the United States, or it could be a symbol of where a couple first met. Thus, symbols can be interpreted on a variety of levels.

Although some symbols, such as the circle, represent universal concepts, others are distinctly cultural or stylistic. Philip Meggs (1989) described how the symbol of a red circle is understood by different cultures. For example, the red circle is the sign of Japan and its people and culture. In contrast, people living in South Carolina use large red circles painted on buildings to indicate liquor stores. In 1933, when prohibition ended, a woman living in Charleston, South Carolina, opened a liquor store. She hired a painter to paint the building white. While they were admiring the freshly painted store, the woman was concerned because the state would not allow her to erect a sign and she wondered how she could identify her store. "At that moment, the painter lit a cigarette, looked at the red circle on his Lucky Strike package, and suggested that he could paint a big red circle on the building. Soon other stores copied this practice, and a symbolic convention was established" (Meggs, 1989, pp. 6–7).

Box 4.3: In His Own Words: Barthes on Semiology

Bio: Roland Barthes was born in 1915 in Cherbourg, France, and he died in 1980 in Paris. Barthes studied grammar and philology at the University of Paris. In 1976, the College de France made him the first chair of literary semiology. As an essayist, social critic, and literary critic, his writings on the topic of semiotics helped establish structuralism and New Criticism as intellectual movements. New Critics attempt to formalize the qualities of poetic thought and language by using the technique of close reading with special attention to the connotative and associative meanings of words and the role of symbol, metaphor, and image in a work. Barthes stressed the role of the active reader in constructing a narrative based on "cues" obtained from reading a text.

Semiology is a science of forms, since it studies significations apart from their content…. Let me therefore restate that any semiology postulates a relation between two terms, a signifier and a signified. This relation concerns objects which belong to different categories, and this is why it is not one of equality but one of equivalence. We must here be on our guard for despite common parlance which simply says that the signifier expresses the signified, we are dealing, in any semio-logical system, not with two, but with three different terms. For what we grasp is not at all one term after the other, but the correlation which unites them: there are, therefore, the signifier, the signified and the sign, which is the associative total of the first two terms. Take a bunch of roses: I use it to signify my passion. Do we have here, then, only a signifier and a signified, the roses and my passion? Not even that: to put it accurately, there are here only "passionified" roses. But on the plane of analysis, we do have three terms; for these roses weighted with passion perfectly and cor-rectly allow themselves to be decomposed into roses and passion: the former and the latter existed before uniting and forming this third object, which is the sign. It is as true to say that on the plane of experience I cannot dissociate the roses from the message they carry, as to say that on the plane of analysis I cannot confuse the roses as signifier and the roses as sign: the signifier is empty, the sign is full, it is a meaning. (Barthes, 1957, pp. 111–113)

This story illustrates how an arbitrary sign can obtain a cultural meaning. A person visiting South Carolina from Japan might interpret the red dot as belonging to a Japanese facility. Similarly, people visiting South Carolina from other states may not understand the meaning of the red dot.

SUMMARY

Signs and symbols have existed since the dawn of civilization. Scholars from a variety of disciplines, including philosophy, psychology, and graphic design, have attempted to classify symbols and understand how to interpret them. In some ways, visual symbols can be compared to language because professional designers use visual abstraction, metaphor, and metonymy while creating visual messages. Visual com-municators have also developed many tests to compare their intended messages with the responses of audiences. By understanding mythic structures and the different levels in which symbols convey mean-ing, we can begin to decode visual messages and gain a better understanding of visual communication.

WEBSITES

- *Semiotics for Beginners*
 http://www.aber.ac.uk/media/Documents/S4B/semiotic.html
- *Symbols*
 http://www.symbols.com/
 http://www.symbols.net/
 http://www.aiga.org/content.cfm/symbol-signs
- *Flags*
 http://www.imagesoft.net/flags/flags.html
- *Dream Symbols*
 http://www.witches-brew.com/dreams/o-dreams.html

EXERCISES

1. The semantic differential is a test that can be applied to visual communication. Select a photograph and create a semantic differential test with half a dozen bipolar characteristics (young/old, glamorous/dowdy, modern/dated, remote/close, artificial/natural, exciting/boring) that relate to the photo. Place a scale with seven increments between each characteristic to make a test. Show the photograph to seven to nine people and have them complete the test. Describe the results.

2. Human feelings cannot be directly photographed or illustrated. Find or create pictures, photographs, or images that express the following feelings:
 - Comfort
 - Discomfort
 - Success
 - Failure
 - Happiness
 - Sadness

3. Successful persuasion that is presented through the mass media often depends on the appropriate use of cultural icons. Using current advertising campaigns, find examples of cultural icons. Describe the meaning of the icon in the advertising context and as a culture code.

4. Watch an adventure film, such as *Raiders of the Lost Ark* or *Star Wars,* and compare the film's story line to Campbell's narrative of the mythological hero.

5. Variations of the frontier myth are still used in today's advertising campaigns, especially for products such as cars, beer, and cigarettes. Find examples of the frontier myth in current advertisements.

6. As we begin the next century, what symbols would you use to represent the 20th century? Why would you choose these? What symbols are emerging to represent the 21st century? What messages do these symbols communicate and why are they different?

7. Graphics and video clips used on the evening news attempt to visually represent the news story being told by the newscaster. Compare and contrast the verbal story with the visual images simultaneously being shown.

8. Select an object and identify the sign, signified, and signifier.

Key Terms

Arbitrary graphics are abstract symbols that have no visual resemblance to the object.

Concept-related graphics capture the essence of an object and stylize it.

Culture codes are conventions that allow an individual to detect meaning in signs. The discovery of culture codes is of major interest to scholars studying semiology.

Denotation is the primary association a word has for members of a particular linguistic community.

Iconography is the study of symbols.

Iconology is the study of symbols in relation to a specific historical period.

Image-related graphics are characterized as outlines, silhouettes, or profiles of the object.

*Metaphor i*s a figure of speech in which one object is spoken about in terms of another.

Myths are real or fictional stories that appeal to the consciousness of people by expressing human emotions or depicting cultural ideals.

Pictorial symbols include photographs and illustrations that clearly represent the object.

Public symbols are graphics that indicate public services or facilities, such as restrooms, coffee shops, telephones, airports, railroad stations, and so forth.

Signs represent and refer to something. For example, a cross frequently represents a church and a graphic representation of a man or woman represents a restroom. Langer: The sign is something to act upon or a means to command action. Peirce: A sign is a thing which serves to convey knowledge of some other thing, which it is said to stand for or represent.

☀ Written Symbols and Typography

The most widely used symbol system is written language, which evolved over centuries. Denise Schmandt-Besserat's (1992) research shows that prior to the first pictographic writing system, an earlier stage of three-dimensional clay tokens was used to process data for accounting purposes. Handmade abstract tokens in the shapes of cones, spheres, discs, and cylinders were used as distinct units to represent animals and agricultural produce. Walter Ong (1998) noted that, similar to computers, these early tokens were a digital symbol system. One clay token represented one object, and tokens could be manipulated. Today, it appears that sophisticated computer technology could have its origins in the most primitive form of information processing.

WRITING SYSTEMS

Writing can be placed into three periods: the first is the arrival of written symbols, the second is the development of the phonetic alphabet, and the third is the invention of the printing press. Now we are moving into a fourth digital stage. In this stage, the written word is further encoded into binary digits and distributed through computer networks. The progression from tokens to digital writing has occurred over many centuries.

Tokens and Emblems

Token-based tallying systems used for the accounting of agricultural produce and livestock led to the development of writing. The shapes of the tokens were assigned different meanings. One shape was used for a sheep and another shape for grain. It was a simple system that used one-to-one correspondence, for example, one token was used to represent one sheep.

Another precursor of writing was the emblem. Emblems refer to specific objects. For example, company logos and flags are contemporary emblems. In earlier times, emblems were derived from totemic signs that contained qualities of the objects they represented. For instance, a bear emblem would be endowed with the qualities of strength and courage. At some point, tokens and emblems began to

combine into complex tokens. Complex tokens were shaped as more recognizable objects, and they were inscribed with markings. The development of complex tokens coincided with the beginning of urban life. Complex tokens would be easily used to differentiate the growing commodities required by urban commerce. One-to-one correspondence was replaced by sets of markings used to represent different numbers and commodities. Each commodity had its own set of markings. For instance, the symbol for four sheep was different from the symbol for four cows.

Historical Development of Writing Systems

Around 3000 BC, the first writing system was established in Mesopotamia for the record keeping of temple and palace property. Cattle, jars of wine, and sacks of grain were written as simplified pictures or pictographs. The need to develop a writing system was a consequence of the growing urban social system. Originally pictures acted as visual expressions of human ideas that were independent of speech. Gelb (1952) defined writing as *"a system of human intercommunication by means of conventional visible marks"* (p. 12, original emphasis). He asserted that early written languages were not forms of speech in written signs but independent forms of visual expression understood by members of a particular culture. For instance, the Maya and Aztec writings reached a level of systematization and convention that can be compared to Sumerian and Egyptian writing. At this point in history, writing was very pictorial.

Pictographs were the earliest forms of symbolic writing. These simplified drawings represented objects and ideas. For example, a picture of a fish denoted a fish and a drawing of a circle represented the sun. This was an analog form of writing. The Mesopotamians wrote on wet clay molded into small slabs known as tablets, using a stylus made from a reed whittled into a sharp point. When the writing was completed, the clay table was left to dry in the sun. The earliest examples of Mesopotamian writing dates back to around 3500 BC and are inscribed with objects such as cows, sheep, and cereals. Over 500 years, pictograph became stylized into cuneiform writing written with a triangular tipped stylus. This style is much more abstract and has little resemblance to the original pictograph. A shift from pictographs to cuneiform is a shift from analog to digital writing systems (described in Chapter 1).

Egyptians

A logogram is a visual sign that represents the written form of a single word. Chinese characters and Egyptian hieroglyphics are examples of logograms. There are two different types of logograms, pictograms and ideograms. Before 3100 BC, the concept of writing was introduced to the Egyptians, and they began to develop hieroglyphic writing. Hieroglyphics are a combination of ideograms (signs representing ideas) and phonograms (signs representing sounds). Consequently, hieroglyphic writing is more complex than simple picture writing. In contrast to the Mesopotamians that used writing primarily for practical administrative purposes, the Egyptians used it for religious and monumental inscriptions. The Egyptians used many different writing materials, including stone, wood, metal, parchment, vellum, and leather. However, the writing material that sets the Egyptians apart from other ancient cultures is papyrus. Papyrus is a light, smooth material made from narrow strips of fresh green papyrus plant stems. Strips of the papyrus plant were placed together at right angles, pressed, and pounded into sheets. Sheets of papyrus could be joined to make scrolls. Egyptians believed in the power of magical names, spells, enchantments, pictures, figures, amulets, ceremonies, and words of power to produce supernatural results. Their civilization was highly intellectual, and they meticulously performed their religious ceremonies.

NO WRITING: *PICTURES*

Forerunners of Writing: *Three-Dimensional Tokens*
(tokens represent livestock and agricultural products)

Semasiography
(pictures express meaning without an intervening linguistic form)

 1. Descriptive-Representational Device
 2. Identifying-Mnemonic Device

Full Writing: *Phonography* (writing expresses language)

1. *Word-Syllabic*

Sumerian	Egyptian	Hittite	Chinese
(Akkadian)		(Aegean)	

2. *Syllabic*

Elamite	West Semitic	Cypro-	Japanese
Hurrian	(Phoenician)	Minoan	Korean
etc.		(Hebrew)	Cypriote
		(Aramaic)	Phaistos
		etc.	Byblos

3. *Alphabetic*

Greek
Aramaic (vocalized)
Hebrew (vocalized)
Latin
Indic
etc.

Figure 5–1: Stages in the Development of Writing

Adapted from Gelb, 1952.

Phonetic Alphabet

The second stage of writing was the development of the alphabet by the Greeks, a digital system. Although many elements in the Greek alphabet were derived from other systems, the Greeks were the first to create an alphabetic system. They adopted the Phoenician alphabet and included vowels. The development of a full Greek alphabet, expressing single sounds of language by means of consonant and vowel signs, is an important step in the history of writing. Each spoken word is broken down into its phonemic components, which are represented by unique letters of the alphabet. Today, we write consonants and vowels in the same way as did the ancient Greeks.

The Greek alphabet was later adopted by the Semites and this became the alphabet adopted by many different linguistic groups. Although the hundreds of alphabets used throughout the world may

differ from each other in appearance, they all have characteristics of outer form, inner structure, or both, which first originated in the small area surrounding the eastern Mediterranean Sea.

Box 5.1: In His Own Words: Robert K. Logan

Bio: Robert K. Logan is a physics professor at the University of Toronto, where he carries out research on computer applications in education. He collaborated with Marshall McLuhan for six years, and they wrote several articles together. Presently, Logan is an active member of the Media Ecology Association, a scholarly organization that promotes the intellectual examination of media as environments and the relationship between media and culture.

The Visual Bias of the Alphabet

The alphabet by separating the sound, meaning, and appearance of a word separated the eye from the rest of the senses, especially the ear. Preliterate man is multisensual whereas alphabetic man is highly visual…. The Greeks created visual space, the geometric space treated in Euclid's elements. With alphabetic literacy, visual metaphors for knowledge crept into usage in the Greek language. We use similar metaphors in English as the following examples illustrate. Our word *idea* derives from the Greed word *eidos,* "the appearance of a thing." *Theory* derives from the Greek word *theorein,* "to view" (the word theater has the same root). The term *speculate* derives from the Latin *specere,* "to look."

The English word see can refer to either knowledge or sight by eye. The terms *vision* or *sight* (insight, foresight) connote knowing. Other visual metaphors abound; *light* refers to knowledge and *darkness* to ignorance; while to *reflect* is to think. The term *contemplate* comes from the Latin *contemplare,* "to observe." Terms such as *bright, brilliant, illuminate, clear, lucid* also link knowing and seeing. The Greek words *idea* and *theory* cannot be found in Homeric Greek. Both these words are products of the alphabet and new visual stress it fostered. (Logan, 1986, pp. 121–122).

DEVELOPMENT OF TYPOGRAPHY

The automation of writing began with the use of movable type in China. The Chinese would carve a page of text in reverse on wooden blocks and then print the page on paper. However, the large number of characters required by the Chinese language limited the development of printing techniques. When printing blocks were brought to Europe, they were quickly turned into the movable type technique of printing. Each block carried one letter of the alphabet. Individual blocks of letters could be grouped together into words, words into paragraphs, and paragraphs into pages.

The alphabet is capable of an infinite number of combinations, and the printing press was developed to manufacture books for many emerging markets, including religious books, vernacular literature, and university textbooks. With the invention of the printing press and movable type came the establishment of typography as trade. Wooden blocks were replaced by cast metal, and type fonts could be designed and mass-produced. Each type style required about 100 characters, which included uppercase and lowercase letters, 10 numerals, and punctuation marks. The individual characters could be assembled and disassembled for repeated use.

The concept of movable type is generally ascribed to Johann Gutenberg. The printing press incorporated the use of movable, mass-produced, cast-metal type fonts and a mechanism that allowed large sheets of paper to be printed. Although handwritten manuscripts and printed books are very different methods for recording information, early printed books tried to look like handwritten manuscripts. Consequently, early type design resembled handwriting.

Typesetters were responsible for the appearance of every printed page. They controlled the features of dropped capitals, hyphenation, accented characters, mathematical formulas, rules, tables, indents, running heads, and footnotes. Occasionally, they would rewrite parts of a text to improve its appearance on the page. Typesetters paid attention to detail, and they prided themselves on the appearance of a well-composed design.

Early Typography

Graphic artist and painter Albrecht Dürer (1471–1528), was one of the first designers to discuss theoretical issues associated with type design. He published three books that dealt with the following subjects: linear geometry and two-dimensional geometric construction; the application of geometry to architecture, decoration, engineering; and letterforms. Dürer's instructions for the construction of Roman letterforms made a significant contribution to the development of alphabet design. His work influenced other designers, such as Nicholas Jenson (1430–1480). Jenson's type design has had a lasting influence because his fonts were extremely legible. He had a talent for designing the spaces between the letters and within each form to create an even tone throughout a page.

Claude Garamond was the first to set up a type foundry and work independently of printing companies. This was the first step in moving away from the scholar-publisher-typefounder-printer-bookseller model of publishing that developed during the Renaissance. Garamond designed a large number of elegant typefaces and achieved a mastery of visual form that is still considered highly readable and beautiful today. Designers still use the Garamond typefaces, and a version is available for computers.

In the 1600s, English type designers began to influence the type styles used in publishing. William Caslon (1692–1766) opened his own shop, and in 1722, he began designing fonts, such as Caslon Old Style. Caslon's style increased the contrast between thick and thin strokes, giving the fonts a rhythmic texture and visual interest. For the next 60 years, Caslon type was used in nearly all English printing, and

Figure 5–2: *Of the Just Shaping of Letters,* by Albrecht Dürer, 1525. Every letter was related to the square and Dürer designed a construction method using a 1:10 ratio of heavy stroke to the height of the letter. Dürer did not use any single alphabet source for his design. Dover Pictorial Archive Series. Used with permission.

Caslon type styles followed English colonialism around the world. For example, Benjamin Franklin introduced the Caslon typeface in America, and it was used in the official publishing of the Declaration of Independence.

Typography and the Bauhaus Movement

In the early part of the 20th century, a major change in typography began to occur. Sans serif typefaces were designed to emphasize the basic shapes of alphabet letters by stripping away serifs and decorations. In 1916, Edward Johnson was commissioned to design a typeface for the London Underground, and it inspired the Gill Sans series of typefaces by Eric Gill. Another successful series of sans serif typefaces was Futura, designed by Paul Renner. Renner believed that instead of passing traditions from one generation to the next, designers should try to solve problems in ways that related to their own times.

As industrial society grew, the Bauhaus School was formed to explore the unity between art and technology. In contrast to the English Arts and Crafts Movement that believed handcrafted work was superior to machine production, the Bauhaus Movement embraced the machine as a symbol of 20th-century efficiency. Bauhaus instructor Laszlo Moholy-Nagy, argued that typography was a communication tool and it needed to have absolute clarity. Herbert Bayer ran the typography and graphic design workshop. He designed a universal typeface that reduced the alphabet to rationally constructed forms. At one point, he omitted capital letters because he argued that capital and lowercase alphabets were two totally different systems of signs. Type was placed flush on the left side of the page, and extreme type sizes were used to establish a hierarchy of emphasis. Elements, including bars, rules, points, and squares, were used to subdivide the space and to call attention to elements on the page. With the growing tensions of World War II, Bayer and many other Bauhaus instructors moved to the United States.

During the 1950s, a design style developed in Switzerland that was called the "Swiss School" or International Typographic Style. Swiss designers, such as Armin Hoffmann and Emil Ruder, gained international acclaim for their spare, economic designs and systematic approach to graphic design and typography theory. The visual characteristics identified with the International Style include visual unity of design through the asymmetrical organization of elements, the use of sans serif typefaces, typography set flush on the left and ragged on the right, and the use of photography and type to present clear and objective visual and verbal messages. The International Style rejected personal expression and eccentric design solutions and favored universal and scientific approaches. The Swiss School created the popular typefaces called Helvetica and Universe.

American Design

From the late 1950s to the early 1970s, Herb Lubalin was an American typographer. Few graphic designers embody the aesthetics of their times as totally as Lubalin did. He built a bridge between modernism and postmodernism by joining rational and emotional methodologies together in the service of commerce. His conceptual typography made letters speak and words emote. He was a pioneer of phototypography, a method that replaced lead casting typesetting techniques with computer-controlled photographic methods. Lubalin promoted the practice of smashing and overlapping letters, and he freed white space from the modern style by refusing to follow the rule that "less is more." His designs were displayed in the marketplace, and his radical approaches to type and page design surfaced in design annuals.

"His understanding of the impact of the new technologies on contemporary perception was visionary" (Heller & Pomeroy, 1997, p. 65). At a 1959 assembly of typographers, Lubalin argued that television was going to influence the ways in which type would be read. He compared the kinetic quality

and speed of television images to advertising passing by on the side of a bus. "He reasoned that in this environment smashing letter forms together and including images in a rebus-like manner made type easier to decipher. (Heller & Pomeroy, 1997, p. 66).

By the 1970s, the International Style had been so thoroughly refined and explored that it was time for a change. Inspired by the work of Lubalin and others, a new style of postmodern design began to emerge, which was more intuitive and playful. In contrast to rational design decisions, designers placed elements in the space because they "felt right." Design became more subjective and eccentric. The introduction of new computer-based typesetting techniques supported this trend by making it easier for designers to create new typefaces. Designers had more creative freedom because individual letters could be manually drawn and photographically turned into a typeface to be used on a phototypesetting machine. But, phototypesetting systems ran on minicomputers, and these machines were quickly replaced by smaller personal computers that ran desktop publishing software programs. Programs were even developed to design typefaces on personal computers.

Typography as a Visual Element

Graphic designers work with images and text to communicate messages. Originally, typography was the composition of printed text from movable type. However, since the introduction of desktop publishing software, typesetting has become the selection and composing of type in a digital document. The traditional role of typesetters has all but disappeared. In many professional design situations, such as book publishing, the new typographer's task is to make reading easy by using a typeface that is functionally right for the design. As a result, legibility becomes a key concern.

In contrast, the type design in print advertising is often open to interpretation by the designer. Advertising messages are often noticed because of their typographic style. Emil Ruder (1981) said the following:

> The importance of the message—of one word or more, rarely of the whole text—must be brought out by typographical means, for it is the visual impact on the public that matters and not so much the legibility. The typographer must therefore strive to achieve harmony between the meaning of a word or words and the typographical form in which he puts them. (p. 134)

Harmony can be achieved in different ways; for instance, the meaning of the word "red" could be emphasized by printing the typography in red ink.

Besides color, typographers can also create meaning in type through their selection of type style, character, and size. The combination of different type styles, characters, type sizes, and letterspacing, along with reversing and distorting the type, can convey different meanings. With the introduction of computerized typesetting, designers have many more options in terms of how they arrange lines of type on a page. For example, computers make it easier to distort type, place it in patterns, and arrange type in a layout.

Basic Classifications of Typefaces

The alphabet is a series of visual signs arranged in a sequence to represent spoken sounds. The alphabet has 26 characters that can be combined into thousands of word sequences. The visual signs of the alphabet are displayed through the design of typefaces. We place typefaces into two broad categories: serif and sans serif. Serifs are the short lines found at the end of letters. The use of serifs originated in stone-cut Roman capital letters as a method for finishing a stoke. Some typographers believe that serif typefaces are easier to read because the serifs enable readers to more easily identify letters and tie

Box 5.2: Case Study: The Beauty of Bodoni

The trick to identifying different typestyles is to look for the distinguishing characteristics of the typestyle. For instance, the Bodoni typestyle has a dramatic contrast between its thick and thin strokes. The serifs are thin, straight lines that bring attention to the bold lines in some letters and the curved shapes of others. Bodoni has become the standard to judge all other Modern typestyles. The typeface is named after Giambattista Bodoni, an innovative type designer and printer in his time. During the late 1700s, the influence of writing and calligraphy in type design was replaced by mathematical measurement and the use of mechanical instruments to construct letterforms. Bodoni was originally designed for use with letterpress printing, and the typeface was inspired by technological advancements in paper stock. Earlier paper was coarse, and type design had to be heavy to hold up in the printing process. Improved paper and the popularity of copperplate engraving led to the creation of typestyles with fine lines.

Bodoni is an easy typeface to recognize because of these features. However, there are additional characteristics that help to identify it. These include the serifs at the top and bottom of the capital "C," the condensed proportions of the "M," and the vertical tail of the "Q."

letters into words. Sans serif refers to letterforms that do not have serifs at the end. Nonserif typefaces became popular at the beginning of the 20th century.

Typefaces are also classified as text (body) or display type. Text or body type is textual material that is set in type and ranges from 6 to 12 points. In contrast, display type is type sized over 14 points. Not every typeface works as both text and display type because very integrate typefaces are not very readable when they are set in small sizes. Therefore typographers make a distinction between type used in headlines or large sizes and type used in body text or small sizes. Typefaces that can be used as both display and body copy are Times, Helvetica, and Garamond. However, computer systems do not tend to make a distinction between typefaces that should be used as text or display typefaces. As a result, display type can be printed in small sizes, but generally the words are very difficult to read; an example of this is Lucinda Blackletter or Old English and brush script.

Typefaces generally are designed as type families. A type family refers to the different weights and styles in which a typeface is set. In traditional typesetting, a family would include a regular typeface, heavier typefaces, lighter typefaces, and italic or slanted typefaces. Today many computer systems can transform a basic typeface into bold and italic. Additionally, computer systems add outline and strikethrough to type style features.

Monospace type is a typeface that has all of its letters spaced at the same width, such as Courier and American Typewriter. In contrast, *proportional type* alters the width of the letters. Consequently, an "I" will take up less space than an "m." Typewriters use monopsace type, and word processors generally use proportional typefaces, such as Times, Helvetica, Century Schoolbook, and Garamond. Computer screens originally used monospace type to display texts, and there are now a number of computer-based typefaces, such as Monaco and OCR. But today, graphical interfaces mostly display proportional type, unless a monospace font is selected.

Typographic Measurements

Type size is measured in points and picas, not in inches. French type designer and founder Pierre Simon Fournier Le Jeune introduced this system of type measurement in 1737. The contemporary

American system of points and picas was adopted during the 1870s. There are approximately 72 points in an inch and 12 points make a pica. Consequently, there are around six picas in an inch. Establishing these size standards enabled typographers to make metal type the exact same height, and the system has now been applied to computerized typesetting.

In metal typography, interline and interword spacing was accomplished by placing metal blocks between the pieces of type. Metal spacers were used for letter and word spacing, paragraph indentions, and centering or justifying lines of type. *Letterspacing* is the interval between letters. *Wordspacing* is the interval between words, and *leading* or *line spacing* is the space between lines of type. Leading is the traditional term used to describe the space between lines of type. This term refers to the fact that metal typesetters would place thin strips of lead between the lines of metal type to increase the spatial interval between them. Today, many desktop publishing programs have replaced the term leading with line spacing.

Typographic Syntax

Similar to language, type has its own syntax. Typographic syntax is defined as the procedure of organizing typographic elements into a cohesive whole. Understanding typographic syntax starts with the basic unit of a letter and moves onward to include the arrangement of words, lines, columns, and margins. The most important consideration in typography is the proportion of letterforms. There are four variables that impact on the visual appearance of letterforms: the ratio of height to stroke width, the differences between the thickest and thinnest strokes, the width of the strokes, and the relationship of the x-height to the height of ascenders, descenders, and capitals.

The contrast between thick and thin strokes in a letterform creates the optical qualities of the letter. With advances in computer typesetting, type designers are now able to make thinner strokes. Additionally, computers enable us to expand and condense type styles to dramatically alter the word proportion in a layout. Although the computer enables designers to experiment with the syntax of typography, this new freedom raises issues concerning the legibility of text.

Serif Typefaces

Bookman
Garamond
Times
Courier

Courier is a monospace type, notice how the letters are evenly spaced.

Sanserif Typefaces

Futura
Helvetica
Swiss

Headline or Display Type

Old English
Zaph Chancery
Arrus
Brush

Figure 5–3: Typefaces. Author's illustration.

Legibility

With the introduction of computer technology, typography has taken on new shapes, weights, and spacing. With metal type, the physical dimensions of the font itself created a space that did not allow

Box 5.3: In his Own Words: Emil Ruder on Typography

Bio: Emil Ruder was born in Zurich, Switzerland, in 1914. He studied in Paris and at the School of Applied Arts in Zurich, where he later taught typography and became the head of the typography department. In his book Typography *(1981), Ruder orchestrated images from art history and architecture with the elements of typography and printing to explain the "new" principles of typographic design. As a typography instructor, his ideas influenced a generation of students that developed the style of "Swiss Typography." He died in Basle in 1970.*

More than graphic design, typography is an expression of technology, precision and good order. Typography is no longer concerned with meeting the lofty and difficult demands of art but with satisfying, formally and functionally, the everyday requirements of a craft. The mechanical production of printing types and composition within a right-angled system of fixed dimensions makes a clear structure and cleanly ordered relationships imperative.

What the typographer has to do first and foremost is to sort out and organize things which are of a very disparate nature. The whole test of a book is so unwieldy that it has to be divided up in such a way that the reader can manage each page comfortably and follow the print without impediment. A line of more than 60 characters is hard to read; too little space between lines destroys the pattern they make, too much exaggerates it….Our age needs printed works, which catch the eye when ideas and products are forever competing for our attention. With an enormous range of typefaces available, thin or thick, large or small, it is a question of selecting the right one, composing the "copy" with these faces and interpreting it. The typographer should have fonts at his disposal which combine agreeably, and mention might be made in this connection of the Univers family which is very well graded and embodies a great deal of careful thought. Let us hope that this achievement will show the way to better things and help to sort out the more or less chaotic state of affairs in typefounding today. (Ruder, 1981, p. 14)

letters to get too close. In the past, art directors spent hours with a razor blade in hand, tightening the space between letters. In contrast, computerized typesetting allows designers to overlap both letters and lines of type. However, type that is too close together can create a legibility problem. For example, when letters in serif typeface are placed too close to each other, it can be difficult to read them. Serifs help the eye pick up the shape of the letter. Humans depend on letter ascenders and descenders to recognize type as symbols.

Most readers are not aware of how the text is typeset and how much attention designers pay to minute spatial details. It takes skill to make letters flow rhythmically into words and words into lines. Too much or too little space between the individual letters and words can disrupt the reading process. Similarly, too much or too little space between lines of type can make reading difficult. Three variables influence legibility: type size, line length, and line spacing. When properly used these variables make reading easier. For instance, the optimum reading sizes of text type are between 9 and 12 points. Designers adjust the line length of text to a maximum of 10 to 12 words or 60 to 70 characters per line to maximize legibility. Using type measurement, this is about 18 to 24 picas for the line length.

Designers also adjust line spacing to improve legibility. When lines are too tight, people will read them more slowly. In contrast, if too much space is placed between lines, readers will have difficulty locating the next line. As line length increases, line spacing should also increase. A general typesetting rule is to place a minimum of two points of line spacing between lines of type. Using traditional typesetting terminology, 12-point type would have two points of lead between the lines, that is, the type would be

set at 12 over 14. The number 14 refers to the type size (12) plus the two points of lead. Although the size of the type is 12, each line of type would take up 14 points because of the added leading (line spacing).

Rhythm

Rhythm is created in typography when letters line up to form words, through the arrangement of lines of text and by the relationships between blocks of type. To impart rhythm into words, the space between the characters needs to be different lengths. A variety of spacing between letters creates a visual tension. Similarly, rhythm can be added to blocks of type by creating unequal line spacing, varying the length of the lines, and adding white spaces. Moreover, the common layout arrangements for blocks of text are justified, flush left, flush right, centered, and runaround. Each arrangement creates a unique rhythm. When arranging large headlines, designers are aware that each individual type style has its own singular rhythm. As a result, large type should be set off from its surroundings to enable each type style to perform its own unique rhythmic function.

Figure 5–4: Echos. Author's illustration.

Type Styles and Connotations

Typefaces have cultural connotations called typographic resonance. Typographic resonance is the connotative properties that typefaces possess beyond their function as an alphabet. These connotations are developed through historical tradition, associations relating to the use of the typeface, and optical properties. For example, the typeface used in elementary textbooks is generally Century Schoolbook. This is a serif typeface, and it is used because it is considered highly legible with strong character differentiation. As a result, this typeface is associated with schools and education.

In print media, designers select typefaces to reflect the tone of the message. Modern type styles are generally preferred for computer- and technology-oriented messages. In contrast, classical type styles, such as Times or Century Schoolbook, are preferred for serious or scholarly texts. Designers can also intensify a message by adding optical properties to type or by using historical typefaces. A simple optical effect is making a word bold to emphasize it. For example, students know that words set in bold in a textbook are important terms that need to be studied when the teacher is giving a test. Similarly, typefaces designed to look like handwriting (script) are generally used for personal invitations. This style of type is less formal and more difficult to read. Therefore, it is not used for long textual passages.

MIXING WORDS AND PICTURES

Typography and modern photography were first fused together by Moholy-Nagy in his design concept of typofoto. The typofoto was the result of the development of new photochemical printing processes that no longer separated image and typography. Moholy-Nagy printed words over pictures and predicted that the future of graphic design lay in the fusion between text and image: "Typographical materials themselves contain strongly optical tangibilities of which they can render the content of the communication in a directly visible—not only in an indirectly intellectual—fashion" (1969, p. 40). Typestyles themselves convey meaning and they can be used in combination with photography to express ideas. Sometimes phototext can replace words. When this occurs, people can interpret messages in ways that are highly individualized, or the message can be understood through a gestalt understanding of the relationship between image and text.

Words often accompany photographs to help the reader interpret the picture. Or in other cases, pictures help to illustrate the words. Traditionally words and pictures are combined. In his *Graphic Design Manual,* Armin Hofmann (1965) said the following:

> Writing is purely a means of communication built up from linear geometrical signs which are understood on the basis of mutual agreement. But the system had first to be invented and it requires a mental effort on everybody's part to elicit a message from signs which were hitherto unfamiliar. (p. 17)

In contrast, pictures embody an intrinsic message. However, "reading" the messages inherent in pictures can be difficult because they range from realistic depictions to nonfigurative graphics.

> Unlike lettering, the picture radiates movements, tone values, and forms as forces which evoke an immediate response. The reconciliation of this typical antagonism calls for a great deal of knowledge and skill in all tasks where picture and lettering are to be connected. (Hofmann, 1965, p. 17)

The visual shapes of letterforms can add a level of meaning to messages, and visual skills are required to effectively combine images and type.

Relationship Between Words and Images

In traditional graphic design, the word is dominant and images are used to illustrate or help people interpret the text. For example, in advertising, the copy generally is the driving force behind the advertising concept. In fact, copy is called the *thinking behind the ad.* But according to Philip Meggs (1989), "The twentieth century, with its fast pace and intense information environment, has radically altered this convention. In an important historical reversal, text often becomes a supporting message used to connote and sharpen the image" (p. 41).

Text can alter the meaning and interpretation of an image. Additionally, words have a more specific meaning than images, and therefore words can bind an image to a specific meaning and direct the spectator toward a specific interpretation. For example, newspaper headlines can direct the reader's understanding of a front-page photograph.

Juxtaposition of Type and Image

In many publications, there is a clear separation between type and image because text is placed in columns separated from the pictures in the layout. Separating type and image enables each element to communicate a message without the interference of the other. However, when designers juxtapose and combine type and images together in new and unique ways, the message can be intensified.

Many advertisements and posters place type over an image. A popular technique is to reverse or drop out the type from the image. White type placed against a dark image background can create a

Our listeners are heavy drinkers.

DIET-PEPSI
BRILLIANTE
MILLER BEER
AMSTEL BEER
MOUSSY BEER
GIACCOBAZZI
CARLING BEER
PERMIAT WINE
HOLSTON BEER
CARDINAL BEER
HEINEKEN BEER
RUFFINO CHIANTI
MONTCLAIR WATER
ASTI CINZANO WINE
KRONENBOURG BEER
TAYLOR LAKE COUNTRY
ANHEUSER BUSCH BEER
LEONARD KREUSCH WINES
FERRARELLI • MICHELOB BEER
TAYLOR CALIFORNIA CELLARS
DRY SACK SHERRY • DR. PEPPER
AMERICAN DAIRY ASSOCIATION
RENFIELD IMPORTERS • LANCER'S
SCHAEFER BEER • MANISCHEVITZ
TAYLOR CREME SHERRY • SUNKIST
HENKELL • SUNKIST • BECK'S BEER
PERRIER • CANADA DRY • PEPSI COLA
MOLSON GOLDEN ALE • COCA COLA
MONSIEUR HENRI • SIGLO • MATEUS
POLAND SPRING WATER • YOO-HOO
LOWENBRAU BEER • SPRITE • RIOJA
BUDWEISER BEER • BLUE NUN • TAB

Figure 5–5: Type arranged to make a shape. Author's illustration.

strong visual hierarchy. However, type overprinted on an image or reversed in white needs to be carefully planned to avoid legibility problems because sufficient contrast is needed between the image and type for people to read the words easily. For instance, people frequently complain that color combinations on web pages and articles in *Wired* magazine are difficult to read because there is not enough contrast between the image and the color of the type.

Visual–Verbal Synergy

In many communicative messages, the designer tries to create a synergy between the words and images. Synergy is the combination of elements to achieve a total effect that is greater than the sum of the individual elements. Understanding the message requires the combined impact of both the visual and verbal elements. This type of interdependence between word and image has a combined impact that is stronger than each element.

Merging of Images and Letterforms

Since the time of medieval manuscripts, artists and designers have found innovative ways to combine images with letterforms. Sometimes, an image can be used as a letterform to communicate an idea, or a designer can use the reverse technique of turning a letterform into an image. Philip Meggs (1989) said the following:

> In human communication alphabet characters are the atoms, and words are the molecules—the smallest unit of spoken and written communication with a meaning other than signifying a sound. By altering and manipulating the visual form of a word or its substrate, graphic designers expand and extend its meaning. (p. 57)

Another way to mix pictures and words is the *rebus*. It represents words or syllables by using pictures of objects whose names sound like the intended letters or words. For example, a picture of an eye sounds like the letter I. Additionally, the picture of a bee reminds us of the letter B. Rebus designs fuse words and images together to create a total visual message.

WRITING SYSTEMS AND CULTURE

Many authors have discussed the relationship between writing systems and culture. For example, Logan (1986), (Havelock (1963), and Ong (1982) argued that the use of the alphabet and the rise of literacy changed Greek culture. In preliterate oral cultures, information must be memorized and passed from one person to the next as stylized poetry. In contrast, the alphabet enables people to preserve prose and transmit ideas from one generation to the next without memorization. More important, the alphabet separates the speaker from the words. Logan (1986) said the following:

> Under the influence of alphabetic literacy, Greek writers created the vocabulary of abstract thought that is still in use to this day, notions such as body, matter, essence, space, translation, time, motion, permanence, change, flux, quality, quantity, combination, and ratio. (p. 105)

Eventually, the Greek spirit moved away from learning through empirical observation to speculation and philosophizing through logic and rationality. This change led to the development of modern science. Another social consequence attributed to the use of the alphabet is the separation of man from nature. Concepts of individualism emerged, and people began to search for their own identity. "Know thyself" becomes an integral aspect of individual self-enhancement. The printing press further reinforced concepts of individuality by separating readers from others.

Before the printed book, reading was a shared activity and people would read to others. As books became more available, the activity became more individualized. More important, books became commodities written by individual authors. Copyright laws were developed to protect the rights of publishers and authors in the marketplace. Social practices emerged to support the economics of book publishing. Today, many social systems that support the publishing industries are being challenged by the introduction of digital technologies because digital texts are often created collaboratively. More important, digital writing can be easily copied and changed. In contrast to the fixed written text, the digital word is a fluid and changing one.

Transformative Theory

Michael Heim (1987) coined the term *transformative theory of language technology* to describe theories that use historical, anthropological, and sociological research to point out the effects of different communication technologies. These theories pay particular attention to how communication technologies have influenced human thought. They examine how changes in writing technologies can be used to better understand other social transformations. For example, in oral cultures, poetry is used for preserving the cultural system of signs by passing information between generations. People had to be present to hear the words of the speaker, and words had to be memorized. In contrast, written words can be sent across distances, leaving the author behind. The separation of speaker from words led to abstract thinking and ideas of individualism.

Language use in oral culture is different from the way it is used by written cultures. Writing is more abstract than speech, and it supports logic and reason. As a result, science and logic developed in Greek culture. The shift to the printing press reinforced many characteristics of the alphabet. Written texts can be compared and analyzed in ways that are not possible with spoken words because they disappear as soon as they are said. However, the introduction of digital writing creates a fluid writing space in which words can be altered and shared in ways not possible with print-based writing. For example, words can appear and vanish at the push of a button.

Print-based Versus Digital Writing Systems

A central difference between print-based and digital writing is the introduction of visual symbols into the writing process. Lanham (1993) said the visual elements introduced by the computer screen destabilize the reading process. Readers no longer look through the "transparent" printed typefaces to read a written passage; they look at the decorative page. Instead of just transparently reading language, readers now become more self-conscious of the text. On computer screens, "the textual surface is now a malleable and self-conscious one. All kinds of production decisions have now become authorial ones" (p. 5). Readers and writers of electronic texts can change the type styles, proportions, and ratios of visual elements displayed on the screen. For instance, the reader can increase the type size of a document to make the text easier to see. The ability to manipulate the decorative elements of page design affects both the process of reading and the process of writing.

Moreover, Bolter (1991) argued that the visual icons of graphical interfaces add a level of picture writing to the writing process. Icons "constitute the computer's original contribution to our writing system. Although an icon may have a name, it is above all a picture that performs or receives an action, and that action gives the icon its meaning" (pp. 51–52). The mouse enables users to position an arrow over images that can be dragged, opened, or copied. Double-clicking will open the file image and display its contents on the screen. These images are symbolic elements that form a new type of picture writing. "Reorganizing and activating these elements *is* writing, just as putting alphabetic characters in a row is writing" (p. 51). Digital writing introduces new visual elements to the writing process.

Box 5.4: In His Own Words: Richard Lanham

Bio: Richard Lanham has been an English professor at the University of California, Los Angeles, since 1965. Lanham has written nine books, including The Electronic Word *(1993).* The Electronic Word *has been adopted by hypertext enthusiasts as a landmark book for legitimizing theory relating to new writing technologies. Lanham's book is an optimistic thesis about the future of electronic written expression.*

The basic changes from print to electronic screen we are now coming to comprehend in their full force. The fixed printed surface becomes volatile and interactive…. Typography becomes allegorical, a new authorial parameter expressive in the very manner suggested by the Italian Futurists when our century began. The graphical and typographical tricks to which the electronic surface lends itself make us self-conscious again about our own apparatus of vision…. The mind therefore specializes on analogy and metaphor, on a sweeping together of chaotic sensory experience into workable categories labeled by words and stacked into hierarchies for quick recovery. Print invites us to forget all these tricks, to look through a deliberately transparent and fixed black-and-white surface of verbal symbols to the conceptual universe beyond. Electronic text's bag of visual tricks makes us self-conscious about the bag of neural tricks that create our own vision, and puts this self-consciousness into oscillation with the visual conventions of transparent print…. The perceptual field of the "reader" becomes considerably richer and more complex in electronic display. (Lanham, 1993, pp. 73–74)

IMPACT OF DIGITAL TECHNOLOGY ON TYPOGRAPHY

Computerized typesetting has changed the processes of writing and typesetting in several ways. First, word processing can make it easier to write. Written passages can be changed and modified easily. Second, desktop publishing brings professional quality typesetting into the office and home. The introduction of desktop publishing enables individuals to create documents that "look" like they were professionally typeset.

Word Processing

In contrast to pen and pencil or a typewriter, writing with a word processor is more fluid. According to Heim (1987):

> Text can be kept tentative and captured in a fluid state while the right word can be found easily inserted later; I can edit and rewrite at the same time; the printed word no longer seems sacred or complete as soon as it is typed— improvements are always possible; I can write more, revise more easily and effectively, eliminate unnecessary words, sentences, paragraphs, perhaps save fragments which might be used later somewhere else. (pp. 31–32)

The ability to edit, correct, and change digital type is an important feature of word processing programs. Additionally, encoding written language into a digital format enables the text to be used in a variety of ways. For instance, it can be sent as an e-mail message over a computer network or imported into a desktop publishing program.

Desktop Publishing

In 1985, Aldus introduced PageMaker, the first desktop publishing program. Desktop publishing software allows users to position text and graphics on an electronic page. After the page is designed, it can be printed on a laser printer by using a page description language called PostScript. While working

at Xerox PARC, John Warnock, a founder of Adobe, started to create PostScript. The text and graphics positioned in a PostScript layout are visually displayed on the computer screen in WYSIWYG: What you see on the computer screen is what you get when the page is printed on the laser printer. Pages designed using PostScript and printed on a laser printer look like pages that were typeset by a professional typesetter. The postscript language describes letters and numbers as mathematical formulas, which allows the design to be printed by a variety of devices. The resolution of the printed design depends upon the printer or typesetting machine used to print the design.

Originally, people thought that desktop publishing would only interest professional typesetters. In contrast, nearly every business began to use desktop publishing software to produce newsletters, brochures, and promotional materials. In many companies, desktop publishing quickly replaced the need to send work to professional typesetters. Many companies have their own in-house typesetting services, and they hire graphic designers to operate their computers. With the development of desktop publishing, many graphic designers added typesetting to their list of skills. Moreover, anyone with a personal computer and a desktop publishing software program can now become a typesetter.

SUMMARY

Writing systems first began as digital tokens to represent commodities. Over time, they developed into writing systems. The development of the phonetic alphabet was adopted by many different cultures as a method for recording spoken language. Writing can be placed into four general periods: written symbols, the alphabet, the printing press, and digital writing. When writing methods change, cultural changes will often follow. For example, after the invention of the printing press, Renaissance typesetters published scholarly texts and typesetting became a specialized trade. Today, individuals can publish their own texts using a personal computer and desktop publishing software. Instead of a specialized trade, typesetting is now accessible to anyone who owns a computer with desktop publishing software.

WEBSITES

- *Adobe Systems*
 http://www.adobe.com/

- *Type Museum*
 http://abc.planet-typography.com/
 http://www.typemuseum.org/museum.htm

- *Principles of Typography*
 http://www.will-harris.com/type.htm
 http://www.online.tusc.k12.al.us/tutorials/typograp/typography.htm
 http://www.sallygentieuwelch.com/pages/Type_Road.html

EXERCISES

1. Many different ancient cultures have developed pictorial systems that are not included in this general overview. Research another culture and describe its use of pictorial symbols as a form of writing and representation. Other cultures to research include Mayans, Aztecs, American Indians, Chinese, Hittite, and so forth.

2. Through the use of simple lines, the Egyptians depicted people in a variety of poses. Can you create a contemporary hieroglyphic that is more representative of how people look today? What characteristics of styles worn today do you consider representative of American culture? Would your contemporary hieroglyphics translate across different cultures? Why or why not?

3. Look in magazines and newspapers and find three typefaces that you like and three that you don't like. Explain why you like and dislike them.

4. Compare and contrast the typefaces and layout of *Wired* magazine to a magazine such as *BusinessWeek, Time,* or *Newsweek.*

5. Select a typestyle and describe it. Try to find words that can verbally show the visual features of the type.

6. Compare and contrast four pages from four different books. Think about how the different typefaces create different feelings. Examine the type size, line spacing, margins, and arrangement of text (flush left, flush right, centered).

7. Desktop publishing software places typesetting in the hands of individuals. How does this change our idea of typesetting? What types of social changes could occur?

KEY TERMS

Desktop publishing electronically integrates text and graphics to produce documents by either laser printers or high-quality printing presses.

Display type is type sized 14 points or over.

Ideograms are signs that represent ideas.

Leading or linespacing is the space between lines of type.

Letterspacing is the interval between letters.

Petroglyphs are pictures painted, drawn, incised, or carved on rocks; they date from the oldest Paleolithic period.

Phonograms are signs that represent sounds.

Phonography refers to writing that expresses language.

Pica is a typographic unit of measurement. Twelve points equal 1 pica and 6 picas equal approximately 1 inch. This measurement is used to measure the length of lines of type and the column widths in which text is set.

Pictographs are the earliest forms of symbolic writing. These simplified drawings represented words in a language; for instance, a picture of a fish denotes a fish.

Points are the smallest unit in typographic measurement. Twelve points equal 1 pica and 1 point equals approximately 1/72 of an inch. The size of type and the spacing between lines of type are measured in points.

PostScript is a page description language developed by Adobe Systems that enables page layouts created on a personal computer to be printed on a laser printer or high-end printing machine.

Rebus is the representation of words or syllables by pictures of objects whose names sound like the intended words.

Sans serif or non-serif refers to letterforms without serifs.

Semasiography refers to pictures that express meaning without an intervening linguistic form.

Serifs are the small decorative elements that are placed at the end of the main stroke of a letterform.

Synergy is the combination of elements to achieve a total effect that is greater than the sum of the individual elements.

Text is a word used in graphic design to refer to the main body of written or printed material.

Text or *body type* is textual material that is set in type that ranges from 6 to 12 points.

Typeface is the consistent design of alphabetical and numerical characters that are unified by specific visual characteristics.

Type family is the complete range of variation of a typeface design, such as italic, bold, expanded, and condensed.

Typographic resonance is the connotative properties that typefaces possess in addition to their function as an alphabet.

Typography is used to describe the use of independent, movable, and reusable bits of metal, each of which has a raised letterform on its top, in the process of printing.

Weight refers to the lightness or heaviness of a typeface, which is set by the ratio of the stroke thickness to the height of the character.

Wordspacing is the interval between words.

Writing is a system of human intercommunication by means of conventional visible marks.

x-height is the height of a lowercase letter without including the ascenders and descenders. It is most easily measured by the lowercase letter x.

☀ Graphic Design

With the development of advertising in the United States, commercial art became a new industry. Commercial artists included illustrators, mechanical layout artists, and letterers. Correspondence schools developed to teach people this new skill in their spare time. However, most commercial artists were trained on the job, and formal education was not necessary. Today, commercial art has evolved into the profession of graphic design, and most designers are college educated. Originally, graphic designers primarily worked with print-based media. However, the introduction of digital media has added computer literacy skills as a professional graphic design requirement and expanded graphic design into multimedia.

MASS MEDIA AND MASS ART

With the introduction of modern technology came mass production and mass media. A new popular culture began to emerge through film, radio, the illustrated press, and other forms of popular entertainment. This new culture engaged a wider audience and eventually developed into a mass commercial culture. Noel Carroll (1998) argued that along with mass culture was the rise of mass art that is multiplied, identical, and reproduced:

> Industrially mass produced, the new art can be distributed everywhere. It is not bound to a unique spatial location. People no longer have to travel to see it. It can be delivered anywhere and everywhere. Art, in the age of mechanical reproduction, can be brought to the spectator. (p. 121)

Mass art removed art from unique religious and cultural contexts and brought it to the public.

With the rise of mass culture, many artists became interested in forms of graphic design directed toward mass rather than elite audiences. These predominantly left-wing artists argued that the commercial world offered them an opportunity to democratize art. Social mass art, such as advertising and poster design, was viewed as an art that could shape the visual habits of the public. It was during this era of technological and social transformation that modern graphic design was established.

As artists rallied around the modernist style of graphics, industries were going through their own transformation. Small, family-run businesses were becoming corporations and design reflected this change. The principles of the new typography developed by the Bauhaus corresponded to the technocratic ideologies of German industry in the period.

The Bauhaus is the most celebrated art school of modern times. It reformed art education by replacing Romantic ideas of artistic self-expression with rational, quasiscientific approaches to design. By erasing the boundaries between fine and applied art, the Bauhaus attempted to bring art into a close relationship with life through design. Design was perceived to be a vehicle for social change and cultural revitalization. The foundation courses taught in many art schools today use design principles that originated at the Bauhaus. The Bauhaus basic courses were designed to teach students a craft and prepare them for future cooperation with industry. A goal of the program was to help students acquire self-confidence and find their own vocation.

One of the first teachers appointed to the Bauhaus was Johannes Itten (1888–1967). Formerly a Swiss elementary school teacher, Itten became a painter relatively late in life. He was a follower of a mystic named Whitford, who opposed the materialist interpretation of the world. Whitford's followers believed that common reality was a veil obscuring a higher and more authentic existence. Therefore, a program of mental and physical exercises, a vegetarian diet, and regular purification was prescribed. This program was designed to help followers perceive a different level of existence. Influenced by his religious beliefs, Itten developed a preliminary six-month program for all students before they went into artistic workshop training at the Bauhaus.

First imagination and creative ability had to be liberated and strengthened. Afterward, commercial considerations could be introduced. Itten (1975) stated, "If new ideas are to assume artistic form, physical, sensual, spiritual, and intellectual forces and abilities must all be equally available and act in concert"(p. 8). Itten's morning classes began with relaxation and breathing exercises. Students were required to play with various textures, forms, colors, and tones in both two and three dimensions. In one exercise, students had to analyze works of art in terms of rhythmic lines and expressive content. Today, Itten is probably best remembered for his theories on design and color. His theory of composition was based on a general theory of contrasts: large–small, long–short, broad–narrow, smooth–rough, hard–soft, sweet–sour, hot–cold, dark–light, and so forth. Besides these contrasts, seven color contrasts were also explored. Students had to approach the contrasts from three different directions: experiencing them with their senses, objectifying them intellectually, and realizing them synthetically.

At the Bauhaus, students began their studies of color and form by being restricted to the basic shapes and color hues. A key concept central to Itten's theories is the notion of contrast and tension. He also believed that color communicates emotional states. Itten made analogies between the emotional and spiritual nature of forms: the square signified peace, death, black, dark red; the triangle was associated with vehemence, life, white, yellow; and the circle presented uniformity, the infinite, peace, and blue. Each form had its own color that was emotionally suited to the form to achieve balance and harmony.

Modernist graphic design originated in Europe and many important theorists and practitioners of the new style were associated at one time or another with the Bauhaus. The Bauhaus school moved a number of times before establishing a school in the United States. Artists associated with the Bauhaus include the following: Walter Gropius, Laszlo Moholy-Nagy, Paul Klee, Wassily Kandinsky, Johannes Itten, Gyorgy Kepes, and Herbert Bayer. Clashes between European modernist designers and the Nazis forced many of these designers to leave Europe and settle in the United States, including Gyorgy Kepes, Laszlo Moholy-Nagy, and Herbert Bayer. Moholy-Nagy established a new Bauhaus school in Chicago that is now called the Institute of Design. Gropius taught architecture at Harvard University, and Bayer began working for American corporations. In 1937, Bayer designed a series of advertisements for the

Box 6.1: In His Own Words: Johannes Itten

Bio: Johannes Itten (1888–1967) was in charge of the "basic course" at the Bauhaus when it was located in Weimar, Germany. The basic course was designed as a trial period to judge students and determine their creative talents. Itten was concerned with problems of design and color. He combined his experiences as a teacher with his knowledge as a painter to develop design theory. His ideas are still being taught today.

The three basic forms, the square, the triangle, and the circle are typified by the four different directions in space. The character of the square is horizontal and vertical, that of the triangle diagonal, and that of the circle circular. I sought first of all to convey these three characters of form to my students so that they truly experienced them. I asked them to stand up and perform a circular movement with their arms until finally the entire body was in a relaxed swing position. This exercise was carried out first with the left, then with the right arm, then simultaneously with both arms, in the same and in opposite directions. Thus the students experienced the circle as an evenly curved, continuously moving line. Concentration of the circle as a form followed—it had to be intensely felt, without bodily movements reinforcing the imagination. Only then was the circle drawn on paper.

The experience of the square produces a tense movement from one corner to the next, caused by the constant repetition of right angles. In the triangle, the whole variety of angles is represented.

The derivations and possibilities of contrast residing in the characters of the forms were studied in a series of exercises. (Itten, 1975, p. 62)

Container Corporation of America (CCA). Striking visual effects dominated these advertisements and his work contributed to the development of an American style of modernist design (see *Bauhaus: Red, Yellow and Blue,* http://www.youtube.com/watch?v=fxvabTsNe7s).

American graphic design is associated with the communication of commercial messages. In contrast, socialized countries use graphic design for distributing cultural and political propaganda and resistance messages. During World War II, graphic design played an important role in the dissemination of propaganda messages. In contrast, in the postwar period, designers in the United States were primarily hired by corporations to promote corporate messages. Logos and trademark symbols had been used for many years in America to sell products and services. However, in the 1950s, design practices expanded into corporate identity systems, which unite the visual messages of large corporations. The goal of corporate identity is to present a consistent corporate public image. Comprehensive corporate identity programs will design everything from the corporate stationery to the logo placement on uniforms and trucks.

Over time, graphic design developed into a profession with its own literature, research practices, and interests that extended beyond graphics and into the styling of products, signage, and clothing. For example, Paul Rand worked with the Westinghouse Company to develop packaging, advertising, and signage. By the 1950s, designers had integrated themselves into the corporate sphere, and multinational corporations began to present a strong visual identity that transcended national borders (see http://www.youtube.com/watch?v=4yOjts0tpco or type Paul Rand into http://www.youtube.com).

From a cultural perspective, the graphic designer can be viewed as an agent of the ideology through whom the views and beliefs of a group find expression. However, besides the cultural attitudes expressed in the content and design of messages, institutional structures also mediate visual forms of expression.

For instance, most designers create visual messages for commercial purposes. The main objective of these designs is to sell products and services.

It has been suggested that the relocation of modernist design into the American corporate sphere dissipated its radical agenda and the utopian dreams envisioned in Europe. Transported to America, modernism became a "look" rather than an ideology. American designers continued the original modernist agenda of creating highly aesthetic approaches to graphics, but they did not maintain the political ideals of earlier modernist artists.

American graphic design schools were influenced by the modernist style through the theories of the Bauhaus and the Swiss School. The Swiss School introduced a new style of publication design that applied a grid structure to compositions. Layouts were created that used a square mathematical grid divided into four columns. Text, black and white photographs, and white space were asymmetrically arranged on the grid. More important, the Swiss School was concerned with method and approach rather than content. It advocated the use of problem-solving methods to reach design solutions. As a result, the work of the Swiss School appears more systematic and research oriented (see ABCs of the Bauhaus, http://www.youtube.com/watch?v=3_c6AlBBCCI).

ROLE OF THE DESIGNER

Early graphic designers had a utopian vision of democratizing art through mass media. Throughout the 20th century, various artists and designers have been associated with political movements. For example, the Situationist International (SI) was a group of French philosophers and artists who created an active

Box 6.2: In His Own Words: Guy Debord

Bio: Guy Debord was involved in the postwar Lettrist International movement, which sought to transform the urban landscape through the fusion of poetry and music. In 1968, a group of avant-garde artists and intellectuals formed the Situationist International to incorporate art and culture into daily life. Debord emerged as the most important member of the group. His book The Society of the Spectacle *(1995) is one of the great theoretical works on modern-day capitalism, cultural imperialism, and the role of mediation in social life.*

THE SPECTACLE APPEARS at once as society itself, as a part of society and as a means of unification. As a part of society, it is that sector where all attention, all consciousness, converges. Being isolated—and precisely for that reason—this sector is the locus of illusion and false consciousness; the unity it imposes is merely the official language of generalized separation.

THE SPECTACLE IS NOT a collection of images; rather, it is a social relationship between people that is mediated by images.

THE SPECTACLE CANNOT be understood either as a deliberate distortion of the visual world or as a product of the technology of the mass dissemination of images....

UNDERSTOOD IN ITS TOTALITY, the spectacle is both the outcome and the goal of the dominant mode of production. It is not something added to the real world—not a decorative element, so to speak. On the contrary, it is the very heart of society's real unreality. In all its specific manifestations and—news or propaganda, advertising or the actual consumption of entertainment—the spectacle epitomized the prevailing model of social life. (Debord, 1995, pp. 12–13)

avant-garde movement between 1957 and 1972. The group was critical of other art movements and society at large. According to Barnard (1995), "The SI used popular, mass-produced images to make their political points, reproducing pornographic photographs with revolutionary slogans printed over them" (p. 74). They scribbled slogans on the walls of Paris taken from their theories, including FREE THE PASSIONS and LIVE WITHOUT DEAD TIME. After 1961, Guy Debord became a prominent member of the group. Debord argued that capitalism had reduced all human interaction to interaction with objects or things. As a result, everything in human society had been turned into a spectacle. Debord's ideas influenced scholars in many disciplines.

Although, artists and designers have been involved with political movements, most designers work for corporations. As designers began working for commercial interests, modernism became identified as a *style* of design. The modern style is very popular in the corporate world. Designers are hired to create visual identity programs and advertising campaigns. Besides corporations, media companies also hire graphic designers to develop special "visual looks" for their media products—advertising, newspapers, magazines, books, and television programs. As a result, graphic designers work for a wide range of corporate and media businesses.

The role of the graphic designer is to combine signs, symbols, words, and pictures into a total message. Philip B. Meggs (1989) described the graphic designer as follows: "The graphic designer is simultaneously message maker and form builder. This complex task involves forming an intricate communications message while building a cohesive composition that gains order and clarity from the relationships between the elements" (p. 1).

A difference between graphic design and other forms of visual art is the communicative function of the message. Designers use many different approaches when they create visual communication. For example, Bob Gill approaches a design project with a problem-solving strategy. When Gill is given an assignment, he first turns it into a problem to solve. For instance, the design of a title for a television situation comedy about a dumb private secretary was turned into a problem by asking the following: What would a stupid secretary do? The answer is this: Make lots of mistakes with the typewriter. Therefore, a visual solution to this assignment would be to create a title screen in a typewriter typeface that showed the secretary's typos. Another example is the poster Gill (1981) designed for the Broadway show "Dancin.'" He described the problem as follows:

> Original problem:
> Logo for the Broadway musical *Dancin'*. It has no plot but many styles of dancing.
> Redefined:
> How can one image give the impression of many styles of dancing? (p. 144)

In contrast to Gill's problem-solving approach, Milton Glazer (1985) approaches design by responding to a cultural-societal desire and using it. He said, "Our designs are always trying to take advantage of what is occurring. Both shaping it and responding to it"(p. 471). From this view, design is seen as "the intervention in the flow of events to produce a desired effect"(p.471). Glazer asked the following question: What will be the effect of the design?

Instead of focusing on the message, Paul Rand's strategy for creating visual messages is to focus on the spectator of the design. Rand (1985) said the role of the graphic designer is to be persuasive or informative. A designer's problem is twofold: "to anticipate the spectator's reactions and to meet his own aesthetic needs" (p. 7). The designer must be able to discover a way to communicate a message between himself or herself and the spectator. "The problem is not simple; its very complexity virtually dictates the solution—that is, the discovery of an image universally comprehensible, one that transcends abstract ideas into concrete forms (p. 7).

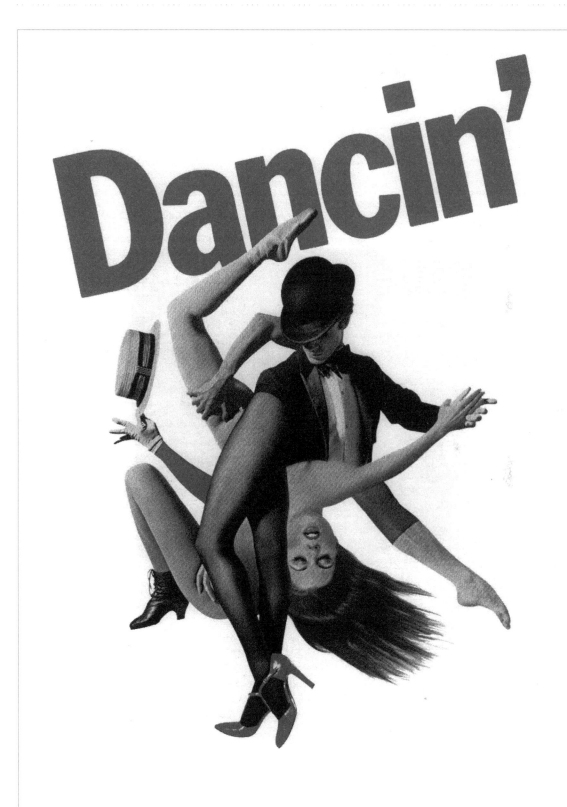

Figure 6–1: Gill's solution for designing a Broadway poster for a show that features many different styles of dancing. Bob Gill. Used with permission.

Rand has been one of the most influential designers in the late 20th century. His clients included Westinghouse, IBM, and Next Computer. The symbol Rand designed for the Westinghouse Corporation transformed their earlier trademark of a circle with a W into something unique. Rand's design updated and modernized the logo by combining a series of dots and lines intended to suggest a printed circuit. However, viewer comments about the design revealed a secondary meaning. Viewers said that the logo also reminded them of a mask. With lines and dots, Rand could evoke both contemporary and historical associations with his design.

To build a cohesive composition, graphic designers need to balance signs, symbols, words, and pictures into a visual hierarchy that leads the eye through the message. The size of an element within the graphic space and its relationship to other elements, including the white areas, is significant in the message process. Various designers approach the creation of visual messages in different ways. However, all designers are aware that the purpose of their designs is to communicate a message to a spectator.

Figure 6–2: A true grid and three basic layouts using the grid process. Author's illustration.

Laying out the art and copy on a page is a visual skill. The task is to place a variety of elements into an eye-catching and unified relationship. The ideas described in Chapter 2 are the building blocks of layout and design. To create well organized and balanced layouts, modernist designers developed the theory of grid design.

Dividing a page into a grid structure with modular units creates a systematic balance for layouts. Contrast is created by placing images over several modular units and leaving other modules white. The grid provides a framework for many designs. This framework also creates continuity between pages. Designers must make careful decisions about the size and placement of the elements on the page and to each other.

According to Emil Ruder, it is the designer's duty to the audience to present clarity and order. White spaces on the page should be recognized as a design element in the composition. Layouts should be based on a grid structure to ensure consistency. The principles of grid layout also include type design. Readable text and letter arrangements should emphasize legibility rather than visual impact. Simple type forms should be used for their universality, clarity, and impersonality. Illustrations should be photographs used to provide variety and contrast within the geometric layout. Various elements in the design should be banded on a rectangular grid to present information economically to the viewer.

Besides grids, there are many ways to lay out a page. For example, print advertising often uses several common layout formats. These advertising formats include big copy, big picture, formal balance, informal balance, Mondrian, and picture window. Each layout creates a different visual hierarchy. Emphasis is accomplished through contrasts that stress the relative importance and separation or connection of graphic elements. Designers need to be aware of the visual hierarchies in their designs to make it easier for spectators to understand the message.

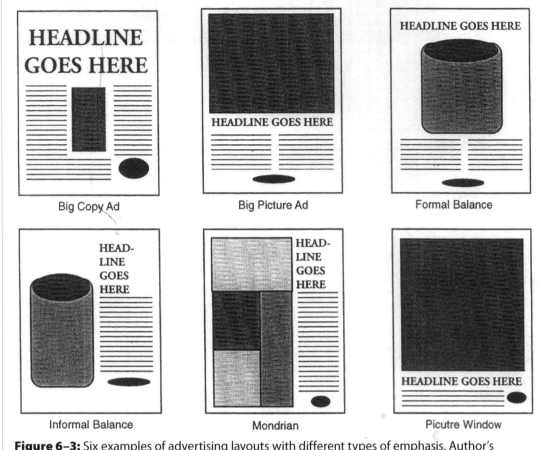

Figure 6–3: Six examples of advertising layouts with different types of emphasis. Author's illustration.

THE DESIGNER IN POSTMODERN CULTURE

Over the past 20 years, a number of designers have broken all of the rules of modernist design, which has led to the title of postmodern design. "If modernism sought to create a better world, postmodernism—to the horror of many observers—appears to accept the world as it is" (Poynor, 2003, p. 11). Poynor (2003) chronicled the changes in graphic design as designers challenged the conventions and rules that modernists considered good design principles. Design trends include postmodernism, deconstructionism, retrievalism, techno, and remix.

The first phase of the shift to break all the rules was called postmodernism. "In the late 1980s and early 1990s, designers would go much further in their attempts to create multilayered communications that captured the complexity and ambiguity of modern experience" (Poynor, 2003, p. 27). Designers became the visual interpreters of the social mood of the day and they assumed their audiences were visually literate. A central school for developing designers that followed postmodern theory was Cranbrook Academy of the Art.

As postmodern theory (Barthes, 1981; Debord, 1995; Jameson, 1991; Lyotard, 1991) and books on design theory (Gill, 1981; Heller, 1998; Heller & Pomeroy, 1997) emerged, graphic designers began to deconstruct design's built-in assumptions. Graphic artists associated with punk rock started an assault on professional design's orderly methods. Nonprofessional designers developed punk graphics that used graphics made by hand, photocopies, found type, scissors, and paste. The second phase of changes

in design practices emerged—deconstruction. Byrne and Witte (1990) defined deconstructionism as "the breaking down of something (an idea, a precept, a word, a value) in order to 'decode' its parts in such a way that these act as 'informers' on the thing, or on any assumptions or convictions we have regarding it" (p. 82). They further stated: "When the deconstructionist approach is applied to design, each layer , through the use of language and image, is an intentional performer in a deliberately playful game wherein the viewer can discover and experience the hidden complexities of language" (p. 83).

A central designer associated with deconstruction is David Carson. He wanted to examine the concept of deconstructing the relationship between written and visual language. The deconstruction would help him to better understand the intentions and dynamics of communication. However, appropriation and retrievalism began to enter the design scene. This new phase had a "prevailing cultural obsession with the past" (Poynor, 2003, p. 71), a belief that writers and artists have already created all the styles that can be invented. All that is left is the imitation of old styles. As a result, design began to recycle old styles from the past, such as the advertising for Old Navy. The commercial goal for the use of appropriation was to trigger comforting emotions in consumers. While designers were grappling with a fixation on the past, a new technology, the computer, was about to change design again.

The Apple Macintosh, introduced in 1984, became a machine for a new era of graphic artists. Computers enabled designers to create fragmented and intricately layered design. The bitmapped look became a new computer aesthetic for this *techno* style of design. As computer processing became more powerful, designs created on screens became overloaded and complex. At times, these new designs overwhelmed the viewer; an example of this is *Wired* magazine. When it was first introduced, some academics found it impossible to read.

Aesthetics associated with computers led to the development of remix culture. Remix is the ability of computers to combine text, video, images, and sounds. It creates a new culture that is emerging on social networking sites such as Facebook, Myspace, and YouTube. "As with postmodern design's use of retro and vernacular imagery, there is a feeling that culture has stalled, that there is nothing left to invent and that 'newness' can only lie in sampling and remixing what already exists" (Poynor, 2003, p. 103). Another aspect of remix is that any individual with a computer and multimedia software can become a designer. Additionally, a profound implication for computers and design is that digital technology collapses all media into a desktop tool in which all information is encoded into ones and zeros.

In the realm of graphic design, the computer has ushered in a new era of freedom that enables artists to cut, paste, and delete their work more fluidly. Media is now a boundless world of the old and new symbols that can be layered and relayered on top of each other. This establishes a new aesthetic that is currently being developed with the use of computers.

ANALYSIS OF GRAPHIC DESIGN

The shift from modernism to postmodernism requires a more visually literate viewer. Philip Meggs (1989) compared the levels of understanding in a graphic design to a set of Chinese boxes, with the smallest box fitting inside the second smallest one and so on. The smallest box represents the elemental denotation read by the visually illiterate spectator. In contrast, the largest box depicts the trained designer who understands visual organization, typography, photography, content, and meaning. The boxes in between represent the various other levels of understanding a design that exist between these two extremes.

Learning how to better understand graphic design requires the spectator to more carefully analyze the design. Answering the following questions can help you better understand the message being

communicated in a simple visual design, such as a sign, symbol, or logo. (Reviewing Chapter 4 will help you answer these questions.)

1. What type of graphic is it—image, concept, arbitrary?
2. What words would you use to describe the design?
3. Is the design balanced? Are the elements arranged in a formal or informal style?
4. Does the arrangement of the visual elements suggest the shape or form of an identifiable object? If yes, what type of metaphorical relationship can be made between the object and the idea it represents?
5. What general feeling does the design convey—serious, fun, classical, modern?
6. Is there a color associated with the design? If yes, what meaning does it convey?
7. Identify the company or idea the sign, symbol, or logo conveys. How do the visual elements correspond to the concept it represents?
8. On what level are you interpreting this message (universal, national, regional, local, or individual)?

An analysis of a more complicated graphic design requires a different set of questions because layouts combine visual and verbal elements together. To analyze the layout of a design that includes images and text, consider the following questions:

1. What categories of type styles are used in the layout?
2. What connotations are associated with the type styles?
3. Is the layout balanced? Are the elements arranged in a formal or informal style?
4. What general feeling does the layout convey—serious, fun, classical, modern, postmodern?
5. How does the visual hierarchy lead the eye through the layout? What elements in the design are emphasized most? What message do these elements convey?
6. Do the visual and verbal messages support each other, contradict each other, or fuse together to convey a meaning that is larger than each?
7. Is there color associated with the layout? If yes, what meaning does it convey?
8. On what level are you interpreting the message in the design? (universal, national, regional, local, or individual)? Does the meaning associated with the design change when you move to different levels?

Asking and answering questions like these will help you think about visual communication more deeply. Often people have an emotional reaction to an image without understanding why or how this is happening.

GRAPHIC DESIGN AND NEW MEDIA

From a professional perspective, the introduction of computers into the discipline of graphic design has changed the profession in three ways. First, computers provide digital tools for the creation of traditional print-based media. Today, most graphic artists work with computer-based software programs instead of drawing tables and drafting tools. Second, the shift from handheld to digital tools has blurred the boundaries between traditional roles in the graphic arts and prepress industries. In traditional prepress, the roles of art director, designer, typesetter, mechanical artist, and printer are clearly defined. But, designing with computers blurs these roles because the designer often becomes the typesetter and the mechanical artist. Software gives the designer more control over the total design process because the same person often does the creative thinking and execution of the design.

Finally, computers create opportunities for designers to expand their discipline from print into digital technologies. Some of these digital alternatives include designing and developing electronic games, multimedia applications, CD-ROMs, interactive computer graphics, World Wide Web sites, and software interfaces. Computers provide new opportunities for designers to go beyond print and work in multimedia design.

Digital Media and Traditional Graphic Design Practices

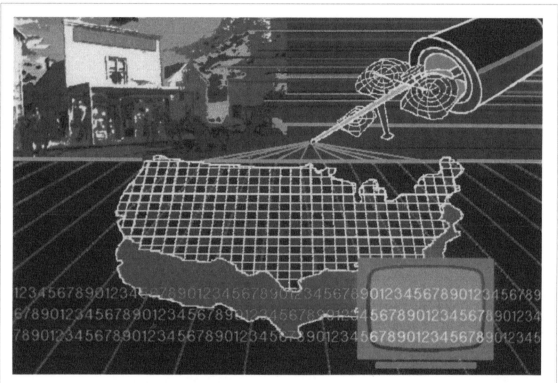

Figure 6–4: Computer graphic design on the theme of Yesterday, Today, and Tomorrow. Notice how the map of the United States implies national reach. Author's illustration.

Desktop publishing software was first introduced in 1985. Five years later, most graphic designers had replaced their traditional drafting tools with computers. By 1994, *Graphic Design: USA* declared the following: "There can be no debate concerning the impact of the personal computer on the professional graphic design community. It has, quite simply and literally, penetrated everywhere and changed everything" (p. 8). Layouts that were formerly done by hand on a drawing table by pasting photographically set blocks of type onto mechanical boards were now digitally generated on a computer screen.

According to Wendy Richmond (1990), "Most designers understand the computer as a replacement tool" (p. 102). Graphic artists are simply replacing their traditional tools with digital tools that do the same tasks. As a replacement tool, desktop publishing eliminates drafting tables, T squares, rulers, triangles, and mechanical paste-up boards. Moreover, the arrival of computers also signaled the arrival of nearly instantaneous printing. All of a sudden, the printing process was no longer constrained by physical blocks of type or even strips of film. The creation of prepress mechanical layouts can be done with computers, and the information is encoded into bits of data that can be easily stored, manipulated, and transmitted to distant places. Designers working in remote locations can send their final designs to clients and printers through the Internet.

Changing Roles of Graphic Design Professionals

In professional publishing environments, desktop publishing systems blur the boundaries between the roles of editors, designers, and production artists. With nondigital technology, editors, writers, designers, artists, layout staff, prepress specialists, and printers had specialized and different jobs. However, the personal computer enables a single person, with the appropriate skills, to perform all these tasks. Although one person does not generally create an entire publication alone, jobs are being redefined by the technology. Editors and writers are becoming more involved in the design of their publications. Similarly, designers and graphic artists are finding themselves working with and even creating the written text. For example, when *Time* magazine turned their traditional prepress production into an electronic prepress facility, the company located the facility close to the editorial department. The move gave editors and designers more flexibility and control over the final page layouts.

While electronic prepress adds more control to the design process, some magazine art directors do not want to operate the computers themselves. Eric Shropshire (1989), a *Playboy* art director, said his role is to design, and he does not want to do the production work. He said that his time is better spent creating new ideas and design concepts: "Other art directors as well as myself find that, in some cases, while the computer may be better for the bottom line, some of the production related tasks now relegated to the in-house Macintosh are still better left to the keyliners [mechanical artists] and support staff"(p. 20). However, the computer requires members of the art department to expand their skills from type design to photo imaging with Photoshop.

In contrast to assigning different roles to personnel in large art departments, people running small design firms can now assume more roles with digital technology. With the aid of desktop publishing and digital prepress tools, small companies can now compete with larger ones. By learning different graphic design, illustration, and imaging software programs, one hardworking individual can produce the same quality of work as a group of people working in a large art department. With the aid of computers, a skilled designer using a variety of software programs can now do a process that used to require many people with a variety of hands-on skills.

However, one problem arising from the ease of access to desktop publishing software is that people without any visual design training often create documents that are poorly designed. Three years after the introduction of the Macintosh, Betsy Sharkey (1988) described in *Adweek* the assault on type design by "civilian" designers, amateurs with desktop publishing software that create visually illiterate page designs. These designs are illiterate because they do not conform to the professional standards of type design and page layout.

Owning a desktop publishing software program does not automatically turn writers into graphic designers. To fill the graphics illiteracy gap, corporations and software companies hire professional designers to create sample templates of page layouts for brochures and newsletters. Once a professional designs a template, a writer can drop copy into the layout. This eliminates the need for the writer to learn how to become a proficient graphic artist. Today, many software programs include a variety of templates with their programs to help nondesigners create professional looking graphics.

Multimedia and Graphic Design

In the past, the term graphic design has been used to refer to the creation of typeset words and illustrations for printed mass communication. Today, the term graphic design no longer applies only to print-based media. The graphic capabilities of personal computer systems are expanding in the areas of audio–visual presentations, photography, illustration, animation, and multimedia. Graphic artists are now developing skill sets for designing with a variety of media types. This is the third stage of integrating computers into the discipline of graphic design. In this stage, the computer is no longer a production

tool. It becomes a medium for the creation and distribution of electronic texts. Simultaneously, as the computer transformed into a global communication network, it also began to integrate sound, video, and animated graphics into electronic documents.

One of the most powerful characteristics of computer technology is its ability to incorporate other media. In the computer industry, multimedia refers to the computer's ability to display multiple media types, and the term is used to describe a variety of application and content products, such as desktop video software, animation programs, CD-ROMs, electronic books, and encyclopedias. Multimedia products add dynamic characteristics to information that was previously presented on static printed pages. With the introduction of multimedia products, graphic designers need to expand their discipline to include both multimedia and interactive communication skills. In *Understanding Hypermedia*, Cotton and Oliver (1993) stated:

> While a printed magazine's art director and graphic designer are thoroughly familiar with the effect of type and image combinations, and know precisely how to create a stylistically consistent look through the use of colour, the hypermedia designer is venturing into relatively new territory, and must learn how to orchestrate these extra audio–visual and computer media within an integrated and interactive whole. (p. 42)

Designing hypermedia programs is a four-step process. "First, forms of multiple media have to be utilized in such a way that they optimize the communication characteristics of particular media, for example using text for what it does best, using animation where that is the best way to encapsulate an idea, and so forth" (Cotton & Oliver, 1993, p. 42). Second, a layout grid has to be created to develop designs that enable different media to be integrated seamlessly into a consistent visual style. Third, control and feedback tools need to be developed to help users navigate through the document. Richmond (1990) asserted that designing for an interactive hypermedia project "presents a very different set of design problems than a non-interactive project, such as a book. A reader knows where he or she is in a book—beginning, middle, or end. A book is meant to be read linearly. Interactive media is meant to be viewed in any order the viewer wants" (p. 183). As a result, designers need to create iconic cues and visual metaphors to help readers know where they are in the document and how to get where they want to go. For example, designers need to decide how much information to place on the screen and how readers will move from one piece of information to the next. Arrows, buttons, and menus are all different visual devices that have developed to enable readers to navigate through digital information space.

Graphic artists working with multimedia are asked to handle many tasks. For instance, they create original art with traditional tools and then scan the art into a computer. Additionally, they use computer tools to design screens, interfaces, web sites, and three-dimensional images. Some multimedia publishers hire designers to develop an overall concept and manage the other artists.

The marriage of art and technology in multimedia has created a new demand for education and new media training. As a result, graphic artists have an opportunity to enlarge their discipline to include multimedia design. Designers have already accepted the fact that computer skills are a standard requirement in the graphic design profession. Originally, this acceptance was based on the digital streamlining of prepress production tasks through desktop publishing software. However, with the introduction of multimedia computer products, the role of the designer expands into the realm of multimedia design. As companies begin to replace printed materials with electronic texts distributed through computer networks, the role of the designer further expands into the world of digital media and information design.

As we move into a world of digital media, Katherine McCoy (1998) said we need trained designers to apply visual communications expertise to developing digital media. "We need graphic designers who are literate in computer science; and we need far more designers literate in cognitive theory and

perceptual processes who can give comprehensible form to electronic virtual environments" (p. 11). Interactive design expands design into new media and this change will require designers to learn new skills.

GRAPHIC DESIGN AND POSTMODERN CULTURE

During the 1920s, the modernists challenged the elite concepts of art and plunged into the worlds of mass production and mass media. These designers "treated the techniques of manufacture not as neutral, transparent means to an end, but as services equipped with cultural meaning and aesthetic character" (Lupton, 1998, p. 159). Today, a new postmodern style of graphic design has emerged that tends to abandon the guiding notions established by modernist design. The postmodern style first emerged in art and architecture and spread into graphic design in the 1980s. As previously discussed, postmodern styles borrow from history and combine dis-cordant styles with a mixture of nostalgia and irony. Postmodern design practices appear highly referential because they use a reservoir of histori-cal and established images that already connote meaning. Publications, such as *Wired* magazine and *Mondo 2000*, exemplify the postmodern style. These publications have discarded the ideas of simplicity, unity, and balance and replaced them with computer-manipulated headlines, unusual text, new type relationships, and saturated colors.

Figure 6–5: Cover of *Mondo 2000,* an example of postmodern graphics (Mondo is no longer in business).

Present theories of graphic design are being influenced by semiotics and French liter-ary theory that emphasize the reader or viewer rather than the author or creator of a work. Postmodernism challenges designers to focus on audience interpretation and to tailor their visual messages to the special needs of their spectators. This theoretical shift in design theory encour-ages designers to work with layers of meaning and content to add more subjective and personal layers of meaning to their messages. As a result, postmodern designs often add additional levels of connotative interpretation to the basic informa-tion being presented in the design. However, this new approach to design creates challenges because adding additional layers of meaning to a message can be at odds with the client's need to present a single clear message. Additionally, the postmodern approach to graphic design views visual communication as a language to be read. Graphic design is seen as a form of visual literature.

Currently, there are four different approaches to graphic design: design as art, design as science, design as literature, and design as problem solving. The first three of these deal with communication and meaning. However, each stresses a different aspect of the sender-transmitter-receiver communication model. "Design as art is concerned with personal content and expression; design as science is concerned with the systematic presentation of objective information; and design as language is concerned with the audience's reading or interpretation of text and content" (McCoy, 1998, p. 10). All three of these

Figure 6–6: Original problem: Counter display for slippers. Redefined: What can hold a slipper and be fun to look at? Bob Gill. Used with permission.

approaches are valuable, and successful visual communicators will understand them all. The fourth approach is illustrated by the work of Bob Gill (1981, pp. 142–143).

Computer technology supports both modernists and postmodern styles of design. Desktop publishing software programs have features that make it easy to design with a grid. Type, photographs, and design elements can be balanced and sized to fit in proportional boxes. Conversely, computers can also be used to explore new ways to use type and arrange elements on a page. Type can be curved and arranged into shapes that are difficult to create with mechanical tools. Computers provide new opportunities to experiment with design on both applied and theoretical levels.

SUMMARY

Graphic design began at the beginning of the 20thcentury with the need for commercial artists to work on print-based media. Early design principles were established at the Bauhaus school, and many of these theories are still being taught today. A modernist style of design developed that embraced industrial ideas of efficiency. This led to the development of grid theory and the rational organization of elements in page layout and design. In the 1980s, a new postmodern style of design emerged that introduced subjective elements and additional layers of meaning into visual messages.

Postmodern design focuses on the interpretation of the spectator, and it arrived at the same time as computer technology. This technological change has enlarged the discipline of graphic design to include all new forms of multimedia, such as interactive video games and web design. Moreover, the shift from linear to interactive methods for displaying information creates a need for the development of new design theories and strategies. The role of the graphic designer is changing as digital media develops and the power of the computer expands.

WEBSITES

- *Art Director's Club*
 http://www.adcglobal.org/
- *Graphic Design*
 http://www.aiga.org/
- *Print Magazine*
 http://www.printmag.com/
- *Designer Paul Rand*
 http://www.paul-rand.com/

Type Bauhaus into http://www.youtube.com to find more examples of Bauhaus design. Several of these designs have been animated.

EXERCISES

1. Look in magazines and newspapers and find three typefaces that you like and three that you do not like. Explain why you like and dislike them.

2. Compare and contrast the typefaces and layout of *Wired* magazine to a magazine such as *Businessweek, Time,* or *Newsweek.*

3. Use the eight graphic design analysis questions to critique a magazine cover.

4. Select a short poem and then cut up letters and words from magazines and newspapers to create a visual version of the poem.

5. Compare and contrast four pages from four different books. Think about how the different typefaces create different feelings. Examine the type size, line spacing, margins, and arrangement of text (flush left, flush right, centered).

KEY TERMS

Deconstructionism is the idea that a visual text is not a discrete whole but a series of irreconcilable parts. As a result, there is more than one reading of a text.

Graphic art is a term that has been traditionally used to refer to drawings, etchings, engravings, book illustrations, and printed advertisements.

Graphic design started at the turn of the century and it developed out of commercial art. *Design theory* was developed at the Bauhaus school, and over the years, graphic design has become an established discipline of study.

Graphic designers lay out print publications and design logos, type styles, and visual messages used in print-based media. However, the introduction of digital media expanded the discipline of graphic design into multimedia design.

Mass art is industrially produced art that can be distributed everywhere.

Modernist style was advocated by the Bauhaus school, and it embraces the industrial ideas of efficiency. The slogan that best depicts the modernist approach to design is "form follows function."

Postmodern styles borrow from history and combine discordant styles with a mix of nostalgia and irony.

Prepress is a term that refers to all of the preproduction steps involved with preparing documents for printing. It includes typesetting, graphic design, photography, color separations, and preparing film or plates for printing.

Remix is the ability of computers to combine text, video, images, and sounds. It creates a new culture that is emerging on social networking sites such as Facebook, Myspace, and YouTube.

Retrievalism has a prevailing cultural obsession with the past and borrows historical design elements for current work.

Techno is the style of design that developed after the introduction of the Macintosh computer in 1984.

☀ UNDERSTANDING VISUAL MEDIA

Part II discusses the different types of media, from print-based to digital. A historical overview is presented in each chapter to place the medium into a context and to demonstrate how visual technologies have developed since the late 1800s. Additionally, the cultural changes with the introduction of digital media are described.

☀ Print Media

The printing press was the first mass medium. It revolutionized writing systems because texts could be duplicated and distributed to many people. As printing technologies advanced, they have increasingly become more visual. Techniques to reproduce illustrations developed into methods to duplicate photographs. With the introduction of computers, software programs were invented to streamline the preparation of texts for printing. Digital computers can easily integrate words and images together in the production of printed texts. However, paper is necessary for texts to be created

EARLY PRINTING TECHNOLOGY

Papermaking is central to the printing process. Originally developed in China, it took hundreds of years for papermaking to reach the Western world. Papermaking first spread to the Arab world and later arrived in Egypt in during the 10th century. Paper spread across North Africa and was introduced in Italy in 1102. Paper was necessary for printing to have speed and efficiency. In 1276, the first paper mill was established in Italy. As the paper industry developed, it was one of the first industries to use trademarks. Trademarks identified mills and individual craftspeople. These marks were embossed into paper products as watermarks. Watermarks are translucent emblems created by pressure from a raised design on a mold. Early trademark symbolism included mermaids, unicorns, animals, flowers, and heraldic shields.

Early printing technologies included woodcuts and engravings. In the early 1300s, pictorial designs were being printed on European textiles. More important, woodcuts were used to create playing cards. Zealous church supporters outlawed card playing. Despite the law, card playing was a popular social activity. An underground block-printing industry developed to produce decks of cards. Working-class people gathered in taverns to play with grimy cards that were block-printed and stenciled on coarse paper. Card designs were an early form of graphic design that was used by an illiterate population. Playing cards illustrate the democratizing characteristic of printing in Europe because a game once played by the kings became available to peasants and craftspeople. The symbol recognition, sequencing, and logical deduction advanced by card playing paved the way for alphabet literacy.

Beyond cards, early block prints were devotional images of saints. Both the image and lettering were carved into the same block of wood. Specially trained artisans who had cut blocks for the textile industry did the carving of wood blocks. Some devotional prints included text. However, carving lines of text backward on a wooden block is a risky task because a single slip could ruin the design. A series of devotional designs would be combined into *block books*. Block books are woodcut picture books. Each page is cut from a block of wood and printed as a complete unit. These books were used in religious instruction.

The Printing Press

The availability of paper, the technique of wood block printing, and a growing demand for books, led to the mechanization of the book production process. Central to this procedure was the development of movable type. Produced after 1450 in the Rhineland, this new technique was advanced by Johann Gutenberg. Gutenberg labored for 10 years before his first printing efforts were finally realized It took 20 years before his Gutenberg Bible was published.

Many steps are required in typographic printing because alphabetic systems require exact alignment. First, the style of letter has to be selected. Originally, type styles imitated the calligraphy of the scribes because early printers were competing with calligraphers for business. As a result, the typographic characters used in the Gutenberg Bible are barely distinguishable from the work of a good calligrapher. In the second step, each character in the type style—capital and small letters, numbers, punctuation, and graphic configurations—had to be engraved into the top of a steel bar to make a punch. The third step drove the punch into a matrix of softer copper or brass to make a negative impression of the letterform. The key to this process was the invention of a type mold used for casting individual letters.

Figure 7–1: Illustration of a printing plant. Dover Pictorial Archive Series, "Early Advertising Images." Used with permission.

Metal used for type had to be soft enough to cast but hard enough to tolerate thousands of impressions. After the development of Gutenberg's system, this method of printing was used for over 400 years.

Relief Engraving and Etching

Illustrations were added to typography through the process of relief engraving. In relief engraving, areas are cut away from the surfaces of metal plates or wood blocks and the impression is taken from the remaining surface of the plate or block. To create a design on a copper plate, the design is drawn on the plate with a protective varnish and the rest of the surface is bitten away with acid. The technique of embellishing metal surfaces with engraved pictures began in classical antiquity and continued to be practiced throughout the Middle Ages.

Copperplate *etching* techniques were developed around the same time that Gutenberg was inventing his movable type system. Plates are covered with a prepared "ground," and the artist draws his or her design on the ground with a sharp needle to expose the metal. Acid is applied to the plate and the exposed metal is bitten out. Ink is applied to the plate, and the flat surface of the plate is then wiped clean. The remaining ink in the bitten out sections of the plate creates the image. Paper is placed over the plate and it is run through a press. It is believed that this type of printing developed to imitate the magnificent ornamentation and illustration of medieval manuscript texts. Printed illustrations could be added to typographic pages and hand colored. Dates and initials began to appear on prints and were eventually signed. Early etched prints are associated with local painting styles, which enable historians to identify the geographic origins of the print.

> **Box 7.1:** Case Study: Influence of Illustration
>
> Over the years, there has been a steady growth of the use of illustrations in printed books. Most of these illustrations were created to convey information or express opinions. A small number were also created as decorative elements. According to Ivins (1943), "Very few illustrations are made for the purpose of expressing the illustrator's personality or as works of art" (p. 155). Illustrators create pictures to serve the needs of their employers, the needs of the community, and to explain the text. Although many "fine art" illustrations have been printed, most of these are created using printing techniques that have become obsolete, such as copperplate engraving and lithography. Book illustrations "have always been directed at particular social and intellectual groups, and the customers, pocketbooks, likes and dislikes of those groups have been considered as carefully as possible in the choice of the method of illustration (p. 156). Similar to the printed book, the printed illustration has been directed toward a middle class audience. Consequently, illustrations conformed to middle class tastes and interests. "The illustrated book has only flourished and been produced in large quantities in a bourgeois society" (p. 156).

Newspapers in America

Newspapers first appeared in Europe in the early part of the 17th century. Shortly afterward, printing came to the new world. The first newspaper printed in America was published in 1690 and others followed. In 1729, Benjamin Franklin took charge of the *Pennsylvania Gazette* and incorporated small illustrations into the newspaper to add visual interest. For example, Franklin added miniature 1- to 1 ½-inch stock cuts of sailing vessels engraved on wood to announce cargo shipments. Engraved images were also printed with advertisements for special customers. From these humble beginnings, an entire

group of small pictorial illustrations developed, including books, horses, hats, clocks, and furniture. These miniature illustrations served as an index to identify the contents of the advertising; they were the beginning of commercial advertising art.

There were two types of colonial newspapers: political and commercial. Political newspapers were subsidized by political parties and expressed a particular point of view. They were locally published, and newspapers became the major source of news in America. Early political presses played a vital role in colonial life, and they contributed to the eventual overthrow of British rule. In contrast, commercial presses catered to the leaders of commerce. They published economic articles and reports on cargo shipments from Europe. In commercial newspapers, illustrations identified stores and merchants through recognizable emblems. Emblems included a spinning wheel to mark the dry goods merchant, a mortar and pestle for the druggist, a pair of spectacles or a watch for the jeweler, and an open book for the stationer. Gradually, these thumbnail illustrations grew to sizable proportions, and eventually illustrations began to dominate advertisements.

From the early 1700s to the early 1800s, the readers of newspapers were primarily confined to educated or wealthy men who controlled local politics and commerce. However, a few pioneering women also owned commercial presses. In 1818, John A. Paxton published *Paxton's Philadelphia Annual Advertiser,* a 67 full-page directory with a variety of attractive, well-designed woodcuts of storefronts, carriages, wagons, trunks, shoes, books, pianos, and sundry vignettes. Illustrations were becoming associated with more printed texts.

HAIR-DRESSER. HARDWARE.

Figure 7–2: Early trade cuts. Dover Pictorial Archive Series, "Early Advertising Images." Used with permission.

In the 1820s, technological developments, including the steam-powered press, enabled publishers to produce thousands of newspapers per hour. This led to the development of the Penny Press. In 1833, printer Benjamin Day started the *New York Sun* and cut the price of the newspaper to one penny. The *Sun's* success started a wave of other penny papers that favored human-interest stories. The Penny Press separated the newspaper from overt political viewpoints, and the political subsidy of newspaper publishing was replaced by market-driven newspapers, which received revenues from advertising and newspaper sales.

With the increased use of visual materials in newspapers, artists began to advertise their skills. The first advertisement from a group of commercial artists appeared in 1834 and read as follows:

Ready to receive orders on behalf of the company for engraving in wood, steel and copperplate and for letterpress and copperplate in all its branches. The corporation, having purchased stock and tools of the American Engraving and Printing Company are prepared to execute orders in the best possible manner, with promptness and on

reasonable terms. The Boston Bewick Company, having been established by the artists, and being incorporated by an Act of the Legislature, it is believed they will not only do credit to the name of the "restorer of the Art of Engraving on Wood" (the late Thomas Bewick) but be able to do business to great advantage to their customers and to the public generally…. Orders for Wood cuts, Designs and Drawing, Maps and Charts, Cards of every description, Diplomas and Seals, Copperplate and Xyolgraphic Printing, Book and Job Printing. (cited in Hornung, 1956, p. xiii)

In the 1850s, newspapers began to expand their news coverage by sending journalists to Washington, DC. By the 1860s, over 100 northern journalists had gone south to cover the story of the Civil War. Their reports were relayed back to their home papers via the telegraph. As news coverage grew, newspapers became competitive, and national news turned into a marketable product. The combination of technological advancements (steam-powered presses and the telegraph) and social events (newspaper competition, beginning of the advertising system, and the Civil War) paved the way for modern journalism. Faster printing technology also encouraged the development of literacy skills and public education.

Magazines

As newspapers matured in the United States, magazines also emerged. In the early 1800s, many communities had their own weekly magazines, but much of the material was reprinted from other sources. Originally, these magazines were totally dependent upon the printed word. Specialized magazines were oriented toward particular groups of readers. For example, various denominations published religious magazines. The *Saturday Evening Post* became the first general interest magazine to appeal to a national audience. The introduction of the railroad combined with an improved postal system enabled publishers to distribute magazines across the United States. By 1850, almost 600 magazines were being produced and they began to include colorized illustrations. Drawings, engravings, etchings, and woodcuts became major magazine features. For instance, one magazine employed up to 150 women to color-tint its illustrations, and during the Civil War, *Harper's* magazine published illustrations with their war stories. Magazine readers relied on battlefield sketches to illustrate Civil War events. *Harper's* magazine married visual illustration to the written word and transformed magazines into a popular, national, mass medium. The magazine started a technological and social trend to increase the use of national, visual, imagery and symbols.

THE INDUSTRIAL REVOLUTION AND ITS IMPACT ON VISUAL COMMUNICATION

Simultaneously, as new inventions made publishing easier, culture began to move into modern times. With modernity came the idea of progress and mechanization. Mechanization starts as the transformation of handicrafts into mechanized production. It then progresses into *scientific management* and the assembly line. Finally, mechanization integrates appliances within the process of work itself. The Industrial Revolution marks a major shift in cultural attitudes from ancient to modern times. Giedion (1948) described the differences between the ancient and modern outlook: "The ancients perceived the world as eternally existing and self-renewing, whereas we perceive it as created and existing within temporal limits; that is, the world is determined toward a specific goal and purpose" (p. 30). Rationalism is associated with the belief that the world has a definite purpose. "Rationalism, whether retaining belief in God or not, reaches its ideological peak in thinkers of the latter half of the eighteenth century. Rationalism goes hand in hand with the idea of progress" (p. 30). During the 18th century, the advance of science was associated with the idea of social progress. "In the nineteenth century the creed of progress was raised into a dogma, a dogma given various interpretations in the course of the century" (p. 30).

Progress and mechanization were key ideas of the 19th century's Industrial Revolution, which marked a dramatic shift in social systems. Major industry transformations occurred, including efficient manufacturing centers, the development of inexpensive products designed to make daily life easier, assembly line production, and advertising. Predominant social values associated with the modern period include nationalism, individualism, working efficiently, belief in a rational order, and a rejection of tradition.

During the Industrial Revolution, advanced printing technologies developed that enabled printers to include more visual images. In the first stage of the mechanization of printing, the artist interprets events and prepares illustrations for the printing process. As technologies advance, the photographic image can be directly transmitted through print. The invention of photography alters the image-making process because it can be directly duplicated and transmitted to mass audiences without having artists recreate the image on a printing plate. During the 19th century, many improvements in the printing process contributed to the printing of photographs. Moreover, improved printing technologies nurtured an image revolution that transformed art, illustration, advertising, and visual communication.

Lithography and the Victorian Era

As Queen Victoria ruled Great Britain, the Industrial Revolution swept across Europe and the United States. This period is called the Victorian Era. It was a time of strong moral and religious beliefs. A style of ornamental graphic pictorialism developed during this time, and pictures were influenced by Islamic design and Moorish ornament. *Chromolithography,* an innovation of the Industrial Revolution, was the method used to create thousands of copies of visual images. The images depicted piety, traditional family values, religion, and patriotism. These ideals were expressed through images of children, maidens, puppies, and flowers.

Lithography, or "stone printing," was invented in Germany by Aloys Senefelder (1771–1834) as an inexpensive way to print his own work. Senefelder discovered that by writing with a grease pencil on a flat printing stone, the image could be etched away around the writing and made into a printing plate. Lithography is based upon the mutual incompatibility of grease and water. An image is drawn on a stone with an oil-based crayon or pencil and water is spread over the stone to moisten all of the areas except the oil-based drawing. Afterward, oil-based ink is rolled over the stone that sticks to the image but not to the wet areas of the stone. A sheet of paper is placed over the image, and a press is used to transfer the ink to the paper.

To add color to the process, chromolithography was invented to print in black with flat colors or tints behind it. This technique was used to publish magazine and book illustrations, posters, art prints, greeting cards, and maps. In 1858, Jules Chéret began producing color lithographic designs. He produced posters in Paris using English machinery based on Senefelder's design. Chéret's work used traditional compositions associated with European mural painters. For example, Chéret used the visual imagery of popular folk art to decorate circus programs. His posters bring together a traditional technique with a feel for the popular idiom. Chéret's designs influenced circus and fair advertisements in the United States and England.

Companies became internationally famous for their quality of large prints created for circuses and theatrical events. Label design was another way in which chromolithography was used. Dozens of brand names, such as Comet, Golden Eagle, Crusader, Black Swan, and Tiger, needed graphic interpretation. Fantasy and exotic themes were created to bring drama and character to these early products.

By the middle of the 19th century, signboards and multicolored posters were placed in public spaces to attract the attention of the passersby. Gradually, walls and fences were being turned into typographic collages. Simultaneously, as signboards were integrated into the landscape, more pictures

were published in magazines. In 1850, *Harper's New Monthly Magazine* started a serialized English fictional story with many woodcut illustrations. This monthly magazine was followed by a weekly periodical, *Harper's Weekly,* which was followed by a magazine for women, *Harper's Bazaar. Harper's Weekly* developed a production department to create wood blocks for printing cartoons. Additionally, the publication used graphic reporting based on drawings from artists and correspondents. Thomas Nast was an early artist and correspondent who began his career by making battlefield sketches of the Civil War. After the war, his social and political concerns strongly influenced his drawings and he began to strip away details and introduce symbols to increase the communicative effectiveness of his illustrations. Eventually, Nast became known as the "Father of American Political Cartooning" because he was one of the first people to develop this new type of visual message. Meggs (1983) described the impact of Nast's illustrations as follows:

> The potential of visual communications was demonstrated when Nast took on the governmental corruption of the political boss William Marcy Tweed, who controlled New York politics from infamous Tammany Hall. Tweed exclaimed that he did not care what the papers wrote, because voters couldn't read, but "they could sure see them damn pictures." Nast's relentless graphic attack culminated in an election day, double-page cartoon of the "Tammany tiger" loose in the Roman Coliseum, devouring liberty, while Tweed as the Roman emperor, surrounded by his elected officials, presided over the slaughter. The opposition won the election. (p. 195)

The editors of *Harper's* contributed to the development of pictorial image standards by hiring talented young illustrators who depicted beautiful young women, square-jawed young men, and rural American folk. Illustrators were selected whose work could dominate the routine typographic format and advertising layouts of the day. With these new types of illustrations, the reader's attention was captured by the visual image rather than the printed word.

Integrating Photography into Printed Media

As the Industrial Revolution progressed, photography was being developed. The invention of photography marks a division between the pretechnological and the present era. The ability to record and reproduce images creates new opportunities to document events and transmit them directly to an observer. Artists were no longer needed to reinterpret events. Photography both equaled and challenged the importance of written language.

Starting in the 1840s, images were used more frequently and effectively in editorial and advertising communication because wood-engraved blocks could be locked into a letterpress and printed. However this technique was very costly and a commercial technique of photoengraving needed to be developed. In 1871, John Calvin Moss of New York invented a practical commercial method for photoengraving by transferring line artwork onto metal letterpress plates. "A negative of the original illustration was made on a copy camera suspended from the ceiling by a rope to prevent vibration. In a highly secret process, a negative of the original art was contact printed to a metal plate coated with a light-sensitive gelatin emulsion, then etched with acid" (Meggs, 1983, p. 173). The plate was refined with hand tools and mounted on a type-high block of wood for printing.

Gradually, the development of photoengraving cut the cost and time required to produce printing blocks. In March 1880, the *New York Daily Graphic* published the first reproduction of a photograph with tones in a newspaper. It was printed using a crude *halftone screen* that was developed by Stephen H. Horgan. By breaking the image into a series of small varying sized dots, tones were created because values were simulated by the amount of ink printed in each area of the image. In 1885, this process led to the development of the *halftone process.* Halftone is a term used to describe the intermediate tones between light and dark. The introduction of halftone printing changed the visual appearance of the printed page and integrated photographs with text. As photography became more prevalent, it

replaced illustration as a method of recording actual events. Illustrators turned away from creating factual scenes and began drawing fantasy and fictional imagery.

VISUAL CONVENTIONS AND INFORMATION DESIGN

Over the centuries, the format of books and printed materials has become standardized. The first printed books often imitated the "look and feel" of handwritten manuscripts. As printing developed, new page standards began to emerge. The process of publishing introduced a new capacity to locate textual errors with precision and to simultaneously transmit this information to scattered readers. Thousands of copies of books could now be disseminated without the danger of a copyist's error. Standardization also produced a uniform spatio-temporal design because identical type styles and page ornamentation could be reproduced. Eisenstein (1979) said the following:

> Editorial decisions made by early printers with regard to layout and presentation probably helped to reorganize the thinking of readers...thoughts of readers are guided by the way the contents of books are arranged and presented. Basic changes in book format might well lead to changes in thought-patterns. (pp. 88–89)

Characteristics of Print Media

Eisenstein identified six characteristics of print media: dissemination, standardization, reorganization, data collection, fixity, and amplification. These characteristics can be used to analyze print as a communications medium. The ability of the printing press to made duplicate copies and distribute them across geographic areas led to the cross-fertilization and cross-cultural exchange of ideas. A new

Box 7.2: Case Study: *Life* Magazine

The editors of *Life* magazine understood the importance of packaging a picture story with dynamic images. In the magazine, images were balanced with the right number of words. *Life*'s captions and headline style emphasized clear simple facts selected to guide the reader's interpretations of the evidence shown in the photographs. *Life* became a clearinghouse for pictures depicting major historical events, scientific discoveries, and cultural ideals. *Life* brought this visual information directly into American homes.

According to Heller and Pomeroy (1997), "*Life* magazine was born during a period of sweeping social and political change, and quickly became the eyes and conscience of its continually expanding readership. Few magazines capture the world through such a powerful lens" (p. 53). The other picture magazines of the time, such as *Look* and *Colliers*, could shape the average American's perceptions of the world, nation, and local neighborhoods. "*Life*'s photo essays alternately celebrated individual courage, attacked tyranny, praised technology and science, and focused on the trivial, superficial, and ephemeral sides of life" (p. 53). *Life*'s publisher, Henry R. Luce, described photography as a new and powerful language. He believed that photography was the most important communications medium because it provided an objective view of the world. However, "*Life*'s pictures were mastered and managed by photo editors who saw the importance of manipulating gesture and nuance.... Before television no other medium reached as many individuals at once; and for decades no magazine stamped the collective consciousness with as many indelible images" (p. 53).

knowledge explosion began that stimulated both intellectual and social activities. Readers could be helped by access to road maps, phrase books, conversion tables, and other information aids.

In book design, repeated encounters with the same typestyles, printers' devices, and page ornamentation led to standardized practices in book layout. On a cultural level, "repeated encounters with identical images of couples, representing three social groups: noble, burgher, peasant, wearing distinctive costumes and set against distinctive regional landscapes probably encouraged a sharpened sense of class-divisions and regional groupings" (Eisenstein, 1979, p. 84). This eventually led to the ideas of cultural diversity and stereotyping.

Printed texts reorganized the presentation of information. Reference books were organized on the use of alphabetical order. Systematic cataloging developed to help booksellers organize their products and attract buyers. Indexing and cross-referencing became tools for examining and comparing scholarly ideas. Arabic numbers were used for pagination, and the use of page numbers led to the development of accurate indexing, annotation, and cross-referencing systems.

The duplicative powers of print enabled books to preserve or *fix* information. Preservation is the most important feature of printed texts. To understand the importance of preservation, we need to recall the conditions for saving information before texts could be set in type. "No manuscript, however useful as a reference guide, could be preserved for long without undergoing corruption by copyists, and even this sort of 'preservation' rested precariously on the shifting demands of local elites and a fluctuating incidence of trained scribal labor" (Eisenstein, 1983, p. 78). The fixed nature of printed

Box 7.3: In Her Own Words: Elizabeth Eisenstein

Bio: Elizabeth Eisenstein attended Vassar College and received an MA and PhD from Radcliffe College. Between 1959 and 1974, she taught at the American University in Washington, DC. In 1975, she became the Alice Freeman Palmer Professor of History at the University of Michigan. In 1988, she retired with the title of Professor Emerita. Her book The Printing Press as an Agent of Change (1979), *is considered to be one of the most important works on the importance of print in Western culture.*

Errors in captioning, reversed images, repeated use of identical blocks, made many early printed illustrations seem more like visual hindrances than like visual aids. Crude woodcuts, contained in texts, which ranged from Bibles to botany books, often fell short of faithfully duplicating the handwork of medieval scribes. Ironically, the contempt of sixteenth-century cognoscenti for the barbarous ignorance of early times may have owned something to the clumsy handling of the new medium; a garbled and inferior woodcut could be, all too easily, mistaken for a true artifact of the benighted "dark ages." Whether they served as visual hindrances or furnished visual aids it does seem clear, at all events, that the new forms of book illustration did not simply perpetuate earlier scribal conventions or leave them unperturbed....

Calligraphy had been intertwined with manuscript illustrations. Even where many hands were at work, rubricators and illuminators usually worked over the same texts as did copyists and scribes. But printed illustrations drew on the talents of goldsmiths, woodcarvers and armorers. Such workers did not necessarily have their hands on the pages of the texts at all; nor were always informed about the destination of their products. A middleman—the print publisher—frequently intervened. The frugal custom, already discussed, of reusing a small assortment of blocks and plates to illustrate a wide variety of textual passages also helped to set picture and words at odds with each other. (Eisenstein, 1979, pp. 258–259)

books also led to the standardization of vernacular languages because European languages had to be set in a written form to be published.

The distribution of messages to large audiences reinforced and amplified cultural ideas, literary ideals, and language styles. "A particular kind of reinforcement was involved in relearning mother-tongues when learning to read" (Eisenstein, 1979, p. 127). The formalization of individual European languages led to the development of nationality. People who read and write different languages are different from each other. On a cultural level, ideas of nationality and stereotypes are associated with the use of the printing press as a form of mass communication.

Caricatures and Cartoons

Visual communication can further reinforce stereotypes. For example, cartoons and caricatures exaggerate human attributes. Caricatures are portraits that exaggerate a person's likeness to depict him or her in a humorous way. Cartoons are caricatures or humorous drawings made for reproduction in newspapers or magazines. There are two basic types of cartoons—humorous and political. Humorous cartoons satirize social rules and behavior. They rely on the reader to be aware of social conventions and the reader has to recognize the relationship between the cartoon and the situation. For instance, cartoonists have expressed opinions about the following: political and economic conditions, social mores, employment, domestic life, families and children, and relations between the sexes. Some techniques used by cartoonists include exaggeration and visual puns. Exaggeration of human body parts, such as

Figure 7–3: A Cruikshank political illustration from the 1800s. Author's collection.

elongated noses, big ears, large heads, small bodies, and huge feet, is a typical humorous technique. Exaggeration works best in situations when the exaggerated body part relates to a psychological characteristic of the cartoon character. Another technique applied to cartoons is visual pun. Visual puns work with symbols that often have two or more meanings, for instance, using two or more symbols that have similar or identical images but different meanings.

Unlike other forms of visual media, cartoonists rely heavily on cultural information that is already known to readers. Political cartoons are not always humorous. In contrast, they are created to express a point about a political topic. As a result, cartoon artists can have an impact on the general public because they regularly express a particular view of the world. For example, the creator of the Dilbert series of cartoons shares his attitudes about office life with millions of people every week. The print version of Dilbert is so popular that the characters have been featured in a weekly television program. As a result, millions of people are now exposed to this cartoonist's personal perspective about work. Humorous and political cartoons are visual conventions that develop in print media.

Comics

Comic books have been a popular form of communication that combines images and text into a printed booklet. Scott McCloud (1993, 2000) has written several books that explain the comics process. He defines comics as "juxtaposed pictorial and other images in deliberate sequence, intended to convey information and/or to produce an aesthetic response in the viewer" (McCloud, 1993, p. 20). They have developed their own series of conventions and visual cues that readers understand, for example, a bubble above a character's head indicates the character's spoken language.

New digital tools have influenced comics, like every other form of communication. According to McCloud (2000), there are three aspects of digital cartooning: digital production, digital delivery, and digital comics. In the 1980s, publishers and artists both began to use computers in the design and production of comics. However, as designers start to use new tools for the creation of work, questions about how these new tools will influence the design process are raised. For example, how does the blurring tool affect the reading experience? While, there are questions about computers and comics, computers do open up new opportunities for people to create and design new projects.

Maps and Information Design

Many visual conventions have emerged as the use of print media grew. Representing both three-dimensional and four-dimensional (time) data on a flat surface is a challenge for information designers. They must visually compress a high volume of information into a small amount of flat space. Some standard conventions applied to the visual design of information include microdesign and macrodesign, layering, and color. Edward R. Tufte (1990) said the following:

> High information displays are not only an appropriate and proper complement to human capabilities, but also such designs are frequently optimal. If the visual task is contrast, comparison, and choice—as so often it is—then the more relevant information within eyespan, the better. (p. 50)

Macrodesigns and microdesigns can support local and global comparisons in the display of information. Simultaneously, they provide a way to understand information without switching back and forth between visual and linguistic symbols.

Maps are a good example of how macrodesign and microdesign work. On the microdesign level, a viewer can examine a specific detail of a map. Conversely, a specific location on a map can be viewed in relationship to the total map. Maps enable viewers to select, personalize, and create their own narratives for interpreting the information. Beyond maps, microdesign and macrodesign also apply to

Figure 7-4: Before information design, legibility was not an issue, as illustrated by this old advertisement. Dover Pictorial Archive Series, "Early Advertising Art." Used with permission.

every type of data display, topographic views, and landscape panoramas. These techniques organize complex information by presenting multiple layers of contextual viewing.

Layering is another technique that information designers apply to the organization of visual data. However, effective layering of information can be difficult because, when various elements are collected together, noninformation patterns can emerge. These patterns can distract the viewer from perceiving information. The result can be a confusing and cluttered design. According to Tufte (1990), proper relationships must be developed between information layers: "These visual relationships must be in relevant proportion and in harmony to the substance of the ideas, evidence, and data conveyed" (p. 54). For example, many train schedules are poorly designed because the thickness of the lines separating the names of the train stations can visually conflict with the times printed on the schedule. Consequently, readers find the schedules difficult to read. By using halftones to replace the lines, reading becomes much easier because the printed grid no longer competes with the printed times. Elements of equal value, equal texture, and equal color will not work together as a layering effect. For layering to work, shapes, sizes, values, and colors must be distinctly different. Additionally, negative space can be utilized to separate information. Tufte (1990) stated, "Information consists of *differences that make a difference*" (p. 65).

Another convention that differentiates information in a visual display is color. Color in information design is used to label, measure, represent, and decorate information. Designers must use colors carefully and avoid color-clutter or the circus effect created by using too many different colors that compete with each other for the viewer's attention. For example, bright strong colors need to be used sparingly or between dull background tones. Bright colors next to white tend to result in unpleasant effects. In contrast, color spots placed on a background of light gray or muted colors highlight data while maintaining an overall harmony in the design. Designers are sensitive to differences between the hue, value, and saturation of colors to make sure that the different colors do not compete with each other on a value level. Primary colors and black yield the maximum amount of differentiation between colors. However, the color black should be avoided in large solid elements. Gradations of colors can be used to express deeper or higher visual information, such as sea, land, and depth, or altitude in maps. Additionally, quantities can be visually illustrated with value scales that progress from light to dark.

Colors need to support the representation of time and space in the visual data. Many visual displays are

Mount Vernon	Wakefield E. 233 St	Woodlawn Webster	Tremont Park Ave.	New York
AM	**AM**	**AM**	**AM**	**AM**
12:22	12:24	12:27	12:29	12:39
5:21	5:25	5:28	5:30	5:40
5:51	5:53	5:56	5:58	6:08
6:22	6:24	6:27	6:29	6:39
6:37	6:39	6:42	6:44	6:54
7:34	7:36	7:39	7:41	7:51
7:43	7:45	7:48	7:50	8:00

Mount Vernon	Wakefield E. 233 St	Woodlawn Webster	Tremont Park Ave.	New York
AM	**AM**	**AM**	**AM**	**AM**
12:22	12:24	12:27	12:29	12:39
5:21	5:25	5:28	5:30	5:40
5:51	5:53	5:56	5:58	6:08
6:22	6:24	6:27	6:29	6:39
6:37	6:39	6:42	6:44	6:54
7:34	7:36	7:39	7:41	7:51
7:43	7:45	7:48	7:50	8:00

Figure 7–5: Shaded lines. Author's illustration.

developed to represent narratives of time and space. A simple example people encounter every day is the train schedule. Other types of widely used information displays that represent space are road maps, daily weather charts, and catalogs. Charts can also be easily used to display representations of information over time. For example, most computer spreadsheet programs have chart-making features that enable users to take daily, monthly, and yearly sales figures and show the results in a bar chart or line graph.

Although we encounter many different visual representations of information in our daily lives, most people are not aware of the design conventions applied to the representation of visual data. A key problem facing the information designer is visual clutter. By using the conventions of microdesign and macrodesign, layering, and color, information designers can represent three-dimensional space and events over time on a two-dimensional surface. Tufte (1990) has written a series of books to aid people in the creation of effective visual information design.

Box 7.4: In His Own Words: Marshall McLuhan on Printed Pictorial Statements

Bio: Marshall McLuhan was born in Edmonton, Alberta, Canada, in 1911. From 1946 until his death in 1980, he was a professor at the University of Toronto. Originally, he was a professor of English literature and later became the director of the university's Centre for Culture and Technology. During the 1950s and 1960s, McLuhan made numerous statements about the impact of media on human cognition, society, and culture. The most famous statement is "The medium is the message." In the 1990s, Wired *magazine listed McLuhan as "Patron Saint" on its masthead.*

The art of making pictorial statements in a precise and repeatable form is one that we have long taken for granted in the West. But, it is usually forgotten that without prints and blueprints, without maps and geometry, the world of modern sciences and technologies could hardly exist.

In the time of Ferdinand and Isabella and other maritime monarchs, maps were top secret, like new electronic discoveries today. When the captains returned from their voyages, every effort was made by the officers of the crown to obtain both originals and copies of the maps made during the voyage. The result was a lucrative black-market trade, and secret maps were widely sold. The sort of maps in question had nothing in common with those of later design, being in fact more like diaries of different adventures and experiences…. We are confronted here once more with the basic function of media—to store and to expedite information. Plainly, to store is to expedite, since what is stored is also more accessible than what has to be gathered. The fact that visual information about flowers and plants cannot be sorted verbally also points to the fact that science in the Western world has long been dependent on the visual factor. Nor is this surprising in a literate culture based on the technology of the alphabet, one that reduces even spoken language to a visual mode. As electricity has created multiple non-visual means of storing and retrieving information, not only culture but science also has shifted its entire base and character. (McLuhan, 1964, pp. 145–146)

CULTURAL ISSUES AND DIGITAL MEDIA

Today, we have internalized the format of a printed book so thoroughly that we often forget the symbolic and visual conventions employed in book design. Characteristics identified by Eisenstein can be used to help us understand the ways in which digital texts are different from printed ones. Electronic texts

reverse the feature of permanence associated with the printed word. Because of this reversal, "electronic typography is both creator-controlled and reader-controlled" (Lanham, 1993, p. 4). The screen upon which words appear can be modified, redesigned, and edited. Consequently, original works can be easily changed and adapted by readers. Moreover, works can be copied in entirety or in sections. The ability to change and copy digital documents destablilizes the idea of copyright. "Copyright is a creation of print" (Lanham, 1993, p. 18) that is difficult to protect in digital media. "Electronic information seems to resist ownership" (Lanham, 1993, p. 19). Currently, copyright laws are being discussed and new strategies are developing to protect digital images and texts. For example, one strategy is to place digital watermarks on images to prevent them from being misused. People can copy the image, but the watermark prevents the image from being printed properly.

In contrast to printing's tendency to standardize language, computer screens have the opposite effect. The changing icon to alphabet ratio of electronic pages makes readers pay attention to icons, images, and their relationships to text. David Jay Bolter (1991) described electronic reading as follows: "Readers must move back and forth from the linear presentation of verbal text to the two-dimensional field of electronic picture writing" (p. 71). Readers of digital texts encounter diagrams, illustrations, windows, and icons, which influence the reading process. Digital readers move between a minimum of two different symbol systems: alphabet and pictorial. "Electronic reading includes activating signs by typing and moving the cursor and then making symbolic sense of the motions that their movements produce" (p. 71).

Bolter's characterization of electronic reading describes three types of thinking that occur during the reading process: linguistic, visual, and behavioral. These correspond to Kay's original design methodology that adapts Bruner's three different learning mentalities to computer interfaces. Thus, electronic reading incorporates three modes of representation: "enactive, iconic, and symbolic: the first is related to direct action, the second to models, and the third to symbolic systems" (Olson & Bruner, 1974, p. 132). Consequently, digital texts add visual communication skills to the reading process.

The Digital Revolution and Its Impact on Print Publishing

Digital prepress tools make it easier to prepare materials for traditional print-based publication. Desktop publishing was quickly accepted by the mainstream publishing industries. For example, *USA Today* is designed with desktop publishing software. With this snazzy-looking national newspaper, Gannett seized on the latest technology and used it to create a new style for newspapers based on computer technology. The adoption of desktop publishing by newspaper and publishing industries has led to the development of new technologies for high-end printing. Microprocessor technology used to run desktop publishing software can also be used to build powerful typesetting and layout machines. Computers running sophisticated software from companies, such as Scitex and Hell Graphics, are used to produce high-volume, magazine-quality printing. These sophisticated programs crop images, color balance photographs, and adjust tones. An entire publication can be laid out on the computer screen, stored, and then transmitted for printing.

Software enables newspapers and magazines to create sophisticated graphics on a personal computer system. With the introduction of news-related graphics systems, computer-generated newspaper graphics can be quickly distributed around the country. Gannett, Knight-Ridder, and Chicago's Tribune Co. developed online systems and started marketing their services to other newspapers. These services provide newspapers with graphics in similar ways in which news services provide news stories. For example, in 1987, Associated Press's (AP) access graphics network quickly acquired 150 newspaper clients, and their network was delivering around 10 graphics per day, including stock charts, weather maps, and news-related diagrams. Besides streamlining the prepress process, sophisticated computer

systems also make it easier for newspapers to integrate graphics into their publications. A major change between print and digital media is the integration of new visual symbols into the reading process and the ability to easily integrate visual communication messages into written messages. Thus, digital media support a wider variety of symbol systems than print media.

Zines and Desktop Publishing

Desktop publishing places publishing capabilities in the hands of individuals. This has led to the development of self-created publications distributed to communities of readers. A growing example of this trend is *zines* (short for magazine). Zines are a cross between a newsletter and a magazine. The practice was started by fans of particular television programs and rock groups. Originally zines were called fan-zines, but the introduction of desktop publishing has increased the number of zine publications. Over the past two decades, over 20,000 titles have been created. Zines help to link people together into communities that share common interests.

People who are enthusiastic about a topic, such as a hobby, popular literature, rock music, movies, and popular entertainment, create zines. These publications mirror the interests of distinct groups of people and reflect trends in popular culture. Most zines are not viewed as commercial publications. However, some do charge a subscription fee to pay for publishing and mailing expenses. When zines begin to incorporate higher quality production values, including illustrations, color printing, and high-quality paper, they will become magazines. Some zines are now published on the World Wide Web. However, the popularity of blogs and online journals has now overshadowed the use of zines. For instance, during the Gulf War, many of the imbedded journalists were using blogging techniques to reach their audiences.

Newspapers, Magazines, and the World Wide Web

With the popularity of the World Wide Web, many newspapers and magazines make their content available to readers through the Internet. These include *The Boston Globe, Los Angeles Times, San Jose Mercury News, Chicago Sun Times, The New York Times,* and *USA Today.* Most major newspapers have a web presence and some papers believe that in the future they will be electronically distributed. Information on the web is in a digital format that enables newspapers to use more images and videos on their sites.

In addition to providing content, websites act as a promotional tool for the newspaper or magazine. The websites of *The New York Times* and *The Wall Street Journal* mirror the look of the printed paper in a digital format. The consistent look of the online version of the paper reassures online readers that they are receiving the same quality of news as the printed version of the publication. Online newspapers have found it difficult to charge people money for general information. However, they have discovered that people will pay to buy archived and old articles that are difficult to find. For instance, *The New York Times* has an archive service.

The fast pace of the Internet, with its ability to quickly distribute information on a global level, often requires online newspapers to depend on news services. This practice is starting to change the journalism profession. Moreover, online news sites are often created by people who can both write and design (discussed more in the next chapter). The delivery of news in a web format adds visual communication skills to journalism because stories are presented in a format that uses more visual conventions than print-based media.

SUMMARY

Since the invention of the printing press, a variety of techniques have developed to print images. As printing technologies advanced, images could more easily be integrated with written words. Halftone printing processes enable photographs to be published in newspapers, magazines, and books. Today, the widespread use of digital media integrates visual symbols into the reading process because images and text are now digital. Many newspapers and magazines now make their content available to web readers. This shift adds new visual conventions to the distribution of print-based information.

WEBSITES

- *Online Magazines*
 http://www.businessweek.com/
 http://www.newsweek.com/

- *Online Newspapers*
 http:// www.globe.com/
 http://www.suntimes.com/
 http://www.latimes.com/
 http://www.nytimes.com/
 http://www.usatoday.com/
 http://www.wsj.com/

- *Caricatures and Cartoons*
 http://www.sklomotion.com/cartoons.html
 http://www.learn-to-draw.com/caricature/

- *Comics*
 http://comics.com/

EXERCISES

1. Find a political cartoon in a newspaper. Explain the cultural information that a reader would need to know to understand the humor in the cartoon.

2. Select a magazine and examine the photographs to see how people are represented. Can you find any examples of stereotyping? What types of models are used in the pictures? Are different ethnic groups represented?

3. Compare a printed copy of a newspaper with its digital counterpart. For example, compare *The New York Times* or *USA Today* to the web version of the paper. How is information organized in each version? How is the organization the same? How is it different?

4. Using Eisenstein's characteristics of print-based culture, compare and contrast printed texts to electronic documents distributed through the Internet.

5. Break the class up into small groups of five to six students. Divide the tasks of writing, creating the layout, and printing the zine between group members. Have each group create its own zine about the topic of visual communication. Exchange zines between groups and discuss the results.

KEY TERMS

Block books were created using woodcut designs that included religious subject matter and a brief text. These books were used for religious instruction.

Caricatures are portraits that exaggerate a person's likeness to depict him or her in a humorous way.

Cartoons are caricatures or humorous drawings made for reproduction in newspapers or magazines.

Chromolithography is a lithographic printing process in which inks of various colors are overprinted in exact registration. The end result is a multicolor image.

Codex is an early illustrated book made from vellum (thin, bleached, animal hide) that could be creased without breaking.

Comics are juxtaposed pictorial images in deliberate sequence, intended to convey information and/ or to produce a response in the viewer.

Continuous narration is a style that does not show a single event but rather a sequence of events. The progression in space also becomes a progression in time.

Etching plates are covered with a prepared "ground," and the artist draws his or her design on the ground with a sharp needle to expose the metal. Acid is applied to the plate, and the exposed metal is bitten out. Ink is then applied to the plate, and the flat surface of the plate is wiped clean, leaving the remaining ink in the bitten out sections of the plate to be printed on the paper.

Halftone process is a method for reproducing monochrome drawings or photographs in which the image is cut into minute evenly spaced dots of various sizes. When printed using black ink, the illusion of grays of various tonal values is created.

Halftone screen is a fine grid of ruled lines on a glass plate. When a piece of art or a photographic image is photographed through the plate, the image is broken into tiny black dots. These dots are printed, and the eye blends them together.

Historicism is the use of subservient forms and styles from the past.

Lithography is a printing process using oil-based images applied to flat stone surfaces. The surface is moistened before the image is inked. It works on the principle that oil and water do not mix.

Micro and macro information designs enforce both local and global comparisons and avoid the disruption of context switching.

Penny Press is a term that refers to newspapers sold for one penny and focused on human interest stories.

Photography is a term derived from Greek words that mean "light writing."

Photogravure is a reproduction process that duplicates an image by using continuous tones of the original picture or photograph. The image is broken into dots with a cross-ruled or lined screen and transferred onto a cylinder or plate for printing.

Relief engraving is when areas are cut away from the surfaces of metal plates or wood blocks and the impression is taken from the remaining surface of the plate or block.

Scientific management is an approach that analyzes the work process and the motions of workers in the factory to transform production lines into a more efficient operation.

Watermarks are translucent emblems created by pressure from a raised design on a mold.

Zines (short for magazines) are a cross between a newsletter and a magazine.

☀ The Photographic Image

The invention of photography was the first type of image making that directly challenged the authority of the written word. Photography enables us to make instant pictures of anything that we see. As a result, the image is an actual representation of an event. For example, family photos record birthdays, weddings, vacations, and special moments. If you participated in the event, seeing the picture can help you recall the moment when the photograph was taken. In contrast, if you did not participate, the photograph can be used to help tell a story. Moreover, by capturing a historical or important moment, photography can bridge time and space and enable us to glimpse moments of a past era.

THE INVENTION OF PHOTOGRAPHY

Photography's historical origins begin with the *camera obscura*, Latin for "dark room." The camera obscura is a darkened room or chamber with a small opening or lens in one side. Light rays passing through the opening are projected onto the opposite wall and the rays create a picture of the bright objects outside. Since the time of Aristotle, the camera obscura has helped artists by enabling them to trace sketches of scenes.

Development of the photographic process began around 1802 with the experiments of Thomas Wedgewood and Humphry Davy. They were trying to copy paintings onto glass; however, their method was unable to fix the image. Joseph Niépce developed the next technique. Niépce was a lithographic printer who was seeking a technique for transferring drawings onto printing plates. He coated a pewter sheet with bitumen of Judae (light-sensitive asphalt), which gets hard when it is exposed to the sun. A drawing was oiled to make it transparent, and it was contact printed to the plate with sunlight. The plate was then washed with lavender oil to remove the unhardened sections. Finally, the plate was etched with acid to make an engraved copy of the original. Niépce called this new technique *heliogravure* or sun engraving. This invention marked the beginning of *photogravure*, a reproduction process that duplicates an image by using continuous tones of the original picture.

In 1826, Niépce placed one of his pewter plates on the back of his camera obscura and pointed it out the window to make a picture directly from nature. It took all day for the image to be created, but

Niépce captured a hazy image of the sunlit buildings outside. Louis Daguerre contacted Niépce because he was conducting similar experiments, and they began sharing ideas. Daguerre switched from pewter to a silver-plated copper sheet sensitized by placing it, silver side down, over a container of iodine crystals. The iodine vapor combined with the silver to create light-sensitive silver iodide and the plate was placed on the back of a camera obscura to be exposed to light through a lens. Afterwards, placing the exposed plate over a heated dish of mercury produced the image. The mercury vapors formed an alloy with the exposed sections of silver. Unexposed silver iodide was later removed. A one-of-a-kind image with extraordinary detail was created. This process was modestly called daguerreotype (Greek for "Daguerre's picture"). In 1833, Daguerre presented this new photographic process to the French Academy of Sciences. The French government acquired the daguerreotype process and made it available to the public.

Simultaneously, Englishman William Henry Fox Talbot was pioneering a process that became the basis for both photography and photographic platemaking. Instead of using metal plates, Talbot experimented with paper treated with silver compounds. At first he created images by directly exposing them to the paper. Later, he began to use his treated paper in a camera obscura, which led to the invention of the camera. Talbot's technique was called *calotype* (Greek for "beautiful picture").

Upon hearing about the work of Daguerre and Talbot, the eminent astronomer and chemist Sir John Herschel addressed the problem of how to permanently fix the image. Herschel coined the word photography from Greek words that meant "light writing." However, images created using Herschel's process were reversed. Talbot fixed the reversal problem by contact printing the reversed image to another sheet of sensitized paper. The reversed image was called a negative and the contact print the positive. The use of a negative allowed an image to be reproduced an infinite number of times. In 1844, Talbot (1846) began publishing a book titled *The Pencil of Nature*. It contained 24 photographs mounted into each copy by hand. Opposite the photograph, a text explained the picture and predicted future uses for photography. *The Pencil of Nature* was a landmark book because it was the first book to include photographs. Today it is available at Project Gutenberg.

Early photographic experiments were exhibited at the 1851 Great Exhibition held in London. These images fueled a craze for photography. That same year, Frederick Scott Archer published his formula for the wet-collodion process. This process created glass negatives that could be used to make hundreds of positive prints. Most of the photographs taken during the Civil War used this technique.

THE CIVIL WAR AND THE ORIGINS OF PHOTOJOURNALISM

In the 1860s, Samuel F.B. Morse, inventor of the Morse code, opened the first photography studio in New York City. He taught the photographic process to many people, including Matthew Brady. Brady was one of the first people to use photography as a medium in its own right. Originally, photography was used as an illustrator's tool to capture current events that were later etched or engraved onto printing plates. In April 1865, Brady used his camera to photograph a group of slaves who suddenly found themselves freed by the war. By documenting this historical moment, photography found its role as a new visual medium of communication.

During the Civil War, Brady sent out photographic teams to document every phase of it. Battlefield photographers along with artist's sketches became reference materials for wood engraved magazine and newspaper illustrations. After the photographic documentation of the Civil War, the federal government hired other photographers, such as Tim O'Sullivan, to accompany expeditions into the unexplored western territories. This was the beginning of photojournalism. Photojournalistic images have an authority that is lacking in other forms of image creation. Photographs present factual evi-

dence of an actual event or situation. Through photography, a particular moment captured on film can come to signify a general truth or a historical event. As a result, photography became a form of documentation.

Every photograph freezes an image of something as it appeared at a particular moment in time. By preserving a moment in history, photography enables us to glimpse at the clothing, context, architecture, and lifestyle of a departed era. Fragments of human history, faces, and emotions remain frozen for future generations to view and reflect upon.

Photography also expands the capabilities of human sight. In contrast to the human eye, the camera has no spatial limitations. Cameras can travel to Mars or deep below the sea to capture images of places and things that have never been witnessed by human eyes. Our ideas of outer space are shaped by photographic images. Similarly, photography can reveal the inner spaces of the human body. With the aid of X-rays and computers, the living structure and ills of human anatomy are revealed. Combined with the microscope, photography can record the moment of human conception and record

Figure 8–1: Matthew Brady Studio: Antietam, Maryland. President Lincoln and General George B. McClellan in the general's tent. Photographed by Alexander Gardner. Reference: Civil War photographs, 1861–1865, compiled by Hirst D. Milhollen and Donald H. Mugridge, Washington, DC, Library of Congress, 1977, No. 0144.

events too small for the eye to perceive. By going where the human eye cannot travel and revealing minuscule aspects of life, the camera has become an indispensable tool for exploring the natural world.

PHOTOGRAPHY AND VISUAL LITERACY

A photograph is an image that is captured using a camera and reproduced on a photosensitive surface. Cameras come in a variety of models and sizes, which are expensive (German and Japanese models) and inexpensive (throwaway cameras). The process of traditional photography involves the following steps:

1. Taking a picture with a camera and recording the image on light-sensitive film
2. Developing the film to create a negative (or positive slide image)
3. Making prints from the negative on light-sensitive paper

Once a photograph is completely processed, it becomes a permanent record of the image. Today, photographers have the option of working with traditional photographic equipment or digital technology. Digital cameras are similar to traditional ones because they use light to create images. But instead of using film, digital cameras capture pictures with light-sensitive computer chips. When the chips are struck by light, they emit an electrical charge. A processor inside the camera converts light into a digital image. The image data are then saved in the camera's memory card.

Similar to your eyes, digital cameras capture light intensity or brightness values. Brightness values are collected for the red, green, and blue color spectrums, and each is stored separately in the image

file. Sophisticated image-editing programs, such as Adobe Photoshop, allow photographers to edit the color channels independently to manipulate the image. Once the digital image is completed, it can be printed out on photographic quality paper.

The quality of a digital image depends upon the number of pixels saved in the image data. Pixels, short for picture elements, are the small square dots that make up a digital image. When printed in small sizes, digital images look great. However, when you start to enlarge them, the pixels can become noticeable and appear jagged. Low-end digital cameras only produce smooth-looking pictures in small sizes. The number of pixels per inch saved in image data determines the image resolution. The larger number of pixels stored in an image, the greater the resolution and the better the image quality.

Printer resolution and the quality of the paper will also affect the clarity of the final digital photograph. For high quality pictures, photographic glossy paper stock should be used. Images that are printed using ink, dye, toner, and wax often fade when they are exposed to the sunlight. To protect digital photographs, they need to be framed with UV-protected glass. Currently, digital photographic prints are often not as durable as traditional ones. However, once an image is stored as data, it no longer has to be printed.

Digital photographs can be distributed and shared electronically over the Internet or incorporated into printed layouts and designs. For instance, many photojournalists now work with digital cameras and electronically send images directly to their newspapers and magazines. Digital photography is faster to publish because it does not require any chemical processing. Once an image is received, it can be placed into a prepress program and made ready for printing. In web-based publications, digital photographs can immediately be uploaded to the site for global distribution, such as the social networking site flickr.

Shot, Angle, and Distance

The process of shooting both traditional and digital pictures involves setting up the shot and selecting an angle. The angle is the relationship between the subject and the photographer. Shooting pictures from different angles can convey different meanings. For example, a photograph of a person shown from an angle that "looks up" suggests superiority. In contrast, a photograph of a person shown from a downward angle creates a different effect. Susan Sontag (1977) said:

> In the normal rhetoric of the photographic portrait, facing the camera signifies solemnity, frankness, the disclosure of the subject's essence. That is why frontality seems right for ceremonial pictures (like weddings, graduations) but less apt for photographs used on billboards to advertise political candidates. (p. 38)

Besides the angle, the distance between the camera and the subject can also influence the message transmitted by the photograph. Extremely close shots communicate a personal and intimate message, which conveys insight into the personality of the subject. As the camera moves away, the viewer becomes less and less involved with the subject's personality and more interested in the background. The distances in shots are described as the following:

1. *Extreme close-up.* A shot of a person's face but not his or her entire head.
2. *Close-up.* A shot of a person's face but not his or her body.
3. *Medium shot.* A shot of a person's face and some of their his or her body or torso.
4. *Long shot.* A shot of the entire body and its surrounding background.
5. *Extreme long shot.* A shot showing the person as relatively small; the picture includes the surrounding background.

Composition

The way subjects are placed into compositions is a critical part of the photographic message. Photographers must be aware of both the subject and background. Subjects placed in the center of the

composition are balanced and do not create any visual tension. Photographs can become more visually interesting when the viewer's eye is drawn from one edge of the frame to the other. By selecting an unexpected angle or balancing the subject with the background, the photograph becomes more expressive.

The photographer's eye focuses on a particular subject before taking the picture. Establishing the composition of a traditional photograph occurs during two stages of the photographic process. First, the photographer sets the composition before taking the photograph. Second, the composition can be adjusted during the printing process. Instead of printing the "full frame" of the negative, portions of the negative can be selected and used in the final print.

In contrast to traditional photography, the composition of digital photographs can be adjusted in many ways. For instance, *National Geographic* magazine rearranged the position of an Egyptian pyramid to create a better cover design. Similarly, the photograph used on the cover of *A Day in the Life of America* was electronically altered to turn a horizontal image into a vertical one.

Perspective also dominates the composition of a photograph because the lens has some characteristics of the human eye. A difference between the eye and lens is the wide peripheral vision of the eye, which the camera cannot duplicate. Different camera lenses record a specific range of visual information. For instance, a telephoto lens collapses space like an accordion and allows the photographer to shoot distant images that are difficult for the normal eye to see. Conversely, a wide-angle lens broadens the visual field. No matter what type of lens is used on a camera, a general photographic rule is this: The image should represent space as we perceive it in the real world. Replicating space as we see it makes photographs easier to read and understand.

Color

Photographs can be taken in black-and-white or in color. But, the process of color photography is far more complex than black and white. The largest problem in color photography is controlling and adjusting the colors and their relationships to each other. Colors in nature that represent depth in space may shift on a flat printed surface and be difficult to understand. To compensate for color problems, the color in photographs can be adjusted with lenses that deepen and minimize certain colors. In digital photography, color can be further manipulated with image-editing software. Image-editing software can convert color images to black and white and alter the saturation of different colors within the image. With the use of lenses and digital photography, color becomes another element for photographers to adjust in the image-making process.

Lighting

The lighting conditions recorded on film can influence the mood of the image. Images shot in low or dim light have a mysterious quality. In contrast, pictures captured at noon in bright sun appear healthy and "sunny." However, bright sunshine is not the best lighting for outdoor portraits because it can produce hard shadows and cause people to frown and screw up their faces. On a sunny day, it is better to place the person in the shadow of a building or dense foliage of a tree to eliminate shadows. In contrast, a sunless day creates flat lighting. The best natural lighting for portraits is hazy sunlight because the light is naturally diffused and the person's features will be photographed with good facial modeling.

Background lighting creates a halo of light around the head and shoulders of the subject and separates them from the background. Side lighting creates a harsh or rugged feeling, and silhouettes create an abstract effect. Lighting used in a photograph should complement the situation and convey the appropriate meaning. *Natural lighting* is defined as the available light in the situation being photographed. Natural lighting is light that comes from the sun or indoor lighting sources. In contrast, studio photography uses artificial lighting. Photo-flood bulbs are set on lighting stands and are adjusted in

height and angle to create the right look for the subject being photographed. In location work, many photographs will supplement natural light with an electronic flash.

The Figure and Ground in Photography

Backgrounds, body gestures, and fashion accessories can influence a viewer's interpretation of a photograph. Portraits are taken to try to record the personality of the person. Backgrounds are often used to help define the person's character. For instance, lawyers are often photographed in front of their law libraries, judges against the background of a courtroom, teachers with the backdrop of the blackboard, and nurses in a hospital setting. These backgrounds help to provide a context in which to construct a meaning from the photograph. In many photographs, the figure and background help to define each other.

Photography Genres

There are a variety of photographic genres, including art photos, snapshots, commercial photography, documentary photography, and photojournalism. A genre is a type, category, or format used to classify media content. Some photographers explore the medium of photography from an artistic perspective, but photography has struggled to become a recognized art medium.

At the turn of the century, photography was the perfect means for expressing the modern era. Alfred Stieglitz founded the American school of photography and he became a spokesperson for photography-as-art. Stieglitz published the magazine *Camera Work,* and he exhibited photographs in his New York galleries, where photography was considered equal to painting. During the 1930s and 1940s, photographers responded to the challenges of their times—the horrors of war and the Great Depression. During the Depression, photographers were hired by the Farm Security Administration (FSA) to compile a comprehensive photodocumentary archive of rural American life. Many photographers responded to the social problems that they encountered during their FSA work. For instance, Dorothea Lange's photographs of starving migrant workers were published in news stories. Because of the images, the government sent food to migrant workers and set up relief camps. Lange's photograph, "Migrant Mother" became a symbol of the Depression era.

Besides depicting reality, art photographers use the medium to create fantasy and abstract images. One technique used to create fantasy images is photomontage, which is a technique of cutting out parts of photographs and recombining them into new images. This may have been the beginning of remixing images. Photomontage became popular during the Dadaist movement. Dadaists experimented with eclectic forms of art and believed that changing the order of art could reform the order of experience to change social conditions. Dadaist photomontages use the techniques of cubism to mock artistic and social conventions. These photomontages are imaginative images that attempt to destroy pictorial illusionism. They are the opposite of realistic photographs.

Figure 8–2: Destitute pea-pickers in California. Mother of seven children, age 32. Nipomo, California. Dorothea Lange. March 1936. Library of Congress, Prints and Photographs Division, LC–USF34–9058–C.

In contrast to art photographs, most photographic images that people encounter are either commercial images or photojournalism. Commercial photography is used in advertisements, packaging design, posters, and billboards. In contrast, photojournalism documents events published in print media.

Photojournalism

A photograph used in magazines and newspapers to document events and illustrate news articles is photojournalism. Photojournalism is defined as "a descriptive term for reporting visual information via various media" (Newton, 2001, p. 5). Photojournalism has been playing a larger role in print and other types of media Moreover, the replacement of verbal description with images has been the subject of debate. Some view photojournalists as people whom objectively record significant events. Others argue that photojournalists reflect ideological content in their work. How a photojournalist selects the camera angle and decides when to shoot a picture can influence the interpretation of an image. The page layout and relationship of the photograph to the news story can also sway a reader's understanding of an image.

> **Box 8.1:** Case Study: Violent Photojournalism
>
> During the Vietnam War, photographs that depicted the agony and horrors of war were published regularly in American newspapers. Additionally, video coverage was shown during the evening news broadcasts. Moral outrage against the war forced politicians to rethink their position. As a result of lessons learned during the Vietnam era, images of the Gulf War (1990–1991) were highly monitored by the American military. Instead of showing the impact of the war on the ground, the military distributed images of planes dropping "smart bombs" on targeted buildings. This new technological image of war tended to resemble a video game and replaced the images of human agony photographed during Vietnam.
>
> According to cultural critic John Berger (1980), "It has become normal for certain mass circulation newspapers to publish war photographs which earlier would have been suppressed as being too shocking" (p. 37). This development can be explained by arguing that newspapers have come to realize that many of their readers are already aware of the horrors of war and they want to be shown the truth. Conversely, it could be argued that newspapers believe their readers have become so accustomed to violent images that newspapers now compete with each other to present ever more violent sensationalism. Berger claimed the following: "The first argument is too idealistic and the second too transparently cynical. Newspapers now carry violent war photographs because of their effect, except in rare cases" (p. 38). ("Photographs of Agony" by John Berger, 1980, pp. 37–40.)

Visual Journalism

With the advent of digital media, visual journalism has become a topic in the journalism industries. Visual Journalism is defined as the practice of deliberately combining words and images to communicate information. Harris and Lester (2002) stated that "Visual journalism, or the telling of stories with words, pictures, and designs, has evolved from the individual histories of typography [Chapter 7], graphic design [Chapter 6], information graphics [Chapter 6], photojournalism, motion pictures [Chapter 9], television [Chapter 10], and computers coming together with various print and screen media [Chapter 11]" (p. 11). Visual journalism and multimedia are also changing the education of journalism students.

Network technologies such as the Internet and the proliferation of the World Wide Web (WWW) have inspired training programmes all over the world to develop courses and curricula, or even entire institutes, devoted to

teach and study journalism in a "new media" environment. The literature on the impact of technology on the practice and education of journalists is expanding rapidly. Digital media and, more recently, multimedia newsrooms are transforming the training and education of journalists worldwide. (Deuze, 2004, p. 280)

While the education of the journalist is changing, new types of visual journalism require the reader to be more engaged in the interpretive process. Visual journalism does not have a precise meaning; in contrast, symbols evoke rather than define information.

Moreover, images are arranged to provoke creative thinking.

METHOD FOR ANALYZING PHOTOJOURNALISM

Roland Barthes (1979) developed a connotative and denotative method for understanding photojournalism. The first point to consider in a photojournalistic message is the overall message itself. The second is the source of the photojournalistic message. Magazine and newspaper editorial staffs select the photographs, create the captions, write the titles, and place the images into layouts. The credibility of the source of the message needs to be examined. For instance, we generally consider *The New York Times* to be highly credible. In contrast, images published in the *National Enquirer* are not. In the next step, the motives and attitudes expressed in the image should be connected to the behavior of the people and social situations being shown. For example, a picture of two baseball players jumping up to hug each other, with their fans in the background, conveys the idea of victory. This is appropriate behavior for athletes. However, this would not be acceptable behavior for two world leaders who just signed a peace treaty.

The relationship between the images and words needs to be analyzed. Photojournalism combines visual imagery with linguistic explanations. Barthes (1979) stated that "These two structures are cooperative but, since their units are heterogeneous, necessarily remain separate from one another: here (in the text) the substance of the message is made up of words; there (in the photograph) of lines, surfaces, shades" (p. 189). An analysis of photojournalism must examine these two different structures to understand how they complement one another. The textual message is generally designed to facilitate our understanding of the image's message. Illustrations generally visually support specific ideas expressed in the written article. The text amplifies messages portrayed in the image and the text can be central to our understanding of the image.

The photographic message consists of two messages: connotative and denotative. Connotative messages are always grounded in history and culture. Barthes indicates six aspects of connotation. The first three (trick effects, pose, and objects) are connotations created by the modification of reality itself. The photographer can attempt to conceal the preparation to which the subjects in the scene are recorded. As a result, the spectator needs to look for staged cues and camera angles that are set up rather than spontaneous. The second three aspects are photogenia, aestheticism, and syntax. According to Barthes (1979), "Connotation is not necessarily immediately graspable at the level of the message itself " (p. 191). In contrast, it must be inferred from how an object has been selected, composed, constructed, and treated according to professional, aesthetic, or ideological norms. Moreover, the images must be viewed in terms of how they use traditional cultural signs. The following are six factors that should be considered when you are examining photojournalism:

- *Trick Effects:* Does the photograph use any trick effects? (Trick effects are the artificial bringing together of objects and subjects or the digital manipulation of an image.)
- *Pose:* What type of pose is in the image? Do the eyes, hands, or gestures have any signification that represents an attitude or idea? For example, eyes raised heavenward and hands clasped give the appearance of praying.

- *Objects:* What messages do the objects in the image convey? (Do the proportion, perspective, and color of objects convey particular meaning?) Are the objects posed in any special way? Are they artificially arranged in front of the camera? Do the objects create any associations? For instance, a bookshelf tends to represent the concept of intellectuals. Similarly, images of photo albums tend to be associated with memories.
- *Photogenia:* How is the subject embellished by lighting, exposure, printing, and photo retouching techniques? What information do these techniques convey? For example, the blurring of an object tends to connote the concept of movement and speed.
- *Aestheticism:* What is the aesthetic character and texture of the image? Does it have any compositional, rhetorical, or historical symbols? Does the combination of elements in the photograph create a larger meaning? For instance, many objects utilized in Christian art have specific meanings; however, together, these individual elements convey the overall message of spirituality.
- *Syntax:* Individual objects can create meaning in a photograph. Additionally, several photographs can come together to form a sequence (for instance, an illustrated magazine). Or, two different negatives can be brought together into one picture. When this happens, the connotation is no longer found at the level of any one of the fragments of the sequence but at a larger level of combined association.

A final element of analysis of photojournalism is to examine whether the messages conveyed in the text and image support each other or whether the message changes when we move back and forth between the image and the text. Does the text project a new meaning into the image that is not denoted by the photograph alone? It is only through careful analysis that the full meaning of a photojournalistic image is revealed. In summary, photojournalism must be examined in terms of its overall message, source credibility, behavioral gestures, relationship between text and image, connotative meaning, and denotative meaning.

ADVERTISING PHOTOGRAPHY

The purpose of advertising photography is to evoke meaning in the spectator. These photographs are taken to activate the appropriate response in the spectator by exploiting cultural knowledge and associations. Through association, expensive products, such as a BMW car or designer clothing, become cultural status symbols. Products become associated with successful lifestyles through carefully planned advertising images. For example, parking a car on a dock with a large yacht behind it associates the car with wealth. Or, selecting a successful sports figure to be the spokesperson for a product associates the personality of the sports figure with the product.

Scholars have been critical about the use of advertising photography because these images communicate commercial ideals of consumption. An underlying message communicated through advertising images is the virtue of consuming products. The underlying purpose of advertising photography is to help persuade consumers to buy particular products and services. Because advertising is a form of persuasion, many scholars apply a rhetorical method of analysis to commercial photography.

Rhetorical Analysis

The study of rhetoric goes back to the Greeks and the writings of Aristotle. Written around 330 BC, Aristotle's work *Rhetoric* argues that there are three means of persuasion—ethos, pathos, and logos. Ethos is the nature of the source of information and this aspect of persuasion examines the

credibility of the speaker. For example, advertisements designed to sell aspirin or headache medicine will frequently use doctors and medical studies to convince consumers that the product being advertised is the best one to use. A doctor recommending a medical product is more credible and persuasive than an actor recommending the same product.

Pathos is the emotion of the audience or how the audience is responding to the message. Frequently, advertising messages are tested with consumers to make sure that people reading the advertisement will have the appropriate response to the message. Advertising relies on emotional appeals to persuade consumers. For example, many fashion and perfume advertisements try to make consumers believe that purchasing a particular brand or product will make the consumer feel more secure or attractive.

Logos is the nature of the message presented by the source to the audience. Proof or evidence is essential for a persuasive presentation. Advertisements generally provide some type of evidence or proof to support the claims being made in the advertisement. The proof can be in the visual or verbal message or both. For example, advertisements often use before and after demonstrations. The

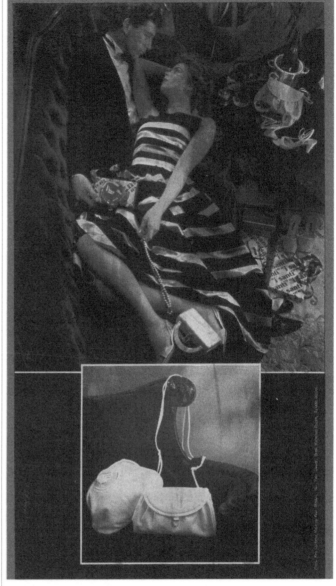

Figure 8–3: Advertising photography.

clothes are dirty. After using the appropriate laundry detergent, the clothes are clean and bright. This type of demonstration is a form of visual persuasion.

Rhetoric is the artful use of language for the purpose of persuasion. In rhetoric, language draws attention to itself to capture and retain the attention of the listener or reader. In both linguistic and visual persuasion, the form of the message is manipulated to engage people's attention and create interest in the content of the message. Advertising messages are deliberately designed and carefully placed to maximize the persuasive effect. Advertising images generally operate on two levels, the literal denotative message and the connotative associations implied by the model, perspective, and objects included in the image.

Some scholars argue that an underlying message in all advertising images is the endorsement and perpetuation of commodity values that are central to capitalist ideology. This perspective has a negative

and highly critical view of advertising. In contrast, others believe that the symbols used in advertising can be taken out of a commodity context and used to create social messages. Disengaged from its commercial function, the rhetorical structure of an advertisement is "indifferent" to the emotional and ideological values the message was originally created to convey. Once advertising elements have been isolated, they can be "recycled" and applied to messages that counter the ones expressed in advertising. For example, a number of publications, such as *Adbusters*, recycle elements of advertisements to create messages that are critical of advertising.

A rhetorical analysis of advertising occurs on three planes: the image plane, the text plane (headline, caption, body-copy), and the plane of the text/image juxtaposition. Models who are selected to appear in advertising photographs generally represent a type of person. The model stands for a class of individuals or a general group. Similarly, families shown in advertising images represent the general category of family. Often, many different stories could be construed from looking at a single advertising photograph. However, the accompanying text directs the reader toward a particular story and specific understanding of the overall message. The role of the text is to explain, develop, and expand the significance of the photograph. However, when the relationship between the text and image is unexpected, a paradoxical situation develops.

Advertising paradoxes are a technique used to involve the spectator with the message. Ambiguous messages are more involving because people need to spend time understanding their meaning. Beyond examining the image plane, the text plane, and the plane of juxtaposition, a rhetorical approach to advertising photography would also consider the presentation of the image, the image itself, and the spectator's reaction to the image.

PHOTOGRAPHY AS A CULTURAL EXPRESSION

As a medium of communication, photography is used on a variety of cultural levels, including personal, economic, informational, journalistic, and social. Today, photography is commonplace, and we encounter photographs in our homes, as we travel to school, and in the magazines that we read. Photography is an endeavor that can be culturally explored in many ways. On a personal level, individuals take photographs to commemorate special moments, such as birthdays, weddings, graduations, vacations, and anniversaries. On an economic level, photography is used by the advertising industries to promote and sell products. From an information perspective, photography is employed to communicate facts, such as evidence in a courtroom setting. In the journalistic context, photographs are a way to report news. On a larger social level, the use of photography often expresses cultural attitudes and ideals.

The Photographer

The term photographer evokes many different meanings. There are professional photographers who make a living taking pictures. Amateur photographers love to take pictures, but they do not necessarily turn this interest into a career. Hobbyists are do-it-yourself photographers who think photography is a fun activity. Most of us have been photographers and have taken snapshots of significant moments in our lives. Photographic subjects are continually vanishing and photographers must be able to shoot a picture at just the right moment. After a subject has vanished, nothing will make it come back. We cannot turn a memory into a photograph. Photographers must seize the moment and capture it on film.

Edward Steichen (1979), director of the photography department for the Museum of Modern Art from 1947 to 1961, made the following comment:

> Good photography in any field becomes alive by virtue of the quality and integrity of the photographer's perception and feeling. When the photographer's emotional reaction is carried through the overall organization of the

image and under the control of an informed intelligence, the resulting photograph takes on the incandescence of truth. (p. 2)

People who are considered good photographers will capture an image that expresses universal human feelings. They will develop a sense for the right moment to shoot a picture and explore different angles of interest to gain the spectator's attention.

The Spectator

When we look at a face in a photograph, it is similar to viewing a face analogous to our own. When we first meet someone face to face, we often busy ourselves constructing an imaginary portrait of the individual. Photographic portraits create a similar type of interest. Spectators of portraits often construct a personality for the subject in the photograph. Therefore, commercial portrait photographers attempt to evoke a congenial and positive reaction from the spectator viewing the subject in the portrait. Portraits are enhanced by clothing, attitude, expression, and lighting, which are all carefully orchestrated to accentuate the personality being portrayed.

Similarly, advertising photography is carefully orchestrated to elicit a very specific response from targeted spectators. Advertisements are designed to make spectators picture themselves in the setting depicted in the photograph. In contrast, snapshots and poorly constructed photographs will not receive very much attention from the spectator. These images often have special significance only for the people involved with the image.

The Subject

Most of us have been the subject of a photograph and we have seen pictures taken of ourselves. For instance, photography is integrated into our activities and identities as members of a family. Photographs taken at birthdays, weddings, and during vacations decorate our homes. In many of these circumstances, we have no control over how we look in the photograph. In contrast, we do have control over our professional portraits. To shoot a good picture, portrait photographers must develop a relationship with the person being photographed. The subject must remain relaxed; otherwise, the personality will hide and the photographer will not be able to capture it with the camera.

In fashion photography, models have no control over the final image selected. As a result, cultural critics have argued that tension is created by fashion models between the concept of self as a subject and the self as an object. In fashion photography, models often become the objects that display the clothes, and their personality is secondary. Moreover, models are in the position of being perpetual spectators of themselves. Stuart Ewen (1988) said:

> Commercial photography—in advertisements, fashion magazines, catalogs—offers visions of perfection which, though lifeless and object-oriented, provide us with models of appearance. For the still camera, the most photogenic subject is one that freezes well, one that can be ripped out of time, suspended, motionless. (p. 85)

The perfect photographic model is a person who can maintain a perpetual smile, whose beauty does not require personal intimacy.

CULTURAL USES OF PHOTOGRAPHY

When cameras first became available in the 1800s, only inventors operated them, and taking photographs had no clear social use. In the 1850s, Henry Fox Talbot established the first photo-processing factory and set the model for the photography industry. Talbot established an economic and ideological relationship between the suppliers of photographic raw materials (cameras, chemicals, film stock,

printing technology, and so on) and their consumers. Today, the consumers of photography fit into several groups—professional, amateur, and snapshot. Products and services have developed to support all these levels of photographic use.

Moreover, global corporations, such as Kodak and Fuji, sell photography products. These companies attempt to set the technical and aesthetic standards of photographic excellence. In Western culture, most of us are both photographer and spectator. Inexpensive cameras, one-hour photography labs, and digital cameras make it easy for anyone to take pictures. Commercial advertising images and photojournalism are prevalent in our daily environments. Besides advertising and photojournalism, photography is also used for information collection. Susan Sontag (1977) said:

> Photographs were enrolled in the service of important institutions of control, notably the family and the police, as symbolic objects and as pieces of information. Thus, in the bureaucratic cataloguing of the world, many important documents are not valid unless they have, affixed to them, a photograph-token of the citizen's face. (pp. 21–22)

Employed by bureaucratic organizations, photographs provide information, and they can be made into an inventory. For instance, meteorologists, coroners, archaeologists, and law enforcement agencies use photography to collect data. Consider how photography is used on drivers' licenses and college identification cards. Moreover, photographic borders create arbitrary frames around an image. This frame separates images and makes them discontinuous from the rest of the world. Frames reinforce a nominalist view of social reality, a view that consists of small units of an infinitive number. According to Sontag (1977), "Through photographs, the world becomes a series of unrelated, freestanding particles; and history, past, and present, a set of anecdotes" (pp. 22–23). Digital facial recognition programs reinforce this idea. Thus, photographs represent only a piece or portion of an entire situation, and they distance themselves from experience.

In advertising, photography is carefully designed with the support of art directors, stylists, and models. Ewen (1988) stated: "From conception to execution, the photograph is carefully distanced from real experience. What is created is an image of a person in which all elements of spontaneity, or of individuality, have been removed" (p. 87). Modesl are turned into generic idealized images of beauty

Box 8.2: In Her Own Words: Susan Sontag

Bio: Susan Sontag was born in 1933. She received an undergraduate degree from the University of Chicago and a master's degree in English literature and philosophy from Harvard. Sontag was an American intellectual who wrote essays on modern culture. Her essays incorporate a philosophical and critical approach to modern subjects, such as photography, theater, and film.

Humankind lingers unregenerately in Plato's cave, still reveling, its age-old habit, in mere images of the truth. But being educated by photographs is not like being educated by older, more artisanal images. For one thing, there are a great many more images around, claiming our attention. The inventory started in 1839 and since then just about everything has been photographed, or so it seems. This very insatiability of the photographing eye changes the terms of confinement in the cave, our world. In teaching us a new visual code, photographs alter and enlarge our notions of what is worth looking at and what we have a right to observe. They are a grammar and, even more importantly, an ethics of seeing. Finally, the most grandiose result of the photographic enterprise is to give us the sense that we can hold the whole world in our heads—as an anthology of images. (Sontag, 1977, pp. 3–4)

and perfection. "Against the flat, clichéd view of reality that they portray in the fashion photograph, all elements of lived experience constitute potential flaws" (p. 89).

Advertising images are idealized versions of reality. In contrast, photojournalism brings the horrors of the world into our homes. War, plane crashes, natural disasters, and tragedy attract people with cameras. After experiencing the catastrophes of the world through photographic images, people are frequently disappointed, surprised, and unmoved when then they see the real thing. Sontag (1999) argued that photographic images "tend to subtract feeling from something we experience at first hand and the feelings they do arouse are, largely, not those we have in real life" (p. 87). As a result, we can become more emotionally disturbed by a photograph than by experiencing the actual event.

Flickr

Social networking sites such as flickr have altered the cultural use of photography. Instead of sharing your photos with friends in a single location, people can now share images with a global community. "Flickr constitutes a 200-million photo sharing system where users participate following a variety of social motivations and themes" (Negoescu & Gatica-Perez, 2008, p. 1). Flickr is a social networking site that enables users to form self-organizing communities. The social nature of flickr creates new opportunities for the image retrieval community. Interactivity and content are the two key features that make this site so popular. Negoescu and Gatica-Perez (2008) described groups in flickr:

> Groups in Flickr are self-organized communities with declared, common interests, and are explicit instantiations of the "content + relations" feature of social media. Groups are created spontaneously but not randomly: people participate in groups (e.g. by sharing pictures) for specific social reasons, and most groups are defined about specific topics or themes (e.g. an event or a photographic style). (p. 1)

The use of social networks to share photographs is a new cultural use of photographs. To make it easier to locate photos, "Flickr supports photo, time and location metadata, as well as a light-weight annotation model" (Kennedy, Naaman, Ahern, Nair & Rattenbury, 2007, p. 1). This is accomplished through the use of tags. Tags are verbal descriptions that users attach to photographs. These descriptions help people locate and organize photographs. "As a cultural phenomena, Billions of images shared on websites such as Flickr serve as a growing record of our culture and environment. Searching, viewing, archiving, and interacting with such collections has broad social and practical importance (Kennedy et al., 2007, p. 1). Now the world can be viewed through the eyes of consumer photographs shared online.

Objectivity and Photography

Although photographs capture realistic moments, the issue of objectivity in photography is a controversial one. Photographers must make decisions that influence the intended meaning associated with an image. Berger (1998) identified six variables that can influence the ways in which viewers interpret photographs:

1. *The viewpoint.* How much distance is between the photographer and the object? What is in the background of the photograph? Where is the photograph taken?
2. *Framing.* What type of balance is used in the photograph? What elements are used in the photograph's composition?
3. *The angle.* Where is the horizon line in the photograph? Is the photograph taken from above? Below? From the side or straight ahead?
4. *Lighting.* What lighting effects are used? Natural sunlight? Studio lighting? High contrast effects?
5. *Focus.* Is the photograph in sharp focus? Is it blurred or slightly out of focus?

6. *The pose.* If a person is the object being photographed, what type of pose is shown? Is the person using any props? What type of facial expression is shown? Does the pose or facial expression convey any particular emotion?

Objectivity is associated with truth in photography. "In media criticism and postmodernism, objectivity is closely linked to the eye witness role in photojournalism and the idea that 'the camera never lies'" (Newton, 2001, p. 8). In digital culture, "objectivity in print journalism does not have the same meaning as it has in visual journalism. Whereas a description of an event may be perfectly balanced, the way it is filmed or graphically animated has different rules and follows a different media logic" (Deuze, 2004, p. 282). Manipulation of images is much easier with digital photography, and thus, it becomes a topic of ethical debate.

DIGITAL IMAGING AND THE CHANGING ROLE OF PHOTOGRAPHY

Photography is often regarded as an objective and realistic record of the visible world. Through the widespread use of photography, we experience many events through mediation rather than through actual experience. Although pictures are considered factual representations, the introduction of digital image technologies enables creators of visual messages to alter reality and show situations that do not exist. For example, advertisers often create impossible visual scenarios to display their products.

Conversely, digital imaging can also provide a more accurate picture of situations that cannot be seen by the human eye. For instance, digital imaging techniques enable us to make pictures of outer space and the inner spaces of the human body. CAT (computerized axial topography) scanners circle the body to produce a three-dimensional model rather than a two-dimensional image. Similarly, MRI (magnetic resonance imaging) scanners formulate a three-dimensional digital model of the human body by placing it in a strong magnet field and detecting variations in the frequency of atomic vibration. These techniques are regularly used in the diagnosis of medical conditions. Besides mapping human conditions, digital imaging is being used to map other planets in our solar system. The Landsat Mulitspectral Scanner System uses a rotating mirror to reflect radiation from the surface of a planet. For example, the Magellan spacecraft was positioned to orbit Venus and systematically scan the planet's surface to collect topographic information. This information was processed to construct a photograph-like digital image.

Beyond scientific investigation, digital imaging has now become a major tool in military defense. During the Gulf War, American forces relied upon digital imaging systems for tactical information because this technology had been incorporated into military weapons systems. Satellite imaging systems did most of the spying and scouting for the attacks and laser-guided bombs had nose cone video cameras that captured information.

Unlike traditional photography and digital photography, digital imaging systems are not dependent upon light as an information source. Ultrasound, radiation, heat, and atomic vibrations can all be recorded with imaging systems. These data can then be processed to create a photographic-like picture that provides specialists with information about situations that cannot be seen with the human eye. As digital imaging technologies advance, their use is being integrated into many social institutions, including entertainment, medical, and the military.

Manipulation

Beyond developing new methods for collecting and visualizing information, digital technology is also being applied to the enhancement of traditional photography. Unlike other media, such as painting, it is inherently difficult to manipulate a traditional photograph. Mitchell (1992) said:

There is no doubt that extensive reworking of photographic images to produce seamless transformations and combinations is technically difficult, time consuming, and outside the mainstream of photographic practice. When we look at photographs we presume, unless we have some clear indications to the contrary, that they have not been reworked. (p. 6)

The traditional photograph's emulsion-coated surface is fragile, and photographers pay particular attention to how they preserve and protect their images for future generations. In contrast, digital systems store information as mathematical data that can be easily manipulated, changed, processed, and combined. Thus, a clear distinction can be made between "handmade" photographs and digital ones. However, when traditional photographs are scanned into digital systems and manipulated, the objectivity and reliability of photography are called into question. Mitchell (1992) stated:

Protagonists of the institutions of journalism, with their interest in being trusted, of the legal system, with their need for provable reliable evidence, and of science, with their foundational faith in the recording instrument, may well fight hard to maintain the hegemony of the standard photographic image. (p. 8)

Digital photography challenges the traditional role of photography in the disciplines of photo-journalism, law, and science because it deconstructs the ideas of photographic objectivity and closure.

Box 8.3: In His Own Words: Fred Ritchin

Bio: Fred Ritchin was the founding director of the photojournalism and documentary photography program at the International Center of Photography. He was also the director of photography for the New York Times Magazine. *He was one of the first people to write and lecture about the impact of digital media on photojournalism.*

Over a hundred and fifty years after its invention, photography is nearly omnipresent, informing virtually every arena of human existence, comparable to the printing press in its impact on the ways in which we view the world. Moreover, due to its mechanical, apparently objective nature and to its near replication of human sight, we often confuse photograph with truth: "The camera does not lie"....That is not the way photographs are read now. Scenes photographed in a straight-forward way are presumed to have contained the people and objects depicted. Unless obviously montaged or otherwise manipulated the photographic attraction resides in a visceral sense that the image mirrors palpable realities. Should photography's relationship to physical existence become suddenly tenuous, its vocabulary would be transformed and its system of representation would have to be reconsidered. (Ritchin, 1990, pp. 1–3)

Reality Versus Fantasy

The introduction of digital imaging technologies calls into question both the authenticity and objectivity of the photography. Simultaneously, while calling into question the credibility of photographs, digital technologies make it easier for artists and photographers to use this medium to visualize fantasy images and manipulate reality.

Throughout the history of photography, photographers have manipulated images to express ideas and alter reality. Dadaist, cubist, and surrealist artists used photomontage techniques during the first half of the century to explore illusionistic paradoxes. Photomontages were also incorporated into poster design and political propaganda.

Today, advertising photographs are regularly altered and retouched. For example, models photographed against plain backgrounds can be placed in front of backgrounds shot at exotic locations.

Skilled artists can carefully combine two digital images to make it appear as if they are a seamless single photograph. This type of image manipulation is now commonplace in our media landscape. As a result, the objectivity of photography is now being challenged.

Ethics

Information about photojournalism ethics has been on the increase since the 1970s. Over the years, a number of books have been written to discuss the issue (Newton, 2001; Gross, Katz, & Ruby, 2003). The manipulation of images by photojournalists is one of the more important issues being discussed. Organizations such as the National Press Photographers Association (NPPA) provide ethical frameworks for newspapers and magazines. In addition, many publications have used the NPPA standards instead of creating their own. One of the key rules is to not digitally alter or manipulate a news photograph. If an image is manipulated, a caption about the manipulation should be published. For example, *Time* magazine published a caption about its digitally manipulated image of O.J. Simpson, but the magazine was still criticized for its use of digital manipulation.

SUMMARY

Photography is a powerful method of image creation because it captures actual events. Most of us have taken photographs, and we are also the subject of photographic images. Many photographs that we encounter are either in the contexts of photojournalism or advertising. Messages expressed in photographs exist on several different levels and they need to be carefully analyzed. As photography becomes increasingly digital, the cultural role of photography is changing. Once considered truthful accounts of actual events, the digital manipulation of photographs is challenging photography's role as a factual document of people, places, and events.

WEBSITES

- *Photography*
 http://www.kodak.com/
 http://photo.net/
 http://www.photographymuseum.com/
 http://www.loc.gov/rr/print/

- *Matthew Brady*
 http://memory.loc.gov/ammem/cwphtml/cwphome.html

- *Dorothea Lange*
 http://metalab.unc.edu/channel/Lange.html

- *Virtual Photography*
 http://googlesightseeing.com/2010/05/virtual-photography-with-google-street-view/

EXERCISES

1. Find photographs that convey the following emotions and concepts: happy, sad, successful, rich, and poor. These photographs can come from a variety of sources, including magazines, photography books, and personal family albums. Explain which characteristics or objects in the photograph convey each particular emotion or idea.

2. Write an essay about a typical day in your life. After writing the essay, create a photo essay that also depicts a typical day in your life. What are the differences between the written and photo essays? Which one do you think more accurately depicts a day in your life?

3. Select a photograph from a newspaper or news magazine. Analyze it using Barthes' approach for examining photojournalism.

4. Select an advertising image from a magazine. Apply a rhetorical approach to understanding the message being conveyed and write a paper that describes the meanings communicated by each rhetorical plane—the image plane, the text plane (headline, caption, body-copy), and the plane of the text/image juxtaposition.

5. The role of photography is changing in contemporary society. Many publications have altered photographic images without informing their readers of the change. Discuss whether it is appropriate to alter photographs in the following contexts:

 ▪ A photograph accompanying a news story
 ▪ A photograph of a scientist who just won a prize
 ▪ A publicity photograph of a movie star
 ▪ A newspaper photograph of an actor at the Academy Awards
 ▪ A photograph of a product in an advertisement
 ▪ A photograph illustrating a magazine story

6. Photography captures a moment in history. Choose a historical photograph and explain the social events surrounding the moment.

KEY TERMS

Digital photography uses a digital camera, a computer, and image-editing software to create photographic quality pictures. It blends the art of photography with the technology of computers.

Ethos is the nature of the source of information.

Genre is a type, category, or format that is used to classify media content.

Image resolution is based on the number of pixels in a digital image. The larger the number of pixels, the greater the resolution and the crisper the image quality.

Logos is the nature of the message presented by the source to the audience and the type of evidence or proof used in the argument.

Natural lighting is defined as the available light in the situation being photographed.

Pathos is the emotion of the audience or how the audience is responding to the message.

Photographs are images represented in the form of a positive print which is shot by a camera (a device with a lens and shutter) and permanently reproduced onto a photo-sensitive paper surface.

Photojournalism is photographs that are used in magazines and newspapers to document events and illustrate news articles.

Photomontage is a technique of cutting out parts of photographs and recombining them into new images.

Pixels is short for picture elements. They are the tiny squares that makeup a digital image.

Rhetoric is the artful use of language for the purpose of persuasion.

☀ Motion Pictures and Film

In its early stage of development, motion pictures were expected to be used the same way as photography—to record physical reality. Currently, film is primarily a form of entertainment. Today's audiences learn to understand film images on a variety of levels, including physiological, psychological, and cultural. Constructing meaning from film is grounded in perception, established through filming and editing techniques, and based on a person's preexisting cultural knowledge.

HISTORY OF FILM

Nineteenth-century inventors developed technologies to capture the pulse of nature through motion studies. Motion studies evolved into the development of moving pictures. In 1860, Étienne Jules Marey invented the sphygmograph to record a human pulse by inscribing the form and frequency of a pulse rate on a smoke-blackened cylinder. Other movement studies included the blood stream, stimulated muscles, the gait of the horse, aquatic animals, and the flight of insects and birds. Eventually, Marey began using photographic plates to record his experiments. Simultaneously, Eadweard Muybridge began his investigation of motion in the United States.

Muybridge started his photography career as an expedition photographer and later settled in San Francisco. Leland Stanford, an entrepreneur of the Central Pacific Railway, commissioned Muybridge to document a trotting horse to find out if a horse lifted all four feet off the ground at once. A $25,000 bet rested on the outcome. Muybridge set up a series of cameras next to each other and each camera captured an isolated phase of the horse's movement. While working on this project, Muybridge became interested in photographing the horse's stride. This led to a series of motion studies of animals and people that was later turned into a reference book for artists.

In the late 1800s, Richard Maddox's invention of a gelatin-bromide dry plate process combined with George Eastman's flexible photographic film set the stage for the creation of motion pictures. Thomas Alva Edison, the inventor of the phonograph, attempted to etch images on his phonograph cylinders to illustrate the music. In 1891, Edison developed the Kinetograph camera and the Kinetoscope peephole viewer that enabled an individual to watch a filmstrip pulled along by the machine. Edison decided

Figure 9–1: Eadweard J. Muybridge's running horse.

viewing moving pictures would be a singular experience. Edison and Dickson made a motion picture called *Fred Ott's Sneeze,* and other pictures followed. They established Kinetoscope arcades and charged customers 25 cents to see early movies of dancers, clowns, and other entertainers. However, Edison's attachment to electricity made his camera large and not easy to move. (*Fred Ott's Sneeze* is available at http://www.archive.org/details/ThomasEdisonCo. FredOttSneeze and also on YouTube.)

Edison patented the Kinetoscope in the United States, but he failed to secure the rights in Europe. Consequently, Robert Paul, an English scientific instrument maker, bought a Kinetograph and made technical improvements to it. Paul added a hand crank to make it more portable. In 1894, Louis and Auguste Lumiére further developed this technology. The Lumiére brothers ran a photographic equipment factory and were hard at work developing a projection system. After purchasing one of Paul's Kinetographs, they invented a camera that could make films and then process and project the movie. They established the 35 mm film size standard for cameras and projectors. In contrast to Edison, the Lumiére brothers thought that large audiences would view motion pictures. Their invention, called the Cinématographe, was soon shortened to the cinema. The Lumière brothers began making movies about a variety of subjects, including workers leaving the factory, a baby enjoying a meal, a young boy teasing a gardener, and a train arriving at a station. After making the films, the Lumiére brothers established the first movie theaters in Paris.

Early films captured daily life in ways similar to photography. For example, the Lumière brothers photographed the ebb and flow of human activity in their first reels, including *Lunch Hour at the Lumière Factory* and *Arrival of a Train.* Audiences were dazzled by their images. In *Arrival of a Train,* a camera was placed on the train platform near the edge of the track. When audiences first saw the film, they screamed and attempted to dodge the image. Erik Barnouw (1983) said, "The use of movement from a distance toward the viewer, and the surprising depth of field in the sequence, offered audiences an experience quite foreign to the theater" (p. 8). (Type "Arrival of a Train" into http://www.youtube. com to see the image.)

The Lumière brothers' films show the crowded character of public places, and they were considered visionaries of this new medium. In contrast to the realism captured by the Lumière brothers, the stage magician Georges Méliès began to specialize in fantasy images. Méliès created illusions by using each frame as a separate unit to animate images by stopping and starting the camera. He combined techniques from both photography and the stage, including the use of masks, multiple exposures, superimposition, and dissolves. His films created cinematic illusions that went beyond theatrical make-believe. For instance, his film *The Haunted Castle* used superimposition for summoning ghosts. Beyond his creativity, Méliès also made contributions to the technical art of filmmaking by developing the first stop-motion special effect, setting up the first film studio with artificial lighting, using time-lapse photography, and creating the first complex multiple exposure with a mask. (Type George Melies into http://www.youtube.com to see his images.)

The films of the Lumière brothers and Méliès can be compared to two different approaches to filmmaking: realism (documentary) and artistic fantasy (fiction). These differences are further illustrated by their approaches to filmmaking. The Lumière Brothers sent their film to shoot the actual coronation of Czar Nicholas. In contrast, Méliès recreated the coronation of Edward VII in his studio.

The Beginnings of the Motion Picture Industries

Moving pictures were invented at the end of the 19th century, and they became an industry in the 20th. By 1910, silent movies were being produced, and actors began to be publicly recognized. In the 1920s, the studio system emerged that applied assembly-line techniques to the filmmaking process. Under this system, stars, directors, writers, editors, and others worked under exclusive contracts for major studios. The system worked so well that each major studio produced a film a week. Films were distributed to vaudeville theaters and shown between live acts. As the demand for films grew, distribution techniques developed. Films were rented to theater operators and marketed in Europe. Film cooperatives began to form and eventually became theater chains.

During both world wars, the United States dominated international film production and distribution because the production of films in other countries was disrupted. Studios organized together under the Motion Picture Export Association of America to promote the export and control of overseas film distribution. Hollywood became the world's largest film production center, drawing money and talent from around the world and away from competing film industries.

FILM AS ARTISTIC EXPRESSION

Motion pictures have been compared to a variety of other artistic forms of expression, including photography, stage drama, and the novel. Similar to photography, film has the concreteness of the image and the ability to record tangible events. Although film has been compared to stage drama, it is different in several significant ways. First, film imagery is not limited by a theatrical stage. Second, film narrative is different from prose narrative. As spectators, we can watch a play our own way and decide where to direct our attention. In contrast, a film's narrative is generally shown from the point of view of the filmmaker. Third, we can see more gestures in a film because actors can act with their face and voice. In most stage productions, voice is the central acting tool because audience members can see only large movements. Monaco (1981) stated, "A film actor, thanks to dubbing, doesn't even require a voice; dialogue can be added later. But the face must be extraordinarily expressive, especially when it is magnified as much as a thousand times in closeups" (p. 33). Finally, film can be shot as raw material and edited into a final format.

Early films recorded stage plays. However, D.W. Griffith, a pioneering filmmaker, abandoned the theater's proscenium arch and moved film in a different direction. Griffith developed the use of expressive lighting and camera angles. He experimented with the dramatic use of intercutting to create visual simile, crosscutting (intercutting and alternating separate narrative plots) as a dramatic tool, and the art of psychological tension by shortening and lengthening the duration of shots. More important, Griffith standardized screen shots (high-angle, close-ups, and long shots) and introduced the use of symbolic juxtaposition. All these techniques contributed to the storytelling aspect of the film and the establishment of film as an artistic medium in its own right. (The film *Birth of a Nation* is available on Google Videos.)

Films can be compared to novels. A difference between novels and films is the way each uses symbolic forms. Novels verbally describe a story, and film pictures the story. However, a similarity exists in the narrative structure used by both. Many novelists and filmmakers often follow the traditional progression of an Aristotelian plot narrative. The action in the plot moves from a state of equilibrium and into rising action. A conflict occurs, and the conflict increases to a climax point, where the conflict must be resolved one way or another. After the climax, the loose ends are tied up, and a new balance is achieved. Cause and effect relationships are established during different sections of the story. The beginning actions influence the middle action, and the middle action leads to the end. However, action must also come from the nature of the characters themselves. The central character becomes the cause of events because the action moves forward as the result of the character's motivation and inner turmoil.

Writing about film in 1916, Hugo Münsterberg observed that the camera parallels mental action. In an early psychological study, Münsterberg (1985) contended the following: "The [film] tells us the human story by overcoming the forms of the outer world namely, space, time and causality, and by adjusting the events to the forms of the inner world, namely, attention, memory, imagination, and emotion" (p. 332). In contrast to staged plays, film removes us further away from physical reality and brings the viewer nearer to the mental world because the mind creates a coherent reality out of the perceptual experience of viewing the film.

Film, Cinema, and Movies

French theorists like to make a distinction between "film" and "cinema." According to James Monaco (1981), "The 'filmic' is that aspect of the art concerning its relationship with the world around it; the 'cinematic' deals strictly with the esthetics and the internal structure of the art" (p. 195). In English, the word "movie" is another label for motion pictures, and this term can be used as a convenient label for the economic function of the motion picture industry. Three different terms are applied to motion pictures: movies, cinema, and film. Similar to popcorn, "movies" are created to be consumed. In America, the term "cinema" refers to high art, and it suggests aesthetics. The term "film" is the most general term with the fewest connotations.

Historically, cinema has been applied to two different general purposes: documentary and fiction. Gene Youngblood (1970) described fictional cinema as follows: "A theatrical-based fiction film deals with a prestylized reality distilled and recorded through the personality of the writer, then visualized by the director, crew, and actors according to certain schemata" (p. 106). Emphasis is placed here on the idea that film is not an objective reality and the making of a film involves many different people. Some documentary films can be considered stylized reality because the filmmaker shifts and reorganizes unstylized material into a narrative form that explains the reality. In contrast, other documentary filmmakers attempt to achieve cinematic realism by "capturing and preserving a picture of time as perceived through unstylized events" (p. 107). The primary difference here is between setting up shots for a film or shooting the natural environment.

THE LANGUAGE OF FILM

Film critics and scholars have compared film to language. Christian Metz (1985) said the study of cinematographic expressiveness can be conducted in ways that are similar to methods derived from linguistics. One reason this can occur is that cinematographic language revolves around the literalness of a plot. Films are put together in a cohesive manner to enable audiences to understand them.

Early books about film attempted to compare film to written and spoken language. For instance, standard theories suggest that the shot be the "word" of film, the scene the sentence, and a sequence of scenes a paragraph. These divisions are arranged in an ascending order of complexity. However, these divisions break down under analysis because a shot has many more elements involved with its interpretation than a word. Unlike a word, each single image is composed of a tremendous amount of visual information. As a result, a film cannot be easily broken up into manageable units that resemble written and spoken language because the denotative and connotative meanings associated with cinematic images can be interpreted in many more ways. Monaco (1981) said, "The reader of a page invents the image, the reader of a film does not, yet both readers must work to interpret the signs they perceive in order to complete the process of intellection" (p. 128).

Although film cannot be directly compared to spoken and written language, it has developed its own form of systematic and cinematic rules. The syntax of film has emerged from the practice of film. Film syntax includes spatial composition or putting the scene together (also called mise-en-scène), time or montage, and the tension between spatial composition and time. After the film is photographed, the filmmaker combines shots together to expresses meaning. Meanings are expressed on three different levels: cultural, artistic, and cinematic.

Culturally derived meanings exist outside the medium, and filmmakers only reproduce them, for instance, as in the ways in which people dress, eat, and behave. Other visual meanings originated in different art forms; for example, gesture is shared with theater. Spatial arrangements can be compared to painting and photography. Artistic meanings developed in the other visual arts can be applied to film. However, the use of montage is unique to film itself. Montage creates cinematic meaning through its ability to switch back and forth between scenes in ways that would be difficult in other media.

Sergei Eisenstein (1949) said that an important feature of film is montage: "Photo-fragments of nature are recorded [then] these fragments are combined in various ways" (p. 3). The earliest filmmakers often regarded montage as the means of placing single shots one after the other like building blocks. The length of the individual pieces established the rhythm for the film. However, in Eisenstein's opinion, montage is a concept that emerges "from the collision of independent shots—shots even opposite to one another" (p. 49). (Sergei Eisenstein's work is available on Google Videos.)

Eisenstein (1949) used the example of a murder to illustrate how film montage works. Shot in one montage-piece, a murder functions as information. However, emotional effects begin to emerge with the reconstruction of the event in montage fragments because associations develop:

1. A hand lifts a knife.
2. The eyes of the victim open suddenly.
3. His hands clutch the table.
4. The knife is jerked up.
5. The eyes blink involuntarily.
6. Blood gushes.
7. A mouth shrieks.
8. Something drips onto a shoe…. (p. 60)

Alone, these fragments are abstract. Combined, they convey an action. Eisenstein's approach to filmmaking deliberately juxtaposed images to create perceptual dissonance, which engaged the audience in the meaning-making process. His work was inspired by Japanese ideograms, and he avoided narrative continuity in favor of a tension between images in time, space, shape, and rhythm. Eisenstein's images were set in counterpoint to force the viewer to derive meaning from conflicting visuals. From Eisenstein's perspective, film is grounded in conflict, which is resolved in the viewer's mind as a completed gestalt. His films use dynamic visual rhetoric that jolts the viewer into an emotional and cognitive experience. In contrast, Hollywood films often lead the viewer through a linear and fluid emotional experience that moves toward a conclusion.

Box 9.1: Case Study: Psycho and Film Codes

In his book *How to Read a Film,* James Monaco (1981) used the movie *Psycho* to illustrate how codes, rules, and identifiable objects operate in film. In the famous *Psycho* shower scene, two barely seen characters are involved in two actions: taking a shower and a murder. In the short duration of this scene, three types of codes are evident: cultural, artistic, and cinematic. "The culturally derived codes have to do with taking showers and murdering people. The shower is in Western culture, an activity that has elements of privacy, sexuality, purgation, relaxation, openness, and regeneration" (p. 147). Hitchcock selected an ironic place to highlight violation and sexual assault. "Murder, on the other hand, fascinates us because of motives. Yet the dimly perceived murderer of *Psycho* has no discernible motive. The act seems gratuitous, almost absurd—which makes it even more striking" (p. 147). The scene is highly cinematic and short. The acting codes play a minor role because of their brevity. Diagonals are important in establishing a feeling of disorientation, and they are a visual element shared with other visual media. "The harsh contrasts and backlighting, which obscure the murderer, are shared with photography" (p. 148). (The shower scene is available on Google Videos.)

The Frame

Film illusion is created through the combination of photography and movement. Frames move past the projector lens at the speed of 24 frames per second, and the difference between frames combined with the speed of projection create the illusion of movement. There are two visual considerations about the frame that need to be considered: (a) the limitations imposed by the frame and (b) the composition within the frame. Film frames are shot in different sizes. The Academy aperture has a 1.33 ratio. In contrast, Cinemascope and Panavision have width ratios of 2.33 and above. A smaller screen size will often focus on the speaker and listener within the frame. Conversely, the wider ratios include the space between characters and the space surrounding them. Filmmakers can change the dimensions of the frame during the shooting process by masking parts of the composition.

When the audience is aware of the area outside the frame, it is considered "open." Conversely, when the image within the frame is self-sufficient, it is called "closed." With the exception of animation, the geographical plane influences composition within the frame. The perception of depth and perspective used in the frame is an important element in the image. Camera lenses, overlapping objects, convergence, relative size, and gradient densities create depth and perspective. All these elements contribute to the illusion of three-dimensional space.

Aumont (1994) identified five functions for the frame: visual, economic, symbolic, narrative, and rhetorical. The visual function separates the image from the physical environment. The frame iso-

lates the visual field to heighten its perception, creating a distinction between inside and out. Elements within the frame are arranged into a composition. Additionally, frames associated with paintings can have an economic function because skillfully made picture frames gilt with gold become visible signifiers of the value of a painting. On a symbolic level, frames show an image area that a spectator should pay attention to. In contemporary culture, many different types of images are framed, including paintings, photographs, television pictures, and data displayed on a computer screen. However, the symbolic function of a frame can change. For instance, television images framed within the interior of a home often establish a personalized or conversational status for the medium. In contrast, frames or windows used on the computer screen separate information spaces.

In Renaissance painting, the frame is considered a "window on the world." The edges of the image are the limits of the image. However, the edges of a frame also build a connection between the interior of the image and its imaginary extension outside the frame. For example, the cinematographer must be aware of both the compositions within the frame and the con-

Figure 9–2: Sandro Botticelli, *Madonna of the Euchrist.* Botticelli's painting is a "window on the world." Dover Electronic Clip Art Series, "120 Italian Renaissance Paintings." Used with permission.

nections outside. Frames also have a rhetorical function because in certain contexts, the frame can be understood as "making a statement." For instance, film directors can animate a frame by rotating it on its axis or through vigorous trembling. These movements express visible forms of emotion, such as a disorienting atmosphere or a character's sense of extreme disturbance.

Space and Time Relationships in Film

Individual frames are combined into a shot. A shot is a continuous picture in which there are no cuts or edits. Shots can be as short as 1/24 of a second or as long as the entire film. Static shots occur when the camera does not move. In contrast, dynamic shots include camera and lens movement. These movements add rhythm and flow to a scene. Film images easily portray a sense of space, and moving from point to point in space conveys time.

Space Relationships—Shots

Spatial relationships are important within shots. Deep focus is a term that refers to the large depth of field in which objects and actors are in clear focus. Clarity creates realism in a scene. In contrast, shallow focus is having a small part of the image in focus. Obviously, this type of shot directs the viewer's attention to the image in focus. According to André Bazin (1967), depth of field helps to shape the ways in which audience members interpret films. He analyzes depth of field in three ways: the

relationship between the image and spectator, the active mental attitude of the shot, and the meaning of the dramatic event (see Box 9.2).

Box 9.2: In His Own Words: André Bazin

Bio: André Bazin was born in France in 1918. In 1951, Bazin founded the quarterly journal Cahiers du Cinema, *a publication devoted to the study of the art of motion pictures. Bazin's criticisms of film inspired the development of the underground film movement, which included French New Wave directors Jean-Luc Godard and Francois Truffaut. Bazin helped to advance the theory of director-as-author or Auteur Theory, which asserts the director of a film should be considered its author. Directors oversee all of the audio and visual elements, and they play a larger role in the visual aspects of a film than the screenplay writer.*

It would lie outside the scope of this article to analyze the psychological modalities of these relations [montage and depth of field], as also their aesthetic consequences, but it might be enough here to note, in general terms:

1. That depth of focus brings the spectator into a relation with the image closer to that which he enjoys with reality. Therefore it is correct to say that, independently of the contents of the image, its structure is more realistic;

2. That it implies, consequently, both a more active mental attitude on the part of the spectator and a more positive contribution on his part to the action in progress. While analytical montage only calls for him to follow his guide, to let his attention follow along smoothly with that of the director who will choose what he should see, here he is called upon to exercise at least a minimum of personal choice. It is from his attention and his will that the meaning of the image in part derives.

3. From the two preceding propositions, which belong to the realm of psychology, there follows a third, which may be described as metaphysical. In analyzing reality, montage presupposes of its very nature the unity of meaning of the dramatic event. (Bazin, 1967, pp. 35–36)

Time Relationships—Film Editing

Editing shapes the rhythm of the film. Messaris (1994) said the following:

> The viewer's interpretation of edited sequences is largely a matter of cross-referencing possible interpretations against a broader context (i.e., the larger story in the movie itself), together with corresponding situations from real life and other movies rather than a matter of 'decoding' formal devices (e.g., an off-screen look followed by a cut to a new shot). (p. 76)

He argued that interpretation is driven by the narrative context of the film, instead of individual elements. This especially applies to viewers who have developed interpretative viewing habits from watching Hollywood movies because viewers interpret the film based on seeing previous Hollywood films.

Point-of-view editing attempts to keep the viewer consistently on one side of the action and interaction. For instance, in a conversation scene, the character on the left side of the screen should remain on the left and the character on the right side should stay on the right from shot to shot. Similarly, "if two people having a conversation are shot in individual close-ups, their lines of sight should intersect (i.e., one should look left the other right); in an action sequence, a movement that unfolds from left to right in one shot should preserve this direction in the next shot" (Messaris, 1994, p. 78). In contrast,

propositional editing involves the cross-cutting between two different images or image categories. Viewers must interpret the juxtaposed images in ways that are consistent with a textual reader's interpretation of analogy, contrast, or causality.

A sequence of edited scenes can create a sense of time passing. To show the passage of long periods, filmmakers will often place a title on the screen that says "five years later" or "two months later," and so forth. Visual devices, such as showing pages of a calendar quickly tearing off or the hands of a clock spinning, have also been used to show the passage of time.

Camera Movement

Unlike still photography, motion picture cameras capture images in time. Some early films simply record stage plays with a fixed camera as they occurred in real time. In contrast, other early filmmakers began to experiment with camera movement. For example, cameras were placed on moving objects, such as cars and boats. As equipment became lighter, cameras were placed on a dolly or crane.

In *The Birth of a Nation,* Griffith made the camera move to anticipate the ways in which the mind encounters actual experience. Today, new technologies such as the steady cam allow the cameraperson to hold the camera and move it around more smoothly. Worn on a harness, the steady cam enables the cameraperson to create the impression of eye movement.

Horizontal camera movements to the left or right are called pans. During a pan, the camera tripod remains motionless while the camera itself is pivoted. Pans capture small gestures made by the actors. Horizontal movements are created with a truck in which both the camera and tripod move. This technique is required for capturing walking or running scenes with actors. Vertical camera movement is called a tilt. More complicated shots are tracking or crane shots. They involve placing the camera on a crane and making long sweeping movements. In this type of shot, the audience becomes very aware of the camera movement. Other large camera movements include a roll, which flips around an image of a person, an object, or a scene. Rolls and flips can disorient or surprise the viewer.

Direct documentary cinema uses a minimal amount of camera movements. In contrast, cinema verité or truthful camera uses more movement, including hand-held cameras. A handheld camera is a highly subjective technique that involves the viewer in the action. This technique was used to film *The Blair Witch Project* (1999) to involve audience members and create a feeling of reality. The unsteady, jerky qualities of the camera movements suggest that someone who just happened to have a camera captured the scenes. Promotion for the film attempted to convey the idea that the movie was showing an actual event, rather than a low-budget fictional movie. (Trailers for *The Blair Witch Project* are on Google Video.)

Camera movement can also be created with the camera lens. Moving the lens slowly on a subject is called a zoom shot. Zooms have the effect of intensifying the image. For example, a zoom shot enables the filmmaker to focus the audience's attention on a particular person or reveal something to the audience. Additionally, zoom shots make the audience feel more involved with the action. Conversely, a reverse zoom moves away from a person or an object to convey the opposite emotion. Using a zoom-out movement at the end of a film is a cue that the film is over.

Film and Sound

Silent films could be shot on location without paying attention to the noise on the set. When sound was added, the needs of the sound stage brought film indoors. As a result, camera movement became more static. In the shift from silent to talking films, a dichotomy appeared between visual actions grounded in experience and abstract ideas expressed through speech. Film narrative was now driven by dialogue and sometimes voice-over. In talking films, the sound becomes as equally important as

the images. During production, both the sound and the picture are recorded linearly and edited later in postproduction.

Sound effects have always been important to filmmakers. Early silent films attempted to simulate sound effects by showing the mechanism from which the sound originated. For instance, a close-up shot of a factory whistle blowing created an association between the image and sound. Today, digital audio systems have revolutionized sound effects. Audio tracks can be created to track natural sounds and actions, for example, the sound of a bullet being fired in a confined space. Digital audio technologies enable filmmakers to create entirely new and ultrarealistic sound effects. Dozens of different tracks can be digitally mastered and synchronized with the film image. For example, the film *Back to the Future* used 11 sound tracks to heighten the movie experience.

Voice-over narratives, spoken dialogue, and sound effects are integral to filmmaking. Another important feature is music. Silent films were generally accompanied with live music. Monaco (1981) stated the following:

> Music has quickly become an integral part of the film experience; silent films were normally "performed" with live music. "Experimental filmmakers of the silent period were already discovering the musical of the image itself. By the late 1930s Sergei Eisenstein, for his film *Alexander Nevsky,* constructed an elaborate scheme to correlate the visual images with the score by the noted composer Prokofiev. In this film as in a number of others, such as Stanley Kubrick's *2001: A Space Odyssey* (1968), music often determines images. (p. 39) (Scenes from *2001: A Space Odyssey* are available on Google Videos.)

The type of music selected to accompany a visual image can influence the viewer's interpretation of a scene. Sad, moody music conveys an unhappy meaning. Conversely, light, upbeat music means the opposite. Most films have musical scores written to accompany their visual imagery that help to set the mood of the film.

Lighting and Color

An important tool used by the filmmaker to convey meaning is lighting. Eisenstein (1949) described the theory of lighting in film as a "collision between a stream of light and an obstacle, like the impact of a stream from a fire-hose striking a concrete object, or the wind buffeting a human figure" (p. 40). Lighting is especially important when filming in black and white because it is dependent upon contrast and tone for the relative darkness and lightness of the image. High contrast images use extreme values, and the range of gray is very limited. Conversely, low contrast images do not use pure blacks or whites, and tones of gray dominate the picture.

Contrast, tone, and exposure range are central factors in film lighting. Until recently, when using color film, the filmmaker had limited lighting parameters in which to illuminate the subject because color film stock is balanced for a particular type of light source. For instance, color stock balanced for 6000°K (the color temperature of an overcast sky) will produce an irritating orange picture if used with standard incandescent light.

A classical Hollywood cinematographic style is to use natural effects. As a result, Hollywood developed a system of lighting that uses balanced key lights with fill lights. This system supported a style of highlight levels with carefully balanced fill lighting. Similar to still photography, full front lighting can washes out the subject, backlighting highlights the subject, side-lighting creates a dramatic chiaroscuro effect, and lighting from below creates a melancholy appearance.

Lighting can also orient the viewer to time. Daytime is generally very bright, and lighting at night is darker. In a daytime scene, everything is illuminated; in contrast, nighttime lighting is more selective. Additionally, the use of cast shadows can be used to show the time of day. For example, long shadows signify the early morning and late afternoon. In contrast, short shadows characterize high noon.

Box 9.3: In His Own Words: Nestor Almendros

Bio: Nestor Almendros was born in 1930 in Barcelona, Spain. In 1948, he emigrated from Spain to Cuba, where he worked for several years and made amateur films. After the Cuban revolution, he worked on several documentaries about the early Castro years. In 1961, Almendros moved to France, where he made film shorts and worked in television. Almendros received two Oscars from the Academy of Motion Picture Arts and Sciences for best cinematography for Days of Heaven *(1978) and* The Blue Lagoon *(1979). In the following passage, Almendros discusses his source of inspiration for the film* The Blue Lagoon:*

One should remember that when people go to the movies, they don't want to feel as if they are in a museum. The images must not overwhelm the work. Pictorial references must serve only as guides; some are unconscious, of course, since each person is himself and his circumstances, but others are voluntary, deliberate. The first sources for *The Blue Lagoon* were the symbolist painters who were contemporaries of Henry DeVere Stacpoole's original novel. But it did not take long for me to go almost inevitably toward one of these painters, namely Gauguin.

There are a few painters from the past that are always helpful to me because they used light to give a three-dimensional feeling to their figures. As I've said before, they are Vermeer for daytime interiors and La Tour for night interiors that are lighted by the luminous source of a flame. To these I must add Rembrandt and Caravaggio for effects of chiaroscuro, and Manet, Renoir, and other Impressionists for day exteriors. The problem in this case was that all of these painters except one—Gauguin—had worked in Europe, and had painted interiors and landscapes completely unlike those in the South Pacific, where *The Blue Lagoon* takes place. Their examples were of no use to me here. And Gauguin was only partially useful, because he is not a painter of light. His work has wide areas of color, shapes, and lines, forcibly harmonized within the frame, but he concedes very little importance to light. So I had to combine Gauguin's shapes and colors with the lighting of earlier masters. (1984, pp. 239–241) (Scenes from *The Blue Lagoon* are available on Google Videos.)

Black-and-White Film and Color Film

Films can be shot in black and white, color, or a combination of both. Today, film can be tinted or colorized because digital techniques can convert black-and-white movies into color ones. However, this is a controversial topic because colorization alters the director's original vision for the film. Old black-and-white films are colorized to appeal to television viewers who are accustomed to watching color films.

In both photography and film, the use of black and white often is used to show the emotionality of internal mental states. In contrast, color often stresses the surfaces of the setting, costumes, and emotion. Today's color-oriented audiences may feel sensually deprived when viewing a black and white film. Because modern audiences often prefer color films, filmmakers, such as Tim Burton, use lighting and special effects in their color films to create the impression of the drab physical and psychological landscapes of black-and-white photography. For instance, Burton's film *Sleepy Hollow* (1999) is a color film that appears to be black and white in scenes.

Other films combine black and white and color film together. In 1939, *The Wizard of Oz* used this combined approach. The use of two different types of film highlighted the contrast between the fantasy world of Oz and the real world of Kansas. For many years, audiences have preferred color films, but some directors choose to shoot their films in black and white. For example, Martin Scorsese's *Raging Bull,* the story of a boxer, and Woody Allen's *Manhattan,* are black-and-white films.

Special Effects

Since its early beginnings, special effects have been integrated into film. For example, *King Kong* (1933) delighted audiences and broke box office records. The beast itself was an 18-inch armature covered with latex, rubber, cotton, and rabbit pelts. Using the techniques of rear projection, stop-action animation, and frontal glass screens, the film created life-like scenes. Stanley Kubrick's *2001: A Space Odyssey* uses multiple images photographed at different times merged into a single image to create dazzling visual effects. Masking out sections of film frames and combining them is a technique used in many movies.

Three characteristics of filmmaking contribute to special effects: (a) Film does not have to be shot continuously because frames can be photographed separately, (b) paintings and models can be photographed in realistic ways, and (c) images can be combined. A simple type of special effect technique is the glass shot. A piece of glass is placed several feet in front of the camera with the area of the scene that must be changed painted over. Talented painters can create very realistic effects with this simple technique. Another popular technique is rear-view projection. In many older films, backgrounds were projected onto a screen behind the actors. For example, thousands of Hollywood taxi rides were filmed this way. However, this technique is difficult with color film because the amount of light required to shoot in color will wash out the image projected on the background screen. With color film, blue screens can be used to add backgrounds in the editing process. For example, the *Star Wars* series (1977-on) combines small models filmed in high speed against a blue screen with optical effects, mechanical effects, and animation.

Animation

In contrast to realistic special effects, cartoon animation is created with the cell technique. Various sections of the cartoon are drawn on separate transparent cells positioned together. However, the production of 10 minutes of animated film requires approximately 14,400 separate drawings. Thus, animation is a time-consuming method of filmmaking. Digital techniques have been developed to help automate the animation process. With today's digital technology, animation can be combined with live action photography to make it appear as if real actors are interacting with animated characters, for example, *Space Jam* and *Who Framed Roger Rabbit?*

FILM GENRES

Many film genres have developed since the invention of moving pictures. A genre is a format or category of media content. Genres use the same formulas for narrative, images, settings, characters, music, plots, and effects. For instance, science fiction is a genre that uses elaborate computer-generated special effects. Fictional film genres include westerns, gangster films, detective dramas, screwball comedies, film noir, musicals, war films, horror films, science fiction, fantasy, and thrillers. Historically, many classic films helped to set the genre formulas.

Analyzing different genres is one approach to film criticism and theory. The study of individual film genres examines the shared surface conventions of plot and iconography across a group of films belonging to the same genre. However, with the influence of semiotics, psychoanalysis, and feminist film theory that focus on the underlying codes or structural oppositions found in a film, genre theory has lost its popularity.

Besides film criticism, genre is also a way for filmmakers to describe their films for market distribution. Audiences are aware of different styles of genre. For example, the pattern of the classic western

is so firmly fixed that viewers must appreciate the minor variations in the characteristics of the actors who play the role of the hero.

Another well-know genre is film noir. It is a style of detective and mystery film that was popular during the 1940s. Film noir is characterized by it use of chiaroscuro light that creates the overall effect of loneliness, alienation, and pessimism. Noir films include *The Maltese Falcon* (1941), *Double Indemnity* (1944), *The Blue Dahlia* (1946), and *The Asphalt Jungle* (1950). Frequently, the theme of these films revolves around greed, lust, violence, and fear. Many noir scenes were shot in dim back alleys or cheap hotel rooms. Menacing angles, elongated shadows, and severe camera angles were also used to heighten the suspense of the film and evoke strangeness or discomfort. Noir filmmakers often shot their films in black and white to achieve an intense dramatic feeling. (Type "film noir" into Google Videos for examples.)

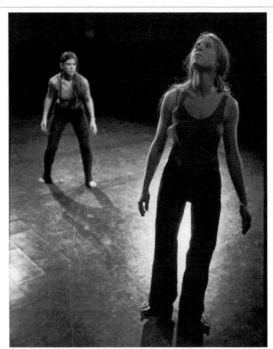

Figure 9–3: Noir filmmakers often shot their films in black and white to achieve an intense dramatic feeling. They also used contrasting light to create an eerie effect. Author's collection.

FILM AND CULTURE

Immediately before and after the invention of film in 1895, critics, journalists, and cinema pioneers debated among themselves about the social use and function of film. Some argued that film was a means of preservation and it should be used for archival purposes to help with research and teaching. Others believed that film created a new form of journalism. Still others contended that film should be used as a private or public instrument to record the images of people for posterity. However, none of these early visions considered the possibility that the film would develop into a medium for telling stories. It was the marriage of film and narrative that sparked the social acceptance of cinema. Narrative is such an important aspect of filmmaking that nonnarrative genres, such as documentary, technical, and educational films, are marginal compared to full-length feature films.

The Film Industry

Today's film industry is a mixture of large and small companies. Both major studios (Columbia, Fox MGM, Paramount, Universal, Warner Brothers, Disney, and Tri-Star [Sony]) and independent filmmakers create films for theatrical distribution. The major studios control most film distribution. Consequently, it can be difficult for independent filmmakers to get their films shown in theaters. The following is a typical distribution pattern for major motion pictures: theatrical distribution, then pay cable television, DVD sales, network television showings, basic cable network, and finally syndication. However, some films go straight to video release and cable stations because it would cost too much to advertise their theatrical release.

Film production is divided into three distinct stages: preproduction, shooting, and postproduction. During preproduction the script is written, actors and technicians are hired, budgets are planned,

locations are found, and shooting schedules are arranged. Careful planning in this stage can make the difference between a successful and unsuccessful movie. The shooting stage creates the raw material that is later edited into the finished film. Editing is central to the narrative of the film. In today's marketplace, some films are tested with audiences before the final edited version of the film is released to theaters.

Film and the Spectator

A film's spectator has been compared to both the reader of a novel and the viewer of a play. Similar to novel readers, film spectators sit in a darkened theater enjoying a certain degree of solitude. However, the public space of a movie theater is also a place where large groups of people come together. Commercial films are designed to be seen by mass audiences. Hollywood film directors create movies that fit into particular genre categories for mass-market consumption.

In contrast to these industry trends, contemporary film theory tends to place the interpretation of a film in the mind of the spectator. Critical theory contends film representations have an impact of their own that influence our social world. In contrast to reflecting reality, film representations are considered dialectical, interactive, and potentially contradictory to reality. From this point of view, the production of film meaning is an activity, which understands the systems of representation used in a film. According to Kuhn (1990), "Cinema's part in the production and circulation of ideologies thus involves its own signifying practices, central among which must be the capacity of the film image to present itself as uncoded, a direct record of the real" (p. 54). Critical theory asserts that a film's ideology is grounded in social relations, such as class and power, and in the ways these relationships are signified in the film.

Ideological and cultural criticism is often motivated by a political impulse, and its goal is to critique the power relationships associated with certain ideologies. Political stances such as Marxism and feminism suggest that films actively place their audiences within an ideological framework, which attempts to shape the spectator's worldview. A film's ideology is not always immediately apparent. Therefore, films need to be analyzed to uncover their underlying meaning.

Relationships Between Film and Culture

One perspective on the relationship between film and culture is the reflectionist view. This view argues that film representation and the real world are distinct from one another and the former is subordinate to the latter. From the reflectionist view, a film is seen as reflective of things that are going on outside of it. Additionally, the reflectionist view considers situations and actions in film to be viewed as unmediated and direct. According to Annette Kuhn (1990), the assumption here "is that social trends and attitudes in a sense produce films, which can then be read as evidence of these trends and attitudes [in the real world]" (p. 16).

In contrast, a sociological perspective views fictional film genres and narratives as indicators of social issues and problems. Consequently, film has as much to do with the real world as it does with the fictional one. For instance, it is widely accepted that Hollywood science fiction during the 1950s showing aliens threatening the human race was really reflecting Cold War fears about communist takeovers. These films include *Invasion of the Body Snatchers* (1956) and *The Thing from Another World* (1951). Similarly, it has been suggested that films during the 1970s expressed concerns about overpopulation, pollution, ecology, and American isolationism. These films include *Silent Running* (1972), *Soylent Green* (1973), and *Logan's Run* (1976). Many science fiction films show future visions that are pessimistic and mirror the profound social decay that people were experiencing at the time they were made. In contrast, films such as *Close Encounters of the Third Kind* (1977) and *E.T.* (1982)

articulate a longing for a return to moral certainties and the traditional values of small-community life. Instead of just reflecting social issues, social concerns are actually being expressed through film.

Watching movies is an activity that many people do as part of their general lifestyle. Based on this idea, movies are considered part of the ordinary life experience. Some researchers have applied Goffman's Frame Analysis, a method for organizing experience, to the study of film. According to Goffman (1974), when individuals attend to a situation, they need to ask the following question: "What is it that's going on here?" (p. 8). Each individual will experience an event differently. For instance, opposing rooters at a basketball game will not experience the game the same way. A goal of Goffman's (1974) approach is to isolate some general frameworks of social understanding for making sense out of events "and to analyze the special vulnerabilities to which these frames of reference are subject" (p. 10). The term frame in this context refers to the basic principles of social organization and an individual's subjective involvement in the organization of experience. This is not social organization but the ways in which individuals organize events in their minds. Due to the strong relationship between actual human interaction and the way people are shown in films, frame analysis is another way to examine film and culture.

Digital Media and Its Impact on Film

The introduction of computers into the filmmaking process is propelling the film industry toward fantasy filmmaking. An early film to use computer-generated imagery was Disney's *Tron* (1982), inspired by the real-life work of computer pioneer Alan Kay. Computers are used to create visual imagery, special effects, and operate animatronic models, such as the model humpback whales used in *Star Trek 4* (1986) and the 7-ton Tyrannosaurus Rex in *Jurassic Park* (1993). Computer technology makes these creatures look believable and realistic. The visual superiority of computer graphic techniques over analog film techniques was demonstrated in *The Crow* (1994) and *Forrest Gump* (1994). *The Crow*'s leading male character, Brandon Lee, was killed in an accident during the shooting of the film. To complete the film, Lee's face was digitally cloned onto a film double's face. Similarly, *Forrest Gump* digitally combined historical film footage with the movie's lead character to create a type of realism that would be impossible with analog film technology. The facial movements of President John F. Kennedy were digitally altered and manipulated to appear as if he were having a conversation with Forrest Gump, played by Tom Hanks.

Computer-Generated Imagery

A major benefit of computer-generated imagery is the fact that actors are no longer placed at risk and fatal accidents can be avoided. Actors have been killed and injured making films. For instance, Margaret Hamilton, the actress playing the wicked witch in *The Wizard of Oz*, was injured several times during the shooting of the film. Barry (1997) stated:

> Her broom and hat caught fire, burning off the skin of her right hand, her eyebrow, and eyelashes, and searing her upper lip and eyelid. Worse, because the make-up was essentially poisonous, made with copper to give the appearance of green skin, it had to be scrubbed off with alcohol. (p. 229)

Hamilton refused to do the next stunt. A double was hired, and the double also had to go to the hospital because she was blown off the broomstick by an exploding pipe hidden beneath the costume.

Today, computer graphics can be used to make films safer and create sensational visual effects. However, in many films, the visual effects can overshadow the narrative story. As visual effect techniques improve, plot lines, stories, and characterization often weaken. As a result, a new direction in filmmaking is emerging in which fragmented sensory stimulation is presented to the audience. With

this trend, some scholars fear that film is moving away from cognitive and emotional experiences toward purely emotional ones with delayed cognitive consequences. Barry (1997) said the following:

> As we move into a faster- and faster-paced world, relief is sought in faster-paced entertainment to block the world out. In the process we move not toward the control and sanity that intelligent reflection provides but toward immediate gratification through sensual stimulation. (p. 231)

Besides realistic special effects, computers can be used to create computer-generated fantasy image worlds. For example, *Toy Story* (1996), *Toy Story 2* (1999), and *Antz* (1998) were entirely produced by people using computers. Film can envelop the viewer within its action. Introducing special effects that surround the viewer with computer-generated imagery and dynamic emotional stimulation raises an important question for film theorists: How do changes in these visual film conventions relate to broader sociocultural contexts?

Microcinema

Traditionally, a young filmmaker who wanted to make a film would have to raise huge sums of money for crew, equipment, and film, which often plunged the filmmaker into debt. However, the cinematic landscape is beginning to change as microcinema develops. Microcinema is a term coined in 1991 by San Francisco's Total Mobile Home Microcinema to describe "underground" films shown in basements. Microcinema also describes animated shorts, impressionistic video manipulation, hard-

Box 9.4: In His Own Words: Gene Youngblood

Bio: Gene Youngblood is a theorist of electronic media arts and a scholar in the history and theory of experimental film and video arts. Since 1970, Youngblood has been conducting interdisciplinary research in digital media. He has collaborated on CD-ROM projects with the Voyerager company and lectured extensively on electronic media. Youngblood has been on the faculty of California Institute of the Arts, California Institute of Technology, Columbia University, the School of the Art Institute of Chicago, and in the film departments of University of Southern California and University of California, Los Angeles.

The mass-audience, mass-consumption era is beginning to disintegrate like Hesse's alter ego Harry Haller in Steppenwolf, who regretted his dual nature until he realized that he not only had two selves but quite literally dozens. It is generally accepted that the post-Industrial Age will also be an age of post-mass consumption…. Inherent in the proliferation of inexpensive film technology, which caused the phenomenon of personal cinema, is the force that soon will transform the socio-economic system that made commercial mass entertainment necessary in the first place. Synaesthetic cinema not only is the end of movies as we've known them aesthetically; the physical hardware of film technology itself is quickly phasing out, and with it the traditional modes of filmmaking and viewing. We're entering the era of image-publishing and image-exchange, the inevitable evolutionary successor to book publishing: the post-mass audience age.

The hardware and software environment presently exists in which one can purchase films as easily as one purchases books or records. The video/film symbiosis accomplished in electron-beam recording results in the end of "movies" as social event and technical discipline. The decisive factor in the demise of cinema and TV as we've known them is the ability to choose information rather than being enslaved to mass broadcasting schedules or distribution patterns, restricted by both mode and (profit) motive. This revolutionary capability exists even though the military/industrial complex withholds it from us. (Youngblood, 1970, pp. 129–130)

hitting documentaries, and garage-born feature-length films. The microcinema movement is spread through word of mouth and computer networks. The Internet is becoming a centralizing force that binds the emerging microcinema community together.

With the aid of new digital technologies, microcinema is transforming the creation, distribution, and screening of films. Today, people engaged in microcinema use affordable image capturing devices and desktop video programs to create films. The Internet becomes the method of film distribution. The plummeting prices of digital video cameras and desktop editing suites are now democratizing the world of moviemaking. In contrast to spending $40,000 to purchase, develop, and print 16mm film, a two-hour digital video cassette can be purchased for $10. With a budget of $10,000, a filmmaker can purchase a digital camera, computer, and editing software.

Microcinema opens a direct communication channel between filmmakers and their audience. More important, for the first time in the history of motion pictures, average people can shoot, edit, and even distribute their visions directly without answering to anyone. *The Blair Witch Project,* a film shot by its actors using Hi-8 video and 16mm film cameras, was produced for $40,000 and grossed an estimated $150 million. In contrast to large budget Hollywood movies with million-dollar advertising budgets, the homemade *Blair Witch Project,* with its terrifying collage of allegedly "found" footage, was promoted through a web-based marketing campaign.

Quickly, digital media are becoming new tools for the creation, distribution, and promotion of digital film projects. The Cannes Film Festival now includes digital films as a category, and digital film-making is being integrated into university film and television departments. Media support for digital films is also coming from cable television's Independent Film Channel and YouTube.

SUMMARY

In contrast to photography, film's primary social role has been one of entertainment because most films are fictional narratives. A strong relationship exists between film and culture because film captures humans interacting with each other. The movie industries have developed their own system for the creation, production, and distribution of films. This system is changing with the introduction of digital technologies. For instance, computer-generated graphics enable filmmakers to create fantasy films with little harm to actors.

Many approaches have been used to analyze film, including genre theory, auteur theory, semiotics, and frame analysis. Additional approaches to film analysis include feminist theory and postcolonialism, which are described in Chapter 12. The introduction of digital media is democratizing the filmmaking process through affordable digital cameras, computer-based editing systems, and Internet distribution. Currently, the microcinema movement is beginning to be culturally recognized by film organizations.

WEBSITES

- *Film Companies*
 http://www.mgmua.com/
 http://www.spe.sony.com/
 http://www.paramount.com/
 http://www.warnerbrothers.com/

- *Microcinema*
 http://www.youtube.com/user/microcinema

EXERCISES

1. List five films that you like and five that you do not. What criteria are you using to evaluate these films?

2. If you were traveling on a long trip and could take only one film with you, what film would you select? Why did you choose this film?

3. What film do you think best shows the culture in which you live today? Explain why you selected this film and try to make comparisons between the film's story and characters and actual people and events.

4. There is a tendency in film to portray gendered roles in a stereotypical manner. Select a film and analyze the relationships between the male and female characters in the film in terms of the following:
 - power/weakness
 - dominance/submission
 - leader/follower

5. Explore the microcinema websites and view the clips of various films. How are these clips similar to and different from clips from Hollywood movies?

6. Write a one- to two-page story concept for a microcinema film project.

KEY TERMS

Auteur Theory asserts that the director of a film should be considered its author. Directors oversee all of the audio and visual elements and they play a larger role in the visual aspects of a film than the screenplay writer.

Codes, in semiotics, are the rules and sets of identifiable elements that enable an observer to interpret a film.

Deep focus is a term that refers to the large depth of field in which objects and actors are in clear focus.

Genre is a format or category of media content.

Jump cut is when the editor takes a section or part of a sequence from one section of the sequence to another.

Microcinema is a term used to describe "underground" films that are shown in basements, animated shorts, impressionistic video manipulation, hard-hitting documentaries, and garage-born feature-length films.

Mise-en-scène is French for "putting in the scene" or the modification of the film in space.

Montage is French for "putting together" or the modification of time in film.

Pan is a horizontal camera movement to the left or right in which the camera is rotated on its tripod.

Point-of-view editing attempts to keep the viewer consistently on one side of the action and interaction.

Reflectionist view is a perspective that assumes representation and the "real world" are distinct from one another and the former is subordinate to the latter.

Shallow focus is having a small part of the image in focus.

Zoom shots are lens movements that increase or decrease the size of the image.

FILMS

Silent Films

DATE	GENRE	FILM
1903	Western	*The Great Train Robbery*
1914	Melodrama	*Perils of Pauline*
1915	War	*Birth of a Nation*
1916	Historical Drama	*Intolerance*
1921	Romance	*The Sheik*
1921	Documentary	*Nanook of the North*
1921	Action/Adventure	*Thief of Baghdad*

Talking Films

DATE	GENRE	FILM
1930	Crime Drama	*Little Caesar*
1931	Horror Movie	*Dracula*
1933	Monster Movie	*King Kong*
1934	Screwball Comedy	*It Happened One Night*
1941	Character Study	*Citizen Kane*
1941	Detective Movie	*The Maltese Falcon* (Film Noir)
1956	Science Fiction	*Forbidden Planet*
1958	Musical	*South Pacific*
1959	Romantic Comedy	*Pillow Talk*
1974	Disaster Movie	*Towering Inferno*
1980	Slasher Movie	*Friday the 13th*

CHAPTER 10

☀ Television

In the United States, television is a widespread and influential visual medium. Films are primarily viewed on television sets, and most people receive their news from the television, rather than the newspaper. Additionally, the introduction of cable and satellite television networks has increased the variety of programs available to viewers. For example, MTV, the music video channel, has become a popular station and has influenced video editing techniques. Similarly, CNN, the Cable News Network, has influenced global television news reporting.

Competition between network television news departments has encouraged the creation of staged media events to visually capture the public's attention. For example, in the 1960s, election campaigns became a battle to control the pictures that would play on the evening news. As a result, political candidates have become image conscious, and they carefully manage their media appearances. Today, the entire process of political conventions is staged for television viewing audiences. The increased reliance on television images to capture a viewer's attention has influenced other media and contributed to the visual orientation of American culture.

DEVELOPMENT OF TELEVISION AND THE TELEVISION INDUSTRY

Many technologies contributed to the invention of television, including the cathode ray tube, iconoscope, and image dissector tube. In 1927, Philo Farnsworth transmitted the first television picture electronically, and in 1930, he patented the first electronic television device. Independently, Allen Dumont and a group of engineers headed by Vladimir Zworykin were developing television for RCA (Radio Corporation of America). A patent battle followed, and Farnsworth won. Farnsworth's patents were then licensed to RCA and AT&T for use in the development of commercial television. RCA first publicly displayed television at the 1939 World's Fair. However, television was also developing in other countries around the world. In 1935, four years before the Americans, the British broadcast a television signal.

In 1939, the Harvard-Yale game was the first event to be broadcast over television. With the outbreak of World War II, television's development was disrupted, and networks did not emerge until after the war was over. Meanwhile, television cameras were improving, and technical standards were being

established. After 1945, three television networks emerged in the United States, based on the three radio networks: NBC, ABC, and CBS. The original programming for television networks was adapted from radio. Moreover, the commercial advertising system established in American radio was adopted by the emerging television networks.

In the early years, television combined the photographic reproduction capabilities of the camera, the motion capacities of film, and the instantaneous transmission of the telephone. As a result, early television used live broadcasting to transmit instant news of events and well-rehearsed studio performances. Initially, live broadcasting was the major source of television programming. As television expanded, live broadcasts were gradually replaced by prerecorded programs. Videotape recording and editing were introduced in the mid-1950s, and by the early 1960s, most dramatic television programs were being produced on film. A major reason for this change was the difficulty in maintaining instantaneous transmissions across time zones because there is a three-hour time difference between New York and Los Angeles.

Although many television programs are preproduced on film, the social uses of television are considerably different from those of film. Most films fall into the category of "fiction" and are designed to entertain. In contrast, a percentage of television's programming forces us to deal with actual issues and events, for example, the evening news and special reports.

On television, a distinction is made between news, entertainment, and commercial advertising content. Originally, advertising's role on television followed the patterns of radio: Sponsors would pay for an entire program. However, as the economics of television changed, single sponsorship was replaced with multiple sponsors. Today, a half-hour program can have up to eight minutes of commercial messages fitted into the beginning, middle, and end of the show. Besides program material and commercials, stations also interject their own promotional material. Programs are constantly being interrupted by prologues, epilogues, station promotions, coming attractions, and commercials. Viewers can see over 14 distinct segments in a half-hour program. The three major networks dominated television content from the late 1950s to the end of the 1970s. This period is called the *network era*. Collectively, these networks accounted for 95% of all prime-time television viewing. However, by 1996, this figure had dropped below 53%. With the decline of audiences, the major networks are experimenting with engaging viewers by incorporating "interactive" components into their programming. Instead of perceiving viewers as "couch potatoes," news and magazine programs offer web-based interaction and solicit viewer opinion polls that are shown during programs. Changes in technology and content style are creating challenges for the television industry today.

The Television Industry

Beyond technology, government regulation has also had an impact on the television industry. During the 1960s, concerns about the monopoly-like impact of the three networks led to a series of regulations to undercut their power. For example, the 1970 passage of the Prime-Time Access Rule (PTAR) took away the 7:30 to 8:00 p.m. time slot from the networks and gave it to local stations. With this law, the FCC hoped to encourage local news and public affair programs. However, most stations filled the time with syndicated game shows or infotainment programming such as *Entertainment Tonight*. At this point, the networks began operating syndication companies that demanded large fees from local television markets for broadcasting reruns of their popular programs. In 1970, the FCC created the Financial Interest and Syndication Rules (fin-syn) to prevent the networks from reaping large profits from program syndication. Then in 1975, the Department of Justice limited the networks' production of nonnews shows to a few hours per week. This limitation forced the networks to purchase programs from independent producers and film studios.

In April 1987, Rupert Murdoch launched the Fox Television Network as a challenge to the "Big Three Networks" (NBC, ABC, and CBS). In doing so, he created a fourth major network. By the mid-1990s, Fox's affiliations rivaled the Big Three, and they were outbidding CBS for pro football broadcasts. The rise of Fox combined with the increased channel options available through cable television services further eroded the viewing audiences of the Big Three Networks.

Cable Television

Cable television originated in rural areas between 1966 and 1972, and the FCC kept cable operators out of the large television markets. However, in 1972, a new set of rules was developed that paved the way for cable's entry into urban areas. Home Box Office (HBO) was one of the first companies to capitalize on this opportunity, and it started the first cable network. Today, over 60 cable television networks deliver programming via satellite. Besides collecting affiliate fees, these networks make local advertising spots available. The largest cable networks include Cable News Network (CNN), ESPN, and USA Network.

With increased competition from cable and home video in the 1990s, the FCC eventually phased out limitations on network production. For instance, Disney can use its vast movie production resources to provide programming for its ABC television network. Today multinational corporations, including Disney, Westinghouse, and General Electric, own the networks, and they are increasingly deciding the types of programming and economic structures used in broadcast television.

The Telecommunications Act of 1996 brought cable under the same federal rules that govern the telephone, radio, and television industries. Additionally, the Act breaks down the regulatory barriers between regional phone companies, long-distance carriers, and cable operators to enable them to enter each other's markets. Congress hoped that the removal of barriers would foster competition and reduce both telephone and cable rates. Moreover, it opened competition in the marketplace to develop new types of interactive services that combine cable, telephone, and Internet capabilities. Today we can watch television on our cell phones and see broadcasts of popular programs on the Internet.

TELEVISION GENRES

Popular television programs are categorized as different types of television genres. Similar to film, the genre approach to television criticism examines television programs with similar formats and characteristics. It has been argued that genre criticism is an effective method for television analyses for three reasons. First, the categorizing of television programs enables the television critic to look closely at the shared conventions of the programs, which are often indicators of changes, movements, and social trends that take place. Second, searching for similarities among television programs provides the critic with information about the motives and objectives of the industry and the people creating the programming. Finally, the genre approach to television is an intertextual analysis of television because many texts are compared with each other.

The Commercial

Commercials are a major component of American television and should be considered a television genre. Elements in a commercial are combined to create an overall effect or impression. Visual impact combined with verbal support conveys the actual advertising message. However, the quick paced rapid editing techniques used in many television commercials often create an emotional message, rather than a rational one. Social, personal, and lifestyle images play an important role in many

advertisements. This visual approach wants the consumers to emotionally identify with the image and to picture themselves feeling good about using a particular product or service.

Advertisers spend a tremendous amount of money to create advertisements. They also hire some of the best Hollywood directors to shoot their commercials. In 1984, Apple Computer's advertising agency hired the British director Ridley Scott, whose movie credits included *Alien* and *Blade Runner,* to launch the Macintosh computer. Scott's science fiction film style features unusual and dramatic lighting effects, which create uneasy effects on people. The Macintosh television commercial used the theme of *1984* to depict Apple's major competition, IBM, as "Big Brother." Echoing the theme of the book, the commercial portrayed the face of Big Brother glowering down from an enormous television screen haranguing a pathetic mass of bald uniformed subordinates. While the Big Brother figure was indoctrinating the subordinates, a fresh-faced young woman ran into the scene. She threw a sledgehammer into the large television monitor, and it vaporized in a flash of light. By throwing the sledgehammer at the screen and destroying it, the woman symbolized how the Macintosh computer represented freedom and creativity in a world dominated by IBM business computers. After the screen explodes, the camera pans the crowd, showing people's mouths open wide as they sit mesmerized, and a voice-over says, "On January 24th, Apple Computer will introduce Macintosh. (Pause) 1984 won't be like *1984.*"

The commercial went on to win many international and national advertising awards, and its style marks a new genre in advertising called the "California Style." A unique aspect of the Apple *1984* commercial is the fact that the product was never actually shown. Chait-Day, Apple's advertising agency, is primarily responsible for this new advertising approach. Chait-Day also used the California Style to develop creative campaigns for Nike. A unique feature of Nike advertising is the fact that written copy is eliminated from most of its advertising messages. This shifts emphasis away from verbal advertising messages toward visual ones. Nike was one of the first companies to rely exclusively on visual imagery and a logo to sell its products. (See Apple, 1984 Super Bowl ad, http://www.youtube.com/watch?v=OYecfV3ubP8)

In the 2011 Super Bowl, Motorola directly challenged Apple by using visual and verbal rhetoric that accused Apple of hypocrisy for the claims in the "1984" commercial. A group of people looking like drones were marching to work in outfits wearing iPod earbuds. "The quarter-minute clip shows an oh-so-cute male Xoom user—reading Orwell's dystopian novel—boarding a subway train in the company of hordes of white-earbudded drones clad in identical white hoodies and baggy pants" (Myslewski, 2011, p. 1). The message is that now Apple is "Big Brother" and the Xoom Tablet will give users more choices. The name of the commercial is "Empower the People," and it is available at http://www.youtube.com. Culturally, commercials can be more than advertising; they can also reflect cultural attitudes.

Broadcast Television Genres

Television has created many genres of its own. These include television-made dramas and situation comedies that take place in suburban homes, courtrooms, hospitals, and police stations. Action adventure stories have also developed into a television format. Shows such as *Dragnet* (1952–1970), *NYPD Blue* (1993–2005), and *Law and Order* (1990–2010) deal with detectives chasing bad guys and car chase scenes. Legal dramas, including *Perry Mason* (1957–1974) and *L.A. Law* (1986–1994), along with programs such as *The Practice, Ally McBeal,* and *the Defenders,* depict courtroom scenes. Many of these shows intermingle professional situations with personal relationships. (*Dragnet, Perry Mason,* and *Ally McBeal* episodes can be found by typing the names of the shows in Google Videos or YouTube.)

Game shows are another popular television genre. For instance, *Wheel of Fortune,* hosted by Pat Sajak and Vanna White, originally aired in 1983. It is still very popular with viewers and is one of the longest running game shows. New game shows, such as *Do You Want to Be a Millionaire?*, offer to give

away millions of dollars to contestants who can answer questions correctly. Dramatic lighting effects are used in these shows to heighten the excitement for audience members and viewers as they watch the contestants play the game.

Cable Television and Network Genres

A typical basic-cable service will include anywhere from 36 to 72 different channels, including local broadcast signals; nonbroadcast local access channels for government, education, and public use; regional Public Broadcasting Stations (PBS); and a variety of national cable satellite networks. Satellite networks and services include ESPN, CNN, CNN Headline News, MTV, USA Network, Bravo, Nickelodeon, Lifetime, C-Span, The Home Shopping Network, and Black Entertainment Network.

In the 1990s, a proliferation of new cable networks emerged that devote their programming to specific subjects, such as history, health and fitness, cooking, books, games, parenting, cartoons, women, and science fiction. Stations such as the Syfy show television programs and movies that primarily fall into the preestablished film genre of science fiction. In contrast, CNN created a new global genre for television news programming, which runs 24 hours a day.

In 1991, after CNN's coverage of the Persian Gulf War, CNN transformed into a global news service. During the war, military leaders in both Iraq and the United States were watching CNN to stay updated on the latest news and events. CNN's global transmissions of the Gulf War became a milestone event. They have been used to illustrate Marshall McLuhan's idea of a *global village,* in which people from around the world simultaneously watch events as they occur. CNN's Headline News Network also created a new format when it transformed radio news into television programming. However, the most influential new genre developed on cable television is MTV.

MTV and Music Videos

MTV (the Music Television Network) was launched in 1981, and it has changed the cultural landscape around the world. MTV is now an international operation with programs designed for Asia, Europe, Brazil, Japan, and Latin America. However, its cultural impact has been criticized for eroding local culture-specific traits among the world's youth and for presenting an overabundance of American culture. Additionally, MTV has been cited as contributing to the decline of civil discourse and for delivering overly sexual messages to today's youth. On the other hand, MTV has been applauded for presenting special programs that deal with tough social issues, such as drug addiction, racism, and social activism. For instance, its *Rock the Vote* campaign helped to register a million young voters in the United States.

MTV-style video editing introduced a new, fast-paced style of editing that sometimes is dismissed as mindless and frivolous because the quick edits densely pack images together into a constantly changing montage. Conversely, MTV-style videos are seen as an information-rich environment that uses pictures, narration, music, and text. MTV-style editing flips between black and white and color, from one type of film stock to another, and from fast to slow motion. Traditional concepts of editing, framing, and balance are often violated. Narrative structure, an important element in film and video, becomes an associative collage that viewers interpret through the juxtaposition of sound and music. According to Stephens (1998), this new style of video has "difficulty sticking to print-like, isolated, one-point-after-another narratives, but by its nature the new video will tend to subvert or, often, ignore them" (p. 188).

Stephens (1998) contended that the rapid succession of instant scenes will lead to the development of a new type of logic based on the presentation of discontinuous peak moments. Styles of nonnarrative techniques and nontraditional forms of organization can be explored through the disjointed progression of visual data and imagery. Instead of structuring video around prose and narrative, it will be

organized like musical arrangements. Moreover, this style of editing has influenced the digital style of remix. Remix is the ability of computers to combine text, video, images, and sounds (see Barnes, 2011).

APPLIED MEDIA AESTHETICS

Box 10.1: In His Own Words: Douglas Rushkoff on MTV

Bio: Douglas Rushkoff is a journalist and cultural media critic. He is the author of Cyberia *and* Media Virus. *Rushkoff was professor of virtual culture at New York University and he lectures and consults about media. In his book,* Playing the Future: What We Can Learn from Digital Kids, *Rushkoff (1999) argues that linear thinking is being replaced with chaos theory, and he uses media as an illustration of how this is happening.*

[Younger audiences] are comfortable in the disassembled mediascape because they are armed; the first weapon to appear in their arsenal was the remote control. As the media became increasingly chaotic, the remote emerged as the surfboard on which the armchair media analyst could come to reckon with any future attempts to program him back into linearity. The minute he felt the hypnotic pull of story or propaganda, he could impose discontinuity onto the flow by changing the channel. At first, this served as a simple negation of the broadcast reality. Whenever a newscaster says something irritating to the viewer's sensibility, even an Archie Bunker can curse at the screen and change the channel in disgust. Eventually, though, in order to maintain their viewerships, the media dispensed with linearity altogether, and devised new styles and formats to appeal to the channel surfer. They didn't realize what they were doing….

Over time and, eventually, to make television more compelling to the remote control viewer, television editors sliced and diced their programming into more rapid-fire segments. Although any film textbook will explain that an audience cannot comprehend a shot with a duration of less than two seconds, and that such rapid-fire editing should be used only for effect, two-second shots and even one-second reactions soon became the norm on television. Like the drips of water coming out of a faucet at an increasing rate, once the speed of edits reached a critical frequency, the linear story just broke apart as the programs reached turbulence. The media chaos this turbulence generated was called MTV. (Rushkoff, 1999, pp. 44–45)

During the time television editing was changing, Herbert Zettl (1990, 1999) developed a theory of applied media aesthetics to explore television and film productions. In contrast to the traditional idea of aesthetics associated with the theory of art, applied aesthetics does not deal with the appreciation of beauty, the isolation of art and life, and the quest for truth. In contrast, art and life are seen as interconnected. Applied media aesthetics examines the visual techniques and elements used to shape ideas. Zettl is interested in how media organizations produce messages. Moreover, applied media aesthetics can help audience members understand how visual messages are constructed. Media play a role in structuring messages. Zettl (1999) said, "If you have ever tried to make oil paints or clay do what you want them to do, you will readily admit that the medium is not neutral by any means. In fact, it has a decisive influence on the final outcome of your creative efforts" (p. 11). Similarly, television, film, and digital media will have an influence on the messages created in each medium. For instance, the size,

shape, and visual quality of wide-screen cinema are very different from the size, shape, and quality of a computer screen. "Obviously, the encoding (production) as well as the decoding (reception) of the message are, to a considerable extent, a function of the technical and aesthetic potentials and requirements of the medium." (p. 11). Applied media aesthetics examines how media shape messages to elicit a particular viewer response.

Applied media aesthetics describes criteria for both the encoding and the decoding of visual messages. Its method is based on the theories and practices developed by Russian painter and Bauhaus instructor, Wassily Kandinsky (1866–1944). Kandinsky advocated an inductive approach to painting in which scenes are built by combining the fundamental building blocks of painting—points, lines, shapes, balance, color, and so forth. Using this approach, Kandinsky was not limited by what he saw in the world; instead, he extended his vision to construct new worlds. Building on Kandinsky's theory, Zettl identified five fundamental image elements of television and film: light and color, two-dimensional space, three-dimensional space, time and motion, and sound. Zettl isolated these elements to examine video programs and their aesthetic characteristics and potentials. Consequently, applied media aesthetics is an approach that can be used in the production process to shape ideas into video messages and in the analysis of these messages.

Lighting Techniques

In television, lighting is used to create the screen space by revealing objects and their location in space. Additionally, it is used to establish the mood or atmosphere of a scene. The two principal methods for creating an atmosphere are *low-key* and *high-key* lighting and a*bove and below eye level key light* positions. The primary lighting source is called the *key light*. High-key lighting uses an abundance of bright light and a light background. It is usually used for television news sets and game shows because it creates an upbeat feeling. In contrast, low-key lighting uses less light. The brightness and contrast change from light to shadow is also more distinct. Illumination is selective, which leaves the background and part of the scene primarily dark. This type of lighting creates a disheartened mood, and it is used for scenes that deal with dungeons, caves, or nighttime exteriors.

Light sources come from above and below an object to produce different types of shadows. The term above and below eye level refers to the eyes of the subject in the scene. People generally expect a light source to come from above the subject. When light comes from below, the shadows on the face are the reverse of what we expect to see, and it appears unusual and ominous. For example, consider what happens when kids telling scary campfire stories place a flashlight under their face to create an eerie feeling of a monster.

Two-Dimensional Space

Unlike the composition of a painting or photograph, the pictorial elements in television are constantly shifting within the frame, and they change from one picture to the next. As a result, television production designers need to think in terms of structuring a dynamic visual field in which elements provide structural continuity. They need to visualize a sequence of shots rather than an individual composition.

Similar to static compositions, balance is a key concept that needs to be considered when shooting a scene. Placing an object in screen-center is the most stable position because the areas surrounding the object are symmetrically distributed. When an object is moved to one side, the composition becomes off-center, and the picture begins to look unbalanced. For example, if a newscaster is placed in an off-center position on the screen, a graphic element should be placed on the other side of the screen to balance the picture. As described in Chapter 2, balance can be symmetrical, asymmetrical, or unbalanced.

Box 10.2: In His Own Words: Kandinsky

Bio: Wassily Kandinsky (1866–1944) was born into a Russian aristocratic family and raised in the Russian Orthodox faith. He was a very good student and pursued an academic career in political economy until 1896, when he went to Munich to study painting. In 1922, Kandinsky joined the Bauhaus and remained a central figure until 1933, when the Nazis closed the school. The Bauhaus credo, "form follows function," inspired educational theories that examined the basic elements of light, space, movement, and texture.

The spectator is too ready to look for a meaning in a picture—i.e., some outward connection between its various parts. Our materialistic age has produced a type of spectator or "connoisseur," who is not content to put himself opposite a picture and let it say its own message. Instead of allowing the inner value of the picture to work, he worries himself in looking for "closeness to nature," or "temperament," or "handling," or "tonality," or "perspective," or what not. His eye does not probe the outer expression to arrive at the inner meaning. In a conversation with an interesting person, we endeavour to get at his fundamental ideas and feelings. We do not bother about the words he uses, nor the spelling of those words, nor the breath necessary for speaking them, nor the movements of his tongue and lips, nor the psychological working on our brain, nor the physical sound in our ear, nor the physiological effect on our nerves. We realize that these things, though interesting and important, are not the main things of the moment, but that the meaning and idea is what concerns us. We should have the same feeling when confronted with a work of art. When this becomes general the artist will be able to dispense with natural form and colour and speak in purely artistic language. (Kandinsky, 1914/1977, pp. 49–50)

The framing of an object is also very important because the object or person must be framed in a way that makes it easy for the viewer to fill in the missing parts and perceive a complete object. For instance, the head can be shot as a highly stable circle. Although the viewer only sees a head, he or she can perceive an entire person. Compared to film, television often uses more close-up shots because it lacks film's panoramic sweep. Television works better with small physical and psychological spaces that demand actor expression. As a result, interaction among characters becomes central to television programming. Television dramas generally take place inside rooms or buildings to place an emphasis on human relationships.

Three-Dimensional Space

As described in Chapter 3, perspective is a method for projecting the three-dimensional world onto a two-dimensional surface. This illusionary third dimension is the most flexible screen dimension in television. Although the screen width (x-axis) and height (y-axis) have defined spatial limits, the depth (z-axis) can continue into infinity. Viewers often perceive the z-axis as starting from the screen and going backward because objects that appear on the surface of the screen do not seem to extend toward us into space. When examining the depth of a television scene, two factors are important: what the camera sees and the viewpoint (camera position) of the event.

Other factors to be considered are the positive and negative volumes, the graphic depth, the type of camera lens used, the z-axis directional forces, and graphic devices. Positive volumes help to define the negative volume of empty space. Positive volumes are objects such as buildings, trees, pillars, rocks, mountains, and furniture. The relationship between positive and negative volumes is essential in the manipulation of three-dimensional space and the illusion of depth in television. Graphic depth

is created when objects are partially hidden by other objects, when objects appear smaller and higher in the background, and when parallel lines appear to converge in the background. The type of camera lens used in a shot also influences the depth depicted in the image. The wide-angle lens stretches the distance between objects, and the narrow-angle lens makes objects appear closer together. The speed in which an object moves toward or away from the camera on the z-axis will also influence the illusion of depth. Finally, graphic devices, such as lines and lettering on the screen, images appearing in secondary frames, and digital video effects (freeze frame, peels, floating frames), influence the illusion of depth.

Time

Television programs relate to different concepts of time. Live television is telecast simultaneously as the event is happening and it occurs in "real-time." Although there might be a slight delay in the transmission process, the televised event is happening at the same time that viewers are watching. Live-on-tape refers to live telecasts recorded for unedited playback at some later time. Instant replay is live recordings of highlights from an event played back immediately after it happened.

Additionally, Zettl (1999) identified six types of objective time in television:

- *Clock time* is the scheduled time of the television program. Television programs and commercials are logged daily on a second-by-second breakdown that relates to clock time.
- *Spot time* is when an event happens, for example, the time a movie plays in a theater or a program starts on television.
- *Running time* is the overall length of a film or movie.
- *Sequence time* is the sum of several scenes that create an entire unit, for instance, a biography of a person's life that is broken up into distinct sequences—childhood, the school years, early career, latter years.
- *Scene time* is the clock time span of an individual scene. Scenes are identifiable parts of a arger event.
- *Shot time* is the smallest unit in a television show or film. It is the interval between two transitions.

Beyond objective time, subjective time is also important. Subjective or psychological time is the way in which we feel or experience time. For example, when we are having fun, clock time seems to pass more quickly. A third type of time is biological time or how alert or tied we feel.

Motion

Motion also plays an important role in television because television images are in a continual state of change. Barry (1997) said:

> The television picture is in fact, not a "picture" at all in the sense that a photograph is, for it exists only instantaneously when an electron gun at the back of a cathode ray tube shoots electronic signals line by line toward the inside face of the TV screen. (pp. 159–160)

The beam moves across the screen and momentarily hits the thousands of phosphorescent dots, and they glow with an intensity determined by the strength of the beam. Then they disappear and change 1/30 of a second later.

The television image is constantly moving. Zettl (1999) identified three aspects of motion that relate to screen events: motion paradox, slow and accelerated motion, and z-axis motion. In general, motion is the change in position of one object's relationship to other objects. Television viewers use their television screens to create a frame of reference for the motion of the image. A motion paradox can occur when the camera moves at the same speed as the moving object. If a camera is located in the

front of a moving police car, the car will remain stable while the background is put into motion. This type of shot reverses the motion in the figure ground relationship between the car and the background.

Slow motion is when an event appears to be moving at a slower pace than normal, and it introduces a surrealistic effect. In contrast, accelerated motion is often used to show events that are fast-forwarding in time. Z-axis motion is the speed that an object moves toward or away from the camera. Camera lenses influence the perceived z-axis speed; for example, a wide-angle lens makes objects appear to become rapidly smaller.

Sound

Television is an audiovisual medium. As a result, dialogue, music, and sound effects are an integral part of the viewing experience. Most television programs use some form of speech, such as dialogue or narration, over a scene. Additionally, most scenes include ambient sounds, including environmental noises (traffic, birds, ocean waves). Sounds can be grouped into two large categories: literal and non-literal. Literal sounds convey specific meaning and are referential, such as words or the chimes of a clock. In contrast, nonliteral sounds and noises do not have specific meanings. For instance, nonliteral sounds are the background noises in scenes. Nonliteral noises can help to place the action within a particular context. For example, a scene shot in a room with the noise of waves crashing on the beach in the background gives the impression of a beach house.

Transitional Effects

Digital electronics provide a wide variety of transition effects for video production. A simple instantaneous change from one image to another is called a *cut*. A cut resembles the way in which the human eye "jumps" from place to place when people are scanning images in front of them. A jump cut is when the editor takes a section or part of a sequence and cuts from one section of it to another. Cuts help to establish the rhythm of an event and its density. For instance, 30-second television commercials that contain more than 30 cuts bombard the viewer with images and appear frenetic.

A dissolve is a gradual transition from one shot to another in which the two images temporarily overlap each other. The length of dissolves varies. Short dissolves are closer to a cut than longer ones. Dissolves create a smooth continuity between shots that would not "cut together" well. They can also be used to bridge time intervals. This type of transition is especially useful when you are dissolving between young and old images of the same character. A *fade* occurs when the image gradually goes to black. At the end of a film, it has the effect of a theater curtain closing. Fades are also used to indicate the end of one event and the beginning of another.

Besides traditional editing techniques, digital video editing also provides many effects to move between events, including freeze, shrink, tumble, stretch, flip, glow, or any combination of these. However, most of these digital transitions add a graphic effect of their own that is not necessarily related to the preceding or following shot or scene. Graphic effects are often placed in secondary frames, a frame within the television screen. The total screen area is called the first-order space, and the secondary frame is the second-order space. For example, "The secondary frame sometimes changes its shape so that we see a variety of scenes as still photos that are peeled off a large stack of snapshots, or else we see a scene, very much like a magic carpet, floating off through the seemingly three-dimensional space of the television receiver" (Zettl, 1999, p. 160).

Television Editing

According to Messaris (1994), television editing could be considered rhetorical because it demands viewers to integrate sequences of events into a coherent sense of spatial and temporal relationships. There are two major reasons for editing images together: to carry forward the story or to juxtapose images to indicate an analogy or contrast. Each of these styles demands something different from the viewer. In the first, viewers must be able to understand a sequence of events as they unfold in time and space. In the second, the viewer must understand the "visual comment" being expressed. Messaris (1994) used the following approach to analyze narrative transitions:

1. A change both in location and in time frame—e.g., the scene change.... In a news program, the transition from a weather forecaster to a satellite picture taken earlier in the day.
2. A change in location only—e.g., the transition between a news anchor-person and a live reporter from the scene of a story or, in a fictional film, suspense-sequence cross-cutting between a person in danger and a would-be rescuer.
3. A change in time frame only—e.g., an instant replay in a sports telecast or, in a movie, a shot of a couple beginning to make love followed by a shot of postcoital embrace.
4. A change in the type of reality depicted on the screen—e.g., a scene in which a character goes into a hallucination (a transition from staged reality to staged fantasy) or, in a talk show, switching from the host and guest to a video clip of the guest's latest movie (a transition from "real reality" to fiction). (p. 93)

When images are brought together to make a comment, Messaris uses the term *propositional editing*. In contrast to narration that requires viewers to work out the temporal or spatial interconnections of the story, propositional editing requires viewers to interpret the relationship between the images. The purpose of propositional editing "is not simply to present a set of events.... But rather to make various comments or propositions about the events themselves as well as about aspects of reality not represented directly" (Messaris, 1994, p. 108). Both Zettl and Messaris have developed theories to help us better understand the meaning of television imagery.

ANALYZING TELEVISION PROGRAMMING

In his book, *Television Aesthetics,* Nikos Metallinos (1996) proposed a model of visual communication that involves a three-part process: the production, transmission, and display of programs. In contrast to Zettl, who focused on the production aspects of television messages, Metallinos wanted to also examine media institutions and the regulations that influence media content. The first step in his method of television analysis required knowledge about the structure of media institutions, an understanding of the creative activities involved in the production process, and an awareness of the laws that govern the content and distribution of television messages. In the second step, the transmission process determines the means by which television messages reach viewers (broadcast, cable, satellite). The method of delivering information can influence the types of audiences that receive the programming. For example, the change from analog to digital broadcasting made it difficult for some people to receive broadcast television because a special box is now required. Additionally, the programming available through cable television is directed toward more select audiences (Court TV, the Food Network, Cartoon Network, Home Shopping Network, etc.). Finally, the televised program itself needs to be examined.

In the process of communicating messages to audiences, there are many obstacles that can break down the communicative process and prevent a message from being received as the sender intended it to be. The first obstacle is technological because messages are not always transmitted properly between

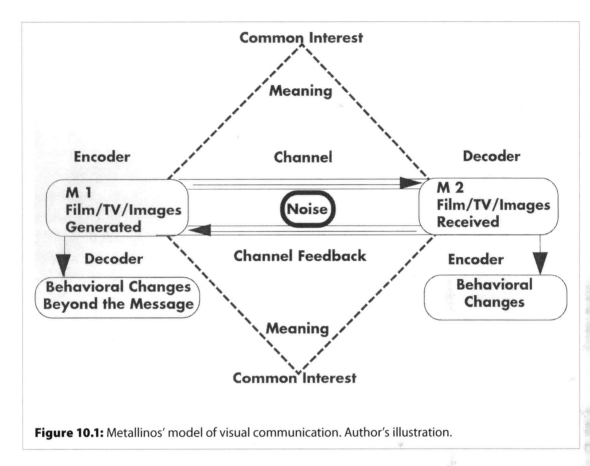

Figure 10.1: Metallinos' model of visual communication. Author's illustration.

senders and receivers. Noise factors, such as bad weather, a cut cable, and a faulty television set, can interfere with transmission. Second, the audience may not clearly understand the artistic representations used in the message. Audience members at the receiving end of the message may be distracted away from the message by people and other home activities. For instance, television messages are often ignored because people leave the room to get something to eat or they quickly flip through many stations waiting for something to catch their attention. Finally, understanding the message itself is an important aspect of the critical evaluation of television programs.

Metallinos puts his three parts of television analysis together into a model of visual communication and then adds a fourth element that can be taken under consideration. The fourth element is the psychological impact of the program or its effects on the viewer. Psychological influences are influences on our behavioral constructs, such as change of attitude, morality, perception, and motivation.

TELEVISION AND CULTURAL TRENDS

With the development of the remote control, many people use this device for channel switching, zapping, or surfing. Zapping is jumping back and forth between channels and clicking through the channels to find something that catches the viewer's attention. Some people will flip back and forth between two programs, trying to watch one while commercials are on the other, or they will start channel surfing as soon as a commercial appears. This has created problems for the television advertising industry and many stations now position commercial breaks at the same time. While zapping, viewers will frequently find the same commercials on several different stations during the same commercial break.

Zapping is particularly popular with younger viewing audiences. Zapping behavior suggests that people are watching television rather than individual programs, and people who zap are basically transforming their televisions into an array of visual imagery without form and content. Berger (1998) referred to this as a macromosaic, "a huge surrealistic collection of bits and pieces of many different programs and stories that become a person's television program" (p. 129). With the aid of the remote control, individuals can create their own electronic television montage.

Decline of Mass Audiences

The increased number of cable television stations, combined with VCR film rentals, DVDs, premium movie channels, and pay-per-view channels, are turning television into a more personalized medium. The emergence of a 500-channel, interactive video environment creates a new type of media landscape that favors individual viewing experiences over shared viewing. The personalization and fragmentation of television content could erode television's social function to present a common culture. Shared viewing experiences help to build national consensus and a common frame of reference. Instead of building cultural relationships, Kenneth J. Gergen (1991) was concerned that television is eroding them. Television is the medium "that most dramatically increases the variety of relationships in which one participates—even if vicariously. One can identify with heroes from a thousand tales, carry on imaginary conversations with talk-show guests from all walks of life, or empathize with athletes from around the globe" (p. 63). These ever-expanding relationships create a situation of social saturation that challenges social patterns. Gergen feared that social saturation will lead to incoherence because individuals encounter a myriad of perspectives, variegated contexts, and connections that present themselves with the speed of flipping television channels.

Moreover, Gergen (1991) described MTV as a medium that breaks down objective reality:

> The shape or identity of an object or persona may change several times within a given video clip, and what appears to be the reality of a photographed world may be revealed to be a drawing (an artistic reality), which then proves to be an artifact of a machine operation (computer graphics). (p. 133)

Additionally, MTV does not recognize traditional aesthetic boundaries because it mixes images from German Expressionism, Surrealism, and Dadaism with noir, gangster, and horror films that blur the distinctions between these various styles and genres. From this perspective, MTV abandons the idea of a coherent world and jolts the viewer with a rapid succession of images that are often less than 2 seconds long. Growing concerns over television imagery include television's contribution to a fragmentation of culture and television's break down of objective reality.

TELEVISION AND DIGITAL MEDIA

Another technological change that is influencing television is the switch from analog to digital systems. In terms of television production, digital editing retains the original quality from one generation to the next. More important, digital technologies create a video image that can be altered without detection. Digital video editing systems allow for the alteration of key frames. For instance, software applications apply an algorithm to images that will automatically smooth the action between the frames. Additionally, digital video can combine images together from different sources to create a realistic image with sound. Barry (1997) said:

> Because any analog recording can be digitized, any filmed or videotaped image from the past can be placed convincingly into news footage. Just as Forrest Gump met Presidents John F. Kennedy and Lyndon Johnson in

film, so Winston Churchill can now be interviewed by Dan Rather on the advisability of deployment of United Nations troops in Serbia. (p. 161)

The ability to combine old and new images together undermines the credibility of the image and makes it easier to create deceptive imagery.

Mixing historical video with actual newscasters begins to blur the boundaries between fact and fiction. Imagery that viewers expect to be unaltered and accurate can be manipulated and distorted without easy visual detection. Television, like the photograph, has a sense of authenticity. Moreover, its ability to simultaneously transmit live events as they occur makes viewers think that they are witnessing the event. However, many broadcast events are consciously staged, framed, and manipulated to produce specific effects and aesthetic reactions. This raises significant questions about the future relationship between television and its role in society.

In contrast to static print images, television images rapidly change. Additionally, the small size of

Box 10.3: Case Study: Television News Imagery

Ann Marie Seward Barry (1997) argued for the development of a visual intelligence that prepares individuals to better understand the digitized images that mimic photographic realism and make them more aware of the political attitudes embedded within and between images. She described how manipulation is more than content selection on television news programs. Barry stated, "While selective content is a manipulative practice across media, other techniques of orchestrating the television image derive exclusively from the television medium itself" (p. 176). Television news programs incorporate likability and credibility elements into the images that they present. For instance, small talk, close-ups, action footage, and frequent camera changes are mingled with news reporting to create a friendly atmosphere. Credibility techniques include directly speaking to viewers in a kind of social-personal-professional exchange, the use of full screen location backgrounds for news stories, and the placement of symbolic visuals in an over-the-shoulder graphic.

"Engineering of the image is most impactful when the complex of positive, negative, or neutral emotional valences derived from image content, editing context, and the viewer's own attitudes and ideas can be structured to a single purposeful end, and the image is so subtly altered that it still seems natural" (p. 176). *Time Magazine*'s controversial cover image of O.J. Simpson illustrates this point. An altered picture of Simpson that appeared on *Time*'s cover "during pretrial hearings and subsequently drew accusations of racism, may be seen as an example of just such an attempt at subtle manipulation. Ultimately the Simpson image became a point of controversy, primarily because as a still image, it could be studied, analyzed, and interpreted" (p. 176).

the television screen often makes viewers look at the image centrally without examining the individual screen elements, like they would when they are watching a film. Consequently, television images are seen as an entire image.

> This means not only that television watching is less active than reading a book or watching a film, but also that it is seldom analyzed for the emotional valence of the images shown. Soft lighting and make-up will give a friendly appearance; hard lighting a mistrustful one, and as we absorb the impression, we begin to use that impression as information in the formation of ideas. (Barry, 1997, p. 176)

A consistent positive image may cause viewers to easily accept other issues connected to the complete image without questioning the individual aspects of the visual message.

Television Industry and Digital Trends

When Congress passed the Telecommunications Act of 1996, it wanted to open competition in the marketplace for the development of new types of broadband communication services. As a result, telephone companies are now entering the cable industry and vice versa. Presently, cable modems provide high-bandwidth access to the Internet through existing coaxial cable systems. A special set-top digital converter in each home enables the cable system to operate as if it were a telephone line transmitting two-way messages.

Besides the development of broadband cable networks, satellites are increasingly being used for television transmission. Services like DIRECTV are now competing with cable networks to provide television services. Beyond providing traditional television programming, these new services are exploring the development of new types of content that provide educational material, entertainment, and information services. As televisions, computers, and telephones merge, new types of programs and visual content will begin to appear.

HDTV

In July 1987, the Federal Communications Commission (FCC) issued its first Notice of Inquiry on advanced television systems. It took almost 10 years for the FCC to approve a High Definition Television (HDTV) standard. HDTV is closer to the image size and quality of film, rather than traditional television. HDTV production is done at a definition of 1,125 lines instead of 526, and it has a larger contrast range and color palette. In 1988, a consortium of broadcasters, electronics and computer manufacturers, and researchers from Europe and the United States began developing a versatile digital system for HDTV formats. The digital standard developed by the consortium, called the Grand Alliance, required less frequency space to store more images, and it holds more information and computer data than analog systems. In 1996, the FCC approved the Grand Alliance's digital system and plans began to replace existing analog broadcast television with new HDTV systems. Digital television can be viewed on lightweight, flat-screen, and wall-mounted screens instead of bulky television sets.

Media convergence is also influencing the future of television. In 1998, HDTV began processing sound and pictures through digital circuits, which set the stage for a power struggle between computer manufacturers and manufacturers of television sets. Today, we have a digital television system that supports HDTV programming. Also, as media converge, the quality of HDTV will allow people to read textual information on their television screens. With the higher resolution on television screens, daily newspapers can be distributed through HDTV systems.

Interactive Television

Early experiments with interactive television began in the late 1970s when Warner Cable announced plans for a two-way cable system called Qube. Using Qube, viewers could respond to their television set with a hand-held keypad. Warner Cable wanted to develop interactive shows, such as soap operas with viewer-selectable plot twists and quiz shows that would allow audience members to play. Additionally, they wanted to provide instant polls for community issues, home banking, and interactive shopping. Qube Systems were built in Columbus, Ohio; Pittsburgh, Pennsylvania; and Dallas, Texas. However, consumer demand for these interactive services did not materialize, and all of the services were dropped except for pay-per-view movies.

With the introduction of the World Wide Web and increased consumer awareness of interactive services, cable systems are again experimenting with interactive systems with the aid of cable modems. John Pavlik (1996) speculated that WebTV has the potential to be more addictive than conventional television because of its interactive engagement. Additionally, he argued that truly interactive television could foster new social uses and link people more closely together into a global village. Currently, WebTV is growing in popularity. Senior citizens particularly like WebTV because it makes Internet access easier than using a personal computer.

YouTube

As digital technologies merge closer together, television is appearing in many new places. For instance, television can now be watched on smart phones. Television programs can also be viewed on computers. Hulu is a website that enables individuals to watch TV shows from the major networks. It streams video to a computer screen with commercial advertising. In contrast, YouTube supports the creation and distribution of user generated content. "Nowadays, hundreds of millions of Internet users are self-publishing consumers" (Cha, Kwak, Rodriguez, Ahn & Moon, 2007, p. 1). Other sites that disseminate user generated content are MSN, Google Videos, and Yahoo! Video.

Wired magazine states that YouTube is what happens "when you put together a million humans, a million camcorders, and a million computers" (Garfield, 2006, p. 224). The widespread use of YouTube has changed the way in which politicians announce their campaigns and made the term *viral videos* a household word. Major events and amateur videos come together to make a visual archive of video entertainment.

Figure 10.2: YouTube has both historical and contemporary videos. Author's screen capture.

SUMMARY

Originally, television programming was presented as live broadcasts of news and staged entertainment events. Although most of the programming presented today is prerecorded, television's power as a socializing force emerges at times of national triumph and disaster. It is at these moments that families come together to share joy and sadness. However, technological factors are potentially changing the cohesive nature of television. MTV style video editing disrupts the traditional narrative structure of television programs by bombarding the viewer with images that rapidly appear on the screen. Some scholars argue that this type of media presentation socially saturates viewers and disrupts social cohesion. In contrast, others argue that this new style of video will enable people to grasp ideas in new ways and develop multiple levels of understanding.

More important, the digitalization of television is altering the ways in which content is presented. First, digital video blurs the boundary between actual and fictional images. Similar to the digital manipulation of photographs, digital video can also be manipulated without obvious detection. Second, digital television is moving toward interactive television. With this shift, television is moving away from the concept of mass audiences and toward the idea of individualized viewing. For example, interactive services such as pay-per-view movies offer viewers the option of watching any movie at any time of the day or night. Moreover, the development of YouTube enables any individuals with a camcorder to become their own video producer. People can now watch user generated content as easily as they watch network programming.

WEBSITES

- *Broadcast Television Networks*
 http://www.abc.com/
 http://www.cbs.com/
 http://www.foxnetwork.com/
 http://www.nbc.com/

- *Cable Television Networks*
 http://www.amctv.com/
 http://www.CNBC.com/
 http://cnn.com/
 http://www. Discovery.com/
 http://www.eonline.com/
 http://www.hbo.com/
 http://www.mtv.com/
 http://www.scifi.com/
 http://www.usanetwork.com/

- *Television News*
 http://www.abcnews.com/
 http://www.cbs.com/
 http://www.cnnfn.com/
 http://www.foxnews.com/
 http://www.msnbc.com/

- *Internet TV*
 www.hulu.com/
 http://www.youtube.com/

- *Google Videos*
 http://video.google.com/

EXERCISES

1. Break up the class into small groups. Have each member of the group find three images that can be placed in a sequence to tell a story. Mix up all of the images and redistribute them to different members of the group. Each member should create a narrative to connect the three random images that group members have received together. Exchange the images with another group member and compare the two different narratives. What are the similarities and differences between the stories? Is there a way to bring the stories closer together? What other images could be added to the story? Could music, sound effects, or captions be added to help in the storytelling process?

2. Create a storyboard for a message designed for a specific target audience. Use both visual and auditory means of communication. (If possible, use either desktop video or traditional video to create your message.) When you are done, consider the following:
 a. How are the different channels used independently from each other?
 b. Are there any times when the combined effect is greater than the sum of the two parts?
 c. At any point does the information presented in one channel duplicate the other? Is the redundancy necessary?

3. Analyze a music video in terms of the cutting, lighting, and shots. Compare the lyrics to the visual imagery. What makes this video visually appealing?

4. Watch an evening news program. Describe the type of visuals that are used to support the stories being reported. Do these visuals help the viewer better understand the story? Why or why not?

5. Utilizing Zettl's approach to media aesthetics, analyze a segment of a television program.

6. Discuss a popular television program using Metallinos' model of visual communication.

7. Camera angles, camera distance, and frame balance all contribute to the visual communication message. Compare a local news broadcast to one presented on CNN. How do these aspects of television influence our perception of the following?
 - Seriousness of the story being reported
 - Friendliness of the newscasters
 - Credibility of the newscasters
 - Truthfulness of the story
 - Objectivity of the report

8. Watch an MTV video and try to make a list of all of the images presented. Now write down what story you think the images are communicating. Compare your story with the stories written by other members of the class. How are the stories similar or different?

KEY TERMS

Biological time is the way our body functions make us feel, for instance, alert or tired.

Cut is an instantaneous change from one image to another in video or film.

Dissolve is a gradual transition from one shot to another in which the two images temporarily overlap each other.

Key light is the primary lighting source in a scene.

Literal sounds convey specific meaning and are referential.

Macromosaic is a huge surrealistic collection of bits and pieces of many different television programs that become a person's individualized television program.

Narrowcasting is specialized programming that is directed toward a target audience.

Network era occurred from the late 1950s to the end of the 1970s when the three major networks dominated television content.

Remix is the ability of computers to combine text, video, images, and sounds.

Subjective or *psychological time* is the way in which we feel or experience time.

User generated content is material that is created by individual users rather than television or film companies.

Zapping or *channel surfing* is a means of jumping back and forth between channels or clicking through the channels to find something that catches the viewer's attention.

☀ Digital Media

The widespread adoption of digital media has radically altered the ways in which people communicate with each other. Traditional media are converging into a worldwide information network that can instantly send messages around the globe. Digital media add new visual symbols and icons to human communication. Software tools, such as desktop publishing, digital video editing, and HTML programming make it easier for both individuals and organizations to create visual and verbal messages. Presently, digital computer systems are used to retouch photographs, create visual imagery, and edit video. In contemporary society, many visual messages are created, assembled, and, in most cases, distributed through digital technologies.

In digital communication, a significant change occurred when computer interface design shifted from text-oriented to graphical interfaces. Graphical display screens help make digital media easier to operate. But more important, they present information in a multimedia format that displays text, graphics, sound, and moving images. Digital interfaces that display multimedia have expanded the ways in which individuals use computer networks. For example, the World Wide Web is now a communication channel that distributes information about everything from college courses to the cheapest airline fares. Distance education, electronic commerce, e-trading, electronic newspapers, and online shopping are all different ways in which people use the web. Graphic designers who want to design interfaces need to know about interactivity and some interface theorists, such as Donald Norman.

GRAPHICAL INTERFACES AND DIGITAL DESIGN

In the history of computing, 1995 will be remembered as the year that Windows '95 was introduced. Launched on August 24, 1995, Windows '95 was a new and improved version of Microsoft's popular Windows graphical user interface software. *Advertising Age* reported that Microsoft spent $200 million on a mass-market global advertising campaign, running in more than 20 countries and in more than a dozen languages. Windows became an instant success, transforming text-oriented computer interfaces into graphical ones. However, behind the Windows '95 hype and hoopla was a 30-year history of interface research and development.

Historical Development of Interactive Computing

In the 1960s, Douglas C. Engelbart developed window-style display screens, the mouse, and interactive concepts that are major features of today's personal computers. Engelbart was a visionary. His decision to create interactive computing was driven by neither recognition nor financial gain. Instead, he was influenced by the catastrophic events of World War II and their emerging social commentary (see Barnes, 1997).

Specifically, Engelbart was moved by Vannevar Bush's 1945 article "As We May Think," which encouraged scientists to create peaceful technologies after the war. In the article, Bush described the creation of a new organizational information system to enable people to make informed decisions. Engelbart has devoted his life to developing these types of devices. Engelbart called his interactive computer system the "augmentation system," and he hoped it would provide society with a new tool to facilitate complex decision making in the postwar era.

To fund his augmentation project, Engelbart wrote and published his paper, called "A Conceptual Framework for the Augmentation of Man's Intellect," which has been reprinted in books. As a result of the article, he received money from the Advanced Research Projects Agency (ARPA). ARPA's funding was allocated as a response by the United States government to the Russian launching of Sputnik. In 1963, the "space race" was on, and funding was available for any project that could potentially place the United States in a technologically superior position to the Russians.

By 1968, Engelbart had a working prototype, and he demonstrated his vision of interactive computing at the Fall Joint Computer Conference in San Francisco. This turned out to be a seminal event in the history of computing because it inspired the next generation of computer developers. Engelbart and his team showed window display screens, the mouse, hypertext, and multimedia applications. However, two years later, major funding for Engelbart's vision began to disappear, and many members of his team left to go work at the newly formed Xerox PARC. (Type "Douglas Engelbart: The Mother of All Demos" into YouTube, http://www.youtube.com/watch?v=JfIgzSoTMOs)

Xerox hired computer scientists that were already experienced in networking and interactive computer systems to design the office of the future (see Barnes, 2007). For instance, they hired Alan Kay, and he set up a research team at PARC to develop graphical interfaces. As described in the first chapter, Kay's interface design model was called "Doing with Images Makes Symbols." In 1979, Steve Jobs took a tour of Xerox PARC and saw an immediate commercial application for Kay's interface technology. Jobs realized that by putting a graphical screen on Apple's Macintosh personal computer, it would make the Macintosh easy to operate.

The Macintosh, as conceived by its original designer, Jef Raskin, was to be a home "appliance," not a programmable computer. Raskin's concept was to create an easy-to-use computer with preprogrammed software applications. By adding a graphical screen to the system, it became "user-friendly." This term would later become the basis for a wildly successful marketing strategy to sell the computer. With the Macintosh, text, graphics, and icons could simultaneously be displayed on the same screen. The use of these visual elements in screen design is called a "world on the screen." Larry Tesler, one of the creators of the Macintosh interface, explained this concept:

> One way to think about it is if you play a video game, there is an illusion of space ships or of roads and cars, depending on the kind of game. The user who gets engrossed in the game starts operating as if they are really working in the real world, when in fact, they are only working in this imaginary simulated world created by a sequence of steps in the computer program. So, what we realized was that we could create an illusion, for example, of an office with folders and documents and file cabinets in the office. And that instead of having the user learn complicated and unfamiliar technological terms, we could use the metaphor of the office, for example, and talk about opening files and closing files and editing documents and other terms that were much more familiar to people. (Palfreman,1992, videotaped interview, Palfreman & Swade, 1991)

Shortly after seeing a prototype of the Macintosh, Bill Gates began developing Microsoft Windows. To date, Microsoft Windows has been the single most influential interface ever developed. Windows brought a graphical point-and-click style design to MS-DOS personal computer users. It created a new marketplace by making the PC user friendly. As interactive technologies advanced, Gates began to expand the Windows interface into the realm of interactive TV and digital devices. His goal is to make Windows the interface standard for all types of digital media.

Figure 11–1: The Macintosh interface was the first commercial graphical user interface, which used visual objects that were familiar to office workers. Author's screen capture.

MODELS FOR INTERFACE DESIGN

Graphical interfaces have become a popular method for interacting with digital media. Designing graphical interfaces requires designers to develop conceptual models to present information and enable people to access it. The issue of interface design is not only an aesthetic one. For example, when graphic artists use computers, they must learn to work with the visual symbols displayed on the screen. Desktop publishing programs, such as PageMaker, use icons and metaphors that are familiar to traditional graphic artists. For instance, PageMaker, later InDesign, recreates an artist's drawing table on the screen and applies a book metaphor to the organization of individual documents. The use of metaphor and mental models is important in interface design.

Cognitive scientist Donald A. Norman (1988) has identified three different features of a conceptual model that interface designers must consider: design model, user's model, and system image. The design model is the designer's conceptual view of the interface. The user's model is produced as users interact with the design. Finally, the system image is the physical structure of the design, which includes the documentation, instructions, icons, and labels.

> The designer expects the user's model to be identical to the design model. But the designer doesn't talk directly with the user—all communication takes place through the system image. If the system image does not make the design model clear and consistent, then the user will end up with the wrong mental model. (Norman, 1988, p. 16)

Mental models are the models that people have of themselves, others, the environment, and objects with which they interact. An individual's mental models are created through experience, training, and instruction. The presentation of visual information through media can influence the development of a viewer's mental model. According to Renk, Branch, and Chang (1994), "Visual information presented to assist in the development of mental models must provide a visual model that is analogous to an actual system and allows the inference of causal relationships" (p. 82). Analogy-making is important in the process of developing mental models. Mental models develop through conscious information processing, and they are built from personal interpretations of existing knowledge.

In interface design, Norman (1988) said, "The mental model of a device is formed largely by interpreting its perceived actions and its visible structure" (p. 17). He referred to the visible structure of a device as its *system image*. When the system image is incoherent, it is difficult for people to easily use the device. For example, many people found it difficult to remember and type commands into a

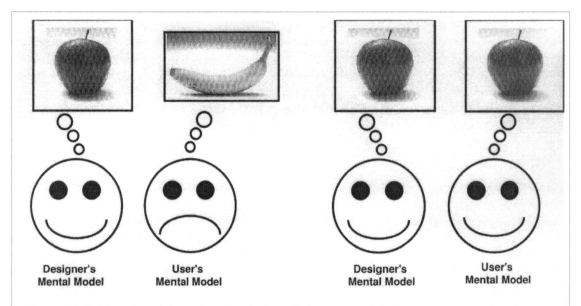

Figure 11–2: Mental models, such as the desktop, help users and designers conceptualize the same image or model. Author's illustrations.

text-oriented interface. In contrast, they found it much easier to point and click on visual icons that used office metaphors. Relating computer operations to office activities establishes a mental model that is easy to understand.

Visual Metaphors

As described in Chapter 4, a metaphor is a figure of speech in which one thing is spoken about in terms of something else. Simply stated, it is a comparison between things that are dissimilar. For example, if you compare a Macintosh computer to one running Windows, then you are making a literal

Box 11.1: Case Study: Conceptual Model of Microsoft Word

According to Donald Norman (1998), developing a good conceptual model is a fundamental aspect of good interface design. "Good designers present explicit conceptual models for users. If they don't, users create their own mental models, which are apt to be defective and lead them astray" (p. 177). The word processing program Microsoft Word uses an excellent conceptual model. The ruler on the top of the page with several sliding pointers is easy to understand. "What is particularly nice about the design is that I can experiment by moving each slider in turn and seeing what happens. As a result, I have formed a good conceptual model of the role the sliders play in the composition of the page" (pp. 177–178). When a slider is moved, a dotted vertical line drops down over the text to confirm that the slider adjusts the location of margins on the page. The sliders on the left move the left margin, and the sliders on the right move the right margin.

"The ruler starts and ends at the edge of the printed region of the document. Moving the mouse pointer to the downward-facing triangle and depressing the mouse button produces a vertical dotted line, helping define this triangle as the indentation for the first line of a paragraph and aiding the user in adjusting it to the desired value" (Norman, 1998, p. 177). Without knowing anything about programming, users can easily change the margins in this program.

comparison between similar things. In contrast, if you say that a computer is like a thinking mind, then you are creating a metaphor. Similar to a linguistic metaphor, a visual one points to a resemblance to something else. For example, the desktop metaphor makes a comparison between objects found in an office and computer commands.

The desktop metaphor is an electronic analog for an office. On the screen, small pictures or icons represent familiar office objects, including file folders, file cabinets, and in and out mail baskets. Objects displayed on the "desktop" are directly manipulated with a mouse. The original interface designers at Xerox PARC realized that it would be easier for office workers to operate a computer if the interface resembled objects from their normal working environment. Therefore, they adopted the idea of the computer screen as a desktop. Apple Computer later used the desktop metaphor for its Macintosh series of machines. Similarly, Microsoft adopted the desktop for its Windows computing environment. Today, most computer users work with a desktop interface (Windows or Macintosh) when they use their computers and connect to the Internet and World Wide Web.

Visual metaphors are used in a variety of software applications. For example, the Adobe Premiere software uses an editing metaphor. Video clips and sounds are electronically placed next to each other to resemble film editing. Some websites also use mental models to help people navigate through the site. Web designer David Siegel (1996) said that metaphors can act like glue to guide a visitor through a website and organize the material. However, the metaphors must be familiar, consistent, and appropriate for the site. "Metaphors pull in visitors, making them feel at home while giving them features to explore. Examples of metaphors include galleries, comic strips, television channels, magazines,

Box 11.2: In Her Own Words: Brenda Laurel

Bio: Brenda Laurel, PhD, is a formally trained actress and video game designer. She is a researcher, writer, and interactive media consultant. Laurel worked at Atari with Alan Kay and as a consultant to Apple Computer. Her books include The Art of Human–Computer Interface Design *and* Computers as Theatre. *In* Computers as Theatre, *Laurel (1993) proposed the metaphor of theater as a method for conceptualizing interface design.*

As researchers grapple with the notion of interaction in the world of computing, they sometimes compare computer users to theatrical audiences. "Users," the argument goes, are like audience members who are able to have a greater influence on the unfolding action than simply the fine-tuning provided by conventional audience response. In fact, I used this analogy in my dissertation in an attempt to create a model for interactive fantasy. The users of such a system, I argued, are like audience members who can march up onto the stage and become various characters, altering the action by what they say and do in their roles…. The problem with the audience-as-active-participant idea is that it adds to the clutter, both psychological and physical. The transformation needs to be subtractive rather than additive. People who are participating in the representation aren't audience members anymore. It's not that the audience joins the actors on the stage; it's that they *become* actors—and the notion of "passive" observers disappears.

In a theatrical view of human–computer activity, the stage is a virtual world. It is populated by agents, both human and computer-generated, and other elements of the representational context (windows, teacups, desktops, or what-have-you). The technical magic that supports the representation, as in the theatre, is behind the scenes. Whether the magic is created by hardware, software, or wetware is of no consequence; its only value is in what it produces on the "stage." In other words, *the representation is all there is.* (Laurel, 1993, pp. 16–17)

tabloids, store environments, museums, postcard racks, amusement parks, inside things (computer, human body, building, ant farm, and so on), safaris, cities, and cupboards" (pp. 35–36).

Metaphors must also be appropriate for the intended audience. For example, an arcade-like metaphor would not be appropriate for a virtual library or online magazine, unless it is a magazine about arcade games. Good metaphors will make a site easier to navigate. Conversely, bad metaphors will expect the user to learn a new set of commands to enter the information space. Simply replacing words with visual icons does not make a metaphor. The metaphor should be clear on the opening page and remain consistent throughout the site. Identifying the type of metaphor used in a site will also help to identify the purpose of the site.

HYPERTEXT AND THE WORLD WIDE WEB

When we move from the printed page to the web page, we need to learn the visual and verbal navigation tools built into hypertext documents. A key characteristic of the World Wide Web is its use of hypertext. Hypertext is a unique computer application. Unlike many software programs, such as spreadsheets, word processing, and desktop publishing, hypertext has no parallel application in the real world because it is unique to computers. Hypertext uses the computer's ability to enable readers to pick and choose blocks of text by interacting with the machine. Moreover, hypertext is a way of organizing information and navigating through information stored on individual computer systems and global networks.

Theodore Nelson coined the term hypertext in the 1960s to describe nonsequential reading and writing displayed on a computer screen. Nonsequential reading, as defined by Nelson, is text that branches and allows the reader to pick and choose blocks of text by interacting with a computer. Today, the term hypertext has been expanded to include a wide range of computer applications, such as interactive books, encyclopedias, online reference indexes, the web, and other forms of nonlinear reading and writing, which are created by means of computer technology.

These applications enable readers to interact with information by picking and choosing topics of interest as they navigate through hypertext documents. To read documents, people must learn to navigate and explore the text, rather than follow a page by page reading path. Learning hypertext navigational skills transforms the reader into an active information explorer who blazes trails through electronic information space. Trailblazing through blocks of electronic texts is in direct contrast to reading a single path of printed words. In other words, traditional books are linear with a single reading path established by the author. Conversely, hypertexts are nonlinear with multiple reading paths discovered by the reader.

Figure 11–3: Hypertext is a nonlinear method of connecting pages together on the World Wide Web. It is a unique application that did not exist before computers. Author's illustration.

Visual Elements and the Browser

Hypertexts have visual tools to help readers navigate through a document. Arrows enable readers to move sequentially from page to page in the document. Arrows pointing to the right move a page forward when you click on them with the mouse. Similarly, arrows pointing to the left move a page backward when you click on them. For example, the back and forward arrows on your browser's toolbar will take you back and forth between pages you viewed on the web. In contrast, back and forward arrows located on a web page will take you backward and forward between pages located on that specific site. Some sites break up text into small sections to make computer text easier to read. This is a technique used in some electronic journals or magazines. It is also a technique used to move between photographs in software programs.

This address will take you to the home page of the journal. A home page is the first page of a website. It generally introduces the user to the site and acts as a starting point for web explorations. When you first connect to your information service provider or university, the first page displayed on the screen will be the home page. For example, when I connect to the web from my office, the first page that appears on my computer screen is the Rochester Institute of Technology home page. In contrast, when I connect to the web from home and open Safari, the first page on my screen is the Apple home page. Users can choose the home page in many navigation programs; for example, if you connect through America Online (AOL), your home page will be AOL. The home icon on the browser toolbar will take you back to your home page. In contrast, a home icon on a website page will take you to the home page of that particular site. If you get lost or trapped in a site, clicking on the home button is one way to escape.

Besides these icons, the browser also has a printer icon. When using the web for research, you will probably want to print out the important documents that you find. Clicking on the print icon will print out web pages as they appear on the screen. Note that when printing on a black-and-white printer, text and graphics that do not have much contrast may not appear on the printout. Other visual tools include the binocular icon for searching topics and a stop sign that will stop a page from loading. The toolbars in a program have text labels underneath each icon to indicate what it does.

DEVELOPING VISUAL CRITICAL SKILLS FOR EVALUATING WEBSITES

Originally, the Internet was developed as an academic and research network. In contrast, the web has become a commercially oriented information space. As a result, the web is blurring the boundaries between information and commercial messages. Web advertising is designed to distract the reader away from media content toward commercial messages. Professional web designers create sites that will direct the reader toward certain messages and away from others. For example, web advertising attempts to distract the eye toward advertising banners and away from general information available on a site.

Web pages that have a consistent visual look convey a stronger sense of cohesive presence and credibility. However, the credibility of a website cannot be judged by its design alone because there are library and resource sites that contain credible information, but they do not "look" visually exciting. Similarly, there are commercial sites that are well designed and look credible, but they are actually parody or bogus sites. Therefore, students need to develop visual literacy skills to be able to distinguish between sites with great graphics and low quality information and sites with low quality graphics and great information. There are three aspects of web design that need to be considered when analyzing websites: content, design, and functionality.

Developing Websites

Developing a website requires the designer to find a balance between content, design, and functionality. The first step in web design is to develop the content for the site and identify the audience for the site. Considering the needs and Internet skill levels of potential site users influences both the content and design. For example, a community library site would want to emphasize local resources and events. Additionally, it should be designed for novice users. In contrast, a site developed to share a special collection, such as the Vatican Library's rare books, would want to support international scholarship and satisfy a global audience. Websites created with a specific purpose and audience in mind are much easier to identify than general purpose sites intended for use by many different types of people. When designing a site, the audience and purpose of the site must be clearly established. Functionality of a site can be diminished when users are unclear about the purpose and the type of information available. By turning recommended design guidelines for content, design, and functionality into questions, you will be able to critically examine websites from a visual perspective.

Content Questions

Sites designed for the access of information will make the amount of content located on the site clearly known. Additionally, the type of information available should be organized into logical units or document groups to help you easily find information. Moreover, the purpose and goals of the site should be clearly articulated. The following are content questions to consider in an analysis of a site:

- Does the site indicate the volume of information contained on it?
- Is the information arranged into logical units and document groups?
- Are the visual hierarchy and relationships among units obvious?
- Is it clear when reference materials are located on the site or linked to other sites?
- Are goals articulated for the different sections and pages of the site?
- Does the site provide full texts or abstracts?
- Are the images on the site protected by a copyright or watermark?

Content on some websites is visual rather than verbal. Digital library collections available on the web include The Vatican Library, The Library of Congress, The IBM/Andrew Wyeth Project, and the Yale University Beinecke (rare books). These sites will frequently place a watermark or embossed logo in the image. Watermarked images indicate that the material on the site is owned by the sponsoring organization. The images are available for viewing, but they cannot be reproduced. When images are copied, the watermark will appear. However, the inclusion of watermarks can indicate that the site is presenting original images with a high level of credibility.

Design Questions

Analyzing the design of a website involves looking at the overall design, the type used in the design, the use of animation and graphics, and visual manipulation. The first step in design analysis is to examine the visual hierarchy of the first page. Visual emphasis is accomplished through contrasts that stress the relative importance and separation or connection of graphic elements. To create a visual hierarchy, the designer must decide which component is the most important, less important, and least important. For instance, in advertising, the designer first decides whether the advertisement should be type-dominant or image-dominant. When the key selling message of the advertisement is stated in the headline, a type-dominant approach would be used. In contrast, if the product were the most important selling point of the message, an image-dominant approach would be better. The purpose of a visual hierarchy is to focus the eye on the most important component of the message being communicated.

A site that is well designed will look credible and reach its intended audience. To make a site work well, the designer needs to understand the web medium. For example, pages should be designed to fit the audience's reading styles and with an understanding about how people are going to use the information. This includes understanding if people are going to read online, download information into text files, or print it onto paper. Here are some critical questions to ask about the design of a website (see also Radford, Barnes & Barr, 2006):

- Does the site understand how users are going to read the material?
- Does the site have great graphics but little information?
- Does the site have a consistent look and feel? For example, are the headers and footers in the same location on every page?
- What types of logos are on the site? Are they corporate logos, software logos, or other types of logos?
- How do the logos relate to the site information?
- Is the page designed for the computer screen, or do you have to scroll through text?

Computer users often do not like to scroll through long passages of text (see Josephson, Barnes & Lipton, 2010). Therefore, large scrolling screens often reduce the functionality of a site. Similar to print media, type used in websites can create connotations that influence meaning making or how we understand a site.

The Web and Type

In contrast to print media, web browsers do not let designers determine the type style that appears on an individual user's computer screen, unless the type is saved as an image. Browsers display type on

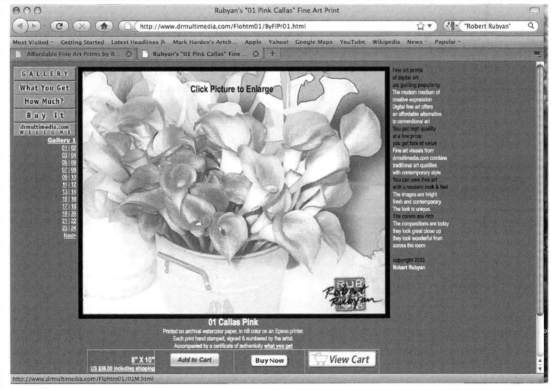

Figure 11–4: The website of graphic designer Robert Rubyan, who uses the site to sell his unique graphics. Used with permission.

the screen in different ways because each browser and computer system show type differently. Although the default typeface most browsers use is Times Roman, the size of the type varies between the browsers. For example, for Microsoft's Internet Explorer, the types size is "medium" or 14 point, while other browsers use 12 point. The monospace type used is Courier 12 point, and in forms or boxes, it goes down to 10 point. Because there are differences between browsers and systems, web pages will look different on different computers.

Moreover, people can change the default typefaces or sizes on their machines. This change could create a significant difference between what the designer sees on his or her screen and the way individual users view the page. When individual users change the default type styles in their browsers, a design can radically change because sans serif typefaces use less room than serif type. Shifting from a serif to nonserif typeface, or vice versa, could alter the layout of a page. The designer's ability to specify type styles helps to ensure that the web page will be easier to read. The readability of a site influences its credibility. Currently, it is difficult to read text on a computer screen; therefore, browsers are generally set with a default serif typeface because it has stronger character differentiation. Web designers who want people to read the text will try to make it legible or easy to print out.

Moreover, sites with full texts of important information, or texts converted from print to electronic formats, will often have a printing option. A printing option is an indication that the designers of the site think the material is valuable enough to be saved, printed, and read like traditional print-based materials. Look at the site design to see if it has considered the following:

- Is there enough contrast between the text and the background to print out?
- Is the type broken up into small paragraphs to make it easier to read?
- Does the type have different weights, such as bold and italic, to make it easy to skim the page for important points?
- Is the information designed to be read on the screen or is there a printing option to download the material and print it?
- Is the type in upper and lowercase or ALL CAPITALS?

People who write in all capital letters do not realize that it is difficult to read. More important, it is bad "netiquette," because in online chat and discussion groups, writing in all caps indicates shouting. If someone is shouting their message on a web page, it implies a lack of manners, and the designer of the site does not understand the rules of online behavior.

Web Animations and Graphics

Web designers use layout techniques and color to create visual hierarchies that move the eye around the page. However, the web also enables designers to add moving pictures, animated graphics, and video to their designs. When a moving image is placed on a web page, it automatically grabs our attention. Roger Black (1997) noted:

> There are certain hardwired facts about human visual response that you'd be a fool to ignore. Like if you put video on a page, a reader won't look at anything else. As animals we've evolved to be aware of any motion around us. It might eat us—or it might get us something to eat. (p. 121)

Web advertisers are aware of the impact of movement on a web page. As a result, many advertising banners that are displayed on sites use animation to grab the viewer's attention. Web advertising banners are deliberately designed to pull our attention away from the content of a site. Clicking on the banner will take you to another page of advertising designed to persuade you to purchase a product or service. Following the patterns of commercial print-based media, some websites sell advertising space to help support the site financially.

Software developments such as Java and Shockwave support the creation of web animations. However, many of these visual effects can be annoying rather than supportive of the design. Sites that use Shockwave and other visual gizmos often display logos for these products on their pages. Users who do not have the software players installed on their computers can generally click on the logo and go to another site that will offer a free download of the appropriate software applet to play the animation on their machine. An applet is a name for a miniature application that will run within the page of a browser. To view applets in a web page, the browser has to support it. Consequently, adding animations to a page can be annoying because not every browser can run the animation. Presently, the web is a medium still in development; applets keep changing, and the version of your browser may not support the latest and greatest ones appearing on the web.

Simple animations, called animated GIFs or multipart GIFs, are another way to add movement to a page. GIF is the acronym for Graphics Interchange Format, the standard image format of the web. As an image format, GIF is used for both still and animated pictures. Multiple GIF images can be combined into a single animation by using an animated-GIF-building program. These animations are small files that load quickly on a computer screen and work with most browsers. However, they can be distracting and will take the eye away from other visual elements that may be more important to the overall message.

Another way to create motion is to use the BLINK tag in an HTML document. A tag is an indicator that surrounds text and graphics to designate certain formats or styles. When the BLINK tag is placed before and after words in the document, the words will blink on the screen. This is a very simple way to draw the eye's attention to text on the screen. However, it should be used with caution because many viewers find blinking text annoying.

Finally, a number of sites include full video segments. For example, *The New York Times* adds video on the web to its print-based stories. With sites like Hulu, YouTube, and Google Videos, the web is beginning to resemble television. Motion can now be added in a number of ways from blinking words to full motion video.

Graphics and Visual Manipulation

Text, images, and color can set a mood or tone for a website. For example, a site using the default colors of black type, blue for links, and a gray or white background implies a "basic look" or the idea of plain information. People who want to make basic information available on the web might use this approach.

Today, the Internet is filled with distracting graphics and advertising. In contrast, when the Internet was first developed, it was primarily used as an academic and research tool. Information was presented only in text, and the Internet was compared to print media. Student access to information available on the Internet was primarily done through educational accounts. The text orientation and use of the Internet within the context of education made it appear to be a serious academic medium. However, once the web added point-and-click visual interfaces and graphics, the Internet began to resemble mass media, such as television and newspapers. As a result, the context of the Internet began to change. Currently, it is more difficult to visually distinguish between academic and commercial online information. The following are some final graphic questions that you should consider:

- Is the graphic designed to grab your attention?
- Is the image being used as a form of visual persuasion to make you think or feel a certain way?
- What type of emotional message does the image convey?
- Does the image complement and support the text?
- Is there a visual metaphor used in the site? What is it?

The visual metaphor applied to a site needs to be examined. Traditional media—newspapers, magazines, radio stations, television stations, and book companies—have developed many sites that provide information. Their websites will try to parallel the more traditional medium that they represent. For example, the CNN site has video and audio clips from its television station, and *The New York Times* site looks like the newspaper. What you understand about the traditional medium sponsoring a site can help you determine the site's credibility.

Functionality Questions

The ability to find information easily within several mouse clicks is an indication that a site is designed for functionality. Moreover, well-designed sites will have escape links to take you back to the home page of the site. Note that when doing a search, you can end in the middle of a site. Look for a visual or verbal link to the site's home page to find out more information about who is sponsoring the site and why. If you cannot find a link or more information, the information should be checked with another source. The following are critical questions based on design functionality:

- Is the site consistent with web conventions? For example, is the text black with blue links?
- Can you find relevant information within three mouse clicks?
 - Is the site easy to navigate?
 - Does the site use images to help you navigate?
 - Does the site provide a site map?
 - Does every page have a link back to the home page of the site?
 - Does each page have an identifying name (or logo), date, and contact e-mail address?

Finding a balance between functionality and design can be very difficult. For example, librarians who create sites often have to choose between overloading a page with information or organizing it into units that will require additional mouse clicks to access information. As a result, some highly legitimate sites with valuable information are not visually pleasing. On the surface, these pages do not attract our attention. We have to read the text carefully or scroll down the screen to functionally use the site.

Web Content and Design Issues

Currently, there is no gatekeeping on the web. In conventional media, gatekeepers are the people who decide what will appear in the media. In contrast, almost anyone can design a website to express his or her point of view—both good and bad. For example, in the United States and other countries, people have become concerned about the growing number of sites that contain "hate speech." Hate speech spreads racial bigotry, Holocaust denial, gay bashing, and other offensive points of view. These sites include the white supremacist group Aryan Nations; the Ku Klux Klan; and Resistance Records, a white power record company. Some of these sites are professionally designed, and many contain logo elements that reflect the point of view expressed in the site. These sites are often filled with images. Pay attention to the symbols because many of these groups use symbols as a form of identification.

The use of online metaphors can also be confusing. For example, a new trend in site development is the use of the virtual library metaphor by commercial companies. Using the metaphor of a library has obvious connotations of visiting one, and most of our physical libraries are nonprofit or educational. However, unlike traditional libraries, corporations and commercial companies are setting up many online libraries. Do not assume that all of the information you access through a "virtual" library is legitimate. Some of these sites have been established with the purpose of distributing a specific type of information. Moreover, the information accessible on this type of site could reflect a bias of the company that supports it.

The addition of advertising to the Internet is a major change that has developed since the introduction of the web. Profit-oriented sites need to run advertising on their sites to make money. On some of these sites, the advertising will dominate the page. You must click through pages of advertising to find any information. In the worst cases, the advertising will pop up in a window that covers the page. You must close this window before you can access information on the site.

Good web design will take you to relevant information within three mouse clicks; in contrast, manipulative designs will trap you in the site. In web marketing, *client pull* is a technique of taking over a viewer's browser and taking users to a website the designer wants them to see. For example, when designers use the HTML programming code called META, the code tells the browser to go to the next page in the site or to go back and forth among the pages. This simple programming trick can trap you in a website, dragging you deeper and deeper into the site with no apparent escape.

A number of websites are portal sites designed to attract mass audiences. These sites include the search engine Yahoo!, CNN, and NBC. The home page of a portal site is designed to get people deeper and deeper into the site. Instead of browsing the many different sites on the Internet, these sites want people to stay or "stick" with their site. Therefore, they are designed to keep you locked in the site and discourage you from leaving. For example, when using Yahoo! as a search engine, you may have to click several times through different screens before you reach a list of links to other sites. While you are clicking, the advertising banner at the top of the page will change to an advertisement that relates to the topic for which you are searching. Although Yahoo! is a popular search engine, it is also a commercial site that is carefully designed to make you notice its advertising (see Josephson, Barnes & Lipton, 2010).

The visual manipulation strategies used in commercial advertising are now being applied to websites. Some sites visually resemble older media, and their advertising techniques are obvious. In contrast, other sites are incorporating new types of programming and animation tricks to grab attention and manipulate how people browse the web. However, a visual phenomenon that is occurring on the web is visual parody. Visual parody is imitating the visual look of another website and exaggerating the content of the original in a ridiculous way.

Common sense and awareness of visual design tricks should help you better understand the purpose of a website and the message it is trying to communicate. As the web becomes a more mainstream medium, you will need to develop a set of critical visual skills to understand the medium and how its images and icons are used to manipulate and persuade.

Other approaches for analyzing web design are eye-tracking (Josephson, 2010), rhetorical (Foss & Kanengieter, 1992; Peterson, 2010), and usability (O'Connell, 2010). Eye-tracking uses eye-tracking apparatus to record the location and duration of individual eye fixations (Josephson, 2010). Foss and Kanengieter (1992) identified three steps in the rhetorical process: (a) identification of the presented elements, (b) processing of the elements, and (c) formulation of the message. Traditionally, eye-tracking and rhetoric have been used to examine pictures. However, in the digital age, usability testing is a topic that brings together graphic designers with information technology specialists. "[Usability] is part of the evaluation of every stage beginning with needs analysis and interface design straight through to development and deployment" (O'Connell, 2010, p. 124). Thus, usability testing is a topic that all web designers need to be aware of, especially designers working in the advertising industries.

Web Advertising

In 14 short years, Web advertising has evolved from banners to experiential promotions (see Barnes & Hair, 2009). In the beginning, advertisers viewed the Internet in similar ways as they considered traditional media (television, newspapers, magazines). In 1998, advertising practitioners began to realize the potential of web communities. Connie Guglielmo (1998) stated: "On the Web, the best

customer is a sticky customer, a consumer who has developed an affection, affinity or addiction to a site that compels him or her to return there often" (p. 35). Additionally, Holland and Baker (2001) argued, "Virtual communities capitalize on the interactivity and many-to-many communications potential of the Web" (p. 40).

Similarly, interface designer Jakob Nielsen (1997) said: "The Web is not like TV. Most fundamentally, the Web is a user-driven narrow-casting medium utilizing low bandwidth with high flexibility, whereas television is a broadcast mass-medium utilizing high bandwidth with little flexibility" (para. 2). A central difference between the web and television is that a large percentage of material distributed on the web is user generated, such as the videos found on YouTube. In 1999, rich media or streaming video became a driving force in web development. Advertisers were waiting for online videos to reach the level of television commercials. Finally, the technology was more widely adopted, and BMW released a series of films on the Internet using well-known actors. These can still be viewed on YouTube (see http://www.youtube.com/watch?v=srrbvNNUKrA).

Newer developments in web advertising include the following: advertising in blogs, using keyword searches in search engines, taking advantage of viral marketing, advertising in social networks, and offering user generated content. Viral marketing is "using customer communication as a means of multiplying a brand's popularity through customers spreading the brand name" (Henning-Thurau, Gwinner, Walsh & Gremler, 2004, p. 39). One of the first viral campaigns was the Anheuser-Bush "Wassup" campaign. Bannan (2000) stated: "Although the ads originally launched on TV, the campaign gained momentum on the Web with lightning speed" (p. IQ20). (The Budweiser "Wassup" campaign can be viewed at http://www.youtube.com/watch?v=ikkg4NobV_w)

Advertising in social networks has been a controversial topic. Using information from social network profiles to target advertising toward consumers could be considered a breach in privacy. Organizations are faced with the challenge of consumer acceptance regarding what is considered a legitimate use of the platform for promotional purposes. Although it is generally seen as acceptable to promote oneself in a social network, the corporate use of social networks has also been increasing.

INTERACTIVE MEDIA

Today, the popularity of the web often overshadows other types of interactive media, such as CD-ROMs and computer games. However, the widespread use of computer and video games should not be neglected in a discussion of interactive forms of communication, especially because these are visually oriented media.

Video Games

Nolan Bushnell, who founded a company called Atari, developed the first video game in 1972. The company sold $13 million worth of video games in its first year. Atari's game called Pong was the first electronic game and the starting point for the future of interactive home video game systems (Sega, Nintendo, PlayStation, Wii).

The sophisticated graphics used in interactive games have suggested new strategies for designing computer interfaces. Users become very involved with the space represented on a computer screen when they are playing games. In fact, science fiction writer William Gibson invented the word "cyberspace" from observing kids playing video arcade games. Gibson described video games as "a feedback loop with photons coming off the screens into the kids' eyes, neurons moving through their bodies, and electrons moving through the video game. These kids clearly *believed* in the space games projected"

(McCaffery, 1992, p. 272). Gibson observed that video game kids and computer users seem to develop a belief that there is some kind of *actual space* behind the screen. It is a "nonspace," a hyperdimensional realm that we enter through technology, a place Gibson called cyberspace.

Besides inspiring future visions of technological design, video games also rely on older visual conventions. For example, some game designers engage the user in a three-dimensional space by immersion through linear perspective and a first-person point of view. Additionally, many video games are played on television sets. According to Bolter and Grusin (1999), "The game units co-opt broadcast television to offer a kind of entertainment whose characteristics include simple but violent narratives and tightly coupled interaction between the player and the screen" (p. 92). For younger viewing audiences, the interactivity of video games seems to be an improvement over conventional television. The use of joysticks, keyboards, and trackballs heightens the player's sense of control over the image. However, the action style of video games is influenced by television genres and, in some cases, television shows have been transformed into computer games (*Wheel of Fortune, Jeopardy, Do You Want to Be a Millionaire?*). Television games that use explicit rules can be readily transformed into computer games. Often the television host is captured virtually through sound bites, video clips, and photographs.

In an early study on the effects of video games, Patricia Markes Greenfield (1984) argued that children growing up with television preferred dynamic visual imagery, and this is one reason they were attracted to video games. A second factor is interactivity, because what happens on the screen is not entirely determined. She said, "Video games are the first medium to combine visual dynamism with an active participatory role for the child" (p. 101). Moreover, she contended that skills and habits developed while watching television are useful for playing video games:

> Pictorial images in general tend to elicit parallel processing, while verbal media, because of the sequential nature of language (you read or hear one word at a time), tend to elicit serial processing. In television there are frequently several things happening on the screen simultaneously. (p. 112)

As a result, children whose primary medium is television might be better prepared to play video games because they have experienced the parallel processing of information.

Greenfield suggested that before the arrival of video games, the generation growing up on film and television were placed in a bind because their most active form of expression, writing, did not have the visual dynamic quality of film and television. People could watch these media, but they could not easily create films or videos. However, with the advent of affordable video equipment and desktop video software, individuals now have the tools to dynamically express themselves using sight, sound, color, and motion. YouTube is an example of the popularity of self-expression. In addition to presenting information in multimedia formats, digital media also provide tools for individuals to create multimedia messages.

Social Media

In 2006, social networks changed the landscape of the Internet. These networks make visible the social relationships between people and enable individuals to share multimedia information (see Boyd & Ellison, 2008). According to Pew American Life, approximately 94% of teens ages 12 through 17 are using the Internet or e-mail (Lenhart, Madden, Macgill & Smith, 2007). These teens have more access to higher speed connections and personal computers than any generation before them. Furthermore, teens have more accessibility to friends and family through social networks, smart phones, and cell phones. These media are visually oriented because smart phones and social networks use graphical user interfaces.

NEW MEDIA THEORY

New media is a term that refers to an array of new digital technologies, including CD-ROM, DVD, interactive television, the web, social networks, and virtual reality. When a new medium of communication is introduced, it frequently emulates older media. For example, the Internet was originally considered a medium for electronic publishing, and the web often incorporates features that are similar to television. However, one of the unique characteristics of the computer is its multimedia capabilities that enable one single medium or monomedium to record, store, and transmit text, photographs, graphics, moving pictures, and sound. Messages that were conveyed through a variety of media, such as books, television, and film, can now all be converted into digital formats and distributed through computer networks.

Immediacy, Hypermediacy, and Remediation

Bolter and Grusin (1999) coined three new terms to explore the implications of new digital media: immediacy, hypermediacy, and remediation. Underlying these terms is the idea that the purpose of media is to transfer sense experiences from one person to another. The more "transparent" the medium, the easier it is for people to immediately receive the message. For example, immersive virtual reality systems (see Chapter 12), in which users wear a helmet with eyepieces, attempt to make the user forget that he or she is wearing a computer interface and interacting with a computer generated image. Virtual reality enthusiasts promise people transparentness, a perceptually immediate experience in which people forget that the event is a mediated one. This logic also can be applied to two- and three-dimensional film, television, and computer images. For example, computers help generate animation and special effects for film and television that are extremely realistic. Similarly, videoconferences could lead to more effective communication than telephone calls because, in addition to language, nonverbal cues are also being transmitted.

Box 11.3: In His Own Words: Jay David Bolter

Bio: Jay David Bolter, PhD, is a professor at Georgia Institute of Technology. He is the coauthor of the hypertext authoring software program called Storyspace. *Bolter has written several books on computers and culture, including* Turing's Man: Western Culture in the Computer Age *and* Writing Space: The Computer, Hypertext and the History of Writing.

Computer-controlled multimedia programs might be positioned at the near edge of cyberspace. The term multimedia is often eschewed both by computer scientists and by cybernauts because it smacks of kiosks and other business applications. Nevertheless, multimedia applications, especially information kiosks and training programs, are like other programs in cyberspace in the sense that they use text sparingly, if not grudgingly. A typical multimedia application relies for its rhetorical effect principally on video and graphics and secondarily on sound. Words are used most often as captions for graphics or to identify buttons. Like the label on an icon in a desktop interface, the text on a button is as much operational as referential. The words function as a magic formula: When the user clicks on the words, he or she calls forth some other graphic or video. In other cases, text in multimedia is confined to rectangles and used to communicate only what cannot be pictured easily. Multimedia designers consider it an admission of failure to clutter the screen with blocks of text. The worst criticism one can make of a multimedia system is to call it a mere "page turner," a set of texts that the user examines one after another—in other words, the electronic equivalent of a printed book. (Bolter, 1996, pp. 106–107)

Graphical interfaces illustrate the principle of immediacy. The desktop metaphor attempts to transform the computer screen into a desktop, which relates computer operations to familiar office activities. Additionally, "the mouse and the pen-based interface allow the user the immediacy of touching, dragging, and manipulating visually attractive ideograms. Immediacy is supposed to make this computer interface 'natural' rather than arbitrary" (Bolter & Grusin, 1999, p. 23). Interface designers are trying to make interfaces transparent to the point at which users are no longer aware that they are confronting a medium, but instead they develop an immediate relationship with the content presented through the medium.

With the addition of multimedia characteristics to hypertext systems, some authors group interactive applications under the category of hypermedia. Hypermedia is the combination of random access and multiple media types. In a sense, hypermedia can be viewed as the marriage between television and the computer. Bolter and Grusin (1999) stated, "If the logic of immediacy leads one either to erase or to render automatic the act of representation, the logic of hypermediacy acknowledges multiple acts of representation and makes them visible" (pp. 33–34). Immediacy implies creating a unified visual space; in contrast, hypermediacy presents mixed spaces. With hypermediacy, representation is not imagined as a window onto the world; instead, it is "windowed," and information windows open other media and representations. Multiple windows simultaneously presenting different types of information is a form of hypermediacy. "The logic of hypermediacy multiplies the signs of mediation and in this way tries to reproduce the rich sensorium of human experience" (p. 34). In contrast to immediacy that makes us forget that we are interacting with a medium, hypermediacy often makes us aware of the medium.

The proliferation of media within our culture leads to the "repurposing" or borrowing of content from one medium to reuse in another. However, when this is done, the reused content can redefine the material. Additionally, one medium can become incorporated or represented within another. Bolter and Grusin (1999) called this *remediation*. They argued that remediation is a defining characteristic of digital media because digital media remediate their predecessors and create a rivalry between new and old media. For example, electronic encyclopedias offer improved versions of printed encyclopedias and add the bonus of electronic linking and searching and video clips. Additionally, new media can entirely absorb the older medium. For example, computer games, such as football or adventure games, remediate cinema, and these games are considered a type of interactive film because players become characters in the narrative. Similarly, they argue that the web remediates television because numerous websites borrow the monitoring function of broadcast television. Digital cameras that broadcast video streams from various places around the world through the web resemble live television broadcasts. Moreover, many websites have adopted the use of advertising in ways that are similar to commercial television.

Many objects found on websites present various elements used in conventional media. Conversely, new media are beginning to influence older media. For example, televised news programs feature multiple video streams, split-screen displays, and composites of graphics and text. Programs, such as *CNN News,* broadcast live images through both network television and the web (Skype). A portion of news television broadcast is devoted to e-mail reactions to the program and responses to stories through the Internet. As a result, digital media both incorporate older media and transform it.

SUMMARY

The widespread adoption of digital media with user-friendly interfaces has transformed computer technology into a major new communications medium. However, unlike older media that often emphasize one type of symbolic form over another, for example, text in books and visuals on television, the computer combines all types of symbols together into one monomedium. The visual aspect of websites

requires students to develop critical visual skills to understand the purpose of the site and the credibility of the information. Theories, such as remediation, are emerging to help students better understand the nature of digital media and how it is different from older forms of media.

Designing interfaces requires the designer to do more than organize pretty images and text. Designers need to understand interactivity and how cognitive models work. Digital media add new areas of study to the graphic design process.

WEBSITES

- *Web Style Guide*
 http://www.webstyleguide.com/wsg3/index.html
- *Web Page Design for Designers*
 http://www.wpdfd.com/
- *Style Guide for Online Hypertext*
 http://www.w3.org/Provider/Style/Overview.html
- *Developing Critical Web Skills*
 http://lib.nmsu.edu/instruction/eval.html
 http://www.vuw.ac.nz/~agsmith/evaln/index.htm
- *History—Douglas Engelbart*
 http://www.youtube.com/watch?v=JfIgzSoTMOs
- Type "Vannever Bush" into http://www.youtube.com to find historical clips on the memex.

EXERCISES

1. Pick a software program that you frequently use, such as a word processing or desktop publishing program, and analyze its interface. What metaphors are utilized? How does the program visually relate to the analog activities it replaces? What problems do you have when you are working with the program? Write a memo to the software designer with your recommendations on how to improve the interface of the program.

2. Using the content questions presented in this chapter, analyze several websites. Write a report about the strengths and weaknesses of each site.

3. Find examples of websites that you think are easy to navigate. Have several other students in the class navigate the same site. Discuss your experiences together.

4. Select a video or computer game. What type of game is it? What is the story or narrative structure of the game? How does this game relate to older media, such as television or movies? Think about how the text interacts with the action.

5. Bolter and Grusin argued that digital media remediate older and more conventional forms of media. Examine websites such as MSNBC and CNN and describe how these sites incorporate older forms of media. Compared to conventional media, how do these sites alter or change the ways in which content is presented? What are the similarities and differences between the digital medium and conventional media?

KEY TERMS

Desktop metaphor is an electronic analog for an office. On the screen, small pictures or icons represent familiar office objects, including file folders, file cabinets, and in and out mail baskets that can be directly manipulated by a pointing device called a mouse.

Desktop video is a computer application that enables people to create multimedia productions,

Graphical user interfaces utilize icons and pictures as a method of interacting with a computer. This type of interface is considered to be "user friendly" because users do not have to remember and type complicated command sequences.

Hypermedia is the combination of random access (hypertext) with multiple media (multimedia).

Hypertext is an application that is unique to computers because it uses the technology to enable readers to pick and choose blocks of text by interacting with the machine.

Immediacy is when a medium becomes transparent to the point in which users no longer are aware of the fact that they are confronting it, but instead they develop an immediate relationship with the content presented through the medium.

Mental models are the models that people have of themselves, others, the environment, and objects with which they interact.

Monomedium refers to the capability of computers to record, store, and transmit text, photographs, graphics, moving pictures, and sound in a single medium rather than a complex of different media.

New media is a term that refers to an array of new digital communication technologies that are appearing on the media landscape, including CD-ROM, interactive television, the World Wide Web, and virtual reality.

Remediation is when one medium is incorporated or represented within another.

Repurposing is the borrowing of content from one medium to reuse in another.

System image refers to the visible structure of a device.

Viral marketing is using customer communication as a means of multiplying a brand's popularity and awarenesss through customers spreading the brand name, especially on the Internet.

☀ VISUAL COMMUNICATION IN CULTURAL CONTEXTS

The final section of the book deals with visual technologies and cultural contexts, starting with the new technology of virtual reality and ending with issues that face contemporary culture with the introduction of digital technologies. Included in this section are discussions about advertising and the role of visual media in education. These chapters attempt to place visual media in the contexts in which they are influencing culture today.

☀ Emerging Visual Contexts

Virtual Reality and Digital Culture

Over the past 150 years, image technologies have advanced from photography to virtual reality devices. With the invention of photography came the promise of a picture that was more factual than hand-produced artwork. A distinction was made between realistic photography and imaginary or interpretive illustrations. However, digital technologies are altering photography's role as a factual recorder of events. In contrast to photography's ability to capture historical moments and facts, digital technology can easily make copies of copies and create images of images. Moreover, digital technology can mix historical and current images together in ways that conflict with more traditional notions of reality. For example, Natalie Cole's music video *Unforgettable* has Natalie singing a duet with her deceased father Nat King Cole. Recent television commercials also mix classic film footage with contemporary actors. These digital techniques make us more aware and self-conscious about the ways in which images are constructed.

Digital technologies alter, improve, and combine visual elements together in ways that are not possible in the real world. Besides altering the ways in which images are created, digital technology, such as virtual reality, changes the ways in which people interact with images. Virtual reality (VR) can immerse people in a computer-generated environment that may or may not resemble an actual one. By simulating reality, VR can communicate information to people in ways that are not possible in the real world.

VIRTUAL REALITY SYSTEMS

Virtual reality is a term that has no clear definition because it is used to describe the following: interface hardware (e.g., head-mounted displays), software applications (e.g., medical imaging), an emerging entertainment industry, and the cultural environment developing around VR technology. According to Frank Biocca and Mark Levy (1995), the phrase virtual reality increasingly refers to an emerging

communication system. Used as a communication system, VR refers to a wide range of methods for interacting with computers. VR products include three-dimensional software, games, helmets, body suits, and data gloves. "In addition to visual data on screens or through stereoscopic goggles and auditory data through headphones or speakers, some advanced systems also offer tactile feedback through wired gloves" (Moran, 2010, p. 281). VR products are being marketed for entertainment, educational, medical, and industry use.

A distinction is made between immersive and nonimmersive VR systems. Looking at a computer monitor is categorized as nonimmersive VR because users can still see the physical room around them; an example is Second Life. In contrast, immersive VR technology literally immerses the user in a computer-generated environment. Utilizing helmets and glasses, the user's vision is confined in the virtual world, and the physical one is not seen.

Biocca and Levy (1995) have developed a model to illustrate how VR is used as a communication system. The model includes three components: the interface, transmission channels, and the organizational infrastructure. In this VR model, the communication interface consists of the physical media, the codes, and information plus the user's sensorimotor channels. Different types of VR devices engage different human senses; for instance, helmets engage the visual sense, and data gloves involve gesture and sometimes tactile sensations.

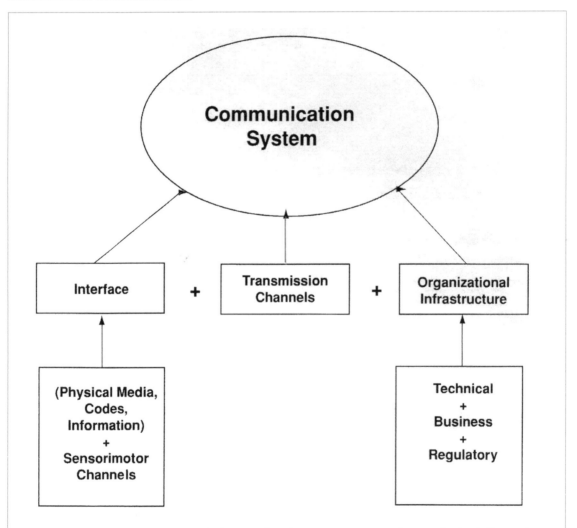

Figure 12–1: Biocca and Levy Model of a Virtual Reality Communication System. Author's illustration.

The growth of VR systems is linked to changes in the transmission channels used to distribute information. For example, some VR systems are connected to the global Internet while others are connected to the microworld of a microscope. The infrastructures associated with VR communication systems include a network of computer research; regulatory, financial, and production infrastructures; and support organizations. For instance, the institutional needs of military and space programs provided the rationale for the early development of VR systems, including flight simulation and telerobotics. Telerobotics is the control of robots at a distance in military, nuclear, space, and oceanographic applications. The virtual worlds entered by users through telerobotics are designed to communicate information. For example, telerobotics systems are designed to help astronauts repair spaceships. Presently, VR is most often used as a serious communication medium to convey scientific, medical, and design information.

Virtual Reality and Communication

Architects, designers, and engineers use immersive and nonimmersive three-dimensional VR systems to bridge the gap between the designer's vision and the finished product. Virtual models of buildings enable architects to "walk through" a visual version of a building before it is built. These VR programs help architects identify potential design flaws before construction begins. Computer-Aided Design (CAD) systems help designers and engineers create automobiles. In the sciences, virtual wind tunnels enable engineers to check the aerodynamics of aircraft wings and sailboat keels.

In medical schools, VR systems enable students to practice surgery on simulated rather than real patients. According to Aukstakalnis and Blatner (1992), "From anatomical interrelationships to practicing difficult operations, a virtual surgical simulator is a powerful tool" (p. 213). Medical simulation is intended for use as a teaching tool, and VR enables medical students to explore a model from many different angles. In VR, anatomical structures can be evaluated in ways that are not possible in the real world because, when patients lie down, their organs can be viewed from only one side. Using VR, medical students can study anatomy by exploring the inside of the human body.

A variety of other medical uses for VR systems include overcoming phobias, physical rehabilitation, and empathic awareness. VR is being used to help people overcome phobias, such as acrophobia (fear of heights) and aerophobia (fear of flying). When patients are "virtually" exposed to situations that cause anxiety, the anxiety often decreases as patients spend more time in the simulated fear. Researchers using VR systems report that subjects who complete the VR treatment report a significant improvement when faced with their phobia in real life.

VR is also being used to help people during physical rehabilitation. Data gloves connected to computer systems can evaluate patient hand motion, and the results are turned into a rehabilitation process. Greenleaf (1997) said, "Real-time visual and auditory feedback can also be used to train the patient to avoid high-risk postures in the workplace or at home" (p. 44). Pioneers of medical VR hope that this technology will help restructure the rehabilitation process into smaller incremental steps, make rehabilitation more realistic and less boring, facilitate home rehabilitation, and provide an index for daily mobility. Besides helping patients, VR can also help therapists.

Medical VR is used as a communication tool to help therapists better understand the conditions of their patients. For example, Responsive Virtual Environments (VE) are designed to facilitate empathic awareness. Empathic awareness enables an individual to enter the private perceptual world of another. For instance, people with brain injuries can suffer from visual degeneration. It is difficult for others to imagine the perceptual worlds of these patients, and VE can be developed to let therapists experience the visual impairments of other people.

For example, Rita Addison, who suffered a brain injury as the result of a car accident, used her background in clinical psychology and photography to create an immersive environment called DETOUR: Brain Deconstruction Ahead. The program was created with the hope that participants could share the altered sensorimotor world that she experiences. Using images of Rita's nature photography taken before the accident, participants first see the world as it appeared to Rita prior to her injury. "Next they are shown medical imagery intended to suggest the neural damage that occurred as a result of the accident, and finally, participants again see Rita's photographs, now distorted by numerous perceptual anomalies experienced by Rita and other TBI (traumatic brain injury) survivors" (Zeltzer & Addison, 1997, p. 62). With virtual environments, participants can develop a stronger understanding about other people and experience empathic awareness.

Virtual Reality and Entertainment

In additional to these practical communication uses, VR systems are also being developed for the entertainment industries. Film studios, amusement parks, video game designers, and toy manufacturers are all interested in how VR systems could be applied to entertainment. Sit-down VR units have been developed as games to simulate flying a fighter aircraft or driving a racecar around a track. Some VR games are being developed to be played by more than one person. For example, Virtual Racquetball can be played against the computer or another player. The possibilities of shared virtual realities go beyond simple games and extend into fantasy games played by multiple players through computer networks, such as World of Warcraft.

Researchers are already investigating how storytelling will be used in virtual environments to create a new form of dramatic narrative. Meyer (1995) said:

> VR creates a world that may be occupied in a way not possible in other media. In particular, VR allows the audience to walk on the stage of the drama and interact with the fictional world. This interactive quality conflicts with the exacting structure of drama, and the conflict between structure and interactivity is a decisive factor. The interactivity must be constrained to preserve the dramatic structure; in other words, being audience to a VR drama is essentially passive with respect to the story. However, the audience may interact with other elements of the world of the story. This level of limited interaction will give rise to VR drama's unique narrative qualities. (p. 219)

The interactive quality of VR stands in opposition to the fixed structure of drama, novels, or film. Film audiences are passive viewers of the unfolding plot. In contrast, VR audiences can interact with elements in the world of the story. "This level of limited interaction will give rise to VR drama's unique narrative qualities" (Meyer, 1995, p. 219). Many entertainment applications are being explored for emerging VR systems. Some of these systems can already be found in theme parks, casinos, and shopping malls with VR game centers.

Virtual Reality Systems and Social Concerns

Although VR is a new technology, many physical and psychological problems have been observed about its use. For example, it has been reported that "scientists are now discovering that nearly 60 percent of the people who immerse themselves in a virtual world suffer side effects for hours after their trips" (Memon, 1995, p. 36). The most obvious physical problem is eyestrain because VR is primarily a visual tool. Wearing a head-mounted display (HMD) displaces the user's "virtual" eye position forward and above. The effect of wearing an HMD is similar to wearing someone else's eyeglasses. The prescription may be the same as yours, but the other person's eyes are farther apart. This creates a sensory rearrangement called *intersensory conflict*. Biocca and Rolland (1995) said the following:

> Sensory rearrangement is a change in the normal relationship between body movements and the resulting inflow of sensory stimuli to the central nervous systems. It can also result from discoordination of one sensory inflow pattern with that of another sense, for example a mismatch between vision and touch. (n.p.).

However, the most frequent complaint about VR is motion sickness, because the body often overcompensates in a virtual world.

Essentially a VR system is motion interaction with computer graphics. As a result, there are potential effects on the body's vestibular system or its sensors for movement. Some VR systems, such as flight simulators, often cause motion sickness because they simulate the sensation of flying. Complaints of eyestrain and motion sickness could make it difficult to turn VR systems into consumer products. For example, it has been reported that the Sega Company canceled plans to develop a game using an HMD after a study of people's reactions to the product.

Beyond eyestrain and motion sickness, people often have aftereffects from being in a virtual world. Schroeder (1996) said the following:

> Another problem concerns the aftereffects of VR use. One solution that has been suggested for this is "cooling-off periods." If, for example, after spending lots of time using a VR system, the user wants to drive a car, a certain period of rest ought to be allowed first for regaining a sense of the real world. (p. 94)

It is unclear whether a "cooling off" period would solve the afterimage problem associated with VR use. Moreover, this solution implies that VR is similar to alcohol or drug abuse and it could create public anxiety about VR technology.

Both the conscious and unconscious impact of VR on people is a topic for discussion. For example, Cartwright (1994) argued that possible psychological consequences of VR could include the following: residual memories that distort the real world, the creation of a virtual ego-center that decenters the sense of self, and the altering of human consciousness. People in virtual environments, who experience events that are outside their range of usual human experience, such as war, rape, and natural disasters, could suffer from post-traumatic stress disorder (PTSD). PTSD occurs after a person has experienced a traumatic event, such as a flood, fire, war, or rape. After experiencing the event, the person may suffer stress-related symptoms, such as recurrent distressing dreams, repeated recollections of the event, flashbacks, and intense distress. Harris (1994) said the following:

> Virtual reality increases the ease of experiencing events "outside the range of usual human experience," since the programmer is limited only by his or her ability to make the event appear real. If those events are "psychologically traumatic" ones, then virtual reality can become not necessarily a form of recreation, but a means of fostering Post-Traumatic Stress Disorder. (n.p.)

In contrast to these concerns, other researchers argue that VR could be beneficial for people if it is used in a supervised medical context.

A basic overview of the advantages and disadvantages of immersive VR suggests that immersive VR technology should be used under supervision and for short periods. Long-term exposure to immersive VR could have unwanted physical and emotional side effects. Used as a tool for specific types of therapy and medical and scientific communication, VR environments could help people recovering from illness and explain injuries to others who are involved in the treatment process. Therefore, an important aspect of VR research is a critical examination of how it is going to be used.

ANALYZING VIRTUAL REALITY

Visual communication theorist Herbert Zettl (1996) has already begun to explore approaches for examining the VR experience. He argued that a brief analysis of VR environments includes three approaches: (a) a media-aesthetic or phenomenological approach, (b) an ontological approach, and (c) an ethical approach. Zettl's aesthetic approach to VR builds on his previous visual communication theories about film and video (see Chapter 10). However, VR systems are different from film and video

in two important ways. First, VR users experience the perception of motion. Second, the role of sound and the structure of images in VR are unlike other visual media. In contrast to images fixed from a specific point of view, VR users can alter their view of a scene. In terms of ethics, Zettl is concerned about the freedom of choice within the parameters of computer-programmed VR and the ethical issues associated with virtual worlds.

In a media-aesthetic analysis of VR, the representation of three-dimensional space needs to be examined in terms of motion simulation and the spatial aspects of sound. According to Zettl, there is little difference between the use of perspective in Renaissance paintings and its use in VR. However, one difference is the speed in which VR software can change the image. In contrast to film and television that have a fixed point of view, VR shifts the point of view. Users are in control of the ways in which they view a scene. For instance, VR HMDs allow users to view a scene from different perspectives. When a user tilts their head up, they may see an object from below, and when they tilt their head down, they see it from above. By turning the head, the view of the landscape changes.

Presently, VR viewpoints are limited and determined by the sophistication of the computer system. In both nonimmersive and immersive VR, movement is activated on the display screen, and the user remains fixed in actual space. Nonimmersive environments are manipulated with a joystick or mouse. In contrast, movements in immersive environments are activated through hand and head movements (dataglove and HMD unit). The kinesthetic sensations and processing of the figure/ground relationship in immersive VR make it feel as if users are actually moving though space. As a result, users experience the sensation that space is moving past them. Sound techniques have also been developed for VR software to localize sound and enhance the sensation of motion. The shift from fixed positioning to simulated spatial navigation is an important distinction between video or film and VR systems.

Zettl (1996) defined ontology "as a branch of metaphysics that deals with the study of the ultimate nature of things" (p. 86). However, he limited his ontological approach to the inherent structural properties of VR. There is an important structural difference between lens-generated and computer-generated images. Lens-generated images capture objects and situations in the real world. They are essentially

Figure 12–2: Plato's "Allegory of the Cave" with prisoners chained to look only at the shadows on the ground. Author's illustration.

analytic images because they reflect and interpret portions of selected reality. In contrast, computer-generated VR images are always medium-manufactured or synthetic images because three-dimensional representations of objects and situations are created by software. Zettl (1996) said the following:

> We could say that the lens-generated image is basically deductive, in which optical portions are snatched from a larger landscape event, and computer images are basically inductive, that is, built up from a great variety of pixels as controlled by numbers. Compared to the linear, analog nature of lens-generated images, computer graphics are nonlinear and modular in nature. (p. 90)

The camera lens captures an instant light image of an object or a scene. In contrast, computer-generated images are built bit by bit with the use of elaborate algorithms. "In practice this means that although the whole world is instantly available to the lens, the computer images or virtual reality are severely limited by what object and event modules have been developed" (Zettl, 1996, p. 90).

Applying an ethical approach to VR, Zettl (1996) used Plato's "Allegory of the Cave" to question whether people will feel more comfortable remaining in a virtual world of shadows instead of existing in the real world. Virtual worlds can be constructed as safe societies in which their own games and modes of behavior are established. For instance, many virtual communities have been established through the Internet, such as World of Warcraft. A benefit of VR is that it can help us better understand reality by revealing things that are normally hidden from our view. For example, medical students explore virtual human bodies.

Conversely, a potential negative consequence of virtual environments is they offer users the opportunity to engage in extreme human behavior, such as mutilation, rape, and murder. For example, violent video games have recently been criticized as a potential influence on teenage high school shootings. In virtual worlds, individuals can exercise free will and make decisions in an environment that is free of threats or reprisals. Instead of interacting with real people, individuals interact with virtual people and objects. Zettl stated, "When operating in the neutral asocial environment of VR, we may quite willingly shed our conscience and reinforce basic instinct instead of seeking a liberating catharsis" (1996, p. 93).

Will people be able to easily transfer between the virtual and real worlds, or will they eventually suffer some type of psychological difficulty? An ethical analysis of VR begins to raise serious questions about the type of virtual worlds that people create and their relationship to human values. Zettl's concerns about VR images can be expanded into other types of digitally generated imagery.

DIGITAL IMAGERY AND CULTURE

During the first half of the 20th century, scholars and critics became interested in the proliferation of images, and VR is a recent development in this expansion. For most, the important visual technology was the camera and its ability to produce images. However, as we move into the 21st century, many images that we encounter are digitally produced, distributed, and, in some case, manipulated. Zettl (1996) argued that the shift from analytical to synthetic imagery has important cultural implications. Beyond inherent structural differences, digital media can be more quickly and easily reproduced and distributed on a global scale.

Digital Imagery—Truth or Falsity

Similar to VR, photography can be discussed in terms of analytic and synthetic imagery. Traditional photographs are analytic because they are actual depictions of world events. The phrase "the camera never lies" illustrates our cultural attitudes toward traditional photography. However, with the development of digital photography, our notions of photography are changing. A significant change is the shift

Box 12.1: In His Own Words: Herbert Zettl

Bio: Herbert Zettl was a professor of Broadcast and Electronic Communication Arts at San Francisco State University. His work on media aesthetics and video production has greatly contributed to the study of visual communication. Zettl is the author of many books on video production and aesthetics, and he has won several educational awards.

One of the main points in the cave analogy is the risk we take when being exposed to the real world, and whether we would not feel more comfortable remaining in the world of shadows, a world in which we can construct our own safe society with its own games, such as bestowing honors and prizes on the one who can best identify the shape of the shadows and recall the order of their appearance. Plato has the prisoners question the wisdom of leaving the cave only to have one's "eyes corrupted".... In fact, there might be a strenuous objection to such exposure to the world of reality and freedom.... Even if we do not react quite so violently toward those who help us understand reality, enlightenment is always accompanied by anxiety and discomfort. The ethical question I would like to raise here is whether our desire to return to the cave of virtual reality is not motivated, at least to some extent, by a basic yearning for irresponsibility, a yearning for not being held accountable for our decisions. Such a morally neutral environment can have negative as well as positive perspectives.

One of the highly practical functions of virtual reality is that it can let us see things that are ordinarily hidden from our view. For instance, a sophisticated VR display can give a medical student an unprecedented view of various organs in the human body, and let the student see how they function under normal and pathological conditions.... However, there is a darker side to such graphic and seemingly harmless VR displays. Today, we have games on the drawing board and already on the market that offer the participants the opportunity to engage in extreme human behavior, such as mutilation, rape, and even murder. In a way, virtual reality provides a perfect existential world, in which we can exercise free will and make any number of decisions, however extreme, without the Kierkegaardian...underlying anxiety of accountability. (Zettl, 1996, pp. 91–92)

from using photography to depict actual events to using digital photographic techniques to present altered realities. Similar to synthetic images created by VR software, digital images can be manipulated in ways that produce synthetic images or pseudophotographs. Instead of capturing actual objects and events, pseudophotographs are digitally manipulated to create artificial ones. For example, *TV Guide* magazine created a cover image that combined the head of talk show host Oprah Winfrey and the body of actress Ann-Margret. The deception was revealed when Ann-Margret's husband noticed a familiar ring on one finger of the repurposed body.

When photography is used to capture reality, photographs of actual events can be more disturbing than fabricated drawings or illustrations. For example, Eddie Adams' famous 1968 photograph of an execution on a Saigon street caused people to feel outrage because they knew they were seeing an event that occurred. Similarly, the 1991 videotape of white Los Angeles police officers beating black motorist Rodney King incensed the nation. However, photographs can be faked to misrepresent situations and relationships. These pseudophotographs can be used to influence people's opinions and reinforce false beliefs. For example, propagandists moved Trotsky next to the podium in a photograph of Lenin addressing a crowd on May 5, 1920. Since the beginning of photography, people have been manipulating images. However, digital technology makes this much easier to do.

Today, digital image manipulation makes it easy to create convincing assemblages from pieces of photographs. For instance, a 1989 *Newsweek* article about the film *Rain Man* included a photograph of Dustin Hoffman and Tom Cruise together. However, the pictures were taken separately because one actor was in Hawaii and the other in New York. Combined, it appeared that the two actors were photographed in the same place.

It is becoming fairly routine to use image processing to put together photographs taken on different occasions. Similar techniques are being used to create movies and television commercials that allow historical figures to interact with contemporary actors. To make this composite work seamlessly, the actions and attitudes of the characters must work together to support the overall narrative being presented. However, Mitchell (1992) contended that "Digital cut-and-paste rearrangements of the elements of a photograph can transform one action pattern into another, and in so doing dramatically alter the image's meaning—our understanding of what the protagonists are doing" (p. 217). Thus, the use of synthetic imagery raises many social issues about how people perceive photography.

Box 12.2: In His Own Words: William J. Mitchell

Bio: William J. Mitchell is dean of the School of Architecture and Planning at the Massachusetts Institute of Technology. He has authored or coauthored the following books: The Logic of Architecture, Digital Design Media, The Art of Computer Graphics Programming, Computer-Aided Architectural Design, *and* City of Bits. *In* The Reconfigured Eye: Visual Truth in the Post-Photographic Era (1992), *Mitchell presented a framework for the study of simulation and image recombinations in contemporary culture:*

For a century and a half photographic evidence seemed unassailably provocative. Chemical photography's temporary standardization and stabilization of the process of image making served the purpose of an era dominated by science, exploration, and industrialization. Photographs appeared to be reliably manufactured commodities, readily distinguishable from other types of images. They were comfortably regarded as causally generated truthful reports about things in the real world, unlike more traditionally crafted images, which seemed notoriously ambiguous and uncertain human constructions—realizations of ineffable representational intentions. The visual discourses of recorded fact and imaginative construction were conveniently segregated. But the emergence of digital imaging has irrevocably subverted these certainties, forcing us to adopt a far more wary and more vigilant interpretive stance—much as recent philosophy and literary theory have shaken our faith in the ultimate grounding of written texts on external reference, alerted us to the endless self-referentiality of symbolic constructions, and confronted us with the inherent instabilities and indeterminacies of verbal meaning.

　　An interlude of false innocence has passed. Today, as we enter the post-photographic era, we must face once again the ineradicable fragility of our ontological distinction between the imaginary and the real, and the tragic elusiveness of the Cartesian dream. We have indeed learned to fix shadows, but not to secure their meaning or to stabilize their truth values; they still flicker on the walls of Plato's cave. (p. 225)

Social Uses of Surveillance Cameras

Today, the widespread placement of cameras in public spaces has become a social concern. In addition to monitoring people's behavior, surveillance videotapes are used as television content. Often these tapes are made without the permission of the person being photographed. Many television programs are

using real-world video captured by average people or police officers. Video cameras placed in homes, stores, banks, parks, and police cars record the daily activities of average citizens. Television programs, including *America's Funniest Home Videos* and *World's Most Amazing Videos,* use video footage shot by average people that capture unusual accidents and situations. Some television programs, such as *Big Brother,* are built around the idea that people are placed in an environment filled with cameras. Interpersonal relationships are captured and directly broadcast or edited into television content.

Cameras are increasingly being used as a surveillance technology. However, when a crime is captured on videotape, it could become material for television news reports and magazine shows. Programs such as *Cops* actually have a film crew travel with police officers to videotape crimes in action and the arrest of criminals. Some police cars have video cameras installed in their front windshields to record crimes. Many of these captured images have become content used in television programs with titles like *The World's Most Dangerous Police Chases* or on the 6 o'clock news.

Besides capturing the images of crimes as they occur, digital techniques have also been developed to help law enforcement agencies solve crimes and catch criminals. For instance, the police use computerized processes to reconstruct images from blurry film or photographs. Applying statistical probability factors to out-of-focus pictures does this. Computerized techniques can take a person or an object in still image and generate still or moving video images. The subject in the original image can be made to perform realistically in computer-generated space.

Additionally, the use of statistical probability to enhance photographs for the purposes of law enforcement further illustrate how the boundaries between photography and pseudophotography are blurring. A consequence of this technological development is a change in the relationship between observing subjects and methods of visual representation. Today, many historically important operations performed by the human eye are being supplanted by practices in which visual images no longer use the observer as the point of reference in the image-making process. For example, VR software constructs three-dimensional models of objects and scenes, and observers navigate through the model.

In other cases, real observers are replaced by computer-manipulated points of reference. Moreover, synthetic images do not directly refer to an object in reality. Crary (1990) asserted, "The formalization and diffusion of computer-generated imagery heralds the ubiquitous implantation of fabricated visual 'spaces' radically different from the mimetic capacities of film, photography, and television" (p. 1). Analog techniques for creating film, photography, and television images correspond to the optical wavelengths of the light spectrum and locations in real space. In contrast, computer-generated images, including computer-aided design, flight simulators, computer animation, robotic image recognition, VR helmets, magnetic resonance imaging (MRI), and multispectral sensors, are techniques that remove the observer from the image-making process. Synthetic images remove the human observer as a reference point in image creation. Moreover, they represent images that are completely computer generated.

In contrast, pseudophotographs fall into a category that is a mixture between traditional photography and synthetic image creation. Digital image manipulation and image reconstruction techniques use portions of actual images in the process of fabricating pictures. In professions such as photojournalism and law enforcement the use of digital image manipulation raises serious ethical questions, as discussed in Chapter 8. Specifically, digital techniques challenge the authority of photographs as factual depictions of events.

Simulated Reality

Today it is said that we live in a culture dominated by images and these images are intertwined with reality. In the 1960s, Daniel Boorstin (1961) observed that images in American culture were creating pseudoexperiences or pseudoevents. Pseudoevents are experiences that seem real but are fabricated in some way, often without our knowing that they are manufactured. Digital technologies extend

our ability to create synthetic images. When used in an entertainment context, synthetic computer-generated images are often more satisfying than real experience. Boorstin warned, "We have become so accustomed to our illusions that we mistake them for reality" (p. 6). As visual culture expands, images and reality intermingle. With digital media, distinguishing the difference between reality and illusion could become increasingly difficult.

To describe the combination of image and reality, Umberto Eco coined the term *hyperreality*. Hyperreality expresses the idea that our images fix up reality to the point in which they are better than real. For example, theme parks and casinos create miniature versions of foreign countries that give visitors the sense that they have experienced the country without the expense or bother of traveling to the real one. Theme parks combine image and reality together to create an experience that is often better than the real world.

When describing the trend toward the simulation of reality, the writings of Jean Baudrillard go beyond Debord's idea of a society of the spectacle (see Chapter 6). The society of the spectacle is a society in which the commercial world is assimilated into a culture of mass media images. Baudrillard described a more advanced state of abstraction in which objects are totally transformed into images and dematerialized into symbolic exchanges. These exchanges occur at the levels of signs, images, and information. Baudrillard (1994) said, "Everywhere the hyperrealism of simulation is translated by the hallucinatory resemblance of the real to itself" (p. 23). He described a series of phases that has transformed the relationship between image and culture:

> it is the reflection of a profound reality;
> it masks and denatures a profound reality;
> it masks the *absence* of a profound reality;
> it has no relation to any reality whatsoever. It is its own pure simulacrum. (p. 6)

Box 12.3: Case Study: Computer Graphics and Their Depiction of Reality

During the late 1960s, early renderings of three-dimensional computer graphics were simple environments that used direct lighting. Today, computer graphic systems can generate complex pictures of scenes that are complete with shadows, shading, textures, and interflections. High-quality simulations have been used for many years in industrial tasks, such as pilot training, automotive design, and architectural walk throughs. Additionally, the movie industry has used simulations and special effects to create dramatic film sequences. Today's inexpensive video games even use convincing imagery, and films such as *Avatar* combine real action with computer-generated landscapes.

Greenberg (1999) asked the question, "But are these images correct? Would they represent the scene accurately if the environment actually existed?" (p. 46). In general, the answer to these questions is no. Despite the inaccuracy of computer-generated images, the pictures are often believable and appealing.

"However, if we could generate simulations guaranteed to be correct—where the algorithms and resulting images were truly accurate representations—the graphics simulations could be used *predictively*. Using such simulations to predict reality is the holy grail of computer graphics" (Greenberg, 1999, p. 46). For this idea to work, predictive simulations would first need to be proved to be correct. "This difficult task requires a major multidisciplinary effort among physicists, computer scientists, and perception psychologists, as well as experimental measurements and comparisons. Unfortunately, relatively little work has sought to correlate the results of computer graphics simulations with real scenes" (Greenberg, 1999, p. 47). However, the question still remains: Could we consider the predictive simulations to be the same as actual events?

In the first phase, the image is an appearance or representation of reality. In the second, it has a negative representation. In the third, images play with the appearance of reality in a way similar to magic. In the final phase, the image no longer belongs to the order of appearances, but to the realm of simulation.

Immersive VR systems are simulations of reality. The ultimate goal of VR is to simulate the real environment and represent objects that are indistinguishable from the real world. In the process, VR systems attempt to make the medium disappear. Ideally, VR should create a sense of space that is as close as possible to our daily visual experiences. However, these images are not correct representations of an actual object. Bolter and Grusin (1999) said, "Today's technology still contains many ruptures: slow frame rates, jagged graphics, bright colors, bland lighting, and system crashes" (p. 22). Distortions in the virtual depiction of reality are unique to this medium and will need to be explored as VR develops.

DIGITAL TECHNOLOGY AND EDUCATION

As we move further into a digital world, nonimmersive VR systems, such as graphical computer screens, are becoming a primary medium of communication, as people shop, play, and build relationships online. As previously discussed, computers add levels of visual communication to the distribution of information. Although we live in a culture that has a proliferation of images, it is also a culture that emphasizes the use of the written word. Traditionally, text and images have been treated differently in American education. Language is perceived as the primary and, sometimes, only method for teaching and learning. As a result, many educators are verbally oriented.

Visualist/Verbalist Debate

In education, a debate has emerged between visualists and verbalists. The debate revolves around how people perceive and construct representations of the world through language, images, and numbers. Verbalists believe that language is required for people to construct and make meaning of their world. Extreme verbalists even deny that mental images exist in and of themselves. Thinking only occurs through language. A word refers to an object, they describe it, and invoke it, but they can never represent its visual presence in the same way that pictures can. As W.J.T. Mitchell (1994) said, "Words can 'cite,' but never 'sight' their objects" (p. 152).

In contrast to verbalists, visualists believe that images are a distinct form of mental representation and visual imagery can be used for thinking and communicating information. For instance, psychologist Rudolf Arnheim (1980) argued that visual perception can become visual imagination. People can mentally rotate objects to solve problems. When asked if the letter "n," rotated 90 degrees, will become another letter, many people can visually rotate it to the letter "u." Architects, engineers, artists, and some mathematicians in their work often use visual imagery.

Cognitive scientists report that visual imagery can be used in four ways: to access information from memory, to support reasoning, to learn new skills, and to aid in the understanding of verbal description. For example, Kosslyn and Koenig (1995) said, "Some of the most famous discoveries in science were made when someone visualized possible events and 'observed' their outcomes" (p. 145). In learning contexts, imagery can be used to master new skills.

Visual Communication and Instructional Design

Although print-based media are the primary medium of education, instructional designers are integrating visual images with verbal texts. More and more computers are being integrated into edu-

cation. Sometimes, instructional design will incorporate visual literacy skills into course materials. For instance, Ligature, a design firm specializing in instructional materials, developed a series of K–8 social studies textbooks in which the visual information was as important as the verbal information (see Laspina, 1998). Maps, photographs, illustrations, and charts were an integral part of the content. Ligature developed a visual/verbal instructional design program, which included the following attributes:

1. Integrating the visual and verbal presentation of lesson content to appeal to a variety of learning styles.
2. Presenting history as a well-told story and integrating "You were here" features to encourage historical empathy.
3. Using text and visuals that encourage students to uncover connections between themselves and history, history and geography, and time and place.
4. Incorporating beautiful images and design layouts to make textbooks inviting to pick and use.
5. Designing functional graphics that illustrate historical concepts and facts to accommodate a variety of learning styles.
6. Developing skills for visual learning throughout the social studies program to prepare students to live in a world that is becoming dominated by visual technologies.

According to James Laspina (1998), the visual learning component of the textbook series was created to formalize children's visual learning abilities by adding visual literacy skills to the texts. Often, children informally learn visual literacy skills by watching television. In contrast, the creators of this new visual textbook series clearly side with the visualist perspective because they added visual information to an examination of social studies topics.

Instructional Screen Design for Nonimmersive VR

Beyond adding visual information to textbooks, many schools are using computers and integrating technology in the classroom. A new discipline called instructional design has emerged to develop multimedia educational materials. In addition to textbooks, instructional designers also develop computer-aided programs and presentation materials. In educational settings, *instructional* screen design means the intentional organization of presentation stimuli (visual, verbal, and numerical symbols) to influence the ways in which students process information. The role of instructional screen design is to act as the communication mechanism between the instructional computer program and the learner. Besides presenting the learning materials, these screens should have an aesthetic appeal. According to Haag and Snetsinger (1994), "Program design with attention paid to the overall aesthetic of the screens may prove to facilitate communication by capturing, holding and focusing the learner's attention on the content" (p. 94). Many design principles established for print-based graphic design can be applied to screen design.

Most nonimmersive VR instructional programs present information on a two-dimensional computer screen. However, some educational programs display information in three dimensions. Three-dimensional screen design creates a rich virtual environment in which students can explore information. For example, Virtus Walkthrough is a software program used to teach mathematics by constructing three-dimensional models. The program has also been used to help teach directions to children with dyslexia. Sophisticated virtual environments, such as Second Life, have also been used for teaching subjects. Three-dimensional nonimmersive VR programs can be used in education to create student motivation, illustrate features of objects, allow students to examine objects, provide learning tools for students with disabilities, and encourage active student participation.

Second Life

Second Life was inspired by Neil Stephenson's description of the Metaverse in the science fiction novel *Snow Crash*. The Metaverse is a computer-mediated reality in which people interact through avatars, visual representations of self. Avatars are used to represent the individual in Second Life. An avatars is a "character that interacts in a 3D virtual environment" (Kelton, 2007, p. 2). Linden Labs released the Second Life software program in 2003. It was designed to be a virtual world in which everything could be digitized (Jennings & Collins, 2008).

Figure 12–3: A classroom in Second Life designed to look like a classroom at the Rochester Institute of Technology. Author's screen capture.

The world is virtually designed and constructed by the users themselves. Moreover, Second Life has its own currency: the Linden dollar. Linden dollars can be exchanged for real-life dollars that buy objects in Second Life. Most of the objects in Second Life are created or built from three-dimensional geometric shapes called prims. Prims can be transformed into virtually any shape, such as houses, clothing, guitars, and cars. A number of educational institutions have built virtual campuses in Second Life by using prims (Gronstedt, 2007). These campuses enable universities to conduct courses in Second Life. Courses such as visual communication, advertising, and marketing have all been taught in Second Life.

Visual Communication Skills for the Digital Age

With the widespread use of digital media, many visual thinking skills are now becoming vital to basic education. Dennis Dake (1994) identified the differences between analog and digital media:

- Empowering individuals with visual language skills
- Promoting interaction with visual imagery
- Increasing storage and retrieval of imagery

- Encouraging flexibility in visual thought
- Developing deeper meaning in visual messages
- Reusing existing visual images for communication [repurposing] (p. 131)

Digital media provide new tools for combining images and text together. Digital images can be stored and manipulated in a variety of ways to allow greater freedom in graphic ideation and visual thinking. Visual ideas can be tested, changed, and altered in a variety of ways to create a final visual statement. The interactive nature of digital media also allows designers to quickly conceive, design, and change images to make visual decisions and explore meaningful associations. Besides making it easier to distribute visual and verbal messages, digital media also enable individuals to create visual messages and develop their visual thinking skills. With the integration of visual communication into textbooks and use of computer-based instructional technology, students need to develop their visual literacy skills.

Remix

Today, people are mixing, remixing, and mashing culture together. This creates a new type of culture that is based on mediated images, sounds, and events. Larry Lessig (2008) coined the term *remix culture* to describe a culture in which copyright material and other cultural artifacts are remixed into new creative works. However, the concept of remix is not a new idea. Artists have been remixing media for many years. Pop art remixes images from popular culture with fine art, for example, Roy Lichtenstein's use of comic art styles with paintings and Andy Warhol's use of soup cans or pictures of Marilyn Monroe.

The role remix could play in education is unclear. Incorporating remix into education will make us deal with different types of learning patterns and the area of visual communication along with the development of multimedia literacy skills. These are two topics that educators have shied away from. However, remix and its collage of images can be used for critical thinking assignments and political discussions. For instance, CNN has used YouTube in political debates to enable average citizens to participate in the election

Figure 12–4: This remixed image combines traditional photographic techniques with computer generated art. Author's illustration.

process. (The YouTube debate is available at http://www.youtube.com/watch?v=XdMHHIO5tQM.) As a result, remix could also be used in education to promote discussion, or it can be used in critical thinking assignments. Consider the following description of user-generated videos:

> Now imagine a kid in jeans and a T-shirt asking a question, less reverentially, more pointedly and using powerful images to underscore the point. Maybe he or she will ask about the war in Iraq—and show clips from a soldier's funeral. Or a mushroom cloud. If global warming is the issue, the videographer might photoshop himself or herself onto a melting glacier. The question might come in the form of a rap song or through spliced images of a candidate's contradictory statement. (Seelye, 2007, para. 3)

Remix could become a powerful tool for exploring students' ideas and making comments on contemporary culture. Meanwhile, remix is having an impact on contemporary culture. Ryan (2010) stated, "Not only are Internet users using Web 2.0 tools to filter professional media into personalized

packages, they are also beginning to interact with professional producers and articulate their preferences" (p. 157). Individuals are influencing the media industries through the use of the Internet.

SUMMARY

When photography was first developed, it was perceived as a factual representation of the world. The introduction of digital technology made it easy to alter photographs and fabricate images. As digital technology develops into VR systems, users could completely immerse themselves in computer-generated environments. However, virtual immersion raises many ethical and social questions about the use of this new visual medium, including eyestrain, flashbacks, and intersensory conflict. Moreover, the impact of virtual experience on real-world behavior is still unclear.

As digital technologies become available for both individual and professional use, the development of visual literacy skills is becoming increasingly important for both the creation and the comprehension of visual messages. Beyond developing skills that enable people to visually communicate, individuals and industries will need to evaluate the ethical issues associated with the use of digital imagery.

In education, virtual worlds and remixed images are creating new opportunities for students. Virtual worlds are an engaging environment to explore a topic such as advertising or marketing. Remix is a new form of cultural creation that can be used to promote discussions in a classroom.

Websites

- *Virtual Reality*
 http://secondlife.com/
 Type "Second Life" into http://www.youtube.com/ to see examples of SecondLife.
 Type "Virtual Reality" into http://www.youtube.com/ to see VR technologies.

- *Developing New Technologies*
 MIT Media Lab: http://www.media.mit.edu/

EXERCISES

1. Conceptualize the design of a virtual world. What scenes would you create and what objects would be used in those scenes? Be as imaginative as possible. How would your world be similar and different from the real one?

2. Discuss the pros and cons of developing immersive virtual reality games for use by children. What type of games should they be?

3. Should legislation be passed to prohibit the digital manipulation of photojournalism? Why or why not?

4. Under what circumstances would it be appropriate to manipulate images? When would it not be appropriate? For instance, should digitally enhanced images be used as evidence in a courtroom trial? Why or why not?

5. What types of visual communication skills do you think students need to live and work in the 21st century? How should these skills be acquired?

6. Which side of the visualist/verbalist debate are you on? State your position and provide examples to support it.

7. What visual skills do you think you need to develop for a career in communication? What skills are needed to live in a visual culture?

KEY TERMS

Analytical images are lens-generated images that capture objects and situations in the real world. These images are analytic because they reflect and interpret portions of selected reality.

Hyperreality conveys the idea that our images fix up reality to the point in which they are better than real.

Immersive virtual reality systems literally immerse the user in a computer-generated environment.

Instructional design is a new discipline that explores the development of multimedia educational materials.

Instructional screen design is defined as the intentional organization of presentation stimuli (visual, verbal, and numerical symbols) to influence the ways in which students process information.

Intersensory conflict is the sensory rearrangement of the relationship between body movements and the resulting inflow of sensory stimuli to the central nervous system.

Nonimmersive virtual reality systems, such as computer monitors or images displayed on a screen, enable users to see both the virtual world and the physical space surrounding them.

Pseudoevents are experiences that seem real but are actually fabricated in some way, often without our knowing that they are manufactured.

Synthetic images are computer-generated VR images that are medium-manufactured or synthetic because three-dimensional representations of objects and situations are created by software and algorithms.

Telerobotics is the control of robots at a distance in military, nuclear, space, and oceanographic applications.

User-centered approaches to software design examine how people will work with the tools, and they shift the focus of human–computer interaction away from people adapting to the machines toward making the machines adapt to the way people work.

Verbalists believe that language is required for people to construct and make meaning of their world. Extreme verbalists deny that mental images exist in and of themselves.

Virtual reality is a term that has no clear definition because it is used to discuss interface hardware (e.g., head-mounted displays), software applications (e.g., medical imaging), an emerging entertainment industry, and the cultural environment developing around it. However, the term virtual reality increasingly refers to an emerging communication system that supports a wide range of methods for interacting with computers.

Visualists believe that images are a distinct form of mental representation and that visual imagery can communicate information and convey meaning.

☀ Cultural Codes and Conventions

Creating and understanding visual messages require a knowledge of cultural codes, design conventions, and basic visual literacy. Presently, the American educational system tends to focus on verbal literacy skills, and it generally neglects to teach students how to interpret visual messages. In contrast to schools, our information landscape is filled with visual messages that compete with each other to attract our attention. The technological development of the World Wide Web increases this trend because, similar to traditional highways, billboards of visual messages already line the access roads to the information highway. As the web enters the classroom, teachers will need to deal with both the visual and verbal attributes of web pages, YouTube videos, and virtual worlds, along with advertising and information design. This chapter describes cultural codes and visual conventions, including advertising, corporate identity, information design, and cartoons.

AMERICAN CULTURAL CODES

Few visual or verbal symbolic codes have meaning in themselves. We learn their meanings through formal education, exposure to media messages, and interaction with others. Currently, we live in a world that is filled with visual imagery; however, our educational systems focus on learning verbal rather than visual communication skills. In contrast to the educational emphasis on verbal skills, some information can be more clearly communicated through pictures. For instance, the international symbols for men's and women's restrooms are much easier to understand through a visual symbol rather than words. Similarly, the study of botany, zoology, anatomy, geography, and astronomy all benefit from the use of visual information. Historically, these disciplines all progressed after the Renaissance because visual representations and diagrams became available to larger numbers of students.

With the invention of photography, motion pictures, television, and computers, visual communication has become a dominant aspect of the information environment outside of the classroom. In electronic contexts—including computer screens, the World Wide Web, multimedia environments, and virtual reality—the use of visual icons can be compared to written language because visual icons execute computer commands. As also described in previous chapters, understanding the relationship

between iconic desktops and physical ones is a key concept behind user-friendly metaphors. Computer screens, desktop publishing, multimedia, and the World Wide Web are all new technologies that foster an increased use of images as a mode of representation and interaction. Many of these visual symbols are representational of real-world experiences and actions. Although it has been said before, digital media introduce new visual languages into the communication process.

In contrast to visual pictures, verbal representations cannot represent an object in the same way a visual representation can. Words refer to an object, they describe it, and invoke it, but they can never represent its visual presence in the same way as pictures. As W.J.T. Mitchell (1994) stated, "Words can 'cite,' but never 'sight' their objects" (p. 152). Although we live in a culture that has a proliferation of images, it is also a culture that emphasizes the use of the written word. Traditionally, there has been a difference between text and image in American education. Mitchell (1994) stated, "The corporate, departmental structure of universities reinforces the sense that verbal and visual media are to be seen as distinct, separate, and parallel spheres that converge only at some higher level of abstraction (aesthetic philosophy; the humanities; the dean's office)" (p. 85).

Visual and Verbal Media in American Education

Reading and writing are taught in every American school, and print-based media are the primary medium of education. As a result, there is a bias in American culture toward the written word. However, with the introduction of computers into the graphic design process, some textbook publishers are beginning to create books in which the visual information assumes the same status as the verbal text. For example, Houghton Mifflin, in partnership with Ligature, a design firm specializing in instructional materials, developed a series of K–8 social studies textbooks in which the visual information was as important as the verbal information. Ligature's visual/verbal instructional program included the following attributes:

1. Integrating the visual and verbal presentation of lesson content to appeal to a variety of different learning styles.
2. Presenting history as a well-told story and integrating "You were here" features to encourage historical empathy.
3. Utilizing text and visuals that encourage students to uncover connections between themselves and history, history and geography, and time and place.
4. Incorporating beautiful images and design layouts to make textbooks inviting to pick up and use.
5. Designing functional graphics that illustrate historical concepts and facts to accommodate a variety of learning styles.
6. Developing skills for visual learning throughout the social studies program to prepare students to live in a world that is becoming dominated by visual technologies.

According to James Laspina (1998), the visual learning component of the textbook series was created to formalize children's visual abilities, which are normally informally learned. For example, most children develop their visual skills by watching television. The creators of this textbook series clearly side with the visualist perspective in taking sides in the educational debate between visualists and verbalists. The debate revolves around how we perceive images of the world and then construct representations of the world through language, image, and numbers. Extreme verbalists deny that mental images exist in and of themselves. In contrast, visualists believe that images are a distinct form of mental representation. This debate has been argued for a number of years, and it mirrors the traditional dichotomy of image and text that exists in education. However, extensive research in visual cognition is now linking visual perception to cognition and discovering neural mechanisms for visual object identification. For

example, the work of Steven Kosslyn (1994) has successfully enunciated the theoretical justification for adopting visual mental imagery as an element of cognitive processing.

Commercialization and American Education

In addition to a bias against the image, educators also tend to have a bias against commercialization in education, and coincidentally, most advertising is visual. A large percentage of the visual messages that we are exposed to on a daily basis are in the form of commercial advertising—television, billboards, printed and digital advertisements. As a result, visual media are frequently associated with commercialism and entertainment. For instance, when educators attempted to introduce Channel One into classrooms, it was a highly controversial issue because it was both visual and commercial. Channel One presented news programming to school children over a satellite and cable system. To pay for the service, Channel One included television commercials that were directed toward children. However, parents became outraged because their children were being exposed to commercials in the classroom. The commercial aspect of the system overshadowed the fact that schools were being given video technology to develop visual communication skills. To counter the commercials, many schools participating in the program added media literacy and critical viewing to their curriculum. Eventually, Channel One disappeared, and the controversy was forgotten.

Today, the new technology of the computer is being introduced into education. In contrast to Channel One, parents are encouraging the use of the computer and the World Wide Web. Every aspect of computing seems to be perceived as a valuable skill that can increase a student's job marketability. However, parents don't seem to realize that the web is primarily a commercial medium that resembles television. Academics generally consider information received from books or text-based materials to be superior and more reliable than information presented visually on television. For example, in his book *Amusing Ourselves to Death* (1985), Neil Postman argued that because American television is primarily an entertainment medium, all information received from television tends to be entertaining.

Additionally, television has been cited as being responsible for a larger educational issue—the decline of alphabet literacy. Educators argue that the widespread use of television has eroded traditional literacy skills because students spend more time watching television than they do reading books, newspapers, or magazines. As a result, there is a bias against the use of television and visual media for general educational instruction. However, this bias against the image is not just a conflict between text and image; it is also based on how people perceive verbal versus visual information. Postman (1979) described the difference as follows:

> Language is, by its nature, slow moving, hierarchical, logical, and continuous. Whether writing or speaking, one must maintain a fixed point of view and a continuity of content; one must move to higher or lower levels of abstraction; one must follow to a greater or lesser degree rules of syntax and logic.... Imagery is fast moving, concrete, discontinuous, alogical, requiring emotional response, its imagery does not provide grounds for argument and contains little ambiguity. There is nothing to debate about. Nothing to refute. Nothing to negate. There are only feelings to be felt. (p. 72)

American cultural connotations associated with "logical" text versus the "emotional" image not only influence our education systems, but they also impact media design. For example, serious academic websites tend be text oriented rather than image oriented. Conversely, advertising and commercial sites use more images to attract attention and emotionally persuade consumers. However, this is changing as everything becomes more visual.

Text Versus Images in American Newspapers

Newspapers can also illustrate the text versus image bias in American culture. Newspapers with high credibility tend to be more textual than graphic. Print media that are primarily text-based with few pictures are considered to be more "high-class" and reliable because the stories are presented in more printed detail. For example, *The New York Times* and *The Wall Street Journal* formerly used very few pictures to accompany their news stories. Additionally, the length and detail of their articles can provide more details about a story than a one-minute television news report or newspapers that are filled with pictures. Newspapers that focus on graphics rather than text visually imply a lower quality of reporting because these papers are designed for audiences that do not like to read very much.

Moreover, newspapers that use pictures and large provocative headlines are literally designed to sell the paper. The catchy images grab one's attention in an effort to sell the media product. Some of these newspaper tabloids, such as the *National Enquirer* and *Star,* will run questionable articles with splashy headlines and sensational photos. However, one newspaper that attempts to combine the use of pictures and legitimate news stories is *USA Today.* It is designed to reach a more visual television-oriented audience, and the newspaper has been criticized for its use of graphics to replace text-based information. If you compare the black-and-white look of *The Wall Street Journal* to the colorful pages of *USA Today,* it is obvious that the former caters to a reading audience and the latter to one that is more visual. As digital technology makes it easier to design visual information, most print media are gradually becoming more visually oriented.

Traditionally, print media have attempted to maintain a visual separation between editorial content and advertising messages. But today, these distinctions are beginning to blur. Competition in the marketplace combined with the introduction of new digital technologies have ushered in a new era of visual publishing that breaks all of the conventions of traditional journalistic styles. Print publishers are introducing vivid color, swirling typefaces, and bold imagery into editorial content. Award-winning magazines, such as *Wired,* make it difficult to visually separate the advertisements from the magazine's layout. The visual connotations associated with *Wired*'s high-tech design are futuristic and computer generated to represent a vision of the computer screen in print. The radical departure of *Wired*'s design abandons conventional printed layouts and introduces a new cultural style that emulates electronic media. Similarly, the advertisements within the magazine attempt to follow the new electronic design style pioneered by the publication.

As previously stated, *Wired* breaks the conventional design rules associated with magazine publishing and is creating a new style that blends together editorial and advertising messages. These messages merge into a seamless design and it becomes the reader's rather than the editor's role to distinguish between editorial content and commercial message. The combined introduction of visual languages on computer screens and changes in printing conventions make it necessary for students to know how to interpret visual layouts, images, and messages.

ADVERTISING

In 1926, the N.W. Ayer and Son advertising agency predicted that future historians would not have to rely on museum collections and ancient prints to reconstruct a faithful picture of that year because a portrayal of the era was being vividly recorded in magazine and newspaper advertising. Advertising as we know it today is predominantly a 20th-century phenomenon. Early advertising art tended to be predominantly informational. But by the 1920s and 1930s, advertisements were beginning to incorporate scenes from daily life, such as religious services, factory workers, sports fans, and working-class

families at home. According to Roland Marchand (1985), instead of mirroring reality, advertisers began to respond to consumers' desires for fantasy and wish fulfillment. They began to create an image of life as it "ought" to be. Working under this premise, the creators of advertising attempted to reflect public aspirations rather than contemporary circumstances. Embedded in this assumption is the idea that people would rather identify themselves with scenes of higher status than ones that reflect their actual situation. As a result, advertising began to portray the ideals and aspirations of the "American Dream," instead of its reality. The American Dream is a vision of the acquisition of material goods, power, and status. Although the American Dream is promised to all, in reality, only a few achieve it. Utilized by advertisers, the myth of the American Dream becomes a strategy for convincing consumers to buy products.

Consumerism

A number of scholars argue that commercial advertisements are a product of a capitalist economy and their goal is to persuade consumers into purchasing products and services. As communication messages, advertisements express an ideological discourse that structures social practices. Commodities in capitalist societies are a form of cultural exchange with meanings attached to them. Moreover, the meaning attached to commodities transforms them into signs. Chemi Montes-Armenteros (1998) asserted the following:

> This signifying value is borrowed from codes that are initially foreign to the consumption of the product, but that eventually become equivalents to the product, establishing a reciprocal signifying relationship: the commodity becomes a fetish. The reiterated depiction of social practices contributes to their being perceived as "natural" rather than as constructions within the capitalist order.... This naturalization presents capitalist social constructs and values as matters of fact, which discourages any attempt at change. (p. 131)

Montes-Armenteros further argued that the role of the commodity in capitalist societies is a primordial one: "Commodities become the currency for the exchange of social meanings" (1998, p. 131). Consequently, the widespread use of advertising creates an intricate system of signs and symbols attached to products and their consumption. *Consumption,* a social ethic that prizes the acquisition of goods over other values, is so deeply embedded within American culture that most people are not consciously aware of its influence.

Advertising Messages and Media Literacy

The widespread use of commercial messages has encouraged many other countries, such as Britain, Canada, and Australia, to introduce media literacy programs. However, media literacy has not been widely adopted in the United States. Understanding advertising messages is a key component to a media literacy program. Advertising messages are ubiquitous. We encounter them throughout our daily activities, from the coupons on breakfast cereal boxes to the billboards on our way home from work or school. It is inevitable that we will encounter numerous commercial messages on a daily basis.

Prior to the end of the 19th century, advertising was considered to be largely informational, and its influence on human behavior was unknown. However, in the 20th century, advertising began to be viewed as persuasive and potentially reprehensible. The purpose of advertising is to persuade spectators to purchase a product or utilize a particular service. In the process of persuasion, advertising both reflects and shapes consumer culture. Advertising messages are designed to appeal to certain segments of the population and make members of these targeted groups envision themselves using the product. Advertising's purpose to create desire and to direct this desire toward the purchase of products is considered by some scholars to be socially disruptive. For instance, Malcom Barnard (1995) stated that the function of an advertisement is to create desire. However, the desire being created is directed toward

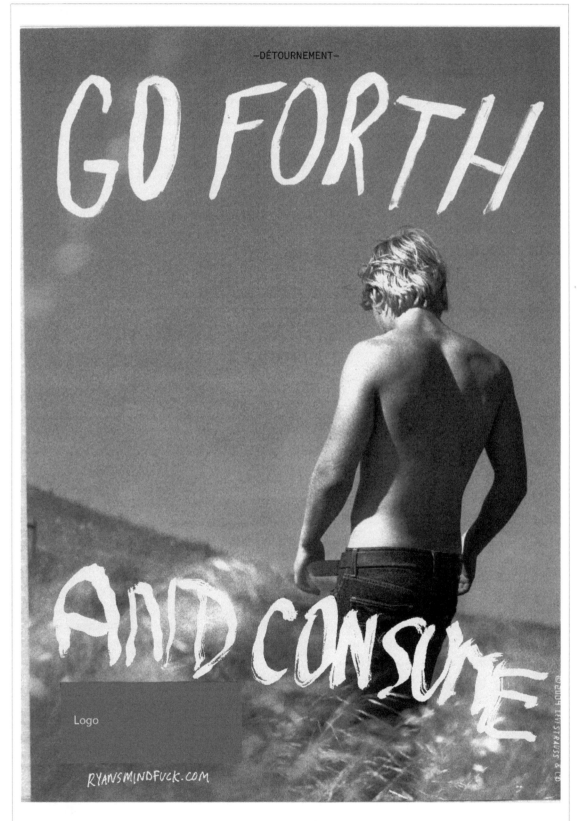

Figure 13–1: *AdBusters* is a magazine that is a satire of consumer culture. *AdBusters.* Used with permission.

"false ideals and in a way that obscures the real structure of society. So ads intend to make us feel we are lacking, they engender desire in us, and they direct our desire towards consumer goods" (p. 34).

Advertisers try to place the spectator in the ad because they want people to identify with the product and feel good about using it. For example, the 1963 slogan, "Come Alive, You're the Pepsi Generation" was accompanied with visual images that depicted young people splashing through ocean waves, throwing Frisbees, and driving dune buggies. These visual and verbal messages captured the feelings of the exuberance of being young. Compared to the "Pepsi Generation," Coke appeared to be a product for an older, more sedate crowd. As a result, Pepsi's sales soared because most people would prefer to associate themselves with a younger rather than an older generation.

In addition to being an effective advertising campaign, the Pepsi Generation advertisements introduced a new genre of advertising called lifestyle advertising. Lifestyle advertising does not have a strong narrative structure. Instead of telling a story, for example, a woman has extremely dirty laundry, she uses product X, and her laundry is now clean, lifestyle advertising shows a series of images of people in different situations. It depicts lifestyle trends rather than demonstrating how a product works. Lifestyle advertising sells a product strictly on emotional appeal. Can you picture yourself in this situation? If you can picture yourself, then you should be using, drinking, driving, or wearing our product. (Pepsi Generation commercials are available at http://www.youtube.com/watch?v=n2LJW-2IkQE&feature =related)

Emotional appeals are a popular strategy for selling products. They are designed to make consumers feel as if they need or want a particular item. This type of advertising strategy depends on visual imagery to communicate the emotional message. In contrast, advertising that uses a rational appeal presents a logical reason why consumers should buy a product. Depending on the product, advertisers will have to select one of these approaches. However, complex products, such as computers and cars, may be sold using a dual approach. Television commercials will be designed to communicate an emotional message and print advertising will provide all of the detailed logical reasons why the product should be purchased. Notice how these advertising strategies support Postman's argument that the differences between visual and verbal messages are emotion and reason. Advertisers understand the power of images, and they know how to design messages that are both visually and verbally persuasive.

Understanding Advertising Messages

Harold Lasswell's general view of communication can be applied to the interpretation of advertising messages. Lasswell (1948) said that a simple question could explain communication: "Who says what to whom in what channel with what effect?" We can apply this to advertising messages by asking the following questions: Who is advertising the product (who)? Whom is the target audience that the message is being sent to (whom)? What medium is being used to send the message (channel)? What effect does the message want to have (effect)?

Generally, it is easy to answer the first question because the advertiser is identified in the advertisement. However, identifying the target audience can be more complicated. The target audience is the group that the advertisement is addressing. People's age, sex, clothing, and situation are visually depicted in the advertisement; this is an indicator of the audience. The channel is the medium in which the message is being sent—newspapers, magazines, television, the web. The medium in which the advertisement is distributed can also be a way to identify the message's intended audience. For example, what type of television program is the commercial running in—the evening news, afternoon soap operas, the Super Bowl? Or, what type of magazine is it printed in—a woman's magazine, a sports magazine, a business magazine? In addition to examining the channel in terms of the audience, you should also consider the type of message the channel supports. Is the channel visual television that

appeals on an emotional level or is it a printed advertisement that presents a logical argument? If a logical argument is being made, what type of evidence does that advertiser provide to convince the audience that what is being said is true? Is the argument persuasive? Why would people in the target audience buy the product? If the appeal is emotional, how does the advertiser want you to feel when you use the product? (Super Bowl ads are available at http://www.youtube.com/watch?v=_6Ce-SJreIA)

After identifying the advertiser, the audience, and the channel of communication, the next step is to think about the effect that the advertiser wants to create as a result of receiving the message. The most obvious effect in advertising is, of course, to buy the product. However, some advertisements are designed to elicit other effects, including the following: promoting a more positive image of the company, making viewers aware of a brand, developing a brand image or personality, evoking a feeling or attitude about a product, introducing a new product, and making the target audience aware of a special offer. Lasswell's simple model of analysis is an easy way to think about whether an advertisement is persuasive, and the model can be applied to all types of advertising, including web advertisements.

Critically Reading Advertising Messages

Lasswell's approach to understanding advertisements examines the explicit meaning of an advertising message. In contrast, a more critical approach to advertising is concerned with the unintentional meanings of an advertising text. The critical process involves the deconstruction of advertising messages. Deconstruction is an oppositional reading of the text, and its purpose is to expose the social and political power structures in society that unite to create the text. The process of reading against the advertising text involves an analysis of both the foreground and the background of the advertisement. This type of comparative reading is designed to reveal the secondary social or cultural messages embedded in an advertisement. Katherine T. Firth (1998) argued that by undressing advertisements, we can begin to understand the role advertising plays in the formation of culture. She proposed a form of textual advertising analysis based on literary and artistic methods of critique. The method utilizes three stages of reading: the surface meaning, the advertiser's intended meaning (similar to Lasswell's technique), and the ideological meaning.

Deconstructing an advertisement is like peeling an onion. Each layer must be revealed before the surface of the onion appears. The first layer, surface meaning, is the overall impression that a reader receives from an advertisement. One way to understand the surface meaning is to list all of the objects and people in the advertisement. The second layer is the advertiser's intended meaning or the sales message that is communicated through the advertisement. In marketing terminology, this is called the strategy behind the ad or the preferred meaning. Strategies generally fall into two categories: product oriented or consumer oriented. Product-oriented approaches are selling messages that focus on the product itself, and they tend to appeal to reason. For example, they communicate a unique product benefit and the selling argument could be summarized as, "You should purchase a _____ because it's the only one that _____." Consumer-oriented strategies tend to sell the personality of the brand, or they associate the product with a lifestyle or an attitude. This approach relies on emotional rather than rational reasons to purchase a product.

Finally, the third level, cultural or ideological meaning, relies on the cultural knowledge and the background of the reader analyzing the message. Advertisements make sense to us when we relate them to our culture and shared belief systems. For example, Americans believe in democracy, free speech, progress, and individualism. These concepts are so much a part of American society that people tend to forget they are not universal beliefs. Subtle ideological values can also be expressed in advertisements. For example, prior to the civil rights movement in the United States, African Americans were

only featured in advertisements in subservient roles, such as porters, cooks, and bellhops. Women have also been stereotyped in similar ways in American and British advertising.

Another way to examine the ideological beliefs depicted in an advertisement is to look at the relationships being depicted between the people featured in it. However, we tend to be so enveloped within our set of cultural beliefs that it is difficult to see how the social systems in which we live support those beliefs. Thus, cultural ideologies tend to remain hidden, and we must look more deeply at the social relationships being portrayed in advertising. To reveal relationships, Firth (1998) suggested asking the following questions: "Who is in charge? Who holds the Power? Who is weak? Who is dominant and who is subordinate…?" (p. 9). Similarly, feminist scholars reveal hidden masculine assumptions by asking the question: Can you exchange a man with a woman in the advertisement? After this role-reversal, would the story of the advertisement still make sense?

Understanding the social relationships within an advertisement depends upon the story and characters being shown. Additionally, how do the props in the advertisement relate to the characters and the narrative created in the advertisement. Finally, the issue of power needs to be explored. Who has control over the story? Does one character have power over another? For example, in a car advertisement, who is driving and who is the passenger? If it is a food advertisement, who in the ad is doing the cooking and who is eating the food? What do these relationships tell us about our own relationships to society?

As society changes, advertisers alter the relationships depicted within advertisements. For instance, with the increased number of working women, some food commercials show dad and the kids making dinner because mom is going to be home late from work. Many household chores that were once only depicted as "women's work" are now being done in advertisements by men, including cooking,

Box 13.1: Messaris on the Cultural Reading of Advertising

Paul Messaris (1994) reported on a cross-cultural analysis of people's interpretations of advertising clichés conducted by Anne Andrée Dumas for her master's thesis at the Annenberg School of Communication at the University of Pennsylvania. Dumas examined the responses of American versus Chinese students to American advertisements. Messaris (1994) described the findings as follows:

One of the images, taken from an ad for a financial-services company, shows a man having a cup of tea on a balcony overlooking a big city. It is early morning, and the man's clothes and grooming suggest that he is a businessman. To a viewer who is familiar with the imagery of U.S. Advertising, the situation should be familiar: a financially successful person with an upper-floor view of the city in which he has "made it." Variations of this image can be found in contemporary ads for such things as liquor, cosmetics, and VCRs, and the historical antecedents of this visual convention may well go back as far as the advertising of the 1920s [see Marchand, 1985]. However, to Dumas's Chinese respondents, who had only recently come to the United States, the connotations of wealth and power in the image of the man on the balcony were not at all apparent. Instead, many of them constructed hypothetical scenarios to account for the absence of family members in a scene of a man having breakfast….

This example is a clear case of shaping of pictorial interpretation by specifically visual past experience…. The kind of visual experience entailed in Dumas's example has to do with (1) exposure to specific visual *subject matter* (a person at a window overlooking a city) and (2) the implicit connotations of the image…. Dumas's example makes clear, there can be no question regarding the existence of significant cultural differences in the area of visual literacy she was concerned with. (p. 169).

cleaning, child care, and the laundry. Moreover, advertisers are aware of the changing balance of racial demographics. As a result, advertisements and commercials now feature actors from diverse racial backgrounds, which tends to go against earlier stereotypical depictions of people.

Box 13.2: Advertising, Oil Painting, and Stereotypes

In his book *Ways of Seeing,* John Berger (1972) provided numerous examples of oil paintings and advertisements that explore the relationship between them. One way in which both media are similar is their stereotyping of women. The following is a list of topics to compare:

- The gestures of models (mannequins) and mythological figures.
- The romantic use of nature (leaves, trees, water) to create a place where innocence can be refound.
- The exotic and nostalgic attraction of the Mediterranean.
- The poses taken up to denote stereotypes of women: serene mother (madonna), free-wheeling secretary (actress, king's mistress), perfect hostess (spectator-owner's wife), sex-object (Venus, nymph surprised), etc.
- The special sexual emphasis given to women's legs.
- The materials particularly used to indicate luxury: engraved metal, furs, polished leather, etc.
- The gestures and embraces of lovers, arranged frontally for the benefit of the spectator.
- The sea, offering a new life.
- The physical stance of men conveying wealth and virility.
- The treatment of distance by perspective—offering mystery.
- The equation of drinking and success.
- The man as knight (horseman) becomes motorist. (p. 138)

According to Berger, there are four reasons why advertising is similar to oil painting. First, oil painting is an art form originating from the principle that "you are what you have." Oil paintings frequently depicted the possessions of their patrons. Second, advertising is essentially nostalgic and uses the past to sell the future. As a result, its references tend to be retrospective and traditional because it lacks the credibility to utilize only contemporary language. Third, advertising turns to the traditional education of the spectator-consumer by integrating history, mythology, and poetry into advertisements. Similarly, oil painting utilizes vague historical, poetic, or moral references. Finally, technology makes it easy to translate the language of oil paintings into advertising clichés. Berger asserted that the relationship of today's color photograph to the spectator-consumer is what oil painting was to the spectator-owner. Both media act upon the spectator's sense of acquiring the real things depicted in the images.

STEREOTYPES

Visual images can have both intentional and unintentional meanings and associations that reinforce cultural attitudes and codes. For example, Elizabeth Eisenstein (1979) asserted that when images and descriptions are printed and detached from living cultures, over the course of time, archetypes are converted to stereotypes. The amplification and reinforcement of certain isolated cultural attributes associated with specific groups of people transform attributes into stereotypical characteristics. For example, freckles and red hair are associated with people from Ireland; northern Europeans are depicted with blonde hair and blue eyes, and southern Europeans are illustrated with dark hair and brown eyes.

Meeting a blonde haired, blue-eyed Italian doesn't fit the stereotype because the media portrays Italians with dark hair and brown eyes. From the printing press to the Internet, images depicted in mass media tend to reinforce stereotypical concepts of people and cultures.

In the 1970s the United States Commission on Civil Rights presented a report on the social roles depicted on American television. It argued that men were in control of their lives and in a position to control the lives of others. In contrast, television portrayed women as being young, family bound, and unemployed. Additionally, working women were stereotyped as working in subservient occupations. The report also criticized the roles of minorities and how black males were portrayed on network television. Similarly, in 1980, Bradley S. Greenberg published *Life on Television,* a content analysis of character portrayal on television. Greenberg (1980) concluded his study with the following observation:

> People on television can be fitted into a relatively small one-way tunnel in terms of central attributes. There is the majority male, a white adult in his late 30s or early 40s. He is even more of a majority if he represents a new minority group on television. For example, it requires great effort to find a Hispanic female on television. And our analysis of the aging shows a parallel absence of older women. So any movement away from this modal Anglo male central-casting type even more strongly reemphasizes the male world. This ideal, mature man finds himself in the midst of very pretty, soft women typically a decade younger. (p. 186).

Landmark programs such as *The Mary Tyler Moore Show* and *All in the Family* started to break television stereotypes and address gender, racial, and social prejudice issues in the United States. Entertainers, including Bill Cosby and Oprah Winfrey, have broken some of the stereotypes associated with people of color. However, academics are still critical of the way television and mass media portray stereotypical views of American life. For instance, Robin Andersen (1997) did an analysis of how television, talk radio, and newspapers presented women on welfare to the American public. She discovered that "poor mothers have been stereotyped as irresponsible, immoral, child-abusing, drug-addicted deviants who drain public finances and violate the public trust" (p. 301). Visual images associated with the welfare issues became iconographic references that continually reinforced the media-created stereotype of poor women. Members of focus groups confirmed the media's stereotypical descriptions because they perceived welfare mothers to be lazy, African American, and living well on taxpayers' money. However, empirical data on welfare recipients reveal that a large number of women on welfare are white, most recipients stay on welfare for only 18 months, and they do not abuse their children. Clearly, the stereotypical images of people depicted in mass media are not accurate depictions.

Moreover, stereotypical images can portray people in an unflattering way and lead to cultural misperceptions. For instance, European cinema has depicted people living in colonized countries as the following: lazy (Mexicans), shifty (Arabs), savage (Africans), and exotic (Asiatics). Additionally, Stam and Spence (1985) argued that audiences have different stereotypical expectations:

> The analysis of stereotypes must also take cultural specificity into account. Many North American black stereotypes are not entirely congruent with those of Brazil, also a multi-ethnic New World society with a large black population. Where there are analogies in the stereotypical images thrown up by the two cultures—the "mammy" is certainly a close relation to the "*maepreta*" (black Mother), there are disparities as well…. The themes of the "tragic Mulatto" and "passing for white", similarly, find little echo in the Brazilian context. Since the Brazilian racial spectrum is not binary (black *or* white) but nuances its shades across a wide variety of racial descriptive terms, and since Brazil, while in many ways oppressive to blacks, has never been a rigidly *segregated* society, no figure exactly corresponds to the North American "tragic mulatto," schizophrenically torn between two radically separate social worlds. (p. 640)

Stereotypes from one country do not necessarily translate into stereotypes in another country. Many of the past stereotypes shown on television have changed with the multicultural American landscape. Blacks and Hispanics are regularly seen on television today. Although, many stereotypes

have changed, the use of stereotypes still exists in mass media. Different cultures deal with different types of stereotypes. For instance, countries that once were colonies of larger nations, such as India, face colonial stereotyping.

Box 13.3: Homi K. Bhabha on Stereotype and Colonial Discourse

According to Homi K. Bhabha (1999), an important aspect of colonial discourse is its dependence on stereotypes and the construction of the "other" through cultural, historical, and racial difference.

My reading of colonial discourse suggests that the point of intervention should shift from the *identification* of images as positive or negative, to an understanding of the *process of subjectification* made possible (and plausible) through stereotypical discourse. To judge the stereotyped image on the basis of a prior political normativity is to dismiss it, not to displace it, which is only possible by engaging with its *effectivity;* with the repertoire of positions of power and resistance, domination and dependence that construct the colonial subject (both colonizer and **colonised**). […] Only then does it become possible to understand the *productive* ambivalence of the object of colonial discourse—that "otherness" which is at once an object of desire and derision, an articulation of difference contained within the fantasy of origin and identity. What such a reading reveals are the boundaries of colonial discourse and it enables a transgression of these limits from the space of that otherness. (pp. 370–371)

CORPORATE IDENTITY AND SPECIAL PURPOSE CODES

The Dilbert series of cartoons makes fun of corporate office life in general. Recently, political cartoonists have been making fun of corporate life at Microsoft. However, corporations do not like to be depicted in a negative way, even if it is humorous. Corporations attempt to control their image in the media. In addition to advertising and public relations efforts, individual corporations develop corporate identity programs that design visual logos and specify how to visually represent the company. These programs describe the following: how the corporate logo should be displayed, how corporate colors should be used, and how corporate identification should be shown in signage, on trucks, on buildings, and in advertisements. The following is an excerpt from the Sony Corporation's Visual Identity program:

> The visual identity of the company is just one element of the total corporate identity; yet, it is one of the key elements. It provides the consumer with his first impression of the company and establishes the tone of continued contact. It can positively affect the behavior of employees by giving them a sense of pride in the company and enabling them to be more efficient in internal and external communications. (Sony Corporation, 1985, n.p.)

Corporations want a consistent application of their visual guidelines to convey a visually strong and cohesive presence for their company in today's competitive visual environment. Logos and how they are presented are a major concern to corporations. For this reason, many corporations have been asking students to remove logos from their websites because the corporate logo is not shown correctly. Logos are central to a company's visual identity because good corporate symbols portray both the personality and the purpose of the company. Designers create logos as a shorthand method of communicating information about products or service. The social function of these symbols is to make people recognize and recall the company that the logo represents.

Logo designs must be suitable for reproduction on everything from advertisements to uniforms. From a psychological perspective, the design must reflect the dignity and tradition of the company as

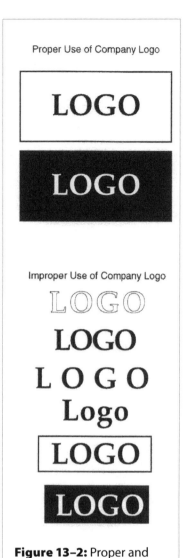

Figure 13–2: Proper and improper use of logos. Author's illustration.

well as its forward-looking aspects. It must be unique and timely. Technically, the design must be able to reproduce in many forms, including colors and plain black, without losing its clarity and design integrity. Simply stated, in all of its variations, the logo must be memorable and legible.

Although we see the proper use of logo elements in visual communication messages every day, the basic design system being applied to the message is not apparent to most people. According to Stuart Ewen (1988), logos create a social relationship of power that helps to shape public perception:

> Whatever the context, the corporate image is designed to dominate its surroundings. The corporate logo appears to spring out of an overarching idea of efficiency; there is no hint of an individual mind or hand having had any impact on its simple statement of corporate dignity. (p. 112)

Transnational corporations utilize both commercial and private media channels to display their visual identities and logos. Corporate identification is especially prevalent in the realm of organized sports. In addition to buying commercial space within the sporting event, hockey areas sell billboard space around the ice rink that display corporate logos, oil and beer companies sponsor race cars that use logo decoration, and sportswear companies give hats, sports shoes, and T-shirts to athletes to wear during sporting events. There are so many corporate logos and identity symbols displayed during these televised events that it is difficult to find a camera angle that does not include a corporate message. Similar to the blurring of the boundaries between print content and advertisements, sporting events blur the boundaries between television commercials and program content. As a result, it is impossible to watch a sporting event on television and escape the corporate messages designed to increase sales, create brand awareness, and transmit a mind-set supportive of corporate culture. Schiller (1986) stated:

> As with many marketing practices, the commercialization of sports is an American specialty, rapidly being extended to the rest of the world. The Superbowl serves as the model. In this professional football extravaganza, promoted beforehand for months in all the media, the marketing message reaches half the American population, an estimated 125,000,000 viewers. (p. 129)

Today, the Super Bowl is equally a corporate and a sporting event. Press coverage of the commercials being premiered during the Super Bowl promotes the advertisements in addition to the game. Landmark Super Bowl commercials include Apple Computer's "1984" commercial that introduced the Macintosh, Budweiser Beer's croaking frogs, and Victoria Secret's fashion show. This last commercial combined television and the web. As the web becomes more widely utilized, the Super Bowl event and its commercial sponsors are adding the web to the corporate media mix. In fact, corporations now tend to dominate the web.

Presently, the web is transforming the original text and academic-oriented Internet into a global shopping and information mall. Despite the fact that the web is more than 20 years old, commercial logos fill its electronic landscape. As a result, it is impossible to escape exposure to corporate messages

while searching the web for data. On the web, on television, and in printed mass media, the increased use of visual representation is introducing more visual conventions into cultural experience.

INTERTEXTUALITY

Intertextuality is the concept that every communication act refers to other communication acts, either explicitly or implicitly. Inherent in the communication process are other texts that shape the meaning of messages for senders and receivers. Simply stated, no message is understood in isolation. The meaning of a message is shaped by an individual's experience with other texts and/or communicative acts. Intertextuality draws attention to the complex ways in which meanings are constituted through relationships to other texts. Text can be viewed historically as a series of texts or in terms of intertextual chains. For instance, movies are generally filled with cross-references that are either made explicitly by the moviemaker or read into the movie by the viewer. As a result, the viewer understands the meaning of the movie through the kinds of intertextual relationships that the filmmaker explicitly depicts and the viewer implicitly creates. (See the Intertextuality Resource at http://www.youtube.com/watch?v=P6BFeVWb8vc) Another example of intertextuality is the Motorola advertisement described in Chapter 10, because it visually and verbally refers to the Apple "1984" commercial.

Meanings embedded in communicative actions are largely shaped by culture and language. For example, Benjamin Lee Whorf argued that language is the primary vehicle of culture. The language that we speak shapes the ways in which we perceive the world. For instance, Whorf argued that in Western culture, languages that express time as past, present, and future shape the concepts of Newtonian space, time, and matter. In contrast, languages such as Hopi have a different concept of time because they perceive it as a flowing continuum. Consequently, Hopi and Western cultures perceive the world in very different ways. A more contemporary example of how language changes our concepts about the world in which we live is the introduction of computer terminology. Words such as memory, storage, upload, and download are not only applied to computers but also people have used the terms to refer to information stored in their memories. As computers proliferate, we now metaphorically speak about human information processing in terms that relate to machine operations. Thus, the introduction of new words alters the way we describe ourselves, and ultimately, it will influence how we perceive people and the world around us.

In addition to altering our vocabulary, rapidly developing digital technologies have transformed computer networks into global communication systems. As a result, the boundaries between mediated and nonmediated visual experiences are blurring. As described in the first chapter, interactive visual technologies enable people to see and hear each other across distances at the same time. These new technologies alter the meaning of face-to-face communication from a nonmediated conversation that takes place at the same time in a single location to one that can occur in mediated environments across geographic locations. Timothy Druckrey (1996) stated the following:

> Over the past five centuries, a vision of technology has evolved that extends from attempts at mechanically creating life to the ability to decode and map the entire sequence of DNA, from the fantasy of space travel to the colonization of cyberspace, from the transmission of messages to the establishment of global databases—in short, the collapse of the border between the material and the immaterial, the real and the impossible. (p. 12)

The introduction of computers into culture is altering both interpersonal and mediated experiences. To adjust to this new form of communication, we depend on knowledge from the real world and exposure to other media. Many of the design conventions developed for print, television, and computer screens are now being applied to the World Wide Web. The web exemplifies intertextuality because it relies on our cultural and media experiences to interpret messages.

Figure 13–3: To understand the meaning of these images, the source image used before the computer manipulation needs to be understood. Author's illustration.

SUMMARY

Despite the American tendency to have a bias against visual imagery, personal computers and digital technologies are increasing the significance of visual imagery within culture. These technologies introduce visual language and commercial messages into the process of computer-based communication. Additionally, the increased use of visual and verbal messages in both print and electronic design is making it difficult to distinguish between commercial and informational messages. With the increased blurring of the boundaries between advertising messages and media content, readers and viewers need to become more critical of the messages that they encounter through media channels. Moreover, understanding these visual messages can require a previous knowledge of cultural codes and design practices.

WEBSITES

- *Advertising*
 http://www.adbusters.org/
 http://www. adage.com/
 http://www.adweek.com/
 http://www.aef.org/
- *Intertextuality*
 http://www.aber.ac.uk/media/Documents/S4B/sem09.html

EXERCISES

1. Analyze five print advertisements utilizing Lasswell's method for understanding advertising.

2. Select an advertisement and apply Firth's methods of undressing an advertisement to reveal its three stages of meaning (the surface meaning, the advertiser's intended meaning, and the ideological meaning).

3. Utilizing the technique of collage, substitute one element from a well-known advertisement that you consider to be inappropriate for the original intention of the ad for another. Describe the ensuing effect. Consider issues such as age, status, ethnicity, gender, setting, and historical time period.

4. Collect two or three political cartoons from the newspaper. Describe the meaning of each cartoon and explain the cultural information required for each to be humorous.

5. Get a copy of a Sunday newspaper magazine, for example, *The New York Times Magazine*. Make a list of the full page or larger advertisements. Now examine each ad for the following:
 a. How many people are in the ad? Are they men or women?
 b. What racial group(s) is (are) being depicted?
 c. What type of product is being shown with what type of person?
 d. Can you make any generalizations about stereotyping that may or may not be occurring in the advertisements that you examined?

6. Examine a copy of a fashion magazine. What are the differences between the advertisements and the editorial sections in this magazine? Are there any visual cues to help identify each type of message?

KEY TERMS

Comics are defined as juxtaposed pictorial and other images in deliberate sequence.

Consumer-oriented strategies tend to sell the personality of the brand or they associate the product with a lifestyle or an attitude.

Consumption is a social ethic that prizes the acquisition of goods over other values.

Corporate identity programs design visual logos and specify how to visually represent the company's logo to the public.

Deconstruction is an oppositional reading of the text, and its purpose is to expose the social and political power structures in society that unite to create the text.

Emotional appeals are designed to make consumers feel as if they need or want a particular item.

Intertextuality is the concept that every communication act refers to other communication acts, either explicitly or implicitly.

Lifestyle advertising depicts lifestyle trends rather than demonstrating how a product works.

Product-oriented approaches are selling messages that focus on the product itself. They tend to appeal to reason.

Rational appeals present a logical reason why consumers should buy a product.

Visual puns work with symbols that can have two or more meanings or with two or more symbols that have similar or identical images but different meanings.

☀ Visual Imagery and Cultural Change

During the 20th century, the social utilization of images expanded beyond the role of art and into the realm of communication. This shift has been influenced by the development of digital technologies, theories on visual cognition, and the cultural use of imagery. Technological advancements in computers and digital imaging systems are creating new ways to incorporate visual imagery into the process of human communication. For instance, VR (virtual reality) systems are being designed to depict phenomena in ways that provide insight into how the physical world works. Along with new technology, theories have developed to explain the role of visual imagery in human cognition. However, the introduction of new technology, such as digital photography, is altering our concepts about the role of traditional visual media within culture. Moreover, the changing role of images raises ethical questions about the ways in which individuals and industries utilize visual media.

NEW THEORIES ABOUT VISUAL COGNITION

For much of the 20th century, philosophers were interested in human symbolic capabilities. The symbolic theories of Suzanne Langer (see Chapter 4) and Nelson Goodman (1968) tested the widespread view that linguistic and logical symbol systems take priority over other, more expressive ones. Goodman's theory of symbols argues that symbols can function on different levels. For example, a zigzag line can function as an artistic symbol to represent mountains in a drawing or a month-long record of the Dow Jones stock average. The way in which one reads the symbol depends upon the graphic context which surrounds it and how the individual viewer perceives it.

Similarly, psychologists, such as David Olson, Gavriel Salomon, and Howard Gardner (see Olson, 1974), have been exploring human symbol systems in terms of information processing and human cognition. Gardner (1983) proposed a theory of multiple intelligences, which incorporates a number of different symbol systems, including linguistic, musical, logical-mathematical, spatial, bodily-kinesthetic, and personal. It is through the use of these various symbol systems that cultural ideas are expressed. Gardner stated, "Symbols pave the royal route from raw intelligences to finished cultures" (p. 300). As a result, mastering the use of symbol systems is an important part of belonging to any

culture. Moreover, new symbol systems can emerge through technological change, for example, the icons utilized in graphical computer interfaces. In contemporary culture, people need to learn this new symbol system in order to participate in society and perform social roles.

THE CHANGING ROLE OF VISUAL IMAGERY

A significant shift in the function of visual imagery has occurred over the past 100 years. Instead of using visual imagery primarily as art, the majority of images created today are utilized in the process of communication. Although it can be argued that art conveys a message and it therefore should be considered communication, the artistic message additionally attempts to elicit an aesthetic and emotive experience from the viewer. For example, Christian paintings created during the Middle Ages were designed to serve the illiterate laity for the same purpose the written word served the clergy. Clearly, Christian symbols were associated with very specific meanings, and they communicated a definite message to worshipers. However, these images were also designed to evoke spiritual awareness in the viewer.

In addition to communicating ideas, the term "art" tends to be associated with concepts of aesthetics and beauty. In contrast, the term visual communication shifts the focus of attention toward the message process, its distribution, reception, and interpretation. For example, the art historian E.H. Gombrich (1999) made a distinction between art and visual communication when he began to discuss maps and instructional illustrations. Early forms of visual communication, such as maps and anatomical drawings, date back to the 1400s. However, it was not until the rise of the Industrial Revolution that the social need for pictorial instruction increased. At the threshold of the Industrial Age, encyclopedias were published that revealed the secrets of the craft traditions and the importance of trade and industry. Additionally, a growing demand emerged for visual instruction with the popularity of handcrafts in the home. With the invention of the sewing machine, basic instruction in manual skills was required, and it was soon realized that the marketing of tools and instruments could benefit from the addition of instructional leaflets. The invention of photography and later video greatly aided the use of pictorial instruction to teach basic skills.

From the post-Industrial Revolution era and into modern times, the invention of new image-making technologies created a social demand for visual forms of communication. Gombrich (1999) stated that when we look around our environment today, "so overriding is the 'demand for images' in Western society that a household which lacks a television set (preferably in colour) is often described as 'deprived'" (p. 7). Today's society is dependent upon images and the function of most of these images is communicative. However, another feature of contemporary image making is the fact that images are mass produced and mass distributed.

Proliferation of Images as Mass Art

According to Noel Carroll (1998), images produced for mass distribution and consumption could be considered a form of mass art. He defined mass art as "art that is produced and distributed by a mass delivery system. The first major one of which to emerge in the West was printing, which was later followed in rapid succession by photography, sound recording, film, radio, and TV" (p. 199). Mass art is an art that has developed within the context of modern industrial society and is designed for use by that society. It is art that is delivered to large consuming populations that cross national, class, religious, political, ethnic, and racial boundaries. The function of mass art is to elicit mass engagement that is conducive to mass accessibility. Moreover, Carroll argued that mass art gravitates toward artistic choices that make it more accessible to large numbers of people because the creators of mass art are typically engaged in artistic practices that convey content, such as television programming or motion pictures.

However, the idea of naming visual content distributed through the mass media an art, places visual imagery within the tradition of art history and criticism. Art critics tend to make a distinction between high art and popular art. High art is art created for members of the upper classes; in contrast, popular art is for everyone else. Thus, art tends to be viewed in terms of class distinctions. However, scholars who want to examine issues relating to visual imagery and culture without focusing on class issues can turn toward the newer discipline of cultural studies.

CULTURAL APPROACHES TO THE STUDY OF IMAGES

Cultural studies focuses on how people make meaning, understand reality, and order their daily experience through the use of cultural symbols that appear in visual media. Everyday experience is at the center of cultural studies, and it examines the ways in which mass communication both shapes and is shaped by history, politics, and economics. For instance, Tagg (1999) examined photography as a means of surveillance. In contrast, a large portion of cultural studies research tends to focus on the investigation of daily experience in terms of issues that relate to race, gender, class, and sexuality. Instead of examining social classes, this type of research highlights cultural differences and how some social groups have been marginalized or ignored throughout history.

The rapid introduction of a variety of new communication technologies, such as digital photography, computers, the World Wide Web, and VR, are challenging today's scholars to find new models and approaches for examining the relationship between visual communication and culture. For example, the new visual technology of VR is being utilized in ways that do not fit within the definition of mass art, and VR does not represent everyday experience, which is at the center of cultural studies. However, VR is a technology that is starting to alter both the ways in which people communicate with each other and the symbols that are utilized in the communication process. James Carey (1989) stated, "Reality is brought into existence, is produced, by communication—by, in short, the construction, apprehension, and utilization of symbolic forms" (p. 25). As symbolic forms change, our views of reality can also change. For example, Jaron Lanier (2010) coined the term *Postsymbolic Communication* to refer to the ability to communicate ideas and feelings through VR systems instead of language. He argued that this would be a more vivid type of communication.

> For instance, instead of saying "I'm hungry; let's go crab hunting," you might simulate your own transparency so your friends could see your empty stomach, or you might turn into a video game about crab hunting so you and your compatriots could get practice before the actual hunt. (p. 190)

As the term VR implies, it is a technology that radically alters the ways in which reality is symbolized because it "virtually" represents it. As an emerging visual technology, VR demonstrates both the changing role of images within contemporary culture and how new symbolic forms can alter the ways in which reality is depicted.

Visual Culture

Visual culture is the "study of the social construction of visual experience" (Mitchell, 1995, p. 540). Bal (2003) stated that taken at face value, visual culture "describes the nature of present-day culture as primarily visual" (p. 6). Mirzoeff (1999) viewed it as art history with a cultural studies perspective. Mitchell (1995) contended that visual culture "must be grounded in the description of the social field of the gaze, the construction of subjectivity, identity, desire, memory, and imagination. (p. 544)

A difference between visual culture and visual communication is the idea that visual communication is about the process of communicating a message. It deals with cognition (Chapter 1), rhetoric

(Chapters 8 and 9), visual literacy (Chapter 2), semiotics (Chapter 4) and visual media (Chapters 7–12). In contrast, visual culture is about "practices of seeing the world and especially the seeing of other people" (Mitchell, 2002, p. 166). Mitchell (2002) continued:

> Vision is (as we say) a cultural construction, that it is learned and cultivated, not simply given by nature; that therefore it might have a history related in some yet to be determined way to the history of arts, technologies, media, and social practices of display and spectatorship; and (finally) that it is deeply involved with human societies, with the ethics and politics, aesthetics and epistemology of seeing and being seen. (p. 166)

As explored in Chapter 3 on perspective, culture is important in the process of visual communication because it influences the ways in which people interpret visual messages. However, it is not the focus of study. So, there is a difference between visual communication and visual culture studies. A primary difference is that art history is not a part of the theoretical foundation of visual communication. The rise of visual areas of research has been spurred on by the increase of images in contemporary culture. Poynor (2010) stated, "…—graphic novels, graphic design, illustration, low cost film-making—where the expressive possibility of the visual are still embraced with conviction. This, rather than art scene-mediated art, is the centre of visual culture" (p. 207). Thus, we now have the topics of visual communication and visual culture, which do at times overlap.

Box 14.1: William J. Mitchell—Shadows on the Wall

For a century and a half photographic evidence seemed unassailably provocative. Chemical photography's temporary standardization and stabilization of the process of image making served the purpose of an era dominated by science, exploration, and industrialization. Photographs appeared to be reliably manufactured commodities, readily distinguishable from other types of images. They were comfortably regarded as causally generated truthful reports about things in the real world, unlike more traditionally crafted images, which seemed notoriously ambiguous and uncertain human constructions—realizations of ineffable representational intentions. The visual discourses of recorded fact and imaginative construction were conveniently segregated. But the emergence of digital imaging has irrevocably subverted these…. An interlude of false innocence has passed. Today, as we enter the post-photographic era, we must face once again the ineradicable fragility of our ontological distinction between the imaginary and the real, and the tragic elusiveness of the Cartesian dream. We have indeed learned to fix shadows, but not to secure their meaning or to stabilize their truth values; they still flicker on the walls of Plato's cave. (Mitchell, 1992, p. 225)

DIGITAL IMAGERY AND CULTURAL CONCERNS

During the first half of the 20th century, scholars and critics were struck by the proliferation of images. For most, the important visual phenomenon was the camera and its ability to produce images. However, as we move into the 21st century, many of the images that we encounter are digitally produced, distributed, and, in some cases, manipulated. As Zettl (1996) argued, the shift from analytical to synthetic imagery has important cultural implications. In addition to an inherent structural difference, digital media can more quickly and easily reproduce and distribute images on a global scale. Thus, the nature of visual communication is changed. A discussion of analytic versus synthetic images illustrates this transformation.

Photography as Evidence

Our cultural concepts about photography tend to make people believe that photographs capture moments of truth. As a result, photographs have been used as a form of legal evidence in American courtrooms. Susan Sontag (1977) said the following:

> Photographs furnish evidence. Something we hear about, but doubt, seems proven when we're shown a photograph of it. In one version of its utility, the camera record incriminates. Starting with their use by the Paris police in the murderous roundup of communards in June 1871, photographs became a useful tool of modern states in the surveillance and control of their increasingly mobile populations. In another version of its utility, the camera record justifies. A photograph passes for incontrovertible proof that a given thing happened. The picture may distort; but there is always a presumption that something exists, or did exist, which is like what's in the picture. (p. 5)

In addition to capturing moments of reality, cameras are increasingly being used as a surveillance technology. Video cameras placed in homes, stores, banks, parks, and police cars record the daily activities of average citizens. A number of television programs, including *America's Funniest Home Videos* and *World's Most Amazing Videos,* utilize video footage shot by average people that capture unusual accidents and situations. Moreover, when a crime is captured on videotape, it could become material for television news reports and magazine shows. Programs such as *Cops* actually have film crews travel with police officers to videotape crimes in action and the arrest of criminals. Television stations, such as CNN, ask viewers to send in their videotapes of weather and other related events.

In addition to capturing the images of crimes as they occur, digital techniques have also been developed to help law enforcement agencies solve crimes and catch criminals. For instance, the police use computerized processes to reconstruct a more focused image from the blurriest film or still photograph.

The use of statistical probability to enhance photographs for the purposes of law enforcement further illustrates how the boundaries between photography and pseudophotography are blurring. Moreover, Jonathan Crary (1990) argued that computer-generated imagery is altering the relationship between an observing subject and modes of representation. Most of the historically important operations performed by the human eye are being supplanted by practices in which visual images no longer utilize the observer as the point of reference. Real observers have been replaced by computer-manipulated points of reference. Moreover, synthetic images do not directly refer to an object situated in reality. Crary asserted the following:

> The formalization and diffusion of computer-generated imagery heralds the ubiquitous implantation of fabricated visual "spaces" radically different from the mimetic capacities of film, photography, and television. These latter three, at least until the mid-1970s, were generally forms of analog media that still corresponded to the optical wavelengths of the spectrum, and to a point of view, static or mobile, located in real space. Computer-aided design, synthetic holography, flight simulators, computer animation, robotic image recognition, ray tracing, texture mapping, motion control, virtual environment helmets, magnetic resonance imaging, and multispectral sensors are only a few of the techniques that are relocating vision to a plane severed from a human observer. (p. 1)

Synthetic images remove the human observer as a reference point in image creation. Moreover, they represent images that are completely computer generated. In contrast, pseudophotographs fall into a category that is a mixture between traditional photography and synthetic image creation. Digital image manipulation and image reconstruction techniques utilize portions of actual images in the process of fabricating a picture. In professions such as photojournalism and law enforcement, the use of digital image manipulation raises serious ethical questions (see Chapter 8).

The Photographic Icon

The rise in the use of images has produced the photographic icon or an image that most people in a culture recognize. Recently, a book called *Icons* was published that displays photographs of 124

iconic music groups and individuals. The list included Marilyn Monroe and Howard Stern. Many of the photographs were considered to be iconic images of the people represented, such as Humphrey Bogart in an image with Ingrid Bergman from *Casablanca*. The authors stated that today, the word icon "has come to mean someone, real or imaginary, who has come to symbolize a concept or an institution, whether it be political, religious, or cultural" (Millidge & Hodge, 2010, p. 6).

Images can also become iconic through mass media exposure. For instance, the first time the image of the Saddam Hussein statue was tumbled, this researcher predicted it would become iconic. Since that original showing, it has come to represent victory in the war in Iraq. Similarly, the picture of Baby Samuel, the fetus with its hand on a doctor's finger, also became iconic. To some, the image appeared to be a fetus reaching out to the doctor. However, Jones (2009) revealed the truth about the image and the controversy around it. The truth is that the doctor reached through a slit in the womb and moved the hand to gain access to the area that needed surgery. "The photograph was first published in *USA Today* on September 7, 1999, as part of a story about prenatal spina bifida surgery" (p. 175). Because of the ambiguity of the image, prolife advocates began to use it as a symbol to support the idea that life begins with the fetus. They argued that the fetus reached out to grasp the finger. Some even said that the fetus reached out to save other fetuses from abortion. The controversy demonstrates how the context in which we see an image can affect the ways in which we interpret it.

Many images are taken out of context and gain a new meaning in the new context. This especially happens with iconic images that are placed into remixed videos (Chapter 6). The new context creates entirely new meanings for the images. For example, images from FOX News have been turned into a number of remixes, which change the context of the image. Yet, the use of these images on YouTube could be an infringement of FOX News's copyright because they are taken from television broadcasts.

Ownership of Images

The use of digital technology is raising many copyright issues. For example, music, film, and television companies can ask YouTube to remove videos due to copyright violations. In the past, mass media was a one-way process. But now, with interactive media, individuals can create their own user-generated content and share it through the Internet. Remix videos and other forms of digital art often contain images that are taken from popular culture. Technically, this is violating a copyright, especially if taken from mass media. Enforcing this law would inhibit creativity and place many of our youth in jail. Larry Lessig (2008) argued that we should develop new systems of copyright that will nurture "the full range of creativity and collaboration that the Internet enables" (p. 294). Digital media is so easy to copy that as all mass media turns digital, it will be next to impossible to enforce our existing copyright laws.

Downloading movies is as easy as downloading music. The largest group of downloaders is college students. "It has been estimated that one out of three college students downloads music illegally" (Sheehan, Tsao & Yang, 2010, p. 241). This is especially problematic because many of these students do not care if the music is copyrighted. The high level of music piracy among college-age students is both behavioral and psychological. This age group spends more time on the Internet and also engages in risky behavior. Music downloading behaviors can be applied to image downloads of movies and pictures for remixed videos. The ease in which the software can make copies combined with risky behavior makes it virtually impossible to enforce the current laws.

MASS DISTRIBUTION OF IMAGERY AND MONOCULTURE

Copyright is an issue that impacts digital artists because digital technology enhances our ability to reproduce and distribute mass images. Walter Benjamin argued that the reproduction of mass images

is more important than the invention of the camera itself. What happens when images are reproduced ad infinitum? Currently, visual technologies reproduce thousands and thousands of images.

> Visual communication dominates every area of our lives. As sleeping becomes the only activity that occupies children more than watching a video screen, we must become more sensitive to how images shape the fabric of our lives. As unhealthy and unrealistic advertising images become more and more implicated in serious social ills, such as in the psychologically based but physically manifested afflictions of anorexia and bulimia; as tobacco addiction increases among young adolescents and well over 1,000 people die each day of tobacco-related causes, we have still only just begun to recognize how patterns in mass media first legitimize and then normalize socially destructive attitudes and behavior. (Barry, 1997, p. 3)

In addition to questioning the social behavior patterns depicted in advertising imagery, the global mass distribution of these images is also being questioned. Matthew P. McAllister (1998) argued that advertisements are part of a larger movement toward globalized advertising. These global ads reflect the motivations of transnational corporations. He described the rise of global marketing in the 1980s:

> The world began to change to fit the needs of global marketers. In fact, these changes were often the result of global marketers' effort and influence. New markets opened as the Cold War ended. Russia, Poland, Romania, and other former Soviet Bloc countries found marketers peeking through the Iron Curtain even before it collapsed. In the economic chaos that followed, such counties were often willing to strike very lucrative deals with international corporations, offering to privatize manufacturing facilities or eliminate restrictions to bring in revenue. Focusing on another Cold War player, marketers are willing to overlook the antidemocratic tendencies of the Chinese government as long as that country increases access to its one-billion-plus citizens. By 1991, retail sales in China had reached $173 billion, a five-fold increase from 1978. (p. 37)

The deregulatory policies of the 1990s made it even easier for international corporations to sell their products on a global level. Additionally, the creation of large, boundary-crossing media systems supported global sales because cable and satellite systems enable marketers to reach millions of people. Media organizations, such as CNN, MTV, ESPN, Star Television, Disney/ABC, and Time-Warner-Turner, can offer media mixes that reach global audiences. According to McAllister (1998), "The development of global markets, global media, global advertising agencies, and global marketers has led to a push toward globalization in marketing: the treatment of the entire planet as one market" (p. 39). In contrast to multinational advertising, where the marketer customizes individual advertising campaigns for individual cultures, global advertising tries to create one universal message that will work in all cultures. However, global advertising strategies tend to be more visual than verbal. As a result, emotional consumer-oriented selling approaches could replace product-oriented strategies in global advertising. This shift tends to replace product information with consumer benefits as the key message strategy. Moreover, McAllister is concerned that the factual usefulness of advertising messages designed to help consumers make informed buying decisions will be replaced with images of American popular culture. This shift could promote cultural imperialism and erode international diversity. Moreover, it has been argued that global advertisements, such as the ones shown during the Olympics, tend to convey an overall message about the superiority of American products and American corporations.

> Despite the portrayals of happy people in [Olympic] ads, it is not a happy picture of the future. On the surface, the globalized ads seemed to celebrate cultural diversity. The ads showed South Africans smiling in their native garb; Indian children playing cricket against unique architecture; Australians talking in colorful slang; Euro-hip Italian lovers on the beach; the biological diversity of the rain forest; the distinctive style of Chinese celebrations. What the corporations that made these want, though, is the ultimate elimination of this diversity. They want cultural uniformity, specifically the uniformity of everyone drinking Coke, or using IBMs, or riding in Budget rent-a-cars. The values and symbols they were saluting in the ads—the distinct international iconography—are the very values and symbols they are trying to eradicate. (McAllister, 1998, p. 57)

A central concern here is the predominance of American culture in advertising that tends to overshadow other cultures' values. McAllister (1998) is further concerned about how the global strate-

gies of marketing and advertising could be turning the planet into a large *monoculture,* a place where everyone eats at the same fast-food restaurants, wears the same jeans, and watches the same movies and television programs.

Along with concerns over the rise of monoculture are concerns about media ownership, because only a handful of corporations own the majority of the global media outlets. To counter media monopolies, some people turn to the Internet. The Internet has been called an antidote to mass media because numerous views are expressed, and many of these would never be found in commercial mass media. For example, when the film *Crash* was banned from being shown in London's West End theaters, its director, David Croneberg, argued that it was possible to show the film on the Internet. "It would be possible for a viewer in France, Great Britain, or anywhere, to view a banned or censored film on his or her computer, via the Internet" (Barnard, 1995, p. 120). Although the Internet is a medium that enables people to express a wide number of perspectives and opinions, it has still been criticized for being culturally dominated by Americans. Following the pattern of global advertising, the Internet tends to promote American ideals and values.

As communication networks come together into a global village, questions are being raised about whether the world is turning into a huge monoculture. More important, this monoculture tends to be dominated by American ideologies. However, it is questionable whether other cultures will allow this to happen.

ROLE OF THE IMAGE IN POSTMODERN CULTURE

Throughout the ages, the role of images within culture has changed. Although some scholars argue that the mass distribution of imagery has turned contemporary culture into a visual one, Aumont (1994) contended that the image itself has lost much of its power because it has been reduced to a method of recording nature and conveying information:

> The medieval image, and perhaps also that produced by more distant civilisation, was fundamentally different from today's, at least insofar as its visible aspect was not regarded as paramount. This was only an earthly, outward appearance, of little value compared to the supernatural and heavenly beings to which it gave access. So, the real image revolution (if there was one) happened a long time ago, when images lost the transcendent power they used to have and were reduced to mere records, however expressive, of appearances. Nowadays, the massive multiplication of images may appear to signal a return of the image, but our civilisation remains, whether we like it or not, a civilisation of language. (p. 241)

In contrast, other scholars (Mirzoeff, 1999; Mitchell, 1994) regard the 20th century as the "civilization of images," because we are surrounded by a proliferation of visual imagery. Moreover, it is being argued that culture has taken a "visual turn" and images are currently challenging the printed word as a means of communicating information (see Laspina, 1998). However, there are conflicting opinions about the cultural impact of the increased use of visual forms of representation. For instance, Stephens (1998) considered new video to be a positive step in the development of human communication. He stated, "The fall of the printed word—the loss of our beloved books—is a large loss. Nevertheless, the rise of the moving image, as we perfect new, nonrapid uses of video, should prove an even larger gain" (p. 230). Similarly, Gregory Ulmer (1989) advocated the use of video in education because video promotes inventive thinking. In contrast, scholars, such as Neil Postman (1979), argued that schools need to preserve culture, and he advocated the use of traditional verbal forms of representation to promote critical thinking skills. Moreover, Jane M. Healy (1990) contended that television viewing has contributed to the decline of traditional literacy and critical thinking skills of students in the United States. As a result, television is considered a negative influence.

Technological advancements are enabling individuals to more easily utilize both visual and verbal forms of expression. Regardless of which side one takes in the visualist/verbalist dispute (Chapter 13), a better understanding of the ways in which contemporary culture utilizes visual imagery is becoming increasingly important. However, it is more difficult to understand the meanings associated with images. Comprehending the denotative relationship between word and object tends to be more direct than interpreting the connotative meaning of an image. As a result, language is still the primary method of human communication. However, as digital technologies make it easier for individuals to communicate through visual forms of representation, educators will need to think about ways in which these new forms of expression can be incorporated into the educational process.

Although the full impact of the proliferation of visual imagery on culture is yet unknown, postmodern culture does tend to promote the role of the image as a predominant form of representation and challenges the hegemony of the word as a significant conveyor of meaning.

> In the opinion of many critics, Postmodernism is intrinsically tied to the emergence of particular technical, social and economic conditions which now prevail throughout much of the world (encapsulated in terms like the "consumer society:", the "media society", the "post-industrial society", and so on). The implications of these changes are wide-ranging, but one frequently invoked issue is the domination of the "image".... A business for example, is not valued by the things that its workers produce but by the way it is *represented* on the stock exchange and the confidence that share holders have in its *image*. (Jobling & Crowley, 1996, pp. 272–273)

Currently, the changing role of imagery within culture tends to be associated with other types of social change, including technological advancements, global advertising, the rise of transnational corporations, and the decline of traditional literacy skills. As a result, an examination of the use of imagery should also consider the role various institutions play in image creation and interpretation.

Postmodern Graphic Design and Culture

Today, a new postmodern style of graphic design is emerging that tends to abandon the guiding notions established by modernist design (see Chapter 6). Postmodern practices now appear highly referential because they utilize a reservoir of historical and established images, which already connote a meaning. Writers create texts that use words based on other texts and words that they have encountered. Cultural life is then viewed as a series of texts that intersect with one another. Postmodern graphic design can be viewed in this context because it utilizes the intertextuality of the graphic or visual text. Visual culture researchers ask the following question: How can graphic images be utilized to critique our world today?

Deconstructive graphics is a term used to describe designs that deploy compositional complexity, the layering of signs, and playful confusion as a strategy to force the spectator to deconstruct "hidden" meanings within a work. The purpose of this type of design is to promote multiple rather than fixed readings. The reader is provoked into becoming an active participant in the construction of the message. The reading of visual images, similar to language, is a highly complex set of activities that works on many levels, starting with the automatic movement of the eye and moving to the intentional level of meaning making (Chapters 3 & 4). In contrast to modernist designers that present absorbing concise information, postmodern designers try to make design a pleasurable experience that stimulates the senses.

Benetton's advertising campaign exemplifies this new type of design. Jobling and Crowley (1996) described their designs as follows:

> "The United Colors of Benetton", have been widely exposed throughout the world on billboards and the pages of glossy magazines. Much of this controversy centers on the fact that these images seem troubling "out of place", thereby confusing the kind of compartmentalized and specialised organisation of graphic communications. One editor of a British fashion magazine refused to accept Benetton's depiction of David Kirby, a young American

dying of AIDS, precisely because it was not in the "right context". These representations, making no claims about the merits of Benetton's products, seem to reflect on the condition of the world—or more accurately, they make space for the viewer to speculate on the knowledge that they contain. Benetton's advertisements are spectacularly "open" texts. That is, they encourage the spectator "to produce a signification which should be neither univocal nor stable". In this sense, Toscani's [the photographer] images for Benetton seem to celebrate the fundamental instability of all texts that Deconstruction takes as a matter of fact. (p. 285)

Figure 14–1: United Colors of Benetton Advertising. Used with permission. Benetton. (Benetton ads can also be found on YouTube by typing in Benetton or going to http://www.youtube.com/watch?v=4zqtDeZMWUE&feature=related)

Although desconstuctive graphic design was a type of experiment promoted by Benetton, it can be considered a form of critical practice, in contrast to the original modernist designers who sought to promote political change with their design. The practitioners of deconstructive graphics are concerned with redirecting the practice of design itself. Design professor Katherine McCoy (1998) said the following:

The deconstruction of meaning holds important lessons about our audiences for visual communicators, but poses some problems as well. While these theories applaud the existence of unstable meaning because of audiences' varying cultural contexts and personal experiences, this can be at odds with the client's need for a single, clear interpretation of the message. Designers find themselves cast in an authoritarian role within this critique. And this focus on theoretical and critical language dynamics sometimes seems to diminish visual values in graphic design, leading to a predominantly verbal approach, as copywriting's dominance has done in advertising. (p. 10)

In advertisements, the copy has been considered to be the "thinking behind the ad." Copywriters tend to direct the message being communicated. Images alone are often difficult to interpret. For instance, Benetton's advertising campaigns have been supported by press releases, and they gener-

ated a tremendous about of publicity and news coverage to clarify the meaning of the ads. Benetton's approach to advertising is to convey a strong company image by promoting universal themes such as racial integration, protection of the environment, and AIDS awareness. Although these advertisements promote positive universal values, the underlying goal is to create a positive image for the company. In the case of Benetton, the advertiser is often more interested in promoting a positive institutional image through social concerns, rather than selling specific products.

Visual Trends in Publishing

In addition to advertising's focus on image over word, magazines such as *Detour* and *Dutch* have appeared that present photography instead of written articles as their editorial content. For instance, *Dutch* has no written articles included in its #24 1999 issue. In contrast to traditional magazine articles, this magazine presents a series of photo "galleries." Following the metaphor of a gallery, numerous blank white pages are incorporated into the magazine's design. Moreover, *Dutch* does not follow the layout format of a typical magazine because page numbers are often missing or they are printed in the center of a blank white page. However, *Dutch* has now folded and *Detour*'s website is not working. A totally visual magazine does not seem to work. Instead, you need to mix print and text into a visually appealing design, such as the *Elephant* magazine on art and visual culture. Moreover, *Elephant* is available on the web in both a digital and a print-based format.

In addition to magazines, newspapers are adding more visual material to their publications. A comparison of the front page of the January 1st, 2000, issue of *The New York Times* with the January 1st, 1900, issue reveals this change. The front page of the 1900 newspaper is text only. In contrast, the 2000 issue has a large color picture of New York City's Times Square. Additionally, smaller photographs are integrated throughout the page. However, a more interesting change is the fact that the cover also includes a photograph of another section of the newspaper to reinforce the *Time*'s new visual look. Jacobson (2010) stated the following:

> In addition to becoming more visual, newspapers are experimenting with an online presence. Newspapers in particular seem to be repackaging their print content for the brave new online world. Marshall Mcluhan [1964] observed that the initial content of a new medium is an older medium, with innovation following later. As newsrooms migrate more of their activities to the Web, it is likely that the shape of the news will also undergo transformation. (p. 64)

In addition to technological changes, postmodern graphic design is experimenting with new types of visually oriented layouts and ways of presenting visual information. However, this shift to the visual tends to make it more difficult to understand visual information because it is sometimes presented without textual explanation. In some cases, an explanation may need to be found through other media. For example, Benetton had to supplement its advertising with publicity to explain the intention of the advertising. Similarly, to understand the purpose of a magazine such as *Dutch*, one has to look to other sources because it tends not to be self-explanatory. This may be one reason why *Dutch* failed. Herein lies the problem of image-only communication. It can be much more difficult to understand than linguistic representations. Without linguistic support, the context of an image may be misunderstood, like the image of Baby Samuel.

SUMMARY

During the past century, the cultural role of the image had increasingly shifted away from artistic representation and toward a method of communication. In every aspect of culture, from education to

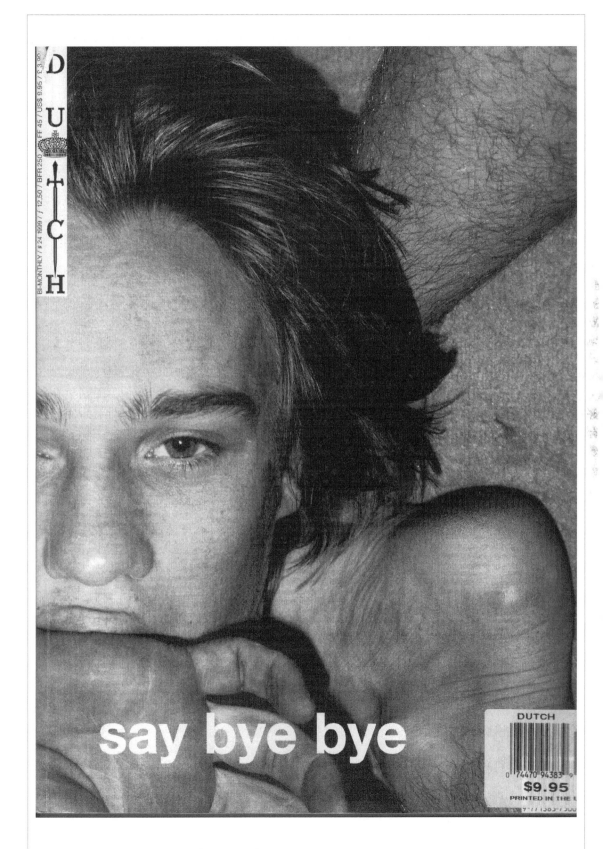

Figure 14–2: Cover of the defunct *Dutch* magazine.

corporations, images are increasingly being utilized for the dissemination of information. As digital technologies become available for both individual and professional use, the development of visual literacy skills is becoming increasingly important for both the creation and the comprehension of visual messages. But ultimately, these visual messages will need to be examined in terms of the cultural values that they depict.

More important, individuals and industries will need to evaluate the ethical issues associated with the use of digital imagery. Visual technologies are developing against the background of larger cultural change, such as the rise of transnational corporations, global marketing, and the Internet. Simultaneously, countries like the United States are witnessing a decline in traditional literacy skills. Developing both visual and verbal skills to better understand and evaluate the changing role of visual imagery within culture is an educational challenge facing us today as we move into a new century.

WEBSITES

- http://www.elephantmag.com/
- *Benetton Ads*
 http://www.icmrindia.org/casestudies/catalogue/Marketing/The%20Story%20Of%20
 Benetton's%20Advertisement%20Campaigns%20-%20Marketing.htm
 (Type "Oliverio Toscani" into http://www.youtube.com to see some of the Benetton ads.)

EXERCISES

1. Compare the use of images in the early 1900s to the use of images in the year 2010.

2. In a world that is increasingly becoming a monoculture, should we protect individual cultural differences? How could we do this?

3. Should legislation be passed to prohibit the digital manipulation of photojournalism? Why or why not?

4. Under what circumstances would it be appropriate to manipulate images? When would it not be appropriate? For instance, should digitally enhanced images be used as evidence in a courtroom trial? Why or why not?

5. Should mass media images be made copyright free? Research and debate both sides of this argument.

6. What types of visual communication skills do you think students need to live and work in the 21st century? How should these skills be acquired?

KEY TERMS

Deconstructive graphics is a term used to describe designs which deploy compositional complexity, the layering of signs, and playful confusion as a strategy to force the spectator to deconstruct "hidden" meanings within a work.

Global advertising tries to create one universal message that will work in all cultures.

Mass art is art that is produced and distributed by a mass delivery system such as printing, photography, sound recording, film, radio, or TV.

Multinational advertising is when the marketer customizes individual advertising campaigns for individual cultures.

☀ References

Almendros, N. (1984). *A man with a camera* (R. P. Belash, Trans.). New York, NY: Farrar, Straus & Giroux.

Andersen, R. (1997). Women, welfare, and the United States media. In C. Christians & M. Traber (Eds.), *Communication: Ethics and universal values* (pp. 300–326). Thousand Oaks, CA: Sage.

Arnheim, R. (1954). *Art and visual perception*. Berkeley: University of California Press.

Arnheim, R. (1969). *Visual thinking*. Berkeley: University of California Press.

Arnheim, R. (1980). A plea for visual thinking. In J.W.T. Mitchell (Ed.), *The language of images* (pp. 171–180). Chicago, IL: The University of Chicago Press.

Aukstakalnis, S. & Blatner, D. (1992). *Silicon mirage: The art and science of virtual reality*. Berkeley, CA: Peachpit Press.

Aumont, J. (1994). *The image*. London: The British Film Institute.

Bal, M. (2003). Visual essentialism and the object of visual culture. *Journal of Visual Culture, 2*(1), 5–32.

Bannan, K. J. (2000). It's catching. *Adweek, 41*(23), IQ20.

Barnard, M. (1995). Advertising: The rhetorical imperative. In C. Jenkins (Ed.), *Visual culture* (pp. 26–41). New York, NY: Routledge.

Barnes, S. B. (1995). *The development of graphical user interfaces from 1970 to 1993, and some of its social implications in offices, schools, and the graphic arts* (Doctoral dissertation). Available from New York University. (UMI No. 9609383)

Barnes, S. B. (1997). Douglas C. Engelbart: Developing the underlying concepts for graphical interfaces and contemporary computing. *IEEE Annals of the History of Computing,. 19*(3), 16–26. (Refereed)

Barnes, S.B. (2000). Bridging the differences between social theory and technological invention in human-computer interface design. *New Media & Society, 2*(3), 373–393.

Barnes, S.B. (2007). Alan Kay: Transforming the computer into a communication medium. *IEEE Annals of the History of Computing, 29*(2), 18–30.

Barnes, S.B. (2009). *Visual impact: The power of visual persuasion*. Cresskill, NJ: Hampton Press.

Barnes, S.B. (2011). Remix culture. In R. M. O'Connell (Ed.), *Teaching with multimedia, vol. 1* (pp. 47–58). Cresskill, NJ: Hampton Press.

Barnes, S. B., & Hair, N.F. (2009). From banners to YouTube: Using the rear-view mirror to look at the future of advertising. *International Journal of Internet Marketing and Advertising, 5*(3), 223–239.

Barnouw, E. (1983). *Documentary: A history of the non-fiction film*. New York, NY: Oxford University Press.

Barnouw, E. (1990). *Tube of plenty* (2nd ed.). New York, NY: Oxford University Press.

Barry, A.M.S. (1997). *Visual intelligence: Perception, image, and manipulation in visual communication*. Albany: State University of New York Press.

Barthes, R. (1957). *Mythologies* (A. Lavers, Trans.). New York, NY: Hill & Wang.

Barthes, R. (1979). The photographic message. In P.R. Petruck (Ed.), *The camera viewed: Writings on twentieth-century photography* (pp. 188–201). New York, NY: E.P. Dutton.

Barthes, R. (1981). *Camera lucida: Reflections on photography* (R. Howard, Trans.). New York, NY: Hill & Wang.

Baudrillard, J. (1994). *Simulacra and simulation* (S.F. Glaser, Trans.): Ann Arbor: The University of Michigan Press.

Bazin, A. (1967). *What is cinema?* Berkeley: University of California Press.

Berger, A. A. (1995). *Essentials of mass communication theory.* Thousand Oaks, CA: Sage.

Berger, A.A. (1998). *Seeing is believing.* Mountain View, CA: Mayfield Press.

Berger, A.A. (1999). *Signs in contemporary culture.* Salem, WI: Sheffield Publishing.

Berger, J. (1972). *Ways of seeing.* New York, NY: Penguin Books.

Berger, J. (1980). *About looking.* New York, NY: Pantheon Books.

Bhabha, H. K. (1999). The other question: The stereotype and colonial discourse. In J. Evans & S. Hall (Eds.), *Visual culture: The reader* (pp. 370–378). Thousand Oaks, CA: Sage Publications.

Biocca, F.A., & Rolland, J.P. (1995). Virtual eyes can rearrange your body: Adaptation to visual displacement in see-through head-mounted displays. *Proceedings of Virtual Reality Annual International Symposium '95* (VRAIS, '95). Retrieved from http://mindlab.msu.edu/mind/presence/presence.html

Biocca, R. & Levy, M.R. (1995). *Communication in the age of virtual reality.* Hillsdale, NJ: Lawrence Erlbaum.

Black, R. (1997). *Web sites that work.* San Jose, CA: Adobe Press.

Bolter, J. D. (1991). *Writing space.* Hillsdale, NJ: Lawrence Erlbaum.

Bolter, J. D. (1996). Virtual reality and the redefinition of self. In L. Strate, R. Jacobson & S.B. Gibson (Eds.), *Communication and cyberspace* (pp. 105–119). Cresskill, NJ: Hampton Press.

Bolter, J. D. & Grusin, R. (1999). *Remediation: Understanding new media.* Cambridge, MA: MIT Press.

Boorstin, D. J. (1961). *The image: A guide to pseudo-events in America.* New York, Atheneum.

Boyd, D. & Ellison, N. B. (2008). Social network sites: Definition, history, and scholarship. *Journal of Computer-Mediated Communication, 13,* 210–230.

Brown, J.S. (1996). The social lie of documents. *First Monday. 1*(1), X. Retrieved from http://firstmonday.org

Bruner, J. S. (1966). *Towards a theory of instruction.* Cambridge, MA: Harvard University Press.

Bruner, J. S. (1986). *Actual minds, possible worlds.* Cambridge, MA: Harvard University Press.

Bruner, J. S. (1990). *Acts of meaning.* Cambridge, MA: Harvard University Press.

Bush, V. (1945). As we may think. *Atlantic Monthly, 176* (1), 641–649.

Bush, V. (1991). As we may think. In J. M. Nyce & P. Kahn (Eds.), *From memex to hypertext: Vannevar Bush and the mind's new machine* (pp. 197–216). Boston, MA: Academic Press.

Byrne, C., & Witte, M. (1990). A brave new world: Understanding deconstruction. *Print,* Vol. XLIV, Issue VI, November/ December.

Campbell, J. (1949). *The hero with a thousand faces.* Princeton, NJ: Princeton University Press.

Campbell, J. (1972). *Myths to live by.* New York, NY: Bantam Books.

Carey, J.W. (1989). *Communication as culture.* New York, NY: Routledge.

Carrell, J. L. (2002). Mirror images. *Smithsonian,* February, pp. 76–82.

Carroll, N. (1998). *A philosophy of mass art.* New York, NY: Oxford University Press.

Cartwright, G.F. (1994, March–April). Virtual or real? The mind in cyberspace. *The Futurist, 28* (2), 22–26.

Cha, M., Kwak, H., Rodriguez, P., Ahn, Y. & Moon, S. (2007, October 24–26). I tube, you tube, everybody tubes: Analyzing the world's largest user generated content video system. *IMC '07,* San Diego, California.

Chandler, D. (2009). *Semiotics for beginners.* Retrieved from http://www.aber.ac.uk/media/Documents/S4B/sem02.html

Chetwynd, T. (1980). *How to interpret your own dreams.* New York, NY: Bell Publishing Company.

Cirlot, J.E. (1962). *A dictionary of symbols* (2nd ed.). New York, NY: Philosophical Library.

Clift, J. D. & Clift, W. B. (1986). *Symbols of transformation in dreams.* New York, NY: Crossroad.

Cobley, P. & Jansz, L. (1997). *Introducing semiotics.* Cambridge, MA: Totem.

Cole, R.V. (1921). *Perspective for artists.* New York, NY: Dover Publications.

Cooper, J.C. (1978). *An illustrated encyclopedia of traditional symbols.* New York, NY: Thames & Hudson.

Cotton, B. & Oliver, R. (1993). *Understanding hypermedia: From multimedia to virtual reality.* London: Phaidon Press.

Crary, J. (1990). *Techniques of the observer.* Cambridge, MA: MIT Press.

Dake, D.M. (1994). Visual thinking skills for the digital age. In D. G. Beauchamp, R. A. Braden, & J. C. Baca (Eds.), *Visual literacy in the digital age* (pp. 131–144). Manhattan, KS: International Visual Literacy Association.

Debes, J.L. (1970). The loom of visual literacy—An overview. In C.M. Williams & J.L. Debes (Eds.), *Proceedings of the First National Conference on Visual Literacy.* New York, NY: Pitman Publishing Corporation.

Debord, G. (1995). *The society of the spectacle.* New York, NY: Zone Books.

Dember, W.N. & Warm, J.S. (1979). *Psychology of perception* (2nd ed.). New York, NY: Holt, Rinehart & Winston.

Deuze, M. (2004). Journalism studies beyond media: On ideology and identity. *Ecquid Novi, 25*(2), 275–293.

Don, F. (1977). *Color your world.* New York, NY: Destiny Books.

Dondis, D.A. (1973). *A primer of visual literacy.* Cambridge, MA: MIT Press.

Dreyfuss, H. (1972). *Symbol sourcebook: An authoritative guide to international graphic symbols.* New York, NY: Van Nostrand Reinhold Company.

Druckrey, T. (1996). *Electronic culture: Technology and visual representation.* New York, NY: Aperture Foundation.

Dubery, F. & Willats, J. (1983). *Perspective and other drawing systems.* New York, NY: Van Nostrand Reinhold.

Dupagne, M. & Seel, P.B. (1998). *HDTV: High-definition television: A global perspective.* Ames: Iowa State University Press.

Eco, U. (1985). How culture conditions the colours we see. In M. Blonsky (Ed.), *On signs* (pp. 157–175). Baltimore, MD: Johns Hopkins University Press.

Eisenstein, E. L. (1979). *The printing press as an agent of change.* Cambridge, UK: Cambridge University Press.

Eisenstein, E. L. (1983). *The printing revolution in early modern Europe.* Cambridge, UK: Cambridge University Press.

Eisenstein, S. (1949). *Film form.* New York, NY: Harcourt Brace Jovanovich, Publishers.

Engelbart, D.C. (1963). A conceptual framework for the augmentation of man's intellect. In P. W. Howerton & D. C. Weeks (Eds.), *Vistas in information handling* (Vol. 1, pp. 1–29). Washington, DC: Spartan Books.

Ewen, S. (1988). *All consuming images.* New York, NY: Basic Books.

Faraday, A. (1974). *The dream game.* New York, NY: Harper & Row.

Felton, G. (1994). *Advertising: Concept and copy.* Englewood Cliffs, NJ: Prentice Hall.

Firth, K. T. (1998). *Undressing the ad.* New York, NY: Peter Lang Publishing.

Foss, S. K. & Kanengieter, M. R. (1992). Visual communication in the basic course. *Communication Education 41*(3), 312–323.

Freud, S. (1913). *The interpretation of dreams.* New York, NY: The Macmillan Company.

Fromm, E. (1951). *The forgotten language.* New York, NY: Grove Press, Inc.

Gardner, H. (1983). *Frames of mind: The theories of multiple intelligences.* New York, NY: Basic Books.

Gardner, H. (1993). *Creating minds.* New York, NY: Basic Books.

Gardner, H. (1999). *Intelligence reframed: Multiple intelligences for the 21st century.* New York, NY: Basic Books.

Garfield, B. (2006, December). YouTube vs., boob tube. *Wired Magazine,* December, 222–227.

Gelb, I.J. (1952). *A study of writing.* Chicago, IL: The University of Chicago Press.

Gergen, K. J. (1991). The saturated self. New York, NY: Basic Books.

Giedion, S. (1948). *Mechanization takes command.* New York, NY: W.W. Norton.

Gill, B. (1981). *Forget all the rules you ever learned about graphic design including the ones in this book.* New York, NY: Watson-Guptill Publications.

Gill, S. (2010). From page to screen and beyond. In S. Josephson, S. B. Barnes & M. Lipton (Eds.), *Visualizing the web* (pp. 27–43). New York, NY: Peter Lang.

Glazer, M. (1985). I listen to the market. In M. Blonsky (Ed.), *On signs* (pp. 465–474). Baltimore, MD: Johns Hopkins University Press.

Goffman, E. (1974). *Frame analysis: An essay on the organization of experience.* New York, NY: Harper Colophon Books.

Gombrich, E.H. (1969). *Art and illusion.* Princeton, NJ: Princeton University Press.

Gombrich, E.H. (1972). *Symbolic images.* Chicago, IL: The University of Chicago Press.

Gombrich, E.H. (1984). *The sense of order.* Ithaca, NY: Cornell University Press.

Gombrich, E.H. (1999). *The uses of images: Studies in the social function of art and visual communication.* London: Phaidon.

Goodman, N. (1968). *Languages of art: An approach to a theory of symbols.* Indianapolis, IN: Bobbs-Merrill.

Goodman, N. (1978). *Ways of worldmaking.* Indianapolis, IN: Hackett Publishing.

Graphic Design: USA. (1994, April). Apple's power Macintosh launched: What does it mean to graphic design? *Graphic Design: USA,* April, 1.

Greenberg, B.S. (1980). *Life on television: Content analyses of U.S. tv drama.* Norwood, NJ: Ablex.

Greenberg, D.P. (1999, August). A framework for realistic image synthesis. *Communications of the ACM, 42*(8), 45–53.

Greenfield, P. M. (1984). *Mind and media.* Cambridge, MA: Harvard University Press.

Greenleaf, W.J. (1997, August). Applying VR to physical medicine and rehabilitation. *Communications of the ACM, 40*(8), 34–39.

Gregory, R.L. (1970). *The intelligent eye.* New York, NY: McGraw-Hill.

Gronstedt, A. (2007). Second Life: The 3-D web world is slowly becoming part of the training industry. *Training and Development,* August, 44–49.

Gross, L. (1974). Modes of communication and the acquisition of symbolic competence. In D.R. Olson (Ed.), *Media and symbols: The forms of expression, communication, and education* (pp. 56–80). Chicago, IL: The University of Chicago Press.

Gross, L., Katz, J. S. & Ruby, J. (2003). *Image ethics in the digital age.* Minneapolis, MN: University of Minnesota Press.

Guglielmo, C. (1998). Web communities can get sticky. *Interactive Week,* July 27,35.

Gumpert, G. & Cathcart, R. (1986). *Intermedia: Interpersonal communication in a media world* (3rd ed.). New York, NY: Oxford University Press.

Haag, B.B. & Snetsinger, W. (1994). Aesthetics and screen design: An integration of principles. In D. G. Beauchamp, R. A. Braden, & J. C. Baca (Eds.), *Visual literacy in the digital age* (pp. 92–97). Manhattan, KS: International Visual Literacy Association.

Harris, C. R. & Lester, P. M. (2002). *Visual journalism.* Boston, MA: Allyn & Bacon.

Harris, L.D. (1994, February 28). The psychodynamic effects of virtual reality. *The Arachnet Electronic Journal on Virtual Culture, 2* (1), n.p.

Hatcher, E.P. (1974). *Visual metaphors.* Albuquerque: University of New Mexico Press.

Hauser, A. (1957A). *The social history of art, volume 2.* New York, NY: Vintage Books.

Hauser, A. (1957 B). *The social history of art, volume 1.* New York, NY: Vintage Books.

Havelock, E.A. (1963). *Preface to Plato.* Cambridge, MA: Harvard University Press.

Healy, J.M. (1990). *Endangered minds.* New York, NY: Simon & Schuster.

Heim, M. (1987). *Electronic language: A philosophical study of word processing.* New Haven, CT: Yale University Press.

Heller, S. (1998). *The education of a graphic designer.* New York, NY: Allworth Press.

Heller, S. & Pomeroy, K. (1997). *Design literacy.* New York, NY: Allworth Press.

Henning-Thurau, T., Gwinner, K.P., Walsh, G. & Gremler, D. (2004). Electronic word-of-mouth via consumer-opinion platforms: What motivates consumers to articulate themselves on the Internet? *Journal of Interactive Marketing, 18*(1), 38–52.

Himmelstein, H. (1984). *Television myth and the American mind.* New York, NY: Praeger.

Hoffman, D. D. (1998). *Visual intelligence: How we create what we see.* New York, NY: W.W. Norton.

Hofmann, A. (1965). *Graphic design manual: Principles and practice.* New York, NY: Van Nostrand Reinhold.

Holland, J. & Baker, S.M. (2001). Customer participation in creating site brand loyalty. *Journal of Interactive Marketing, 15*(4), 40.

Hornung, C.P. (1956). *Handbook of early advertising art.* New York, NY: Dover Publications.

Hughes, R. (1991). *The shock of the new.* New York, NY: McGraw-Hill.

International Paper. (1989). *Pocket pal: A graphics arts production handbook.* Memphis, TN: International Paper Company.

Itten, J. (1970). *The elements of color* (E. Van Hagen, Trans). New York, NY: Van Nostrand Reinhold.

Itten, J. (1975). *Design and form.* New York, NY: Van Nostrand Reinhold.

Ivins, Jr., W. M. (1943). *How prints look.* Boston, MA: Beacon Press.

Ivins, Jr., W.M. (1946). *Art & geometry: A study in space intuitions.* New York, NY: Dover Publications.

Jacobson, S. (2010). Emerging models of multimedia journalism: A content analysis of multimedia packages published on nytimes.com. *Atlantic Journal of Communication, 18*(2), 63–78.

Jaffé, A. (1964). Symbolism in the visual arts. In C. Jung, (Ed,), *Man an his symbols.* (pp. 255–322). NewYork, NY: Dell Publishing.

Jameson, F. (1991). *Postmodernism, or the cultural logic of late capitalism.* Durham, NC: Duke University Press.

Janson, H.W. (1995). *History of art, fifth edition.* Upper Saddle River, NJ: Prentice Hall.

Jennings, N. & Collins, C. (2008). Virtual or virtually: Educational institutions in Second Life. *International Journal of Social Sciences, 2*(3), 180–186.

Jobling, P. & Crowley, D. (1996). *Graphic design: Reproduction and representation since 1800.* Manchester, UK: Manchester University Press.

Jones, K. T. (2009). The persuasive function of the visual ideograph. In S.B. Barnes (Ed.), *Visual impact: The power of visual persuasion* (pp. 73–184). Cresskill, NJ: Hampton Press.

Josephson, S., Barnes, S. B., & Lipton, M. (2010). *Visualizing the web.* New York, NY: Peter Lang Publishing.

Josephson, S. (2010). Using eye-tracking to see how viewers process information in cyberspace. In S. Josephson, S. B Barnes & M. Lipton (Eds.), *Visualizing the web* (pp. 99–122). New York, NY: Peter Lang.

Jung, C.G. (1964). *Man and his symbols.* New York, NY: Dell.

Kandinsky, W. (1977). *Concerning the spiritual in art.* New York, NY: Dover Publications

Kay, A.C. (1990). User interface: A personal view. In B. Laurel (Ed.), *The art of human–computer interface design* (pp. 191–207). Reading, MA: Addison-Wesley.

Kelton, A. J. (2007). Second Life: Reaching into the virtual world for real-world learning. *Research Bulletin, Educause Center for Applied Research, 17,* 10–13.

Kemp, M. (1990). *The science of art.* New Haven, CT: Yale University Press.

Kennedy, L., Naaman, M., Ahern, S., Nair, R. & Rattenbury, T. (2007, September). How Flickr helps us make sense of the world: Context and content in community contributed media collections. *MM '07,* Augsburg, Bavaria, Germany.

Kerlow, I.V. & Rosebush, J. (1986). *Computer graphics for designers and artists.* New York, NY: Van Nostrand Reinhold.

Koch, R. (1930). *The book of signs.* New York, NY: Dover Publications.

Kosslyn, S.M. (1994). *Image and the brain: The resolution of the imagery debate.* Cambridge, MA: MIT Press.

Kosslyn, S.M. & Koenig, O. (1995). *Wet mind: The new cognitive neuroscience.* New York, NY: Free Press.

Kuhn, A. (1990). *Alien zone: Cultural theory and contemporary science fiction cinema.* New York, NY: Verso.

Lakoff, G. & Johnson, M. (1980). *Metaphors we live by.* Chicago, IL: The University of Chicago Press.

Landa, R. (1983). *An introduction to design.* Englewood Cliffs, NJ: Prentice Hall.

Langer, S.K. (1953). *Feeling and form.* New York, NY: Charles Scribner's Sons.

Langer, S.K. (1957). *Philosophy in a new key.* Cambridge, MA: Harvard University Press.

Lanham, R.A. (1993). *The electronic word.* Chicago, IL: The University of Chicago Press.

Lanier, J. (2010). *You are not a gadget.* New York, NY: Knopf.

Laspina, J.A. (1998). *The visual turn and the transformation of the textbook.* Mahwah, NJ: Lawrence Erlbaum.

Lasswell, H. D. (1948). *Power and personality.* New York, NY: W.W. Norton & Company.

Laurel, B. (1993). *Computers as theatre.* Reading, MA: Addison-Wesley.

Lenhart, A., Madden, M., Macgill, A. R. & Smith, A. (2007). Teens and social media: The use of social media gains a greater foothold in teen life as they embrace the conversational nature of interactive online media. *Pew Internet and American Life Project.*

Lessig, L. (2008). *Remix: Making art and commerce thrive in the hybrid economy.* New York, NY: Penguin.

Lester, P. (2011). *Visual communication: Images with messages* (5th ed.). Boston, MA: Wadsworth.

Levy, S. (1994). *Insanely great: The life and times of Macintosh, the computer that changed everything.* New York, NY: Viking.

Livingstone, M. (2002). *Vision and art: The biology of seeing.* New York, NY: Abrams.

Logan, R. K. (1986). *The alphabet effect.* New York, NY: St. Martin's Press.

Lupton, E. (1998). Designer as producer. In S. Heller (Ed.), *The education of a graphic designer* (pp. 159–162). New York, NY: Allworth Press.

Lyotard, J-F. (1991). *The inhuman: Reflections on time.* Stanford, CA: Stanford University Press.

Marchand, R. (1985). *Advertising the American dream.* Berkeley: University of California Press.

McAllister, M. P. (1998). Sponsorship, globalization, and the summer Olympics. In K. T. Firth (Ed.), *Undressing the ad* (pp. 35–64). New York: NY: Peter Lang Publishing.

McCaffery, L. (1992). *Storming the reality studio: A casebook of cyberpunk and postmodern fiction.* Durham, NC: Duke University Press.

McCloud, S. (1993). *Understand comics: The invisible art.* New York, NY: HarperCollins.

McCloud, S. (2000). *Reinventing comics.* New York, NY: HarperCollins.

McCoy, K. (1998). Education in an adolescent profession. In S. Heller (Ed.), *The education of a graphic designer* (pp. 3–12). New York, NY: Allworth Press.

McLuhan, M. (1964). *Understanding media.* New York, NY: Signet Books.

Meggs, P. B. (1983). *A history of graphic design.* New York, NY: Van Nostrand Reinhold.

Meggs, P.B. (1989). *Type & image: The language of graphic design.* New York, NY: Van Nostrand Reinhold.

Memon, F. (1995, March 9). How virtual reality could make you sick. *New York Post,* p. 36.

Messaris, P. (1994). *Visual literacy: Image, mind, & reality.* Boulder, CO: Westview Press.

Metallinos, N. (1996). *Television aesthetics.* Mahwah, NJ: Lawrence Erlbaum.

Metz, C. (1985). Some points in the semiotics of the cinema. In G. Mast & M. Cohen (Eds.), *Film theory and criticism* (3rd ed., pp. 164–176). New York, NY: Oxford University Press.

Meyer, K. (1995). Dramatic narrative in virtual reality. In F. Biocca & M.R. Levy (Eds.), *Communication in the age of virtual reality* (pp. 219–258). Mahwah, NJ: Lawrence Erlbaum.

Meyrowitz, J. (1985). *No sense of place.* New York, NY: Oxford University Press.

Michaels, C.F. & Carello, C. (1981). *Direct perception.* Englewood Cliffs, NJ: Prentice Hall.

Miller, G.H. (1983). *The dictionary of dreams.* Devon, UK: Blaketon-Hall Limited.

Millidge, J. & Hodge, J. (2010). *Icons.* East Bridgewater, MA: World Publications Group.

Mirzoeff, N. (1998). *The visual culture reader.* New York, NY: Routledge.

Mirzoeff, N. (1999). *An introduction to visual culture.* London: Routledge.

Mitchell, W.J. (1992). *The reconfigured eye: Visual truth in the post-photographic era.* Cambridge, MA: MIT Press.

Mitchell, W.J.T. (1994). *Picture theory.* Chicago, IL: The University of Chicago Press.

Mitchell, W.J.T. (1995, December). Interdisciplinarity and visual culture. *Art Bulletin, LXXVII*(4), 540–544.

Mitchell, W. J. T. (2002). Showing seeing: A critique of visual culture. *Journal of Visual Culture,* 1 (2), 165–181.

Modley, R. & Myers, W.R. (1976). *Handbook of pictorial symbols.* Mineola, NY: Dover Pictorial Archives.

Moholy-Nagy, L. (1969). Typofoto. In J. Seligman (Trans.), *Painting, photography, film* (p. 40). Cambridge, MA; The MIT Press.

Monaco, J. (1981). *How to read a film.* New York, NY: Oxford University Press.

Montes-Armenteros, C. (1998). Ideology in public service advertisements. In K.T. Frith (Ed.), *Undressing the Ad* (pp. 131–149). New York, NY: Peter Lang.

Moody, F. (1995). I sing the body electronic: A year with Microsoft on the multimedia frontier. New York, NY: Viking.

Moran, T. P. (2010). *Introduction to the history of communication: Evolutions & revolutions.* New York, NY: Peter Lang.

Morgan, J. & Welton, P. (1992). *See what I mean?* (2nd ed.). London: Hodder & Stoughton.

Münsterberg, H. (1985). The film: A psychological study. In G. Mast & M. Cohen (Eds.), *Film theory and criticism* (3rd ed., pp. 331–339). New York, NY: Oxford University Press.

Murch, G.M. (1973). *Visual and auditory perception.* Indianapolis, IN: The Bobbs-Merrill Company.

Myslewski, R. (2011). Motorola Super Bowl ad rips Apple drones. *The Register.* Retrieved fromhttp://www.theregister. co.uk/2011/02/05/motorola_super_bowl

Negoescu, R-A. & Gatica-Perez, D. (2008, July). Analyzing Flickr groups. *CIVR'08,* Niagara Falls, Ontario, Canada.

Negroponte, N. (1995). *Being digital.* New York, NY: Random House.

Newton, J. H. (2001). *The burden of visual truth.* Mahwah, NJ: Lawrence Erlbaum.

Nielsen, J. (1997). The telephone is the best metaphor for the web. *Alertbox for May13.* Retrieved fromhttp://www.useit. com/alertbox/9705b.html

Norman, D.A. (1988). *The psychology of everyday things.* New York, NY: Basic Books.

Norman, D.A. (1998). *The invisible computer.* Cambridge, MA: MIT Press.

Nystrom, C. (2000). Symbols, thought, and reality: The contributions of Benjamin Lee Whorf and Susanne K. Langer to media ecology. *The New Jersey Journal of Communication, 8*(1), 8–33.

O'Connell, R. (2010). Web site usability: Tips, techniques, and methods. In S. Josephson, S. B. Barnes & M. Lipton (Eds.), *Visualizing the web* (pp. 123–140). New York, NY: Peter Lang.

Olson, D. E. (1974). *Media and symbols.* Chicago, IL: The University of Chicago Press.

Olson D.R. & Bruner, J.S. (1974). Learning through experience and learning through media. In D.E. Olson (Ed.), *Media and symbols,* (pp. 125–150). Chicago, IL: The University of Chicago Press.

Ong, W.J. (1982). *Orality and literacy: The technologizing of the word.* London: Methuen.

Ong, W. J. (1998). Writing: Ancient origins with modern implications. *Communications Research Trends, 18*(2), 4–21.

Palfreman, J. (1992). *The dream machine.* London, UK; BBC TV [video].

Palfreman, J. & Swade, D. (1991). *The dream machine.* London, UK: BBC Books.

Papert, S. (1996). *The connected family: Bridging the digital generation gap.* Atlanta, GA: Longstreet Press.

Pavlik, J.V. (1996). *New media technology: Cultural and commercial perspectives* (2nd ed.). Boston, MA: Allyn & Bacon.

Peirce, C.S. (1998*). The essential Peirce, Volume II.* Bloomington: Indiana University Press.

Peterson, V.V. (2010). An elemental approach to web site visuals. In S. Josephson, S. B. Barnes & M. Lipton (Eds.), *Visualizing the web* (pp. 65–84). New York, NY: Peter Lang.

Piaget, J. (1971). *Biology and knowledge: An essay on the relations between organic regulations and cognitive processes.* Chicago, IL: The University of Chicago Press.

Pinker, S. (1984). *Visual cognition .* Cambridge, MA: MIT Press

Postman, N. (1979). *Teaching as a conserving activity.* New York, NY: Dell.

Postman, N. (1985). *Amusing ourselves to death.* New York, NY: Penguin Books.

Poynor, R. (2003). *No more rules: Graphic design and postmodernism.* London, UK: Laurence King Publishing.

Poynor, R. (2010). Where is art now? *Elephant, 4: Autumn,* 204–207.

Radford, M. L., Barnes, S. B. & Barr, L. R. (2006). *Web research: Selecting, evaluating, and citing* (2nd ed.). Boston, MA: Allyn & Bacon.

Rand, P. (1985). *Paul Rand: A designer's art.* New Haven, CT: Yale University Press.

Redon, O. (1986). *To myself: Notes on life, art and artists.* New York, NY: George Braziller.

Reeves, B. & Nass, C. (1996). *The media equation.* New York, NY: Cambridge University Press.

Renk, J.M., Branch, R.C., & Chang, E. (1994). Visual information strategies in mental model development. *Selected Readings from the 25th Annual Conference of the International Visual Literacy Association,* 81–91.

Richmond, W. (1990). *Design & technology: Erasing the boundaries.* New York, NY: Van Nostrand Reinhold.

Ritchin, R. (1990). *In our own image: The coming revolution in photography.* New York, NY: Aperture.

Ruder, E. (1981). *Typography: A manual of design.* New York, NY: Hastings House.

Rushkoff, D. (1999). *Playing the future: What we can learn from digital kids.* New York, NY: Riverhead Books.

Ryan, J. (2010). *A history of the Internet and the digital future.* London: Reaktion Books.

Saussure, F. de. (1974). *Course in general linguistics* (W. Baskin, Trans.). London: Fontana/Collins.

Saussure, F. de. (1983). *Course in general linguistics*(R. Harris, Trans.). London: Duckworth.

Schiller, H.I. (1986). *Culture Inc.: The corporate takeover of public expression.* New York, NY: Oxford University Press.

Schmandt-Besserat, D. (1992). *Before writing: From counting to cuneiform.* Austin, TX: University of Texas Press.

Schroeder, R. (1996). *Possible world: The social dynamic of virtual reality technology.* Boulder, CO: Westview Press.

Sebeok, T.A. (1985). Pandora's box: How and why to communicate 10,000 years into the future. In M. Blonsky (Ed.), *On signs* (pp. 448–466). Baltimore, MD: Johns Hopkins University Press.

Seelye, K. (2007, June 14). YouTube passes debates to a new generation. *The New York Times,* n.p.

Siegel, D. (1996). *Creating killer web sites: The art of third-generation site design.* Indianapolis, IN: Hayden Books.

Sharkey, B. (1988). Pandora's desktop. *Adweek Special Report, American Design, October 3,* 4–10.

Sheehan, B., Tsao, J. & Yang, S. (2010). Motivations for gratifications of digital music piracy among college students. *Atlantic Journal of Communication, 18*(5), 241–258.

Shropshire, E. (1989). Computer graphics and the art directors at *Playboy. Art Product New*s, *July/August,*16–20.

Smith, K., Moriarty, S., Barbatsis, G. & Kenney, K. (2005). *Handbook of visual communication: Theory, methods, and media.* Mahwah, NJ: Lawrence Erlbaum Associates.

Solso, R. L. (1994). *Cognition and the visual arts.* Cambridge, MA: MIT Press.

Sontag, S. (1977). *On photography.* New York, NY: Dell.

Sontag, S. (1999). The image-world. In J. Evans & S. Hall (Eds.), *Visual culture: The reader* (pp. 80–94). London: Sage.

Sony Corporation, (1985). *Sony Corporation's Visual Identity program.* New York, NY: Sony Corporation.

Stam, R. & Spence, L. (1985). Colonialism, racism, and representation: An introduction. In B. Nichols (Ed.), *Movies and methods, Vol. 2,* pp. 632–649). Berkeley: University of California Press.

Steichen, E. (1979). Photography at The Museum of Modern Art. In P.R. Petruck (Ed.), *The camera viewed: Writings on twentieth-century photography* (pp. 1–2). New York, NY: E.P. Dutton.

Stephens, M. (1998). *The rise of the image and the fall of the word.* New York, NY: Oxford University Press.

Stiebner, E.D. & Urban, D. (1982). *Signs & emblems.* New York, NY: Van Nostrand Reinhold.

Strate, L., Jacobson, R., & Gibson, S. (1996). *Communication and cyberspace.* Cresskill, NJ: Hampton Press.

Sturken, M. & Cartwright, L. (2001). *Practices of looking: An introduction to visual culture.* New York, NY: Oxford University Press.

Tagg, J. (1999). Evidence, truth and order: Photographic records and the growth of the state. In J. Evans & S. Hall (Eds.), *Visual culture: The reader* (pp. 244–273). London: Sage.

Talbot, W. H. (1846). *The pencil of nature.* London, UK: Longman, Brown, Green & Longmans.

Tufte, E.R. (1990). *Envisioning information.* Cheshire, CT: Graphics Press.

Ulmer, G. (1989). *Teletheory: Grammatology in the age of video,* New York, NY: Routledge.

vonWodtke, M. (1993). *Mind over media: Creative thinking skills for electronic media.* New York, NY: McGraw-Hill.

White, J.V. (1990). *Color for the electronic age.* New York, NY: Watson-Guptill.

Wileman, R.E. (1980). *Exercises in visual thinking.* New York, NY: Hastings House.

Williams, R. (1999). Beyond visual literacy: Omniphasism, a theory of balance. *Journal of Visual Literacy,19*(2), 159–178.

Williams, R. (2009). The artist's eye: Understanding the effects of the unconscious mind on image meaning, image consumption, and behavior. In S.B. Barnes (Ed.), *Visual impact* (pp. 21–43). Cresskill, NJ: Hampton Press.

Williamson, J. (1978). *Decoding advertisements.* London: Marion Boyars.

Youngblood, G. (1970). *Expanded cinema.* New York, NY: E.P. Dutton.

Zahan, D. (1977). *Color symbolism.* Dallas, TX: Spring Publications.

Zeltzer, D. & Addison, R.K. (1997, August). Responsive virtual environments. *Communications of the ACM, 40*(8), 61–64.

Zettl, H. (1996). Back to Plato's cave: Virtual reality. In L. Strate, R. Jacobson, & S. Gibson (Eds.), *Communication and cyberspace* (pp. 83–94). Cresskill, NJ: Hampton Press.

Zettl, H. (1990). *Sight sound motion: Applied media aesthetics* (2nd ed.). Belmont, CA: Wadsworth.

Zettl, H. (1999). *Sight sound motion: Applied media aesthetics* (3rd ed.). Belmont, CA: Wadsworth.

Index

Susan B. Barnes, *General Editor*

Visual communication is the process through which individuals in relationships, organizations, and cultures interpret and create visual messages in response to their environment, one another, and social structures. This series seeks to enhance our understanding of visual communication, and explores the role of visual communication in culture. Topics of interest include visual perception and cognition; signs and symbols; typography and image; research on graphic design; and the use of visual imagery in education. On a cultural level, research on visual media analysis and critical methods that examine the larger cultural messages imbedded in visual images is welcome. By providing a variety of approaches to the analysis of visual media and messages, this book series is designed to explore issues relating to visual literacy, visual communication, visual rhetoric, visual culture, and any unique method for examining visual communication.

For additional information about this series or for the submission of manuscripts, please contact Dr. Barnes at *susanbbarnes@gmail.com.*

To order other books in this series, please contact our Customer Service Department:

> (800) 770-LANG (within the U.S.)
> (212) 647-7706 (outside the U.S.)
> (212) 647-7707 FAX

Or browse online by series at www.peterlang.com.